T H E S O U N D O F S L E A T

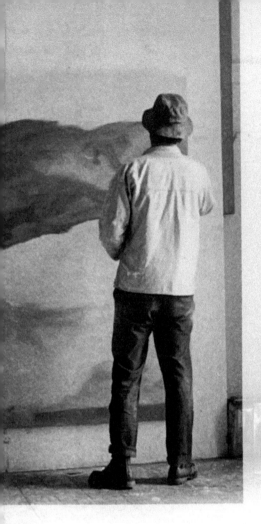

THE SOUND OF SLEAT

JON SCHUELER

EDITED BY

Magda Salvesen and Diane Cousineau

PICADOR USA, NEW YORK, 1999
JON SCHUELER FOUNDATION, NEW YORK, 2023

Book design by Songhee Kim

Frontispiece: Jon Schueler Painting in his studio in Mallaig, Scotland, 1977.

Library of Congress Catalog Number: 2023907103

Hardback ISBN: 979-8-9852884-2-1
Paperback ISBN: 979-8-9852884-3-8
eBook ISBN: 979-8-9852884-4-5

First Picador USA Edition: 1999
Second Jon Schueler Foundation Edition: 2023

ACKNOWLEDGMENTS

Excerpts from *The Sound of Sleat* have been published in *It is*, no. 5, spring 1960; *The New England Review* (now *The New England Review and Bread Loaf Quarterly*), vol.1, no.3, spring, 1979; *Jon Schueler: 1916–1992*, the Mallaig Heritage Centre, Scotland, 1995; *ARTnews*, May 1996; *Terra Nova*, vol. 1, no. 4, 1996; *The Mighty Eighth: The Air War in Europe as Told by the Men Who Fought It*, Gerald Astor, Donald I. Fine Books (Penguin Putnam Inc.), 1996.

All black-and white photographs come from the artist's estate. Credits: Acme, page 253; Oliver Baker, page 235; Ruth Channing, page 191; Jean Conver, page 176; Joellen Hall, page 27; Richard Lytle, page 59; Archie Iain McLellan, frontispiece/title page and page 279; George Oliver, 329 (bottom); Antonia Reeve, 358; Magda Salvesen, pages 213, 269, 271, 329 (top), 335; Walter Silver, page 1; Jon Schueler, pages 15, 28, 137, 150, 185, 190, 201.

Special thanks to the following for use of their letters: Leo Castelli, B.H. Friedman, Joellen Hall, Ben Heller, Cindy Lee (McKinley), Henry McKenzie Johnston, Sandra Pailet, and Alastair Reid.

CONTENTS

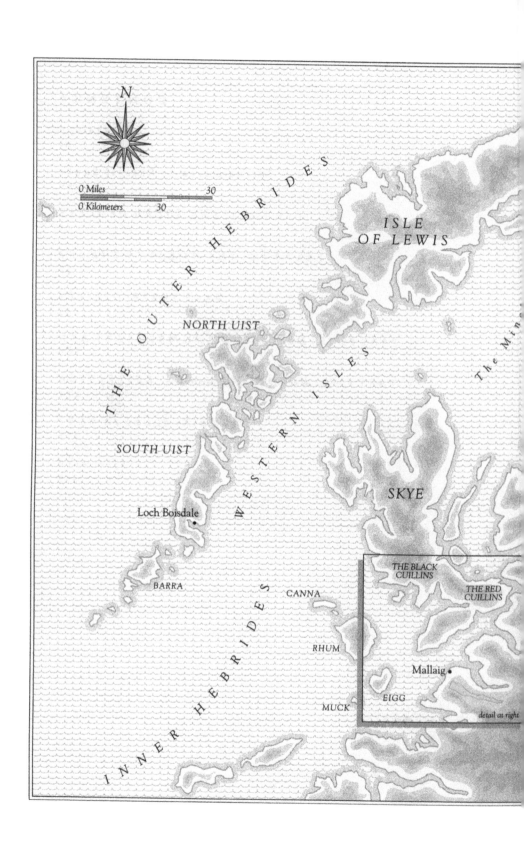

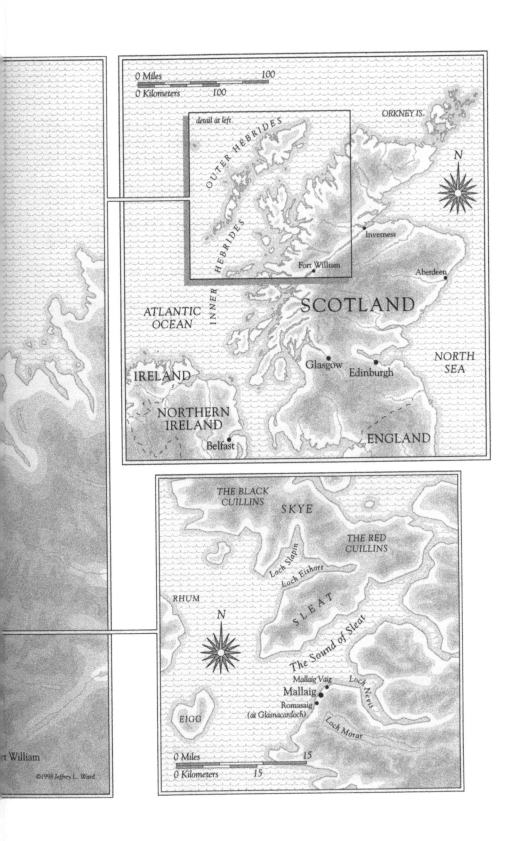

0 Miles 100
0 Kilometers 100

detail at left

ORKNEY IS.

OUTER HEBRIDES

INNER HEBRIDES

Inverness

Fort William

ATLANTIC OCEAN

SCOTLAND

Aberdeen

IRELAND

Glasgow
Edinburgh

NORTH SEA

NORTHERN IRELAND

Belfast

ENGLAND

©1998 Jeffrey L. Ward

THE BLACK CUILLINS

SKYE

THE RED CUILLINS

Loch Slapin
Loch Eishort

RHUM

SLEAT

The Sound of Sleat

Mallaig Vaig
Mallaig
Romasaig
(at Glasnacardoch)

Loch Nevis

Loch Morar

EIGG

0 Miles 15
0 Kilometers 15

t William

1916 Born September 12, Milwaukee, Wisconsin. Parents, George Arnold and Clara (née Haase) Schueler. Childhood and adolescence in Milwaukee where his father is a distributor of Hood tires.

1917 Death of his mother, February 5.

1920 Father remarries June 23: Margaret Vogt. Two children, Robert (b.1922) and Paula (b.1926).

c. 1928 Finds out that his stepmother is not his real mother.

1934–40 Studies at the University of Wisconsin. B.A. in Economics (1938). M.A. in English Literature (1940).

1940–41 Works for the *New Haven Evening Register*.

1941 Summer at the Breadloaf School of English, Vermont, as a scholarship student. Plans to be a writer.

1941 In September joins Air Corps of the U.S. Army. Basic training in the United States. Marries Jane Elton, August 22, 1942. (Divorced 1952.) November 1942, sent to Molesworth, England. B17 navigator, 303rd Bomber Group, 427th Squadron. Missions over France and Germany. Meets Bunty Challis in November 1942. Spring of 1943, Assistant Command Navigator, 8th Bomber Command. 1st Lieutenant. Hospitalized. Returns to the U.S. c. September 1943. Medical retirement February 1944.

1944–47 Living with his wife, Jane, in Los Angeles, California. Tries to write a book on his war experience, but meanwhile, articles for magazines, radio announcing jobs, and a scheme to set up a night club where Anita O' Day would be the principal singer. Builds a house in Topanga Canyon. Birth of two daughters: Jamie (September 24, 1944) and Joya (September 3, 1946).

1945 Schueler and his wife sign up for a portrait-painting class with David Lax in Los Angeles.

1947–48 Moves, with his wife and children, to San Francisco. Teaches literature at the University of San Francisco, paints part-time, and apparently takes some classes in 1948 at the California School of Fine Arts.

1949–51 Full time at the California School of Fine Arts, assisted by the G.I. Bill for training and subsistence. Particularly respects Clyfford Still, but also studies under Richard Diebenkorn, David Park, and Hassel Smith. Mark Rothko teaches there summer semester of 1949. Takes up the double bass.

1951 In August, moves to New York. Clyfford Still introduces him to his friends; visits Rothko's studio; meets Newman, Kline, Reinhardt, etc.

1951–57 Lives in New York at 70 East 12th Street and from September 1952 (to October 1962) at 68 East 12th Street. Summers (usually) with his children: on Block Island, Rhode Island, 1953, 1954, and 1955; on Martha's Vineyard, Massachusetts, 1956 and 1957.

1956 Marries Joellen (Jody) Hall Peet Todd, October 13,1956, whom he had met on Martha's Vineyard that summer. (Divorced March 10, 1959.)

1957 September 5, sails for Britain and sets up a studio in Mallaig Vaig, just beyond the small fishing village of Mallaig, in the West Highlands of Scotland. Goes out on the *Margaret Ann* for the first time in October. Jody arrives on November 27.

1958 Leaves Mallaig in March. Visits Italy before finding a studio in the Parisian suburb of Clamart. Jody returns to the United States on May 23. Finishes the altar painting for the Prêtres Passionistes in June. After a trip to England and Spain paints in Arcueil, Paris, trading studios with Sam Francis.

1959 Returns in January to New York City.

1950s Has one-person exhibitions in New York at the Stable Gallery (1954) and the Leo Castelli Gallery (1957 and 1959).

1960–62 Teaches at Yale Summer School, Norfolk, Connecticut (in 1960 meets Sandra Pailet and 1961 Sandra Levowitz). Visiting artist at Yale University School of Art, New Haven, 1960–62. Lives in Guilford, Connecticut, fall of 1960 to early summer 1961.

1962 Marries, January 27, Judy Dearing (whom he had met in October 1961). Divorced April 25.

1962–1967 Studio at 901 Broadway, New York City.

1962 and 1963 Spends part of the summer in Maine.

1962 Meets Mary Rogers in October. Their marriage on June 20, 1964, is annulled on May 5, 1965.

1963–67 Visiting artist at the Maryland Institute, Maryland and, 1965–1966 at the University of Pennsylvania.

1963 In December, starts the Women Paintings, using models.

1965 Summer in Galileo, Majorca, writing.

1966 Summer in Europe with his daughter, Jamie.

1967 Summer on the Isle of Skye in Scotland with Elise Piquet (whom he had met in September 1966). Works on a series of watercolors for the first time.

1967–January 1970 Based in Chester, Connecticut with Elise Piquet.

1968–69 Head of Graduate and Undergraduate Painting and Sculpture at the University of Illinois, Urbana-Champaign.

1960s One-person exhibitions at the Hirschl & Adler Galleries (1960) and the Stable Gallery (1961 and 1963), New York; and at the Maryland Institute, Baltimore (1967).

1970–1975 Based entirely in Mallaig, Scotland, living in Romasaig, the old schoolhouse. Short visits abroad (Italy, France, Morocco) and to the United States.

1970 In February, meets Magda Salvesen in Edinburgh, Scotland. She joins him in Mallaig in the Spring of 1971. After a year's separation from June 1975, Schueler and Salvesen get married on July 29, 1976.

1971 Films of Scotland makes a half-hour documentary film, *Jon Schueler: An Artist and His Vision*.

1972 Spends three months in Paris, writing.

1975 July 2, moves back to the United States. Sublets a studio at 10 Jones Street, New York City 1975–1976, and then buys a loft at 40 W. 22nd Street, which he moves into with Magda in March 1977. Keeps Romasaig, his studio in Mallaig, spending three months there most years.

1970s One-person exhibitions in Scotland at the Richard Demarco Gallery, Edinburgh (1971) and, sponsored by Richard Nathanson, at the Edinburgh College of Art (1973); in the United States, at the Whitney Museum of American Art, New York (1975). Ben Heller becomes his dealer in the United States from the fall of 1973 to c.1977.

1981 The Talbot Rice Art Centre, University of Edinburgh, becomes his studio and exhibition space for six weeks while he paints enormous paintings.

1980–1992 One-person exhibitions at the John C. Stoller Gallery, Minneapolis, Minnesota (1980); the Dorothy Rosenthal Gallery, Chicago, Illinois (1981, 1984); the Dorry Gates Gallery, Kansas City, Missouri (1982, 1986, 1991); the A.M. Sachs Gallery, New York (1983, 1984); the Katharina Rich Perlow Gallery, New York (1986, 1987, 1989, 1991); the Scottish Gallery, Edinburgh, Scotland (1991).

1992 August 5, dies in New York.

INTRODUCTION

By Russell Banks

Jon Schueler's *The Sound of Sleat*, which he worked at for over twenty years, is as much constructed, like a *tableau de rêve* by Joseph Cornell, or scored, like a piece of orchestral music by Duke Ellington, as it is written. It's a collage of prose narratives, arranged sequentially. Moving back and forth in time, flowing like memory itself from the immediate present to the recent past on to the distant past and back, combining reflection with anecdote, linking gossip to confession, juxtaposing journal entries and personal letters written and received, and questioning its own premises and ambitions even as it issues and defends the author's evolving *arts poetica*, in the end this book functions, among other things, as a nearly unique portrait of the imagination of the artist. Not just the artist named Jon Schueler (1916–1992), a prominent member of the so-called Second Generation of New York Abstract Expressionists, but the Artist generally, perhaps even universally.

I myself would call it A Portrait of the Imagination of the *American* Artist, and will try to expand a little on that later on. For now, however, let me merely point out that *The Sound of Sleat*, like the imagination of any artist, is in many ways about its own nature and is thus a dramatization of its ongoing process of perception and presentation, a display of its way of being. A self-reflexive memoir, it is one of those rare books that is necessarily greater than the sum of its parts. Despite that, and rarer still, the individual parts themselves are full of event and drama, are wonderfully revealing, are often very beautiful and sometimes darkly humorous. They're even at times downright sexy. In fact, one might say that *The Sound of Sleat* has almost too many aspects, too many parts: it is alternatively obsessive, self-conscious, ruminative, and proud; it is lyrical, funny, poignant, and modest. It offers all these faces and more. Yet, miraculously, despite its chimerical, multifaceted nature, it is a terrific, fast read. For at the heart of the book there lies a suspenseful tale, the story of a brave man struggling to name and tame his demons, demons inherited from a traumatic childhood and World War, so that he can use them in the making of his art.

· · ·

It was not always there; that suspenseful tale was not always apparent and central. So that Jon Schueler's longtime friend, Diane Cousineau, and his dedicated widow, Magda Salvesen, receive proper credit for their editorial work, readers should know something of the history of the manuscript of *The Sound of Sleat*. I first learned of its existence in the summer of 1982, when I stayed at Jon's and Magda's West Twenty-second Street loft for three months, while they were living in Provincetown, Massachusetts. Normally , they spent these months in Mallaig, Scotland, where, as the reader of this book will quickly discover, Jon's heart lay and had been lying since the end of World War Two, when he first learned of the Western Isles from a woman he was in love with, a woman who figures large in his story. That summer, however, he and Magda headed for Cape Cod. I remember thinking that perhaps Jon wished to test his deep, ongoing need for his isolated Scottish sanctuary, where life, especially as he grew older, was neither convenient nor easy of access and where the art world, for better *and* worse, never entered.

Jon and I had known each other slightly since the early 1960s, when I was in my early twenties and he, in his late forties, was briefly married to my ex-wife's college roommate (more about that latter, too). My moving to New York City in 1982 to teach at Columbia University had made it possible for us to renew and extend our friendship, and Jon and I quickly became close. I loved his paintings—there were a dozen or more of them in various sizes and media hanging on the walls of the bright, spacious loft, most of them inspired by the storm-tossed skies over Mallaig—and I was thrilled by the prospect of living in their company for three whole months.

Before he handed over the keys to the place, he asked me if sometime during the summer I'd mind reading the manuscript of a book he had written and which he planned to revise over the summer. Sort of a memoir, he said. No problem, I assured him. It was in his corner office on the desk, he told me, and left for the Cape. Then one morning a week or two later, having caught up on my end-of-semester academic work, I went looking for Jon's book. On the desk was a large carton. Inside the carton was an enormous typewritten manuscript, twenty-seven hundred pages, at least, many of them single spaced. This will be a serious test of our friendship, I thought, and began to read.

The next time I looked up, it had grown dark outside. I switched on the lamp and kept reading and read nothing else until I had finished. Was it because I knew Jon personally and

had loved his paintings for so long that his book had taken me over with such ease? Well, yes, partially. That often happens with a friend's book—although I have read few books by friends that swept me up as quickly and completely as Jon's did. But, also, Jon was the same age as my father, who had died three years earlier, and he held for me a father's mystery and attraction: he was like me in many defining ways, more so than my real father, in fact, but he had seen and done things I never would, if for no other reason than I had been born too late; further, as an older artist, Jon led his life in a way that was exemplary to me, and in the event that I ever became an older artist myself, I wanted to learn from him how to behave. So, yes, for several, rather personal reasons, I was eager to know my friend, Jon Schueler, and from the first page it was evident that his book was possibly the best way for me to do it.

Beyond that, it was written in clear and elegant prose. And beyond *that*, there was a wealth of firsthand information about a world that fascinated me. Like most writers and artists of my generation, I felt deprived by having missed out on the epoch-making New York art scene of the 1940s and '50s, when the center of the art world shifted from Paris to Manhattan, and for the first time American painters, writers, jazz musicians, and intellectuals of nearly every stripe made a world-class bohemia together. Jon had come east to New York at precisely that moment, after having studied with Clyfford Still in San Francisco, and within a week was drinking at the Cedar Tavern with de Kooning, Pollock, Rothko, and Kline. He swiftly came to know all the painters whose work would come to define the period, knew their lovers and husbands and wives, the dealers and critics, and dealt with them all intimately and professionally. A talented and energetic bassist, he hung out with jazz musicians and jammed all night into the day with his West Coast cohort, Oscar Pettiford, among others. A serious student of literature (he'd studied for a master's degree in English) who loved the company of writers, he'd known Robert Graves and been close with Alastair Reid for years, was friends with Philip Hamburger, Whitney Balliett, E.J. Kahn, and many other literary lights from Manhattan to the Hamptons, from Paris to Majorca. Heady stuff! There was in that early manuscript a wealth of anecdotal, economic, and art historical information that, because Jon had lived it, almost made me feel that I had lived it too.

Running through this material, or rather alongside it, as well as under and above it, was an ongoing paean to the fierce beauty

of Mallaig, a tiny fishing village located on the Sound of Sleat in Western Scotland. Again and again, Jon's manuscript returned to this wild, isolated place, ruminating on its austere, turbulent light, the sharp winds and storms that kept the skies in constant motion and change, and the dour but always hospitable people who lived there year-round, the natives who had welcomed the strangely obsessed American painter in much the same way as the natives of Arles had welcomed van Gogh a century earlier. Cutting against that lovesong was another song, elegiac and pained, a dirge of war and the loss of friends and mental breakdown and the melancholy end of an affair. Behind that, as if from an old-fashioned music box, there was the song in a minor key, sung in repeated, abruptly cut off phrases, of a fragmented family and a childhood scarified by secrets and lies and emotional neglect. Behind that, still another song, this one constant and continuous—a praise-hymn to the lifelong work of making pictures.

In these more than twenty-seven hundred closely written pages, then, I could make out the rough outlines of at least five different stories, none of which on its own came coherently forward and then closed in resolution, and all of which taken together, seemed somehow inadvertently to obscure a central narrative that, if it were made clearly present, would have made sense of them all. I could intuit its presence behind the others, but could not read it there. And I could not imagine how to bring it into view. Friendship with Jon allowed me, as it did others among his friends who had read the manuscript—the writers B.H. Friedman and Jay Parini and Jon's wife, Magda—to fill that absence with our personal knowledge of the man who had written it. For us, it was *his* story, Jon Schueler's, and fascinating for that, but bewildering, probably, for a reader who did not know Jon personally. The book was too long, too densely interwoven, too inclusive for a stranger to find a suspenseful unfolding of meaningful action there. In a word, to find drama there.

"Why do I write in such apparent disorder?" he asks early on in the book. "In the first place the disorder is only apparent, or only partial. In the second place I believe in the disorder. I don't know where to find the truth except in the disorder. Unless I can weave my way through it, stating, questioning, looking, resolving, breaking apart, forming, destroying, deciding, undeciding, worrying, asserting (this is the way I paint), I feel that I have lost contact and am creating an artifact. Or not creating." (page 118) For authenticity, for creation, Jon needed to trust and apply disorder as a principle of composition. For his book to become an

artifact, however, a text to be read by strangers, Jon needed an editor.

I thought, after Jon died in 1992, that the book would likely never be published. But then Magda Salvesen and Diane Cousineau went to work. Sadly for Jon, who never had the pleasure of reading it in its final, published form, but happily for the rest of us and for strangers who will read this book, Magda and Diane, without changing Jon's language or altering his voice, without misreading his intentions and desires for the book, have been able, through excision of repetitions and redundancies and by careful arrangement of what remained, to edit that original manuscript in such a way that the central story now emerges with power and clarity. Though the essential structure of the book is the same as Jon had it in that earlier manuscript, foreground is now clearly distinguished from background, front-story from back-story, cause from effect. *The Sound of Sleat* is now indeed the story of an artist's lifelong struggle to free himself from the psychological, cultural, and economic conditions that threatened to stifle his imagination. But it's no longer Jon Schueler's story alone. Dramatized here is any man's or woman's struggle, artist or not, for control of his or her destiny. Jon, I am sure, would cheerfully agree and be honored by his widow's and his friend's loving labor and delighted by the fruits of it.

Jon may well have written an extraordinary book, but it is, of course, his paintings that he most wanted to be known and remembered for. In attempting to describe Jon's paintings, critics have invoked Turner, for *their* look and the palette. Or Clyfford Still, for the monastic rigor of their imagery, the strictness of attention they require. Or Rothko, for the religiosity of the pictures, the inescapable sense that they portray something beyond the canvas, some transcendental reality that lies on the farther side of the picture and is not the subject of the picture. Schueler writes, "I wanted to push through figuration into abstraction, and through abstraction into non-objectivity, and to come out the other side. My 'avant-garde' was to paint, not nature, but about nature. To recognize that nature informed me, that my fantasy and imagery and paint itself could only be as true and informing as my own intense response and subjectivity."(page 222) There's something essentially Emersonian about Schueler's use of nature in his paintings, his trust in his subjective response to it, and his belief that if he stared at it hard enough and long enough, he would see the universal

mind or oversoul staring back. He's a classically American artist in this, a man who paints nature in order to see God and searches for God in order to know himself.

There is a description in *The Sound of Sleat* of a visit to Jon's studio in Mallaig by Jon's longtime friend and dealer, Ben Heller. After Heller, in preparation for an upcoming show in New York, had gone through every painting in the studio, the two men take a walk along the Burma Road, a lane that curls along the cliffs a short ways from the studio where there are grand views of the Isle of Skye and the Sound of Sleat. One can feel on that walk (for I have made it with Jon myself) that one has stepped into any number of paintings. Jon writes:

"And there it all was spread out in front of us.

"We sat and rested a while.

" 'What people don't realize,' he [Heller] said, 'is that your work is completely abstract.'

"I nodded.

" 'And then what they don't realize is that your work is absolutely real.'

" 'That's it, Ben,' I said. 'That's exactly it. That's what I want. The abstract *is* real and the real *is* abstract.'

"It's right in front of you. Right in front of your eyes. That's where the mystery is. That's where the truth lies." (page 350)

This is a Whitmanesque assertion, the sort of neo-Buddhist claim that made Emerson recognize in the rough-hewn Brooklyn poet a true fellow-spirit, despite their extreme social differences. The American genius in art, practically from the beginning, has been to embrace this paradox, that the abstract is real and the real is abstract, and for us it's no mere article of faith; it's at the heart of how we perceive the world, especially the natural world. For that reason, Schueler is the direct descendent of Marin, Dove, Avery, and Burchfield, more than of the New York Abstract Expressionists, who, except perhaps for Pollock, had a much more European cast of mind. We never really discussed it together, and Jon might have found it strange, but I associate his work with that of his near contemporaries Morris Graves and Mark Tobey and think of the three of them together as the legitimate heirs to the transcendental impulse that characterizes so much of American art. I believe that, in time, when the work of the so-called Second Generation Abstract Expressionists has been reviewed and properly catalogued and appraised, Schueler's work will be regarded in that light and held in that high esteem, and the whole notion of there even being such a thing as a Second Generation will no longer hold much credence.

• • •

But I'm no art critic or art historian. I'm merely an old friend of
the author of this book. When I first met Jon he was forty-seven.
It was the winter of 1963–1964, and I was just twenty-four and
recently married. My young wife and I thought it slightly scan-
dalous that her college roommate, Mary Rogers, was living with
a man twice her age. We drove down from New Hampshire,
on our way through New York to my wife's parents' home in
Virginia, and visited the couple in Jon's large studio on Broad-
way and Twentieth Street, expecting to meet an old man, I sup-
pose, someone stodgy and conservative, an over-the-hill artist.
We knew, of course, that he was a successful artist, but we were
young and hip and foolish and arrogant, and we loved each oth-
er essentially for our youthful good looks, so we could not un-
derstand how one of our youthful, good-looking friends could
have failed to follow our example.

Jon thoroughly intimidated me, however. He was leonine in
appearance, slim and athletic, with a movie star's beauty, and he
had the easy, unpretentious charm of a Midwestern tractor sales-
man. He knew I was a beginning writer and, rather than wait for
me to interview him, began at once to interview me, as if he had
something to learn from me, which was, of course, absurd and
nearly impossible, for he was much better read than I, and he,
unlike me, had tested what he had read against a turbulent life,
while I had merely tested it against what else I had read. He was
an adult, and I saw at once that I was still a boy, and he had the
great good grace to let me know it without humiliating me.

I was grateful to him for that then, and especially so later,
when we renewed out friendship in the 1980s, when I myself was
a man in his late forties, and Jon had moved on to the next part
of the program, an artist in the later stages of his career. By then
I had been divorced as many times as he and had been as thrilled
and disappointed as he by the ups and downs of an artist's life,
and consequently this time we could sit and drink good wine and
talk as equals. But because he had been so generous to me when
I was a callow youth, I had now, these many years later, no ax to
grind, no point to prove. His kindness and curiosity those many
years earlier had made it possible for us to be friends now, in mid-
dle and old age.

It was this quality of mind, his eager openness to others, that
drew people to Jon when he was strong and that brought them
to his side when his health began to fail, for that mind never

left him, not even at the end. He was a passionate, yet sweetly gentle man who left behind an enormous room filled with grieving friends who, six years after his death, still miss him terribly. But he also left behind that carton on his desk in the corner office of his studio, and inside the carton, the twenty-seven-hundred page manuscript that became this marvelous book, and here, for us, he seems miraculously to live again.

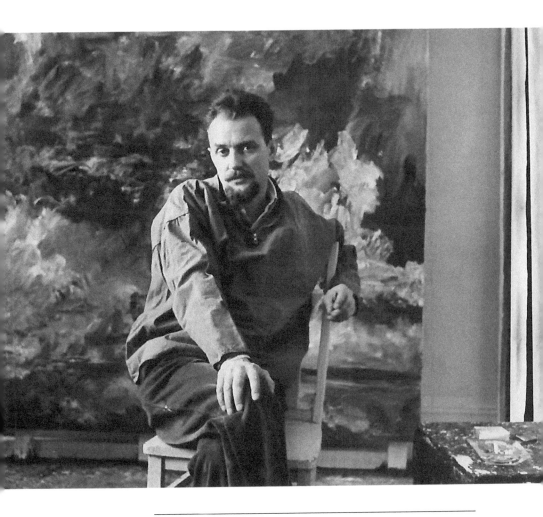

Jon Schueler in his studio at 68 East 12th Street, New York City—
one of the photos taken by Walter Silver for School of New York:
Some Younger Artists, edited by B.H. Friedman, Grove Press,
New York, 1959. Winter Sunday, Mallaig Vaig, 1958 (80" x
70") is in the background.

T H E S O U N D O F S L E A T

At the time of the opening journal entry Jon Schueler was forty. Considered one of the up-and-coming artists of the younger generation, by 1957 his paintings had been shown in a one-man exhibition at the Stable Gallery in New York and in various annuals and a touring group show. The March exhibition at the new Leo Castelli Gallery would enable him to leave New York in the fall and set off for Scotland in search of a landscape that he believed would be crucial to his work. This quest would bring him to the Sound of Sleat—the body of water between the mainland and the island of Skye—and to Mallaig, the small fishing village that overlooks this sound and the other Inner Hebridean islands of Rhum, Eigg, and Muck.

Schueler grew up in a middle-class family in Milwaukee, Wisconsin, and completed his undergraduate and graduate studies in English at the University of Wisconsin between 1934 and 1940. His plans to become a writer were interrupted by his decision to join the Air Corps of the United States Army in September of 1941. He married Jane Elton in 1942, just before being sent to Britain, where he served as a B-17 navigator. Discharged in 1944, as a result of combat fatigue, he and his wife soon moved to California. In the confusion of the next few years, their two daughters, Jamie and Joya, were born, and he engaged in schemes of setting up a night club and building a house, worked as a radio announcer, completed a few bits of writing, and started teaching English Literature at the University of San Francisco in 1947. In 1945, however, he had accompanied his wife to a portrait painting class, and painting gradually became his dominant activity.

Schueler enrolled at the California School of Fine Arts in San Francisco (on the GI Bill) in 1948. Three years later, he moved to New York City, leaving his two daughters living with their mother. The artist Philip Guston introduced him to Eleanor Ward, the director of the Stable Gallery, where he had his first one-man exhibition in 1954. However, after a fight with Ward over payment for a painting, he was eased out of the gallery and joined the new—and soon to be renowned—Leo Castelli Gallery.

The imagery in Schueler's paintings, informed in the early 50s by the large, bold abstractions of his mentor Clyfford Still, gradually became more explicitly concerned with nature. He fantasized increasingly about Scotland as the place that would provide the climate, skies, and the sense of the north that he craved. This dream is mentioned in

early letters, and friends remember his constant and insistent talk of this as-yet unknown country. However, lack of resources and the complications of his private life delayed the departure.

In the summer of 1956 on Martha's Vineyard, Massachusetts, he met the artist Joellen ("Jody") Hall, who at that point was married to the Scottish poet, Ruthven Todd, and Schueler's two-year relationship with June Lathrop came to an end. Their wedding took place in October of that year, with Tina, Jody's nine-year-old daughter, acting as flower girl.

Plans were formed to go to Scotland. But growing tensions within the marriage and Jody's reluctance to go to such a northern country resulted in Schueler setting off alone.

Part One was written between January 1957 and December 1958 in New York; Mallaig, Scotland; and Paris. Each of the parts of this book was culled from much longer versions that had been arranged by Jon Schueler before he died in 1992. Although he had begun writing journals and longer pieces as far back as the war years, it was only after his experience in Mallaig that he committed himself to a complex autobiographical project that would attempt to integrate past and present. A combination of journals, letters, and longer reflections on the creative process, this book began to take shape in January of 1957.

NEW YORK, 16 JANUARY 1957

It's two o'clock in the morning. There is snow on the ground. At the moment I am very happy about the painting I finished tonight. This is Number 2, 1957. I haven't titled it as yet. (I must remember to number the paintings as I finish them, so at least I'll have some semblance of order in my records—when I make some records). Forms revealed. Movements growing stronger. Indications of solidity. Something emerging from the fogged landscape I have been doing. Horizon in the distance. I think I needed the horizon, so that I would know it was there. But now that I know it is there, I want to eliminate it. Perhaps at times it may emerge, or be suggested, but now it is time for it to disappear, and give way to more positive dynamics.[1]

I am a bad father, a bad stepfather, a bad husband, an indifferent friend, a confused and disloyal lover. Only one thing: I am a good painter. And I had damn well become a far better one to make up for all the rest. Henry Miller: "Balzac, like Beethoven, seemingly gave the maximum that a man

[1] Later titled *Emergent*, (50" x 60"). See color illustration 3.

can give." I must find my maximum in painting. I can't give directly to people. I am completely incapable. Every time I have tried, I have ended up hurting someone.

VINEYARD HAVEN, MASSACHUSETTS, 26 AUGUST 1957

I'm going to try keeping my journal again—the first entry in a very long time. I have just finished two months of painting at Martha's Vineyard—twenty-one canvases. Jody and Tina[2] went back to New York Saturday. I shall be sailing for Scotland September 5, and from that day on I shall be alone a great deal. This is going to mean a lot for my painting, I know. It's going to be tough in many ways, and I must always remember why I am doing it. It's not just an adventure—going to the Highlands alone—and it's not just for the inspiration I'll find there. I'm putting myself to a test. I've used up energy and time in many wasteful ways during my life, and a good share of it with women. Now I want to put the total energy and the total time and the total feeling into my work. If each day brings a rage, it will be the rage of creation, and not the rage imposed by the outside. I shall make the paint live and the image soar with ecstasy. I have relinquished—I have tried to relinquish, or it has been forced upon me to relinquish—nearly everything which I have wanted at one time or another in my life. Everything except the need to create and to have my works go out into the world and proclaim their life and my life. I wanted to love and to be loved. I wanted a home, cars, houses, respect, a woman, parents. I wanted to get close to someone. I wanted to communicate—so badly. It's impossible. I can't seem to do it with one person, nor for that matter, can I hear that person's voice. I wanted things to work with June[3] and myself. The very wanting was crazy in terms of my work. Not until I started suffering, feeling the loss of June, did I begin to feel close to my work. I paint in terms of loss and renunciation. Yet my paintings are an affirmation of faith.

I must continue my journal. If I am going to be alone, I shall need the word—if only my own on paper.

[2]Joellen Hall Peet Todd Schueler (1921), Schueler's second wife as of Oct. 13, 1956. Christina (Tina), age 10, Jody's daughter by her first husband, Mel Peet. Jody had received her M.F.A. from the University of Iowa in 1944. She then moved to New York where she studied at the Art Student League in 1945 and at Stanley Hayter's atelier in 1949. Her first one-person exhibition would be in 1965 at the Poindexter Galley in New York.

[3]June Lathrop, a girl friend from 1955 to the summer of 1956 when Jon met Jody. They had planned on getting married and buying a house in New England. Together, they had seen the movie I Know Where I'm Going with Wendy Hiller. The photography of the Western Highlands fueled Schueler's interest in Scotland.

EDINBURGH, 16 SEPTEMBER 1957
LETTER TO JODY

Dear Jody:

I'm finally coming up for air—but slowly. The crossing was great . . . On the last day we passed just to the north of the Scilly Islands, which lie off Land's End—and they were beautiful beyond belief. Rough, craggy, with a grey, sometimes misty sky. Waves beating against the rocks, throwing spray fifty feet into the air. Dimly seen views of sandy inlets and green fields—tantalizing like a striptease. The light of the sun breaking through silver white, hard on the turbulent water, blinding, hard and powerful. God—this is what I had come three thousand miles to see—and this was the first thing I saw! I could ask for no more. I was certain that the west coast of Scotland would be like that. . . . We got up at 5:30 Friday morning to leave the ship which was already at dock in Southampton. . . . That Friday was sheer insanity. I was sick as a dog—had had a fever the night before. And now I was up and seeing immigration officers. Mine seemed to take a dim view of an artist coming into Britain with only $450 on him to stay for 11 months. I said I had a bank account of $1,000 when he asked, but could furnish no proof. I didn't quite get what he was after at the time, so didn't mention anything about income—just answered questions, and the next thing I knew he had stamped something about "three months" on the passport, and this has to be renewed. . . . I felt very sentimental all during the train ride through England, remembering the war,[4] and I felt very sentimental here in Scotland because I have been wanting to come here for so long. . . . It has been very cold, and I haven't been warm since I arrived in Britain. Just like the last time. I probably won't be warm until I leave. The British admit that it is cold, but they just don't seem to care to do anything about it. There is no heat anywhere. I doubt if they'll start lighting fires for another couple of months. When it's at its coldest—perhaps at night—people just leave their coats on. . . . Get a map from the British Tourist Office so you can refer to places I mention. I have had lots of conversations, and am planning to visit Oban and Ballachulish and Fort William. But then I am going further north, and am very much interested in Gairloch, Lochinver and Scourie. Every place sounds wonderful. It's going to be hard to make a choice. Saturday I walked all over Edinburgh—truly one of the most beautiful cities in the world. It's beyond description. I walked up the steep hill and went through the old castle and I looked out over the city to the hills to the north, and everything was as I wanted it to be. I kept marveling at the light and at the color and something about it struck me personally and I couldn't

[4]Schueler had been a B-17 navigator during World War II. For an account of the contribution of the U.S. Eighth Air Force, see *The Mighty Eighth: The Air War in Europe as Told by the Men who Fought it*, by Gerald Astor (New York: Donald I. Fine Books, 1997), which draws upon Schueler's experiences.

figure out what it was. The next day when I was riding along on a bus in the country (on an all-day bus tour) I was noticing the same thing again and I was looking at the clouds especially, and then I realized that I was seeing all of the violets and ultramarine reds I have been putting into my paintings for the last few months.

The food has been uniformly bad, except for one restaurant... And the women are beyond belief. They seem to be uniformly unattractive—so I never could imagine staying in this country indefinitely. Perhaps it's different in the Highlands—probably worse. The more beautiful the landscape, the less attractive the women.

... My main costs are those of getting settled and of stocking up on materials. After that living will be comparatively inexpensive.

How is everything with you? Have you started painting? How is Tina? I expect letters are somewhere, and I'll be getting them one of these days. . . . I'll write as regularly as possible, but I'll be on the move, and sometimes it's difficult for me to write at a time like that. I just got my typewriter from the baggage room at the station—it's the only thing that saves me.

... Scotland is beautiful, cold, and lonely. About what I expected. I doubt whether it will be any lonelier in Ballachulish than in Edinburgh. And then I'll be working. Please mail watercolor set. . . . Tell Leo[5] to sell some paintings. Give my best to Dave and Astrid[6] and Bob and Abby[7] and to all those children.

Love,
Jon

NEW YORK, 11 SEPTEMBER 1957
LETTER TO JODY
(Out of sequence because this and Schueler's previous letter crossed in the mail.)

... I've been concentrating for long hours on little black and white wash drawings—landscape ideas about some special feelings I'm trying to recapture.

[5]Leo Castelli, his dealer in New York. Schueler was the first artist to have a one-man exhibition (1957) at Castelli's recently opened gallery at 4 East 77th Street. Castelli's interest in what is often called the second generation of Abstract Expressionists (such as Schueler), would switch within a few years to the younger generation of Jasper Johns and Robert Rauschenberg and, in the 1960's, to Pop artists such as Roy Lichtenstein and Andy Warhol.

[6]In the 1950's Schueler saw a great deal of David Myers, the Editor of *Modern Screen*, and his wife Astrid.

[7]B(ernard) H(arper) Friedman and his wife, Abby. At this point Bob was writing part-time while working for Uris Building Corps. Six novels were to appear and many monographs on artists, biographies of Jackson Pollock and Gertrude Vanderbilt Whitney, essays, etc. He and Abby met and became close friends of Schueler in 1955 after buying *Sun and Fog* (48" x 54").

I'm taking great delight in not seeing anyone or wanting to go out anywhere. I'm like a mole dug in for the season! I think of nothing but you and my little drawings. You are always with me, darling

<div align="center">

MALLAIG VAIG[8], 26 SEPTEMBER 1957
LETTER TO JODY

</div>

Dear Jody:

The wind is howling tonight—I don't know whether there is a storm brewing or just some temporary aberration in the weather. The wind came up this afternoon, then strange clouds forming over the sea, half obliterating some of the islands. Beautiful, and very real. Fortunately, I had coal delivered today. Tonight I am warm for the first time—warm, that is, on my right side, which is toward the fire. But I think everything is going to work out very well—I think I shall be able to keep the place warm enough to work in. . . . Yesterday and today I have been busy getting the essentials organized—coal, food, stuff moved, etc. Also, ordered a bunch of stretchers from the joiner. Canvas should be here any day from Edinburgh. Now that I have heat, I can sit down in the evening. Last night, all I could do was pace until I felt that I could get to sleep—which I didn't. But I had had tea and a shot of whiskey with Mrs. MacDonald (a wonderful, mad, toothless woman who owns this place—and who literally cackles), her daughter and son-in-law. They were very hospitable, and we had a good talk. I didn't like the two women at first, but now I'm beginning to enjoy them. They distrust me less, and that helps.

At American Express in Edinburgh, I received your first three letters which had been forwarded from Southampton. I'm wondering where you are—can't quite figure out whether you have gone to Florida to see Tina[9] or whether you are going there October 4. If you're going Oct. 4, we have some problem about my Air Force check . . .[10] which probably will arrive that day or the 5th. I'm approaching some real difficulty in regard to money. If you have sold the car, I wish that you would send me some money—just so I can get a little ahead. . . . I shall write checks on the New York account for $50 (Jane)[11], and $8.00 (kid's allowance) and $18.70 (insurance). I'll write these around Oct.5. Once we're in communication, and once I'm ahead of the time lag, we can handle

[8]Mallaig Vaig, a very small crofting community one and a half miles beyond the fishing village of Mallaig, Inverness-shire, Scotland.

[9]Tina had gone to stay with her father and stepmother.

[10]Monthly Air Force disability retirement pay (at this point $165 a month) which remained an important source of income.

[11]Jane Elton Schueler, Jon's first wife. Married from 1942 to 1952, they had two daughters, Jamie (1944), and Joya (1946).

this differently if you want to. But I thought that this would be best for the present. . . .

I'm beat after a big day and am going to climb into the cold bed. Wish there were something more there than a hot water bottle! And how about a good, home-cooked meal?

Love,
Jon

NEW YORK, 3 OCTOBER 1957
LETTER FROM JODY

My darling, darling, Jon,

I feel absolutely frantic you are not getting my letters—even as I write this, I wonder if you will ever receive it. . . . I worry so about your not being able to cook and trying to handle all those problems by yourself. Not to mention how much I want to be there with you. We could at least generate more heat together than the coal stove. Do you think it would be dreadful of me to come in November? I am torn by loyalties . . . yet I can't but help feel I should be with you. . . . I could plan to break the length of time in Scotland by return-ing for a few weeks maybe in Feb, or March—I will demand the money from my trust[12] if necessary. I air mailed you $900 yesterday. I finally sold the car but had to take a terrible drop in price ($975). . . . So, all our bills are paid now and we have the car money and our rent. That is something! If things are too rough there we could pack up and leave—it would take time and money, but if you can't do your work under those conditions, it would be a waste of time to stay! The important thing is for you to be able to function in your work! Baby—I can't sleep at night for thinking of you—it all sounds too terrible. . . .

I want to come and be with you. I want to cook for you and keep warm with you in bed. It's all very simple—basic needs. Do you understand? I went to Bluhm's[13] opening and talked to Leo—he was very charming and I gave him "glowing accounts" of you—he wants to pick up the paintings next week. A new rack is being constructed in the back room now (they found an apartment) so he will be able to store them. . . .

NEW YORK, 4 OCTOBER 1957
LETTER FROM JODY

. . . I just wrote and mailed a letter to you saying I wanted to come over in November instead of being with Tina at Xmas. As soon as I mailed it, it

[12]Jody's trust was controlled by her father, Joel E. Hall.
[13]Norman Bluhm (b. 1920), Abstract Expressionist. This was the first of his two one-man exhibitions (1957 and 1960) at the Leo Castelli Gallery.

was as though I had committed a terrible sin against Tina. I was very up-set—and I know I can't do it to her. . . . I am beginning for the first time to realize my behavior toward her and, believe me, when it hit me, I knew that never again would I let my own selfish desires keep me from giving her what she needs from a mother. I also feel that way where you are con-cerned, but as we both chose to do things this way and Tina was more or less there as a result of my choice, I feel she should not be further victim-ized I'm writing all this without knowing what you are thinking or whether you even wanted me to come anyway. I have to untangle my emo-tions often these days to separate my dependent feelings and my love for you—my own loneliness from my concern over your loneliness. . . . Please be patient with me

<div align="center">

MALLAIG VAIG, 7 OCTOBER 1957

LETTER TO JODY

</div>

Dear, sweet Joellen:

I just received the two letters written on Oct. 4, when at first you decided to come here in November and then felt blasted by your conscience. Well, my heart goes out to you and I can imagine what you are going through. I must say that suddenly you become more human to me, because, if nothing else, one of the big advantages that can come out of all this for each of us . . . is that we're put hard up against some decisions, and we go through all the emotions sur-rounding them, and maybe if we come out the other side . . . we can truly say we've grown—and maybe we'll know something—you about yourself, me about myself, you about Tina and art and men, me about art and women and chil-dren (and money). . . . Part of the thing here for me is to meet something head on—to figure out what I want to do, and then to overcome everything that comes with it. Now, this part of Scotland is exactly what I wanted—visually. I have everything I could hope for. I had to get through the rest . . . such as cold, but more important—emotional difficulties—such as loneliness and all the cra-ziness that can go with it. I think you have to come out the other side of loneli-ness, or one is forever dependent on other people—and I'm out not to be—it's absolutely necessary for my work. . . . There's no doubt about it, I was misera-ble for a while. I was literally held together during that period by the landscape. I went through my low of all lows Sunday, September 30—and even on that day I took a long walk and was overwhelmed by the beauty that surrounded me. . . . I think the final blow was that it was Sunday in Scotland and I had heard that they were very rigid in observance—don't work on Sunday, etc.—and I was afraid to call on my new neighbors . . . Well, it was totally unnecessary. Now—here are some of the things I have—another eight days later. I have excellent

neighbors.[14] John MacPhie is a hell of a nice guy. When he heard I was ordering coal, he was going to carry it across the valley to my place, because he knew I wasn't used to heavy work. He's at least five years older—works terribly hard all day—getting up at five in the morning—and then has all sorts of heavy work to do around his croft. I think he felt that it was totally unnecessary for me to have paid to have the coal carried across—in fact, when I told him and Betty that I had paid ten shillings (less than a dollar and a half) to have half a ton of coal carried across, they were horrified. Betty insists on doing my laundry for me, and sews things, etc., and refuses to take any money for it. She keeps me up on the neighborhood gossip . . . and she puts me wise to all sorts of things, so that it's getting easier and easier for me to function here. Ian, their boy, comes over and helps in every possible way. He cleans out my grate—as much as anyone, he showed me how to build a fire—he brings in coal, and has helped with everything and anything. He's fascinated by the whole art bit, and has watched the studio take place with great interest. Heat: For another ten dollars a month, I can throw in plenty of coal, and use the electric heaters when I feel like it—and everything will be quite warm enough. Your sending on the money helped me a lot in that respect. I have a fine studio now—gleaming white—the light comes in great—though it's from the northwest—it doesn't make much difference because the sun is seldom out anyway. I have one of the best easels I have ever had. I have some stretchers designed better than I have ever used. All this thanks to Mr. Grieve, the joiner, who takes quite an interest in me, and lends me tools, etc., and is ready to solve any problems. Another thing about the cable saying you were going to send money: I bought some sensible clothes—designed for these parts—the boots, the sweater, and I've sent for some long underwear, and I have a great raincoat. All of a sudden I'm comfortable—and now it's an adventure for me to go out in all kinds of weather . . . More: I'm getting to know everyone in town, and it's sort of fun, because I realize from things I've heard that no one quite figures me out, and they wonder what I'm doing here, etc. More: I've met Jim Manson, the captain of the fishing boat, an old timer. . . . The boat is going into the water at high tide tonight and tomorrow noon we're going to sea. Now, damn it, it will probably be cold and cramped and wet and rough, but it will be as wonderful as it can be—if you get the point. That's why I don't want you to worry about me—part of the wonder here, part of everything that is great, and everything that is making me terribly excited and full of life—part of all that is the rough part—the

[14]John and Betty MacPhie, and their ten-year-old son, Ian. The road from Mallaig stopped short of the few scattered houses in Mallaig Vaig. Schueler was to give the MacPhies a small painting, *Betty's View* (18" x 25 ¾") in return for their many kindnesses to him during this period.

weather, the primitive conditions, etc. The weather! Without the weather I wouldn't have what I came after. Today I cycled to Morar (a little town along the coast to the south) and I went out of my mind. Every day is a grey day here, and I've noticed more and more the blues and the purples. But from Morar—out to the sea—the cloudy sky and the water and the islands (Eigg and Rhum loom huge in the distance, menacing, sharply defined in outline, but hazy and indistinct in content) everything was a deep, deep blue—the most penetrating, somber, magnificent, symphonic blue I have ever seen. It was a very simple subject—yet immense and about the whole world and the whole universe, and about all the great throbbing tragedy of movement and life . . . and, by God, it was about everything I've been thinking about, and I just have to raise myself one way or another to the point where I can truly feel it and express it, and where I get far, far beyond the point of techniques and doesn't this look just like some Impressionist, and whatever anyone might be whispering in my ear—you or critics or buyers or dealers or friends or artists or enemies or what. . . .

. . . I'm dying to paint. I know I'm gaining vision—and perhaps it's helping me that I'm getting more relaxed (the Scots are not in a hurry) and taking time off to go out leisurely and look and look and look, and to go out to sea in a fishing boat so that I can look and feel some more. . . . About your coming: I want you, too, and could certainly stand those simple basic needs. But now that you're up against some truths, keep at it and see where you come out, and come over here when it's right and proper that you do so. You'll know, and when you want to come, tell me, and I'll be waiting for you. . . . Don't mind burdening me with the mixed-up crap I love you, and I think we'll have a great time when you're here—particularly if you lose the idea that men are helpless and have to be guided by the nose. I love your mothering, but as you are realizing, it's probably needed all the way around,

Love—Keep warm,

Jon

I'm sailing on the *Margaret Ann* at noon tomorrow. Will probably be back on Saturday. So there will be a few days without letters.

<div align="right">

NEW YORK, 9 OCTOBER 1957
LETTER FROM JODY

</div>

. . . I just came back from Astrid's where the movers picked up *The Wave* and *Night Sky*—Leo[15] phoned and said that Baur[16] was coming tomorrow to

[15]Leo Castelli had requested these paintings of 1957 (35" x 46") and 1956, which had been loaned to the Myers.

[16]John I. H. Baur, Curator of painting and sculpture 1952-58 at the Whitney Museum

have a look at your recent work—he feels Baur is interested in you seriously—
so we'll all be excited to see what comes of it all. . . .

NEW YORK, 10 OCTOBER 1957
LETTER FROM JODY

. . . Leo just phoned to report about the pictures I sent over yesterday—Great!! He
said to tell you More[17] . . . and he chose *In the Wild Garden*[18] for a show at the Whit-
ney in November. It is a survey show of contemporary painters. He said More was
enchanted by your paintings—really loved them and said he felt you were one of the
best painters around![19] I feel like shouting for Joy! I then asked Leo how the paint-
ings looked in the gallery. . . . He said, "Oh, they look really wonderful—they have
gained stature here—it was very difficult to see them in the light in your studio."—
Aren't you happy! He also said a sale will probably come out of the show—very like-
ly to anyway. So paint on my love, I was mad as hell you don't want me there any-
more now that you don't need me! But I have a couple of months to simmer down
over that one—and all the emotion I have put into my decision to come! . .

MALLAIG VAIG, 13 OCTOBER 1957
LETTER TO JODY

. . . I've been trying to create some kind of a plan in my mind to get you organized
before you start traveling back and forth between New York and Scotland in a
mania of guilt and sexual desire. In the first place, it will just keep everybody in
an uproar—and in the second place we can't afford it. Now, this is what I have fig-
ured out—which is about as much as I can: I have this place until May 25. There-
fore, a great deal hangs on that date. I have decided that the best thing to do is to
put in an intensive work period through the winter. Ship my paintings off. Take
a tour—see part of England, then go to the Continent and tour there. After that,
see what happens. Tentatively, I'd like to settle in Paris for a year. I think that af-
ter eight months here I'll want the city. So—it seems to me, without considering

of American Art. He included Schueler's work in *Nature in Abstraction: The Relation of
Abstract Paintings and Sculpture to Nature in Twentieth Century Art* (New York: Macmil-
lan, 1958), and as director of the Whitney (1968–1974) was instrumental in organiz-
ing an exhibition of Schueler's work at that museum in 1975.

[17]Herman More, Director of the Whitney Museum of American Art from 1948–58.
He was selecting for the Whitney Annual.

[18]68" x 40," 1957.

[19]cf: *New York Times*, Nov. 20, 1957: "Art: Another Whitney Annual Opens. Among
the outstanding paintings in varying degrees of abstraction are examples by James
Brooks, Carl (sic) Morris, George McNeil, Philip Guston, Charles Seliger, Marca-Rel-
li, Lawrence Kupferman, Jan (sic) Schueler and Kenzo Okada."

anything else except the fact that you wanted to be with Tina for Xmas—that the best thing for you to do would be to take the first boat that is practical after Xmas and come over here. After we have taken our tour and found a place to settle, you send for Tina. . . . For god's sake, don't do anything that you're going to construe as a sacrifice for me that will involve Tina. I'll merely have to pay and pay and pay, and I don't want to. If this plan suits you, and you want to do it, fine. If you end up by figuring it out as something that I used to wrench you away from your daughter (I have a hunch you're now thinking that Tina being in Florida is the result of some diabolical scheme of mine), then for god's sake, stay where you are. I can't stand having tiny tots sacrificed on the altar of my ambition. I'd much rather they would all go and cling to their mothers somewhere. . . .

I feel so damn sexy I can hardly stand it—particularly when I read your letters. Makes it hard for me to be sensible about all your plans. Everything will be well prepared when you arrive, cock at rigid attention. . . .

MALLAIG VAIG, 13 OCTOBER 1957
LETTER TO JODY

. . . Did five drawings—a couple of them good. Light very good in morning and early afternoon. So those will be my painting hours.

You should have seen me at the wheel of the *Margaret Ann* on Friday—dusk, heavy sea, turbulent tides and wind, boat pitching and rolling so that you could only stand up by hanging on, spray over the decks and against the windows of the wheelhouse—you would have died a thousand deaths. I loved it loved it loved it. If I ever give up painting it will be to go to sea. Jim Manson—really fascinating guy, 53, man of quiet courage, singleness of purpose.[20] He loves his work, gets as excited as a kid by a catch. He sails into waters that our companion ship (they sail in twos) stayed safely out of. He knows his business, and knows every tide and rock and ripple in the entire area. . . . He had me handling the wheel every day from the first day aboard, when we were traveling through a heavy swell. On Friday I took her from South Uist to a loch on the northwest corner of Skye. We fished there unsuccessfully. Then he took her down the coast—notoriously bad tides—heavy sea, churning waters—huge cliffs dropping abruptly into the sea—sailing nearly within touching distance of the cliffs—peering almost straight up to see the guy hanging over the rail in the lighthouse far above. . . . Then, after we got past the very worst of the passage, he gave the wheel to me. I took her all the way down the coast—it was dusk, then darkness—we fished a loch—then I took her again. You should

[20]This is the first of a number of fishing trips Schueler was to take with the skipper, Jim Mason in his wooden boat the *Margaret Ann I* and its successor, the *Margaret Ann II*. He was also in the 1970s to go out with Jim's son, Jimmy, in the *Crystal Sea*.

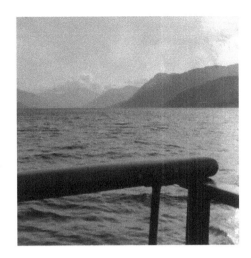

Crossing the Sound of Sleat on the ferry from Mallaig to Skye, with a view of Loch Hourn, Scotland, October 1957.

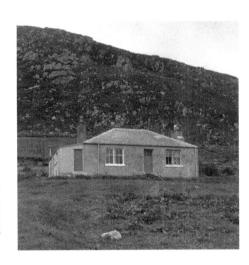

The Bungalow, Mallaig Vaig, Mallaig, Scotland, October 1957, where Schueler (joined by Jody the following month) lived until March 1958.

have seen us tossing! By God, I felt great. Finally we got down to the island of Soay. . . and as we were approaching it—in the dark—he went down to have tea in the fo'c'sle and left me in charge of the boat. I took her into the channel before he came back up, and through the channel, and then he took her into Loch Scavaig. When we were going into Loch Scavaig, he said very quietly, "What you did just now—bringing the boat in here—was worth hundreds of pounds. (I don't know exactly what he meant by that). Most men would have been afraid to do it." . . . I felt terrific . . . The loch is sinister—black—and ugly winds whistle into it from the Cuillins—the biggest mountains in the area. They are sharp and ugly compared to all the other mountains in Scotland. You can see them off on the distance from your kitchen. In fact, I was looking out the window there today—I do constantly—the scene is never the same from one minute to the next—I bet

I'll hardly be able to get you out of the sink long enough to get you into bed. . . .

One thing serious—don't you really realize that at one time we had every-thing planned, that you just as well could have been here with Tina—but that you worked very hard to see to it that that couldn't happen?[21] The only thing that scares me is that you act as though none of that ever happened. . . . but to hell with it. I've lost all family feeling and trying to strive—and maybe it's just as well. I'll start over again with you as a mistress and see what happens.

. . . Delighted to hear about More's reaction.

Your choice fine. Love you for being concerned in that way. . . .

NEW YORK, 17 OCTOBER 1957
LETTER FROM JODY

Darling Jon,

You know I *do* love just being a woman. Do I *have* to prove myself in some other way? Is it so weak of me not to forge ahead in painting and dedicate myself to this life? Could you find it pleasant to just live with me, and not find me boring if I would be such a flop as a person? I ask myself these questions through the day and wonder—I want to be real, a *real* per-son—to feel real and be real to you and Tina and the outside world. You know when I'm happiest? Really now—I'm serious—it's when I'm baking a pie—or bread—and puttering around in the kitchen—but not for myself—it has to be for someone I love—and that's not sentiment—I love to dress in the evening and go out with you as your wife. I want to feel free to show my love for Tina. . . . Are my dreams of what I want to be so far from what I am?

When I look or think of Joan Mitchell or Grace Hartigan[22] I see such a different physical type—they are strong, "virile," heavy and forward, and I am quite the opposite in temperament and build. Just from the outside I wouldn't say I have the equipment to be a real career woman—and my femi-nine instincts draw me in another direction inwardly.

I do have a talent that is part of my reality as a person—my paintings are me and are a part of me and I will always want to paint, I believe—but I don't feel like it's necessary any longer for me to prove my worth by being an artist. I am an artist—I know that—good—bad—mediocre—what have you—it isn't the point—But I feel like directing my ego drives in the direction of womanliness and letting the Art follow at whatever speed it

[21]At one point, Schueler had planned that his children and Tina would accompany them.

[22]Joan Mitchell (1926-1992) and Grace Hartigan (b.1922), two of the best-known New York women artists of Jody's generation.

must for me. Maybe I have wanted too much for myself and haven't come to grips with anything as a result. I want to "grab hold"—I was thinking of this phrase of yours in the bathtub tonight and it seemed suddenly very much to the point for me right now. . .

MALLAIG VAIG, 21 OCTOBER 1957
LETTER TO B. H. FRIEDMAN

. . . to the north is Loch Nevis . . . I tell you, it's exactly what I wanted to find. It's relatively new land, you know, so it really is in the process of birth—it's springing from the sea, and it hasn't had time to get worn down to a pattern of regularity. High in the hills are moors which are constantly bogged, because natural drainage patterns haven't formed. Rock formations are thrust up in every direction imaginable—including straight up. And it's caught in the complicated, primeval, birth pang hysteria of weather that's really weather, that has everything to it, that never stops changing. That's the big thing to me. I could stand in any one spot, and literally from minute to minute, quite often, the entire thing changes and what was real one minute has become effervescent the next and has formed into something else the following. This is what knocks me out. I've never seen so much damn color, and so much change of color . . . I'm sure I've dreamed about it, but I didn't realize how rich it would be—and best of all, all sorts of color in the sky, working into and out of that in the land, because the sky is just as raw and new as the land, and it hasn't formed into regular patterns either. Just when I think I've seen everything, I look out the window— like tonight before sunset . . . and whoosh, a yellowish umber form was spread across the sky and threatening to annihilate the Bungalow at Mallaig Vaig . . .

. . . Now, as regards to painting, the way it makes me feel is that there is something here that I have been searching for and that I have been thinking about, and maybe I can find out more about how it works. And it also makes me feel, more strongly than any other landscape I've ever been in, that God is creating here so fast and so powerfully and so abundantly and so magnificently, that it's going to be one hell of a challenge to try to create something that will equal or (when I'm feeling particularly manic and filled with rage at just seeing all this) outdo such a prodigal, intense, potent, imaginative job. . . . Incidentally, my canvas finally arrived . . . and I've painted my first picture— 79" x 43" (vertical picture)—it's called *My Garden is the Sea*[23] and I really like it. I feel great. Probably the best thing that happened to me (in fact, one of the best things that ever happened to me) was my trip in the herring boat, the *Margaret Ann*. When I got back I was going to write and tell you all about it, but then the canvas came and one thing and another—and it's probably just as well or I would have told

[23]Later entitled *October*.

you about every minute of each of the five days, and I doubt if it would have interested anyone else as much as it did me. But—emotion diffused in tranquility—I'll tell you about a few of the things now. In the first place, I have a hell of an imagination about trips. I don't think it ever comes to consciousness ordinarily—though one way or another, I'm usually made aware that it is working. But when I first flew, and I flew during the war, I'd always have all sorts of premonitions and dreams and one thing or another of disaster. Now, I'd heard a few stories about the boats around here and about the sea, etc., and damn it, the old mind got whirling and somehow I was sure that if I got on that boat, I'd be the albatross around the captain's neck—but let's not try to push that one along—in any case, I figured out we'd probably sink. . . . Now understand, these guys are just going out to do a job—one the skipper has been doing day in and day out for nearly forty years. But to Schueler it was a voyage into the jaws of death—every feeling at the time being pure cliché. On the other hand, I was excited as a kid about going—for some reason this has always been a dream of mine—I'm not sure why because I have never been particularly interested in fishing. Well—on Monday . . .

DE LAND, 22 OCTOBER 1957[24]
LETTER FROM JODY

. . . I love your letters so—and then sometimes at night or during the day I get a feeling of panic for fear you will be disappointed when you see me and I won't be all you have dreamed about and vice versa—and maybe our sex will be a flop because we have dreamed so intensely about it for so long I do love you madly—I love your face—your eyes—your wonderful chin, your pot belly—your bony legs, the back of your head and last but not least your smile Oh suddenly I feel great again now that I've given expression to some of my fears about whether I love you or not—it's as though I'm free again to love you. . . .

MALLAIG VAIG, 24 OCTOBER 1957
LETTER TO JODY[25]

My darling: Well—just received your wire this evening—what welcome, very welcome news. I've been wondering which boat you'd be taking and how long it would take to get here, so that I would know how many days to cunt—I mean count. Keep that thing warm, keep it ready. Bring plenty of diaphragms, vaginal jellies, douche bags, and any other complicated female

[24]Jody was in Florida with Tina.

[25]In subsequent, as in previous letters, there are pages and pages of instructions about travel, money, etc.

paraphernalia. And bring that warm, sucking mouth of yours—I'm thinking about that tonight and wish it were here right now. . . .

. . . I hope you're having a successful visit with Tina. I'm dying to hear all about it. . . .

. . . I'll meet you, and guide you from then on—straight to the double bed in Mallaig Vaig, where you'll find yourself immediately on your back. Or would you like to see some paintings first? I'm working better than I ever have in my life. Have finished three canvases—have lots to tell you—excited as I can be. Will write about that tomorrow. This country is wonderful—the landscape becoming more thrilling to me every day. You're going to love it. And I feel so damned healthy, I could take off and fly—I've never felt healthier. . . . Listen, sweet one, we've both had tough, struggling, complicated lives. Now we're going to have a wonderful time—loving, fucking, working, and wandering around this magnificent country-side. Whenever we're cold, we'll just hop in the sack. . . . Bring your paint-brushes, etc.—I have canvas, stretchers, paints, and everything else. Good night, my love—I'm going to dream of lying on top of you with my cock deep inside. . . .

MALLAIG VAIG, 29 (?) OCTOBER 1957
LETTER TO JODY

Tuesday morning: Well—I didn't get to finish this letter last night. I had want-ed to go through the three letters I got and look for any more practical mat-ters and somehow I forgot all about them. I'll do it now. . . . Emphatically, don't give Tina or anyone else the idea that she might be coming here in the spring if she just manages to dislike being with her father enough. I'll give you two hints: (1) This is a working studio here—I didn't set it up as a nursery. (2) For Tina's sake, remember that Mel is her father and not just the propri-etor of an orphanage. She has been kicked around from man to man—now let her relate to one man for a while—and it's just as well that it's her father. And to relate has to be all the way—it can't just be until she's bored or tired of the children—or she'll never be able to relate to a man as long as she lives. . . .

DE LAND, 1 NOVEMBER 1957
LETTER FROM JODY

. . . I am beginning to know what being the wife of a serious painter means and I am willing to go along with you in whatever you need most for ful-fillment in your work—it is hard not to want to be with you and share what I can share with you—sometimes I feel I shouldn't invade your painting even to the extent of sharing pleasure with you over accomplishment—but I do love painting so and I genuinely love what you are doing. I no longer feel an identity in that direction—or if I do, I am aware of it and

cautious—which is a far step from last summer, and it will make a tremendous difference to you I know. Having me both there and not there at the same time is what I have in mind to be. If I can accomplish this, it will mean that I can stay in your arms where I want to be. Anyway, all I want to say is, I am serious about your work and sensitive about your needs—because I want to see all those exciting paintings come into being and go out into the world and be close to the man who made them. I don't feel I am identifying now—I'm just being a woman—quite different from a man and his needs really. Have I said I love you in this letter?

. . . I'm still looking at your picture. I'm especially peering at the lower section all covered over with corduroy! You look great in that beret.

Your wife, your mistress, your tender, sweet, big-assed Joellen

MALLAIG VAIG, 5 NOVEMBER 1957
LETTER TO JODY

Hello, sweet wench: Did I write a note this morning? I write you so often that I can't quite figure out when I wrote the last letter—and I think of you so much, that I'm never sure what I told you in letters and what I told you in fantasy. . . . Everything is sexy here to me—that's odd, isn't it—because the Scots certainly don't seem like an unduly sexy people—though maybe hidden behind all their propriety and plainness they are. But the very fact of the bracing air, and the exciting moods of the sea and land, and the wind—tonight blowing from the north—howling—and the north wind is a cold wind—all these things make me feel alive and creative and passionate. I want you in my arms, I want your cunt wet and open and my cock deep inside. And I'd like to inject some of my spirit of adventure into you—I'm sure that it will be catching—so that you get a big wallop out of all the wonders around here. Just to see the shepherds with their crooks and their heavy, nail studded shoes, swinging with the kind of heavy, rocking walk they have, down the street in Mallaig. Or an odd, tail end of a rainbow resting on the water across Loch Nevis.

. . . I hope you got through some of my tougher letters O.K. I'm still a hard bastard, and I fly off the handle, and I get mad at things out of the past (though not lately—once I got them out, they were out), but I love you and miss you—and I throw it all into one package. I've got that wing out ready for you to nestle under it—and what a wing it is!. . .

God—I'm having the damnedest work problem in the world right now. I'm so full of everything and my hand moves with such certainty and my imagination is so fertile and I feel so good about it that I practically run from my work at times. I can feel it happen—when it all becomes too much for me—yet I know that it is precisely then that I should really plow in. . . .

MALLAIG VAIG, 6 NOVEMBER 1957
LETTER TO JODY

. . . I realized here that there is a certain purity to working alone, and I'll want to do it once in awhile—but unless one wants to live alone, which I don't, you have to surmount whatever is in you that gets screwed up by having people around. . . .

—The toughest practical problem, I think, is the bad picture. . . . Here we are, Jon and big-assed Joellen, in love, people of good will, and Jon produces a bad painting. . . . Let's say I was writing a novel. I'd be zooming along. I'd have a great idea. I'd write it. I'd keep going—paragraph after paragraph. With any sense, a man would never show his wife the novel paragraph by paragraph—but that's what I do when I show you pictures as I complete them (to say nothing of the unfinished ones). Now—in the novel—I go back over it—the great idea is still there—or the germ of it—but the paragraphs concerning it, because it was such a new idea—are badly written—the seed is there, not the plant or the flower . . . So I rewrite and rewrite until it becomes real. Now everyone loves it. But I loved it at first—when the idea first bloomed— and it was important that I loved it at that time, or else it wouldn't have bloomed. . . . This is the way it is with the bad picture. Although at the end of a period of work the picture is ultimately dropped—or changed, or whatever—yet, at the time, it is exceedingly important that I paint it uncritically, sentimentally, or whatever—and that I paint it with full love and enthusiasm, and that I feel that enthusiasm about it until such time as I have made the idea in it become more real and meaningful in another picture—or perhaps have creatively discarded the idea. Now—this is easy in the studio alone. . . . My enthusiasm over one picture can drive me into the next—so it's the enthusiasm that's important, not the picture. . . . This is the tough problem in having someone around, and for me it's a realistic problem. I could refuse to show you all my paintings, but this would be ridiculous to me. On the other hand, I can't pick out the bad ones and put them face to the wall because I don't know at that point that they are bad. On the other hand, if I show them, it's probably too soon for me to know, certainly too soon for me to discuss. Maybe you can figure out some way of coping—I really can't. All I can do is paint the pictures. . . .

I'll tell you another thing, my sweetheart, now that I'm being so loving and trusting: When you haven't been a lousy, hostile bitch, you've been very good for my work in many ways—you've been an understanding wife and sensitive to my needs—and for this I've always loved you. . . .

DE LAND, 8 NOVEMBER 1957
LETTER FROM JODY

. . . I sorted out all your letters today and stacked them in order and I am going to read each one over tonight before I go to sleep and just see how your moods and feeling toward me go each day—I bet they are a lot smoother with an ocean between us! I plan to bring my love letters with me to soothe my wounds when you have been particularly mean to me! Maybe we should just continue to communicate by letter! Maybe I will just write you a letter each day and tell you all my secret evil thoughts against you and present it to you each evening. . . .

. . . You haven't scared me any worse than I've scared myself about being trapped with you in our love nest in Mallaig Vaig! So be on guard—I'm coming with full battle gear ready for the slaughter! Oh god! With the slightest twist of my imagination I can reduce our love nest to a torture chamber! . .

MALLAIG VAIG, 14 NOVEMBER 1957
LETTER TO JODY

My darling, much loved Jody:

. . . It's going to be so wonderful having you with me—less than two weeks. I wonder how you are doing? I worry through each step with you, get just as excited about all the errands, all the packing, all the decisions, what to buy and what not to buy!. . . I want to see you. I love you. Everything else can wait. So much has happened that will enable our love to flow more freely. You certainly must have learned by now that you can't destroy me—no matter what your fantasies—so this should put you at ease. In fact, I doubt if a woman can destroy a man—a man can destroy himself with a woman, if he wants to. . . . It's a funny thing about those power fantasies—every creative person has them—it's part of the mania, and, I believe, even part of the drive—yet, unless they are overcome and brought into some kind of realistic focus, they are the things which destroy productivity and therefore destroy art. I'm certain, for example, that it's underneath the kind of thing of a de Kooning[26] taking to drink. Now, I want you to relax and paint for the fun of it, or don't paint for the fun of it, and do whatever you damned please for once in your life—and I'll bet that somewhere along the line you'll add up those paintings and find more than you

[26]Willem de Kooning (1904-97) and Jackson Pollock (1912-56), both leading members of what is often called The New York School, or the first generation of American Abstract Expressionists were well known for their drinking habits. In the 1950's the Cedar Bar and the White Horse Tavern were gathering points for artists and jazz musicians.

had before and better ones. And in the meantime you'll have gotten in some loving, and you will have found the joy, rather than the resentment, of having a child, and all sorts of things. I love you, and I'm looking forward so to our being together—and I know what it will be like, and I know how loving you are, and how impossible you can be, and what a goddamned worrywart you are. And I know my failures as a painter, and I know that when I feel them, I look for a patsy, and I know that I'm looking less and less for a patsy, and more and more at the failures—which is giving me lots of strength. So, we'll be very human together, and if we can find that ideal you spoke of— of each one feeling free within a marriage, we'll really have something. . . .

Love you,

Jon

MALLAIG VAIG, 9 DECEMBER 1957
LETTER TO JAMIE AND JOYA[27]

My darling, sweet little girls:

How are things? When are you going to write your old man a letter? I'm far far north in the hills and the cold, and would like to have my heart warmed up a bit.

I'm enclosing your December allowance check, and also the check for Mommy, which you can give to her, thereby saving me one shilling and six pence in postage this month. Also, I want to get this in the mail, and I don't have time to write two letters. . . . Jody arrived nearly two weeks ago and she's settling in very well and enjoying the place very much. All the neighbors were wondering what she would be like, and as we walk or cycle into town, the women stand at their windows and peer through the curtains. . . .

. . . Did you see my picture in the December 2 issue of *Life* magazine?[28] I thought it was pretty good, and I decided that it looked much more like me than I do now with my beard, and inasmuch as I sort of get a kick out of looking at myself, I'll probably shave it off one of these days. Jody thinks I look like the Devil right now, but I always think of myself as being rather

[27]The children, who lived with their mother in San Francisco, were then thirteen and eleven.

[28]"Old Master's Modern Heirs: the scorned work of Monet's later years inspires a present generation of painters." (Jon Schueler, Sue Mitchell, Hyde Solomon, Jean-Paul Riopelle.) Schueler was naturally pleased at the publicity from the article, which included a color photograph of him in front of *The Lake*, 1955 (54" x 48"). However, he was ambivalent about being called an "heir" of Claude Monet. He certainly admired the French Impressionist's work but felt that the late unfinished paintings and the watercolor sketches by J. M. W. Turner (1775-1851) were of more significance to him at this point.

saintly. The hills and mountains around here are now covered with snow and look very beautiful. The lower hills near us and the land near the sea have no snow—but off in the distance you can see the white mountains, and we take walks up Loch Nevis, and the mountains there are covered. The snow becomes different colors in the changing light. One time I saw it when it was a turquoise green. . . .

I have a painting in a museum show this fall, and another early next year, and I have sold two paintings this fall—one to a New York collector, and one to a German collector, and the painting is already in Germany. It seemed funny to have it come over here, and maybe someday if I'm ever in Germany I'll go to see it! They were both pictures I did this summer—though I think they were finished after you left.[29]

Jody is going to Mallaig now, and I'll give her this to mail. She is going to get the messages. That's what the people here say when they talk about shopping. If you're going to get groceries, etc, you're going to get the messages. If the grocer delivers and leaves the box of groceries at the top of the hill, you have to go up and bring down the messages. It's a wonderful term. Of course, a message is a message, too, and that tends to confuse things. Jody has to go from grocery to grocery to shop, because no one store seems to have everything. For example, only one of the groceries carries grapefruit juice. You can only buy milk at the vegetable and fruit store (which also sells candy) or at the bakery. You get ham or bacon at the grocery, but beef or lamb at the meat market. The most fun is the ships' chandler, which is a store to service the needs of the fishing boats and which sells just about everything. That's where I got my raincoat and my fisherman's sweater and my fisherman's barker—a sort of canvas blouse which goes over the sweater. I got my Wellingtons at the shoe repair shop. And my heavy boot socks at the grocery. So it goes. One thing about the post office, you just get stamps and mail there, though it is run by a guy who owns a little candy shop and magazine and newspaper shop next door—where they have a couple of freezers and you can buy ice cream cones and frozen vegetables and fish. You can't get frozen vegetables at the grocery, but you can at the fish shop.

Whenever you look out at the hills in the valley of Mallaig Vaig, there are always cows and sheep grazing—and whenever you walk any place you see the sheep. They are everywhere—high on the cliffs—sometimes you wonder how they can keep their balance—but they find things to eat wherever they go. They tell me that the little lambs in the spring are wonderful to see, and I'm certainly looking forward to it. It's hard to take pictures now, because the light is so bad, but I shall in the spring and send you some. End of page. Love, love, and love. I think of you all the time.

Daddy

[29]Schueler's daughters had spent part of the summer of 1957 with him and Jody and Tina on Martha's Vineyard, Mass.

MALLAIG VAIG, 28 DECEMBER 1957

. . . Spent this last week at Dumfries with Alastair Reid[30] and his parents. A fine time—and I enjoyed talking to Alastair—but I was somewhat depressed most of the time. Jody depresses me. Am I still mirroring a woman's emotions? When she feels better—today—I felt better. But a depressed woman—a cold woman, is depressing.

Shaved off my beard in anger on Xmas day—like a self-castration—I'm not sure why I did it—all of a sudden I didn't like it—but more because of the disapproval of others—particularly Alastair—as though he symbolized the outside world—outside of Mallaig—and outside of my dream. Mallaig is a stage for me in some respects—I live parts I have always wanted to live. Before Jody came, I could be kind.

MALLAIG VAIG, 29 DECEMBER 1957

—Tomorrow I am going to start a series of drawings. Face and figure—Models—Jody, Betty, Ian, John. There is something I must know about people—then next fall, perhaps, I'll start my paintings on Woman—or Women. I am very excited about this—woman emerging from the landscape. I tried one at Martha's Vineyard—it was a failure, but I should have kept it. That was the summer of 1956.[31]

Reading *Voss* by Patrick White—on p. 46 Voss says, "If I had mastered the art of music, I would set myself the task of creating a composition by which the various instruments would represent the moral characteristics of human beings in conflict with one another."—I have thought about the hard and soft in music—the great, mass sounds and the delicate filigree of sensuousness—I have felt its movement and thought about that meaning in paint. Force—moral force in landscape—in man—in woman? Probably not in woman—Definitely not in woman. In Man. In Man painting of woman. Sensual man of moral nature painting of woman.

Woman: Birth, earth, lust, heat, anger, sensual, evil, flesh, beauty, hope, love, comfort (?). I have seldom found comfort in woman. I shall cease to look for it.

Painting—moral force opposite the sensual materials. I feel morality in the hard sky of winter. Love for me is a softness, a giving up, a retreat. Not always. There were moments when I loved June and she loved me. And then

[30]Alastair Reid, born in Scotland in 1926: poet, translator, essayist and author of books for children. His first book of poetry, *To Lighten My House*, had appeared in 1953. Reid remembers that he met Schueler in New York in the winter of 1953-54, when already Schueler was talking about wanting to go to Scotland.

[31]The use of models for the "Woman in the Sky" series doesn't really get started until late 1963. The portraits mentioned here were seemingly not done.

it was a moral love and it was part of the hard fact of my ambition and my need as a man.

—Today was evil in its hate and in its helpless anger. I do not have love in marriage. I don't know what I do have, but I don't like it.

MALLAIG VAIG, 5 JANUARY 1958

My marriage hangs on a thread. I feel a madness about it—something insubstantial—I can't tell what it is. This morning I said, "I don't know whether I want to go to the country (in Greece) again—after having been here for so long." Jody: "Do you mean you want to spend the summer in the country?" Me: "I don't know yet what I want to do." Jody: "Well, if you go to the city, I'll spend the summer in the country." Me: "Okay, go ahead." A few minutes later, after I have obviously clammed up, she says, "There, I shouldn't have said that (or some such thing), I realize you should be considered, too."

There's nothing wrong with that. It's just not about my life. I don't understand—I have no communication, no trust, I'm in a never-never land—perhaps of my own making, but I don't think entirely so. Now—finally—I am interested only in art, and am making my life count. I'll never again travel or make any move except in terms of my work. Nor will I argue about it. I'm hung on Jody's constant rebellion and need to dominate by reacting to it. I wish I were alone again. I felt virile and healthy, and now I feel tired and worn and I'm gathering dark circles under my eyes. My married life is a constant paradox, like life in death—or death in life. There is something terribly, terribly wrong—and I know this, because Jody is always, always right, and always works to convince me that I am mad. If I am mad, I want to be alone.[32] I don't want this terrible pressure. I want out. I cannot use up my energies in this abominable futility. I must think through my paintings. I must stay out of discussions about this with Jody. I must again be alone. I lend myself to this battle, and this is my madness. My only sane course is to put all my energy into my work.

I'm letting my beard grow again.

I worked today on my first canvas for 1958—vertical—65" x 48"—the thought for it started the other night walking home late from Mallaig in the snow—the storm up near Loch Nevis in the sound—was umber—dirty, dark, foreboding.[33]

—For some other pictures—remember the etched landscape of Mallaig Vaig—with the frost. Hard lines. Frozen forms. Silver and golden umber—dull. Earth oranges—and earth lavender at the shore.

[32]Jody's words were especially painful because of Schueler's break-down during the war, which he recounts in detail later in the book.

[33]Later titled *Rain*.

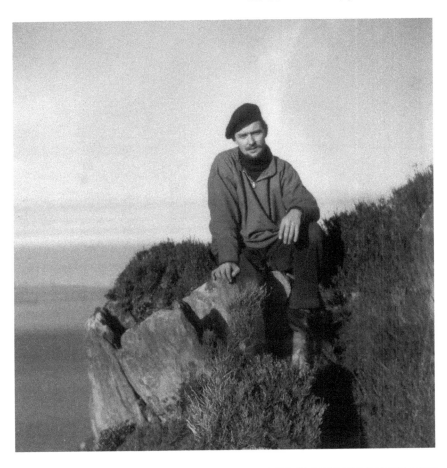

Jon Schueler in Mallaig, Scotland, winter of 1957–1958.

I'm no longer loved. I feel threatened, rather than loved. My strength is in my work and only in my work. Nowhere else.

MALLAIG VAIG, JANUARY 1958
(Undated letter from Jody to Mary Anne Peet found on the table, lying face up, while Jody was out for a walk. It was never mailed.)

. . . I feel on a perpetual see-saw living with Jon—we never have just simple quarrels—how relaxing that would be! For instance, when I arrived Jon had a hideous little beard stuck on the end of his chin and an enormous mustache drooping down to meet it. (The snapshots glamorize it enormously!) His voice was unnaturally high-pitched (from excitement, I guess) and I was rather thrown off when I saw him—he looked like every cliché of

Joellen (Jody) Hall Schueler in Mallaig, Scotland, winter of 1957–58.

an artist bohemian in rough attire that one could imagine—but my joy at seeing him equaled my disappointment over this rather shaky stab at masculinity—but I couldn't help feeling, Is this the Jon I married? I would be caught staring at him still uncertain whether it was the beard that was making him seem so foreign to me or was I seeing him objectively for the first time, as absence from a person for a period can make them seem a new person when you see them not clothed in the wrappings of your subjective superstructure—Well be that as it may—I was having a hard time relating to that strange bearded man—and he was feeling great—on top of the world—and playfully (or not?) assuming a different character each day—or each hour—God—I can't begin to explain him—how he really is! On top of all this he was convinced somehow before I arrived that I wasn't going to like it here and would try to maneuver him away to France or some such idyllic spot—So in the midst of 2 weeks of grey wet days when I first arrived when I couldn't see anything much to exclaim about because of the weather, I realized he was watching me cautiously and if I didn't exclaim profusely each second over the marvels of his chosen haven I was damned and against him! Actually, as the days became clearer and we took walks around I began to feel a growing intimacy with the landscape and truly did love it—but this is even worse because now I am in his picture! Each

cloud formation I rejoice over is really a response to his choice of subject in nature—which is the main feature here and is truly exciting and is the material of his painting. I feel I am constantly invading the privacy of his inner world when I go up on the Burma Road[34] and sit quietly on a rock high up and look out over and down to the sea and off to the island of Skye with its dramatic mountainous contours changing each second as clouds and wind and lights blow over them—it is all so oriental in feeling—imagine a Chinese painting of cliffs and mountains and mists over and around them and that's what it's like here—so naturally it was easy for me to respond—it's everything I ever dreamed of in nature in a way—but I can't paint about it—I feel too guilty if I do—as though I'm trying to out-do Jon or something—so one day I did a small portrait of Jon—oh yes—that reminds me—to continue about the beard: When *Life* magazine came out Jon looked at the picture and said "Now that looks like me"—and he went to the mirror and looked at his beard and decided he was in disguise and maybe it should come off. However—the beard evidently meant a great deal to him as he decided to grow it after he came back from the herring boat fishing trip in which he lived for 5 days on a boat in rough seas with five seasoned fishermen—he said it was the most important experience of his life—so he decided to grow the beard. It was a gesture, and I realize now a very meaningful one to him in many ways. He loved it and was having such fun wearing it until I arrived with my own inner set of manias! I thought I did fairly well, though, because I knew I mustn't say anything against it. On the other hand I didn't exclaim for joy over it either—but as the weeks wore away, it became sort of fun in a way—I just didn't think of him as Jon anymore, but a totally new person—sort of evil—it looked evil I swear—and he began to play an evil role very easily—this was all so subjective in a way—it's hard to describe just what went on—but I used to laugh over it and say I wish I had two of him, one with the beard and one without—for I used to love his chin—bare! However—everything was false in a way—and I swear it was because of that beard—I suddenly began to really feel he was evil—and really I don't know who or what he really was anymore—most peculiar—and I began to grow very distant and cold and blanked out completely on him—this was the day before we left for Dumfries—all the time we were in Dumfries (over Xmas)

(*Letter ends here.*)

[34]The Burma Road was an exquisite, handmade path, with bridges over the small ravines, which led from Mallaig Vaig, where Jon and Jody were living, to Mallaig Mohr. It was laboriously built by Alexander Macdonald, one of the brothers who lived in the only house in Mallaig Mohr, after he served in World War. II. The present, much wider, path lies higher up the hill, blasted out of the rock by the army corps of engineers as peace time training.

MALLAIG VAIG, 31 JANUARY 1958

Jody drove me to almost maniacal frenzy—I honestly was afraid I was losing my reason. I wish to hell she'd leave and let me alone—but I can't quite find it in me to send her away. Yet her ability to continually, day after day—to destroy—is fantastic. I feel my work going bad—I can't concentrate on it any longer. She is talking of a trip to London. I hope she goes and stays—I'd like her to go on and then send her her stuff—before I hate her so much I can't stand it. She has desecrated my studio, and tried to belittle and defile all of its meanings. I wish I could stop—but I can't stay off it. I've started a large painting—big gashes and splashes of red.[35] I'm feeling the vitality again—the will, the determination—one more month of painting—then packing—then out—some place new. I don't see anything or feel anything anymore—only rage against that damned woman. When I get her out of here, I never want to lay eyes on her again. Period. She always wants to play at love after she's done her worst. There is no love. I wish my friends would somehow not make something sentimental out of us. There is nothing sentimental about us. It's Jody's insane, phony, gushing world—to cover the mania of quiet destruction which is the only core to her being.

The wind is howling. I was going to go out on the *Margaret Ann*, but I don't know—it would probably revitalize me—but would it be better to face up to the terrible predicament I'm in, in regard to my painting?

MALLAIG VAIG, 5 FEBRUARY 1958
LETTER TO JANE, JAMIE AND JOYA

Dear Jane: And dear Kids:

I'm enclosing checks for this month, and two bits worth of news will follow. I'll try to get off a decent letter to you in a week or so. I'm on a sort of a last lap now—finishing up a lot of paintings and have stretched my last canvases. I expect to be finished painting around Feb 22, and then comes the big job of unstretching, rolling, packing, etc. That will take another month, and then I'll be off, leaving beautiful Mallaig Vaig with its winds and rain and its drama and excitement. I've really loved it here, and it has been a wonderful place to work. Jody has been here for a couple of months, and I'm afraid that it is just no place for a woman—she hasn't liked it at all.

I think I told you about the big snow, didn't I? We had heavy snow on the ground for about ten days—and everything was beautiful beyond belief. I took a long hike into the back country—a magnificent valley with a number of small lochs—and it was like a fairyland. You had the feeling that no one had ever been there before. In the meanwhile, the coal was running low,

[35] *Winter Storm* (79" x 66").

and no trucks could get up the big hill leading to the valley, and I was pretty tense wondering whether we'd get by. Well, we did—and the coal came, and I found out that the snowfall was the most severe and the longest lasting that had been seen here since one could remember. There is something about the weather here—changing all of the time—powerful scenery, powerful skies, powerful winds, powerful rains, everything pitched up that it makes one feel as though one is living on the edge of a volcano. I love it, yet I know that I'll be glad for a rest from the tension, too.

I think I shall be going to Paris when I leave here. I would like to paint in isolation for another year—perhaps in Greece or Norway, but I feel that I should go to Paris and try to get a gallery there. The only way I can do it is to be there and to get known. And that's a long, slow process, and may or may not work out. Paris is expensive now, and I'll probably have a hell of a time finding a studio. If it turns out to be absolutely impossible, I may go to Rome. Things are easier there, and there is some art market. Jody is leaving for New York around the end of May and she and Tina will probably spend next year there. . . .

Saturday night I went into town at night for the first time since I've been here. I took Jody to dinner at the West Highland Hotel. Inasmuch as we were the only people eating there, we were served on a little table before the fire (electric) in the "writing room", with the hotel dog lying at our feet and it was rather fun. I had a good talk with Archie MacLellan, son of the owner, and then we went off to our first movie. It was so bad we had to leave, and walked the mile and a half home and played our game of checkers and that was that!

Write soon.

Best love to all,

Daddy

In March of 1958, Jody and Jon Schueler left the Scottish village of Mallaig. Schueler's forty-five paintings were sent to the Leo Castelli Gallery in New York. Despite the tenseness of their relationship, Jody accompanied Jon on the trip to Italy, where he considered Rome as a possible place for his next studio. Ultimately, they ended up in Paris. While Jon searched for a new studio, certain that the marriage was over, Jody, with time to fill in before her ship left for New York in May, traveled around France, and visited London, reappearing from time to time in Paris. During the time of Schueler's absence from New York (September 1957–January 1959), important exhibitions were taking place and new relationships between dealers and painters were being formed. While the paintings of more established artists such as Mark Rothko, Willem

de Kooning and Jackson Pollock were commanding higher prices than ever, the lesser-known artists of the first and second generation of Abstract Expressionists were being maneuvered out of the limelight by such artists as Jasper Johns (b.1930), and Robert Rauschenberg (b.1925), whose work laid the foundation for the Pop Art movement.

PARIS, APRIL 1958

The beginning of a book entitled *Forty-Five Paintings*.[36]

I'm sitting here alone in a small room on the seventh floor of a cheap Paris hotel. I'm faced with some non-descript, tan wallpaper, an unmade bed, a view of the silvered roof across the Rue du Vieux Colombier, and a desire to understand what happened to me during the past six months. Did I succeed or did I fail miserably? At this moment, I really don't know.

My life seems to be a shambles. My marriage has ended. I am without a studio. I left, just before the coming spring and summer, which might have brought warmth and spirit to my work, the wonderful Highland village which I had grown to love. I am very, very tired. I am over four thousand miles away from my two daughters, over three thousand miles away from the dear friends who live in New York. I am living on borrowed money. I am unbelievably alone. I go to bed tired and I wake up tired, yet I spend most of the waking day summoning up the energy I know I'll need to set up a new studio and to plunge into a new period of work. My mind moves sluggishly along a path of regrets. It's only for moments here and there that I am able to think of a future and to try to form it.

The only thing I can hang on to is that I have painted forty-five paintings. Just the number. I don't really know whether they are good or bad, though to be honest, I expect now that they are good. Most of them. Or at least some of them. The number is the only solid fact. The one solid fact of my life. Forty-five paintings.

I wish there were a reward. At least A for effort. Maybe a week of lying in the sun, or a pleasant tour of Europe, or two days of sitting in a soft chair and reading a book and feeling good, or a kiss and warm body full of womanly love that I knew was love . . .

[36]This was to have been the story of finding and living in Mallaig. As time went by, Schueler enlarged the project.

NEW YORK, 9 APRIL 1958
LETTER FROM BEN HELLER[37]

Dear Jon:

I was looking in my book section next to the bed last night and, lo and behold, found your letter from so long ago unanswered. My goodness! I'm a bad correspondent. I will have a try to make up for lost time.

I am sure you are pretty well aware of the local gossip: Helen and Bob Motherwell[38] were married Sunday, Sam Hunter[39] is leaving for the Minneapolis Museum to take over the modern curatorship in June, and according to which paper you read, B.H. Friedman pushed (Bob) or knocked (Lee)[40] Mike Goldberg[41] over in the Five Spot[42] and so on.

The big news this year lay neither in the personal notes nor [in] the particular shows that were put on, but in the continually changing atmosphere regarding contemporary painting. I am sure you are aware of some of the changes. If, however, you take the picture as a whole, what is going on is part of the traditional cycle of acceptance: First some collectors, then some dealers, then the Museum of Modern Art touches and runs away, a few more dealers get interested, more museums, more collectors, etc.

Now, not only the European artist is affected but the European dealers are coming over here, not only from various countries but on something of a regular basis in several instances: From England, we have Gimpel and Tooth, from Paris, Stadler, Larcade (Rive Droite) and Tapié; from Italy Franchetti and Cardazzo.[43] They have bought works by Americans and are arranging shows. As a matter of fact, the publications are so aware of these changes,

[37]Ben Heller, president of Wm. Heller, Inc., a company specializing in the production of knitted fabrics. A significant collector of contemporary American art, both for his company and for his personal collection, he owned several of Schueler's paintings by this point.

[38]The marriage of Abstract Expressionist Robert Motherwell (1915-91), best known for his *Elegy to the Spanish Republic* series (monumental canvases of black, ovoid masses juxtaposed with columnar verticals), and Helen Frankenthaler (b. 1928), whose color-stained paintings were to be particularly influential, caused much interested comment within the art world in 1958.

[39]Sam Hunter (b.1923), author of *American Art in the Twentieth Century: Painting, Sculpture, Architecture* (New York: Abrams 1973), and many other monographs and books on contemporary art.

[40]Lee Krasner (1908-84), wife of Jackson Pollock, and a painter in her own right.

[41]Michael Goldberg (b. 1924), painter of exuberant gestural abstractions. Evidently, B.H. Friedman felt that Goldberg was baiting him.

[42]The Five Spot, 5 Cooper Square, not far from the Cedar Bar, was a gathering spot for writers, artists, and others interested in jazz.

[43]Giogio Franchetti, Roman collector, and Carlo Cardazzo, the Gallerie del Naviglio, Milan.

that *Time* has just recently written up the boom in the contemporary art market as opposed to our current recession, describing prices reached by Pollock, de Kooning, Rothko, etc.[44] *Life* is working on a story describing the Europeans coming here. They even gathered a few painters and dealers at our place in that we are supposed to be an influence: showing all the various dealers' American work, suggesting here and there names of painters, galleries, etc. or some such thing.

Then, too, the Modern Art [MoMA] has mounted a superb show of seventeen painters which they are sending through Europe and expect to show in the museum upon its return if things go well. This show has all the older painters with the exception of Vicente and Hofmann to the tune of four or five of each of their works and includes such less popular (to MoMA) painters as Barney Newman, Tworkov, Gottlieb and Stamos.[45]

I guess you also must have heard from Leo [Castelli] how well Jasper Johns's show went and how Philip[46] just about sold out and how Mark [Rothko] sold as much as he wanted for this year. This largesse of course, is not spread throughout the market but points a finger toward the future. There have been a lot of good shows throughout the year: Leo has had continually excellent shows for the members of the gallery. Philip's and Mark's were stunning, Esteban [Vicente] and Adja[47] have had good shows—Adja's being more serious and not quite as sweet as in the past, Stamos's show was probably his best work, although it still does not move me too deeply, Gottlieb had a tremendously beautiful retrospective show at the Jewish Museum, followed by an exhibit of his new work at Emmerich, and on and on, but I am sure you get these reports, at least, from the magazines.

The atmosphere has even changed in *ARTnews*, if you noticed it. Some of it, I flatter myself, is due to a point I made one evening at the Club[48] when Tom Hess, Alfred Barr and Harold Rosenberg[49] were discussing the

[44] As Heller indicates, Pollock (1912–56), de Kooning (1904–97) and Rothko (1903–70) were regarded as the most significant American artists of this time. The "drip" paintings of Pollock (who had recently died), the women paintings and gestural abstractions of de Kooning, and the soft-edged floating rectangles of color by Rothko, were now attracting international attention.

[45] An invitation to an artist to show in an exhibition organized by the Museum of Modern art in New York implied admission to (or exclusion from) an inner circle of the approved avant-garde. Esteban Vicente (b. 1906); Hans Hoffmann (1880–1966); Barnett Newman (1905–1970); Jack Tworkov (1900–1982); Adolph Gottlieb (1903–1974); Theodoros Stamos (b. 1922).

[46] Philip Guston (1913–80).

[47] Adja Yunkers (1900–1983)

[48] The Club, since 1949, had been a meeting place for New York artists and a few collectors and critics.

[49] Tom Hess, editor of *ARTnews*; Alfred Barr, director of MoMA; the writer Harold Rosenberg, best known as an art critic.

perennial question "Has the situation changed?" After about one-half hour's discussion, we always seemed to revert back to de Kooning. I pointed out to them that they had been continually talking about de Kooning and practically no one else. When Hess, somewhat flustered, denied this, I also pointed out the same thing is happening in his magazine. I sat down to a surprising burst of applause and noted that in the next two articles and editorials he did include the names of many other painters with new emphases.

I was even able to be of some influence at the museum on the selection of the European show, encouraging them to include such painters as Adolph [Gottlieb], Barney [Newman] and Jack [Tworkov], but all of this is a long story which we can discuss when you get back home.

The museum, incidentally, is in full bloom now with a show of Seurat and Juan Gris. *La Grande Jatte* looks twice as good as it ever did in Chicago and the drawings are incredible. All in all, then, it has been a very active year.

On the other hand, the major problem of the young painter, so-called, has been to achieve his own image and find some way to exist in this political rat race. The necessarily slow and quiet development of work is always a problem, the loneliness involved, unavoidable, and the desires for recognition and a place in the sun difficult to overcome.

I am sure that painting in Scotland and being away from this all and getting a perspective on it must be very helpful to you.

As far as Judy and myself, we have been having exciting times, too, for one on top of another we bought Leo Castelli's house out in East Hampton and a new cooperative apartment here in New York. The apartment was totally unexpected, as we had just begun to think we might want to move some time in the future. Now, sometime between July and December we will be moving into a large apartment at 75th Street and Central Park with room to hang all our paintings, a view of the park and a chance for our kids to be closer to their school and friends.

If I don't stop now, neither my secretary nor I will get any work done today. So my love and Judy's to you and Jody and hope to see you in the not too distant future,

Ben

PARIS, 25 APRIL 1958
LETTER TO LEO CASTELLI

Dear Leo:

This is just a quick note to let you know where I am—which is Paris. God—no one ever took such a long trip to get to Paris—but I made it. The only trouble is—now that I'm here, I can't find a place to work in the city. Which I guess is no surprise. But I have found a place in Herblay—a little country town about a half hour from Paris by train—it will be sort of like living in a small suburb of New York—which means I'll be more alone than ever I was in Mallaig. And what I was lusting after was the

beat of the city, the noise, the traffic, and most of all, the people. Inevitably, an artist ends up alone, whether he wants it or not. . . . It's a completely un-imaginative, uninspiring little spot—which is hard enough to find in France—but for that reason, I may like it—I'm thinking that it might be good to work in a bland atmosphere for a while after the hopped-up stimulation of Scotland. In any case, I'd work in a pissoir, if someone would offer to rent me one. Jody is now in the south of France—Orange—and is returning to New York on a boat which leaves Genoa 23rd May.

Have my pictures arrived as yet? Have they been stretched?

I've been getting glowing reports of the shows that you have been giving—which is good to hear.

I hear from Bob [Friedman][50] that a cousin of his bought *The Wave*. Just in time. I wish that you'd send me the money as soon as possible—through American Express, to my order. I'm getting desperate for money—and this is no exaggeration. I did a number of stupid things—taking a freighter from Glasgow—thinking it was going to save me money—and it cost me over three times as much as the train. Then, instead of coming directly to Paris when I knew I had to—going on to Rome—all sorts of baggage forwarding expenses because I have all of my painting gear with me. With each attempt I made to save money, I got more and more involved with expenses, until I used up most of what I had set aside for this next venture. Would it be possible for you to lend me some money against future sales to help me work through the summer? I'm going to need about $500 over the proceeds from the sale of *The Wave*, because I expect another productive period is coming on, and I have canvas to buy, etc. Plus getting the work back at the end of the summer. I wouldn't need it all at once—this is an estimate for the summer. If possible, show some of my paintings before the gallery closes this spring. I need another sale badly.

I think that the way to see Europe is to take an old-fashioned tour. I've seen quite a bit, but I was always under the terrible pressure of thinking about finding a place to work—and this has distorted everything in my mind. Until I have a studio, I cannot really look at Europe. Yet—even with pacing the streets in Rome looking for a place and trying to decide if I could work there—I got to know a lot about the city. I want to go back there. But it's not a city for me to work in, unless I'd have to. In Italy, I would rather work in Siena. Mostly because of the past. I was refreshed. I could imagine Simone Martini working, and looking at his work I could understand his mind and what it must have been like then, and the freshness and the vitality and the searching and the earnest expression of an ideal. There was a reality for me in the square and the town hall and the tower which no amount of postcards, tourists, motor scooters, and whatnot

[50]In fact, Kal Noselson, who bought *The Wave*, and two other Schuelers was Friedman's brother-in-law.

could efface. But it was too soon after Mallaig. The images of Mallaig are still in my mind. It's as though I want to digest that experience now—so perhaps suburbia will be just the place.

Until I move into my studio, my address is The Studio Hotel, 4, rue du Vieux Colombier, Paris VI. But you had better write, c/o American Express. Will you be coming to Paris this summer? When? I'm looking forward to seeing you and to having a firsthand report on this year's activities.

Please send the *The Wave* money as soon as possible, and let me know about the possibility of a loan.

Signed, Desperate.

Sincerely, Jon

Best to Ileana[51]—will she be coming over this summer also?

P.S. Don't deposit any more money to my account in New York—I'm closing it. From now on, send directly to me through American Express.

<div style="text-align:center">

PARIS, 26 APRIL 1958
LETTER TO LEO CASTELLI

</div>

Dear Leo:

Since I wrote to you yesterday, I have a studio! The one thing that always goes right in my life, is that wherever I go there is a studio waiting for me. Yet I never really believe that it's going to be there and always get terribly depressed while looking for it—certain that this time I shall fail. I had been searching all over Paris every day and in every way, and the other night I was taking a walk and noticed a real estate agent's office—rather elegant looking—with the lights on. It was the most unlikely place to stop in at under the circumstances, but I did and had a long talk with the owner—a young guy, dynamic, spoke some English—name: Yves Sambidi Ravenne—and he liked artists. He had various ideas, none very good, until he remembered a property of his mother's which was up for sale—and on it a carriage house which might be used as a studio until such time as the property was sold. We looked at it last night and it's perfect—at least until winter sets in—by which time I may come back to the States. This will give me six good months of work. The property is at Clamart—a half hour by Métro and bus from the Left Bank—in the direction of Versailles—a rather unprepossessing suburb at first sight. But there are a number of rather large properties surrounded by high stone walls. The one we entered last night was like a fairy land—beautiful trees, gardens, a lovely old house and many small houses of one sort or another—fruit trees in full bloom, birds singing and all the rest. I was absolutely enchanted. (This after an atrocious day when I had just about given up ever finding anything in Paris—having been told over and over "*c'est impossible.*") Built right next

[51]Ileana was Castelli's wife. She later married Michael Sonnabend and with him opened the Sonnabend Gallery in Paris in 1962. In 1970 the gallery moved to New York.

to a wall and rising above it, is the carriage house. Above the garage—a huge room with windows on three sides. The room is at least 20' x 20'. High ceiling. Wooden floor. Unfortunately, there is stained glass in the windows, but they are going to have that changed for me. On a higher floor (both floors are reached by stairways outside of the building) are two more small rooms—an attic, really—which I shall use for stacking paintings—and perhaps to sleep, although the main floor is so wonderfully light and airy, I shall hate to leave it. The plumbing is only basic—cold water taps—and the toilet doesn't work at present—but what the hell. I have to pay about $85.00 a month—but this is much less than even the most inadequate apartments in Paris proper. The condition is that should the property be sold, I will move out. I'll chance it. . . .

Now—I am desperately anxious to get to work, and wonder if you could cable me some money right away so that I can get set up. I had no idea yesterday that I would be finding a place so soon—but now I have rent to pay, paints and canvas to buy, etc. If possible, please cable $500 through American Express to my order. If not, cable what you can

It's raining this morning, but Paris looks more beautiful than ever. Being without a studio does terrible things to an artist. It's as though he was deprived of his skeleton, his structure—and somehow feels that he has to start all over again in forming one—from the very beginning, from nothing. The day I stopped working in Mallaig Vaig and started to tear down my paintings and the studio, I became depressed and I don't think I have felt a moment's peace since then—excepting a few times when I have seen some paintings which moved me. By the way—I was sick when I heard about the museum fire[52] and the loss of the Monet. It felt like death to me. The following day I went to see the two huge oval rooms of Monet's at Place de la Concorde [L'Orangerie]— what do they call them? Les Nymphiedes [Les Nymphéas], or some such thing. Such magnificent work. Let me know if my paintings have arrived. Are they stretched? I wish that I could see them outside the studio. Perhaps I shall be back next year after all—though in a way, I think it would be better to be away during a show. Dorazio[53] said he heard you were ill. Are you all right now?

Best regards,

Jon

[52]The fire at the Museum of Modern Art on April 15, 1958 destroyed three paintings, two of them by Claude Monet (a small one and the long *Water Lilies*, c. 6' x 18'). The director of the museum, Alfred Barr, immediately sought a replacement. With the insurance money, and through the generosity of Mrs. Simon Guggenheim, MoMA was soon able to acquire not only the *Water Lilies* triptych but also the 19' painting which was also installed in the new Monet Gallery.

[53]Piero Dorazio, b. 1927, Italian artist whom Schueler had contacted in Rome on Leo Castelli's suggestion. Their friendship is sustained over the years through Dorazio's visits to New York. In 1978. Schueler stayed with him and wife, Juliana, in Umbria.

CLAMART, 8 MAY 1958

I have a studio near Paris.

I am alone—Jody is in London. I think she is finally gone for good. In my relationship with her—I saw all of my most evil characteristics brought out, mirrored, exposed. Perhaps this was good. I hope I have laid them bare to the sun, and that they will dry up—shrivel to dust.

Today I felt the sickness of being alone gradually turn to work. A few drawings—faces—and then my thoughts turned more and more to painting. I couldn't be more alone—more so than in Mallaig, because I speak French so poorly.

Although life has been hell for the past few months, and I seemed to make one mistake after another, I may have benefitted. I'll know when I start painting. I think things are more real—less romantic. In fact, for once in my life, I don't have a romantic thought in me. But I'm tired. When I went to Scotland I was filled with Romantic thoughts—I loved so the idea of what I was doing—and I think I get once removed from important creative feelings when that happens. Now—I have a studio with good light. Canvas and lumber are arriving at the end of the week. I don't really want to be here—nor do I "not want to"—it's a place—and I think I'm here for a purpose—though I don't know what it is.

I think I can gain strength by writing in my journal. It makes the days more real, and I do not feel the time suspended like a dream of loneliness.

—Things I would like to do besides paint:

—Write.

—I would like to be a good father to my children.

—I would like to be kind.

—I would like to love, and make my love felt.

CLAMART, 12 JUNE 1958

A fact. My mother died when I was six months old. I don't remember this—except in the vibration of every moment in my daily life.

Another fact: I have no discipline in writing, because I have not done enough writing. For this story I use the only discipline I know: that of painting. The story too will have to grow organically. Of course, it isn't a painting, so it won't end up like the painting. The painting, when it is finished, is a single impulse existing on the surface of the canvas. The story is linear, so the impulses are separate. Everything will stand out starkly, the hurt of this morning, the desire to work, or the frustration, attaining equal or perhaps larger status than an idea, a scene or a subtle emotion which is perhaps the point of the day's writing. We shall see.

I'm thinking about the creative act. For years it was often practically impossible for me to paint. But I wanted desperately to paint. The only thing I could think of was to practically lock myself in my studio, day after

day, night after night. Doing nothing, but feeling the frustration of wanting to work, and not having the courage to touch the canvas. Feeling misery, pain, terror, failure, every ravaging, enervating emotion one can think of, and not having the strength to find the only release possible—the painting. This was my work method. I'm reminded of Picasso, saying "I do not seek, I discover." That's his way. He's a lucky man. I like the assurance with which he is able to make that statement. Schueler says, "I do not discover, I seek." That's the story of my painting. An eternal search. I never know precisely what I am looking for. I have faith that it is there, that I shall discover it, that I shall reveal this truth—but I don't know when it shall be revealed. Perhaps it was in a picture long past, or perhaps I am circling blindly around the sacred fountain, like a man without a compass. I'm always dealing with the unknown and with the mystery, and therefore there is little sense of satisfaction or of discovery. Every morning when I begin work, I do so with the feeling I'm beginning anew. It's almost as though I don't know how to paint, as though I have to start all over again and learn from the beginning, with the possibility of failure at every step while I discover the canvas before me.

And yet I am a free man in my painting. This is what my freedom is: To be uncertain, questing, wondering. I don't really want certainty there. I want to keep looking. When I discover something certain, I only want to look behind it or around it, or smash it to bits if need be. I'm not satisfied with the apparent truth, because in my life I knew the apparent truth was false. I mean the pretense about my mother, that there was no mother, that the mothers before my step-mother didn't exist. It takes a lot of delicate juggling and complicated maneuvering to get oneself to believe what one knows isn't true.[54]

<div align="right">

NEW YORK, 13 JUNE 1958
LETTER FROM LEO CASTELLI

</div>

Dear Jon,

I have sensational news for you. In the past few weeks I sold no less than four of your new paintings. Here is how:

Snow Cloud and Blue Sky to Whitney Museum $1300-10% discount*
 [1958, 80" x 71"]

[54]After the death of his mother in February 1917, when Jon Schueler was six months old, he was looked after by a nurse and then by his paternal aunt Marie and uncle Fred until his father remarried three years later in 1920. The relationship with his new step-mother was complicated by the fact that she came to claim that she was his mother and forbade contact with his real mother's relations.
*See color illustration 5

Red Snow Cloud and the Sun Roy Neuberger	$900
[1958, 66" x 79"]	
I Think of the Open Sea Kal Noselson	$600*
[1957, 72" x 60"]	
The Sea from Mallaig Vaig Mrs. Jack Lesnow	$430
[1957, 38"x 53"]	

Our accounts stand, therefore, as follows: I owe you $2066.67. On the other hand, I incurred the following expenses in connection with the shipment of paintings that you sent from Scotland:

Stretching and stripping	$130.00
W.R. Keating (customs, carriage, etc. charged on arrival)	$ 73.10
	$203.10

This sum should really be deducted from what I owe you, but since the Whitney sale was just confirmed a few minutes ago, and I feel particularly good, I decided to share this expense with you fifty-fifty. Therefore, a total of $1965.12 is still due to you. From this we have to deduct an additional $100.00, since, on the sale of *The Wave*, you were supposed to receive $400, but I sent you a check for $500 at that time. We arrive then at a final figure of $1865.12, of which a check for $500 is included herewith.

. . . I shall leave for Paris in about twelve days. . . . I'll, of course, let you know as soon as I get there, and look very much forward to seeing you in the near future.

In the meantime, kindest regards,

Leo

CLAMART, 17 JUNE 1958
LETTER TO LEO CASTELLI

Dear Leo:

Thanks a lot for your letter of June 13. I certainly was pleased and excited by all of the good news, and I want to thank you for your part in the sales, and for all the effort you must have had to put out. . . .

. . . I'm looking forward to seeing you—and am glad that you're well enough to make the trip to France. I have no telephone, but there is a Passioniste order of priests across the way—they are good friends of mine—who have a telephone—and will take a message for me. . . . I have just finished a large painting† which I painted for their chapel. It is about the Passion and the Resurrection of Christ and will hang above the altar. (This is

*See color illustration 4

†See color illustration 6

a gift, of course.) After I have titled it, I'll let you know, so you have a record for your files.

I heard that you had some complications about the Noselson sale. I was sorry to hear that—and notice by the figure that we came out rather badly. When you come, I would like to go over prices with you—and be sure that we have a firm price on each picture—allowing only for a 10 percent discount to museums, collectors, or for bargaining purposes. I am very anxious that my prices are stable—not only for my own account, but to substantiate the prices various people have paid when they bought my work. Inasmuch as *I Think of the Open Sea* was a $900 painting, and an important work, I don't want word to get out that it was sold for $600. Do you have a list of prices I sent you? I can't seem to find my copy at the moment, and wish that you would bring yours. Also, while you're at it, a receipt for the paintings I sent—for my files.

What is the item of stripping? I didn't think that would be necessary until we chose paintings for the show. I wish that some cheaper way could be found to restretch. . . .

. . . Well—we can go over all these matters when I see you. In any case, some paintings are sold, thank God—and just in the nick of time! My materials' costs are mounting, I have to eat, and I'll soon have all of the terrible costs to face again of crating and shipping. What a damned mania. Thanks for sharing on some of those costs—as it's a terrible burden. I'm having some thoughts of going to Greece to work—and I almost hope I don't, as that will probably break me entirely. The safest place to paint is in New York—but there are no snow clouds.

Best regards,

Jon

<div style="text-align:center">

CLAMART, 18 JUNE 1958
LETTER TO LEO CASTELLI
</div>

Dear Leo:

This is a postscript to yesterday's letter. I found my copy of the list of the paintings, with sizes, that I sent you. Unfortunately, I can't seem to find the list of the prices that I sent you. But it looks to me as though something very unfortunate has happened in regard to price in three instances:

1. I think that *Red Snow Cloud and the Sun*, which you sold to Roy Neuberger for $900, was priced at around $1,250. It was one of my best large canvases.

2. I'm positive that *I Think of the Open Sea*, which you sold to Kal Noselson for $600, was priced at $900. This also was one of my best large canvases.

3. I'm sure that *The Sea from Mallaig Vaig*, which you sold to Mrs. Jack Lesnow for $430 was priced at either $500 or $550.

These discrepancies make me unhappy in the extreme. When we first started doing business together, I made it very clear that I wanted absolutely firm prices—that I want to set my prices reasonably, and I did set them at a level lower than other New York painters. I made it clear that I didn't want one person to pay one price and someone else to pay another. That at times I would price a painting high when this painting (like the pink painting) meant a great deal to me, and I was only willing to sell it at a price. And that you would work within the area of 10 percent off, because that seemed to be the custom in regard to museums and big collectors, and I felt then the custom could be extended fairly to others.

When my paintings are sold at lower than the prices I state, I feel that three things happen: I am out of money—and my only capital is tied up in these works. Once they are sold, they are gone. I am out of pride, because I have made it a principle that there should be no bargaining. I am out of goodwill, because my entire price structure collapses. There is now no reason why everyone who has purchased paintings from me in the past, and everyone who will purchase in the future, should not complain about the price they pay. I was very firm when I sold Ben *A Walk in the Country*.[55] I was firm for a matter of principle, and with a friend. Last year another friend of mine wanted to buy a large painting of mine for the price of a small one and asked me about it. I said I could not do it, that it wouldn't be fair—and he did not buy. Yet the discrepancy would have been no greater than those noted above—and he can now accuse me of unfairness.

I am very serious about this. I am nearly physically sick to think that a painting like *I Think of the Open Sea* should go for $600—unless I had so stated ahead of time. I'm still puzzling over your letter, and it may be that you mean $600 is net to me, but I don't think that's what you mean.

I want to prevent the possibility of this ever happening again, and I suggest that you bring with you a list of all the paintings of mine that you have. I shall go over all of the prices, and make a price on each that is firm and final, in case this hasn't already been done. I have never at any time had any intention of my paintings being sold at less than the minimum prices I set, and I had thought I had made this clear. I shall also review each price with you in case you don't think it is fair.

Now, I want to state this accurately and simply again for all future dealings: (1) The price I state will be the only price that will be quoted. (2) Museums and big collectors will get 10 percent off list price. (3) My friends and those committed to my work will get 10 percent off list price. (4) You can bargain, at your discretion, within the limits of 10 percent off list, and no more. (5) If for any reason, a question comes up of further bargaining off list, and you think it has validity, it should be referred to me. In any case, the client should be told my stand and not be led to expect that I

[55] A trilogy, (96" x 48", 88" x 82", 96" x 48")

shall in any way modify my stand. On no account should a painting be sold under the stated price without my express authority in each instance. If you should sell at a lower price, you do it on your own responsibility and I expect to be reimbursed—but I see no reason for you to do so. My principle, to repeat, is this: Absolutely firm prices and standard prices. If a client doesn't want to pay the price, he has a choice of buying a smaller painting or of buying someone else's painting.

I am very unhappy about what has happened (if I interpret the figures correctly), and feel that my dignity as well as my pocketbook has been hurt. However, if we learn a lesson from it so that such circumstance can't happen again, then it shall be all to the good. Two other points: If, for any reason, my prices should be too high—now or in the future—we will get together, talk them over, and I shall lower them—all of them—not piecemeal as the paintings are sold.

I am sorry to somewhat dampen the enthusiasm about the sales, but for me—I have never felt such unhappiness in regard to a sale—except for the Museum sale, which was proper. If we are to do business with each other, we have to be frank with each other.

I'm looking forward to seeing you, and hope that we can dispatch business talk quickly, and have plenty of friendly talk after. It seems like centuries since I have seen the face of a friend from home.

Best regards,

Jon

CLAMART, 18 JUNE 1958

—Finished Passion painting for the priests on Monday. Response very enthusiastic.

—I'm dull and tired, I'm way in myself. Day after day alone. I'm sure it's my fault. Tomorrow I'm going to write notes to people on lists[56]—see if I can't meet someone.

—Sold 4 paintings—but Leo screwed up on prices. I told him to keep prices firm.

—I must be strong. I think it is important that I make this venture work—that I conquer idea of being alone. Paint paintings. Write book. Meet people—on my own initiative. This last is the hardest for me. Also—the book—I get hung up—and don't paint or write.

—I would like to be able to love.

—I would like to take care of someone.

• • •

[56]Schueler had been given names of people to contact in Paris by Ben Heller and others.

I think the book is important—start thinking of the story—not about day-to-day misery.

NEW YORK, 19 JUNE 1958
LETTER FROM LEO CASTELLI

Dear Jon,

Thank you so much for your letter of June 17th. I'll follow your instructions as to the remittance of the balance as soon as the money comes in, which will be soon, I hope.

As to the Noselson sale, we came out a little better than appears from my letter. My secretary put down $600 for it, instead of $750, and I did not notice the mistake when I read and signed the letter. So I owe you actually $100 more; that is, a total of $1465.11. The reason I had to grant Noselson the $150 reduction on this painting was that he felt that he had overpaid on *The Wave*. As he was not entirely wrong, I did not insist.

The stripping was put on the paintings sold to the Whitney, Neuberger, Noselson and Lesnow.

That's all for the moment. I'll be in Paris beginning of July and will get in touch with you immediately at the phone number that you have given me. I look forward to seeing you.

Best regards,

Leo

NEW YORK, 21 JUNE 1958
LETTER FROM LEO CASTELLI

Dear Jon,

I'm surprised, not to say shocked, by your letter of June 18. I was under the impression of having done extremely well for you. You may not realize it from over there, but there is a recession here, and people do not spend money as freely as they did at the time of your show.

I never received a price list from you, and since you cannot find yours, it seems probable that you didn't make one. Being under the delusion that you trusted me and thought that I would act in your best interests, and being no mind reader, I made the prices myself. I based the prices on those we had fixed for your show, but also took into account special circumstances, such as the scarcity of buyers, your need for money, and your wish to stay in Europe as long as possible. Had I not adopted an intelligent and flexible policy, your stay abroad, your pocketbook, and, possibly your dignity, might have suffered more.

It is true that Roy Neuberger got his painting rather reasonably. This

however, is the second major painting of yours that he has bought.[57] Furthermore, he has been extremely helpful in increasing your reputation and in interesting the Whitney in your work. If there is anybody who deserves special consideration, it is certainly he.

I may add that I find the five-point program as outlined in your letter entirely unacceptable, especially as to its tone and spirit. No one has ever prescribed to me what business methods I should follow, and I do not intend to let anyone do it now.

I feel that this letter, though unpleasant, is necessary so that we both understand each other.

In all events, we will discuss our future dealings when I get to Paris, around the fifth of July.

I hope you are still enjoying your studio and doing good work. We are both looking forward to seeing you.

Best,

Leo

CLAMART, 26 JUNE 1958
LETTER TO LEO CASTELLI

Dear Leo:

Thanks for your letter of June 19—telling of the error in price quotation, which set me off on a long stream of evidently unnecessary worries. I have a horror of getting into a situation where perhaps someone else feels they have been cheated, or where someone hasn't done right by me, as the saying goes. Being this far from New York, distortions become even more distorted. But your letter set things right and I'm now back on a feeling that I'm glad four paintings were sold, I have some money in the bank, and all's right with the world.

I have done a painting for the Passioniste priests who have a seminary next door. They have a little chapel and asked me to do a picture encompassing the Passion of Christ and the Resurrection—quite an order, but I did it—and very much to their satisfaction. A resident philosopher has already written a paper on it, and now they want me to design an altar and tell them how to decorate the chapel, etc.—they want to repaint and have everything done in terms of the painting. Well, I've designed very few altars in my life. . . . I'm anxious to have you see the painting as it ended up being a very important picture for me—both as a culmination of many ideas I had been expressing and as a force which will lead into the future. By the time you arrive it will be in their chapel—which at present is a poor thing, with terrible wallpaper, etc.—but which I hope to get totally reorganized by the fall.

[57]The first one was *Storm in Limbo*, 1957 (60" x 45")

A friend of mine[58] from London arrived unexpectedly last weekend and has stayed on for a few days—so I've had a chance to talk for the first time since I've been here and that has relieved the pressure enormously. I can see why prisoners go whacky in solitary [confinement]—though it pressures one's thinking, too, and has had a lot of important results for my painting and should have more in the months to come.

Sorry about all of the confusion about the sales, and about any of my contributions to that confusion.

I'm looking forward to some long talks when you get here—and hope it will be soon.

Best regards,

Jon

Dear Leo:

I feel as though I have been a thousand percent wrong, and a little worse than that, and literally the only thing I can do is apologize with complete humility. Reasons, explanations—which even I don't understand—are quite useless. I only hope that I haven't done some kind of irreparable damage.

All of the facts involved are beside the point, and that's why it's hard for me to talk about or even know precisely what happened. Despite cheerful little notes that I write back to the States, I have been living here in a state which at times seems to me to border on madness. Mallaig was an experience of the utmost in visual excitement, driving work, and a marital disintegration, which seemed to tear at every shred of moral fiber in me. The moment I stopped working, I started to go to pieces, and I have been carrying on one of the biggest struggles of my life since then to try to put things together. In Clamart, with these emotions broiling inside of me and feeding on each other like cancer, I have been living in complete isolation, seldom talking to anyone, seldom getting to Paris. Oddly enough, my paintings have taken on a look of clarity and light, as though truth were finally breaking through. But my daily life has been composed almost entirely of trying to contain persistent fantasies and to conquer the burden of solitude. I began to realize that I was suspicious of everyone—even blew up at a priest thinking he was criticizing me—when actually he was doing quite the opposite. With all of the work I was doing, I added two burdens: I decided to write a book on the Mallaig experience—and writing is an infinitely difficult emotional experience for me; I took on the task of painting the Passion of Christ—which took all told about 10 days to execute and which set me into a turmoil of emotion, as though I had to live through the agony completely. I can't tell you how literally

[58]Michael Hutchins

real this was. I don't like to talk about these things ordinarily, because I feel that my emotions are of no interest to the outside world and that only the paintings count. But in this instance, I know of nothing else to offer you—as the so-called facts in the situation seem to have been created in my fevered imagination. It was in the midst of the Passion experience, when even the priests were pointing out that I was looking unusually haggard (I swear that I have never painted a picture which was so essential for me to paint), that the business about the sales came up. I was perfectly happy to hear about them— reacted immediately with pleasure, and wrote to you accordingly. Within twenty-four hours I was surrounded by enemies, somehow everybody was trying to take advantage of me; evidently I created the "price-list" in my mind which doesn't in actuality exist—I felt compelled to create a rigidity of structure to save a world which wasn't even threatened. At that point I wrote you. Within a few days, something felt wrong about the whole thing—and when I heard about the price mistake, I thought perhaps that had been the cause, was satisfied, and seemed to drop the matter from my mind. Incidentally, before—I'd waver back and forth between feeling I was cheating others and others were somehow after me.

As I said—there is nothing for me to say—as all of the "facts" are meaningless. You obviously did an excellent job for me. The prices are obviously right. (The only one which was evidently out of line was Kal paying too much rather than too little for *The Wave*.) Certainly if you are going to handle my work in a market like the art market, you have to have freedom and flexibility, and my assumption should be (which it certainly has been up until now) that you were doing the right thing, showing consideration for me and for the buyers, working within your knowledge of conditions, etc. Before I received your letter this morning, the rigidity of the ideas which had seemed my only salvation a week before, had seemed foolish, and I had hoped to say that first of all when you arrived. I had one corollary feeling—which is probably the most sound one I had had—and that is that by the nature of my temperament—particularly these days—I should stay as far out of the business end of art as possible. In the worst way, the business gets into and becomes part of the fantasy world I am experiencing at the given moment. I can't tell you how literally I have been on the cross during the past few weeks. Every pulsation from the outside world has seemed to claw at my flesh and nerves. I'm feeling much better now, actually—but I'm under no illusions about it. A friend from London arrived unexpectedly last Saturday and has stayed with me and is leaving tomorrow. I have been talking in a steady stream since he arrived, and with each day have felt better. But I can't predict how it will be after I am alone again. Until recently I couldn't contact people, I somehow couldn't make the effort to contact those names that had been suggested to me. I tried Stadler[59]

[59]Rodolphe Stadler, Parisian gallery owner (then as now). The Galerie Stadler was

and Tapié[60]—and they seemed very cold (though perhaps they actually were not). I have an idea I was more afraid to be with people than alone. But I have written some notes, and a chap introduced by Ben Heller has written to me, and I have an engagement next Tuesday—so perhaps I shall enter the world again. The studio that I have "enjoyed", in my more polite communications, has been a self-created prison for me—but I think I have the door pried open.

This is not in the nature of an excuse. I feel that I owe you something, and I know of nothing else to offer except what truth I am aware of. I hope I have not destroyed our relationship, but I may have.

One other thing—I don't want you to feel that I am moaning about Clamart. With all of the tension and strange feelings which have gone with living in a state of almost solitary confinement—I feel that it has been an important creative experience, was absolutely necessary to somehow purge the misery of the past and prepare for the work of the future. In itself, it has not been a terrible thing—only a very difficult and necessary thing. The jailer should have been more diligent in preventing communication with the outside world until the term of the sentence had been completed. Clamart for me personally is also some kind of tremendous challenge and battle, which I had hoped I was winning with dignity and courage. Until the business intruded, I was, for the most part, slugging only at the devils in myself. I'm afraid that you (and, in fact, some others of my friends) caught some of the punches.

Again, I apologize.

Most sincerely,

Jon

NEW YORK, 1 JULY 1958
TELEGRAM FROM LEO CASTELLI

DON'T WORRY LOOK FORWARD SEEING YOU SOON AFFECTIONATELY
LEO

LONDON, AUGUST 1958

Time passes: In the story and in the writing of it.

I'm now in London. I had to leave Clamart and Paris. Clamart seemed more than I could bear after finishing the painting for the priests. I finished a few more paintings and then I tried to make myself healthy by studying

particularly influential in the 1950's showing, among others, Antoni Tapies (Spanish), Karel Appel (Dutch) and Georges Mathieu (French).

[60]Michel Tapié, collector, impresario, art consultant to the Galerie Stadler, promoter of the avant-garde, knew everyone in the art world.

French at the Alliance Français and spending long hours with Jo Kantor. God bless her soul, she was good for me, and I felt almost human again. I felt the loneliness disappearing and I decided that I would take my last two months in Europe and use them for a tour of the great galleries to see the great paintings of Europe. But I took my typewriter with me. When I arrived in London, I decided to drop anchor again and try to continue with the story. Facing it brings back all of the old depression and I feel the weight of it growing each day. I cannot afford to halt again. I must press on with this.

Before I left Paris, Jean Larcade, owner of the Gallerie Rive Droite, came to my studio. He had asked to see my paintings. As usual, I felt as though I was graciously allowing him to come and look at them. He became more and more sullen as we approached the studio. After looking at two paintings he said, "They seem to be unfinished." I damned him then and there. I said I didn't want to hear his comments. I despise and hate the critic. Why can't they stay at home. I offer something of myself. It doesn't have to be accepted. I don't ask that. I just want knives left at home.

Today I'm a little sick of the use I have made of women. I'm bored with my own story of frustration and turmoil and mix-up with June and Jody. Yet it's so much a part of the story that I can't quite skip it. [Robert] Graves skipped it in *Good-bye to All That*. Was this right? Creatively? I liked the book. I understood it. I knew why he said goodbye. I could even read his woman drama between the lines.

Quickly, then, the past leading up to Mallaig Vaig.

At the end of that summer of 1956, Jody, Tina and I drove back to New York. I spent the entire trip singing. Because I was sick inside. I had nothing to say to them. Something was going wrong, but it was out of my control. I was not sure why I was where I was.

Once back in the city, I was overcome with feelings of guilt about June. Night after night in bed, I'd try to explain to Jody. I couldn't stop talking.

I went back to June. It seemed natural to be with her. We went for a walk and had dinner and went to a movie. And slept together. We were together for a week. I started to work. Big and red. I desperately wanted to get married. That was what was wrong with me. Why the hell should an artist desperately want to get married?

I was indecisive. I felt enormous pressures, as though I had to choose one of these women. I was being driven, forced. I can't explain the feelings beyond that, but they were absolutely real. I became cold on the surface. How can I choose? Which would be right for my work. I'll always do what is right for my work. Jody seemed right. I saw Dr. Hogan, my psychiatrist, for the first time in years. For once, that goddamned bastard didn't stop me. He suggested, mildly, that I wait for six months. Had I waited for six weeks I wouldn't have married. But I married. I married in haste, in hate, in guilt, in compulsion.

NEW YORK, SEPTEMBER 1958
LETTER FROM OSCAR PETTIFORD[61]

Dear Jon,

I guess you knew I was thinking of you. Well, I finally made it. I will arrive at Plymouth and from there on train to London (Sept. 4th). I'm happy to hear you are doing so well, for you deserve to. Your work is such a concentrated effort, it takes a lot of painstaking work and ability to achieve. You must pardon my letter writing; I haven't written a letter in ten years (smiles), it's the truth! All is well here healthwise I hope you stay at least until I arrive. Our tour will carry us all over England it seems. Also the Continent. I've been waiting a long time for this trip. We will be working our asses off, but I'll enjoy it anyway. It's swell of you to write, as I was thinking of seeing you on arrival. I'll call as soon as I arrive. Call Harold Davidson Ltd., and maybe he can tell you where we will be staying.

Till then. As ever.

O.P.

NEW YORK, 28 FEBRUARY 1955
LETTER TO PEG MURRAY[62]

. . . Last Monday Cherry[63] had an opening of his show at the Stable Gallery. The show is wonderful—his paintings look beautiful, and I'm more than ever convinced that he is doing some fine work. Afterwards I gave a party for him at my place—which turned out to be a real ball. Quite the best party I have ever given, I suppose—although it was similar in tone to every other party I have given. Lots of people of all types and sizes. Bill Baird, whose puppets you may have seen on TV—drawing naked women on a sign I put up for Cherry in the studio. Pretty girl playing the soprano recorder while Oscar Pettiford and some other musicians jammed in

[61]The letter introduces Oscar Pettiford (1922-60), the great double bass player and cellist who played with Dizzie Gillespie and Duke Ellington before forming his own group in the mid fifties. Schueler probably first met Pettiford in New York in 1943. They kept loosely in touch over the years, meeting up in Los Angeles, San Francisco, New York and later this year in Paris. His admiration for Pettiford led him to take up the bass himself circa 1948. This September 1958 letter is followed by an earlier one which suggests the intermingling of musicians and artists that Schueler thrived on in New York in the 1950's.

[62]Peg Murray, actress, singer and producer. Schueler was friendly with the members of her company, the Touring Players, joining them on Block Island, Rhode Island, for the summers of 1953, 1954 and 1955. Murray was the scat singer in the trio formed in 1954, with Schueler on the bass and Peter Daniels playing the piano.

[63]Herman Cherry (1909-92), an abstract colorist, but in this case showing large, black paintings.

the background. (Peter [Daniels] didn't make it—he was rehearsing the Rehearsal girls—but I had another piano player friend of mine—Charlie Mack). Artists underfoot all over the place. Actors and actresses well represented. Ada looking cool and clean and helping Von hold up the bar—and ultimately holding up Von[64]. Music great—Pettiford playing some fabulous solos. Schueler playing some less fabulous but full of well-meant, if not well directed energy. Norman and Virginia Brooks[65] beaming in corner. Every five minutes some girl coming up to me and saying "Is that really Ezzard Charles?"—and then demanding to be introduced. Charles came with Pettiford—really the high point of the evening for Cherry—who is a fight fan and a Charles fan. Later Cherry talking excitedly to Charles explaining to him why boxing and painting were somehow involved in the same thing—the boxer and the artist both having to continually face and resolve the unexpected within a prescribed area. Charles suggesting he never quite thought of it that way. About sixty or more people—most of them crowded in the back room, because that's where the music was. Two stupid girls sit on coffee table and it collapses. Jon acts as a benign host, sweeps up, and doesn't even get mad until following day. Immense quantities of liquor consumed. Depressed afterward—as usual after a party. Wished that you could have been here. . . .

LLAFRANCH, COSTA BRAVA, 12 SEPTEMBER 1958
LETTER TO ALASTAIR REID[66]

Dear Alastair:

I'm feeling so goddamned good—not hysterically good, but common, ordinary good—which my suspicious nature tells me is bad for a painter. I shall probably have a totally unsuccessful work year in Paris. But the sun shines, Bernadette smiles and irons my cotton jacket, the Chatlain family squabble in French—which is much better than squabbling in English—and I sit around like a clod. I'm leaving Tuesday or Wednesday for Paris and for the game of studio hunting. . . .

My stay in Majorca did wonders for me—and though I don't know exactly why, I'm not going to question it. I'm delighted that I decided to stay in Europe to work. Once again, I feel as though I'm just beginning, and that's a good feeling for me. A nice addition is that because I have lived in Paris, I feel a bit as though I am going home, too. The three days in

[64]Von Stuart, actor and later TV playwright, and his companion, Ada.

[65]Ezzard Charles (1921–1975) was a heavyweight champion 1949–1951.

[66]Schueler had just visited Alastair Reid in Deya, Majorca. He then took up the invitation of a Parisian girlfriend to visit her family on holiday in the south of Spain. Travel by public transportation was inexpensive at that time.

Deya were perfect, I enjoyed our conversations immensely, and once again felt the warmth of Scottish hospitality. . . .

I'm off to the beach with Bernadette. I seem to be preparing for a pleasant diversity of women in Paris—which, if I find diversity as stimulating and enjoyable as I suspect it will be, could keep me out of a lot of trouble. Will it be enough to use only remembered pain for my painting? If not, art will just have to become mundane—I was going to say "fail", but I hate the word. As a matter of fact, in my painting for Les Prêtres Passionistes, there was a shadow in the glow of the Resurrection which suggested to me that the light of Truth is only complete with the remembrance and knowledge of the pain which gave it its being. So everything is going to be all right.

My best to you,

Jon

<div style="text-align:center">

DEYA, 24 SEPTEMBER 1958
LETTER FROM ALASTAIR REID

</div>

Dear Jon:

You kill me, you really do. What I mean is, that is said with GREAT affection and respect and humour on my part. Because you are never going to be by halves, you're going to do and be it all, and I think that's TERRIFIC.

. . . I see it about going back. Only thing you really have to learn, thinks me, is to do WITHOUT plans and live in the great, endless, beautiful, eternal present moment, where all art is made, and where all pure joy exists. But you'll get there. I'll give you lessons. Best thing of all is, you have firmly decided to have your cake and eat it too, which is a prerequisite to living at all! So I'm just sending you a blessing.

. . . I'm glad you liked the word book too.[67] It was a lark we made. BUY LOTS OF COPIES, and give it to EVERYONE for Christmas. Have a good sail home, and take greetings from me to distribute judiciously. And tell me how New York is, and how you are in it. Letters addressed here will always get to me eventually.

And I hope the work is successful, and you become Scotland's greatest living painter.

Joy and abundance,

Alastair

[67]Alastair Reid's book for children, *Ounce Dice Trice*, Atlantic/Little Brown (1958).

After much vacillation, Schueler decided not to return to New York in the fall of 1958 but to trade studios with the American Abstract painter Sam Francis, who had a place in Arcueil, a suburb of Paris. He settled down to a second bout of painting, becoming more sociable than in Clamart, and produced about eighteen paintings during this four-month period.

ARCUEIL, 9 OCTOBER 1958
LETTER TO CINDY LEE[68]

... When I'm working (and I don't mean just when I'm actually wielding the brush, but when I am in a work period, twenty-four hours a day of it), I suffer the spiraling tortures of the damned—the search begins and I know no such thing as home or certainty and I keep looking and looking and feeling the loneliness grow. I'm totally moved into my studio now and the walls have cut off the rest of the world—and I feel as though I shall be forgotten and that I shall forget all the rest. I get moments of happiness—like last night when my lumber arrived. That made me feel good as I stacked the lumber against the wall. And I kept wishing that I didn't have to go out, so that I could work with it and sit in the studio and think. For a moment—with the lumber—I didn't feel lonely. None of my paintings are finished—so I feel unfinished. ...

NEW YORK, 17 OCTOBER 1958
LETTER FROM CINDY

... Jon—Jon—the hours I have spent on us—you, too, have done the same—in all sorts of directions and as days go—*even more so.*

You know, dear you—I only knew you briefly—but the intensity of you struck and I felt—vice versa and we moved—that's why we talk about being together again.—I know your need—woman all for you—with you—cooking, loving—making—doing, passive—passionate—docile but with spirit—but above all—gravitation around you—Why not—You're a man

[68]Schueler and Cindy (Emilia), née Laraçuen, Lee (later McKinley) met in Paris, spending a week together before she returned to the United States. Later she became one of the writer Robert Graves's Black Goddesses. The figure of the Black Goddess enlarged Graves's theory of the poetic muse first described in *The White Goddess: A Historical Grammar of Poetic Myth*, London: Faber and Faber, 1948).

with your wonderful ego—strong—weak—the all—but where—when I think about it—*would I come in?* . . .

The painting alone, and don't be idealistic, would be a big factor—let's face it. You—above anyone—respect a real personal expression—I'm sure and therefore—let me paint.—But listen—Jon, me love, you really are a competitive—jealous guy on this score—*anyone else* painting. How can you visualize you working like fury in the next room and walking in and finding a mess of tubes, etc. in the corner—me working? You've come in to rest—and there sits *more*. I am very, very good in expression, technique—I only say this quietly and not in a blustering manner. I don't like criticism, evaluation, anything either, when I am working—I am very prolific—would you really like spending your hard-earned money from painting to buy that lazy—good for nothing artist—me—canvas, paints, etc.—The gal sitting in the corner cluttering up your neat (I think you're probably neat as hell from what I saw) living quarters when she should either be busy cooking, washing clothes, running errands, being in bed waiting? I really don't think, Jon, that after a few weeks of real existence that you could not resist starting to have conflicts about *my* painting and attacking in various ways—some direct, some indirect. . . .

I remember when Bill Waldren[69] and you had a big discussion on art—I kept quiet because something about you told me that I should—There were times when I wouldn't have minded interjecting something—just out of just human—warm interest—but it was not worth it to me because it would have been taken as me trying to be a competitive female. Remember you once saying something about you'd like to have some artists up to talk at the studio and really talk and then you added—without a damn woman around—Christ, when men are together they talk different and don't need a woman to mess it up—Okay—you are RIGHT—there is a time when men want to talk to men and women want to talk to women and that's that—but I think you do put women in a category that they have *their time and place* and purpose—like a separate entity. Just because women don't have penises—it doesn't mean that they don't have *much* of the same feelings, desires, yearnings.—I know you know all this, but I feel not *really*. . . .

Look—you need to be YOU—and I wouldn't change you for the world—never—except I don't think there is really much unbending on your part.

You set me on fire by wanting me so much, always being so honest, so real—so much from the inside-out with me—sending me the fare . . .

I'm sad as hell . . . would love a *sharing* relationship with someone—I've always wanted it, but since I wasn't ready—I really couldn't understand in the

[69]William Waldren, an American painter who became an archeologist. He lived in Deya, Mallorca, and after Robert Graves's death founded a museum to commemorate his work.

terms of this sharing—giving and could only take. Now I'm ready with my arms open wide—and I thought *you*.

Caramba! This is too bad—

With much feeling—

Cindy

<div align="right">

ARCUEIL, 25 OCTOBER 1958

(Written later but inserted here to help keep the Jon-Cindy letters together)

LETTER TO CINDY LEE
</div>

Oh you sweet darling girl:

I could kiss you, throw my arms around you—and were you handy, I'd give you a bit of loving that you'd never forget. My god—an honest woman—or at least as honest as a human being can get under the circumstances. And more amazing—an honest woman painter! You saw it, you felt it, and you said it. Believe me—our lives would have been a shambles within about a week after you had arrived.

. . . And do write. We're still at the point we were (in reality) when I put you on the airport bus—before the fantasies started. If we continue to like each other for what we are—really—we'll each have made a friend—and that's not bad.

Love,

Jon

<div align="right">

ARCUEIL, 12 OCTOBER 1958

LETTER TO ALASTAIR REID
</div>

Dear Alastair:

So you think I'm in New York! Ho—that's rich. My god, Alastair—you don't know me at all. You took my next-to-final plan as my final plan—and if you do that sort of thing, you never will be able to keep track of me. I won't go into any detail, but before the brain stopped whirling, I had decided on taking Sam's[70] studio for a few months. In the meanwhile, Norman Bluhm[71] had decided to stay in my studio, giving the other one to Esteban [Vicente]—not realizing—but then—many wires, letters, etc.—and I hope everybody is happy and painting lustily. I'm in the biggest barn of a place you can possibly imagine—what really amounts to two studios—I live in the smaller one—with a coal stove—and an oil stove in the larger. Impossible to heat, of course, so it should be a dramatic winter. Concrete

[70]Sam Francis (1923-94), painter of large areas of floating colors and delicate drippings.

[71]Norman Bluhm, who was evidently given three days to move out of Schueler's New York studio, was not pleased with the arrangements.

floors—very cold and damp. But huge skylights and lots of space. I'm doing a lot of work and feel back in my uncomfortable element. And thank you, thank you for your letter. An expression of faith always helps me after I go through one of my whirligigs. It's the only way I seem to be able to think—if one can call that thinking—but ultimately I usually get results. Sometimes a few people get annoyed in the process.

. . . So you're going to New York and Mexico? Your plans change just as much as mine—it's just that you have that wonderful appearance of rationality. I don't believe a bit of it. Which reminds me of when I was changing my mind from day to day. Each day I'd come to a decision, I'd sit down and write hosts of letters, denying the news of the day before and announcing the new plans. The letter I always wrote first seemed to be to the *New Yorker*—in regard to my subscription. In the end I was so embarrassed as I visualized the people in the subscription dept.—that I couldn't get myself to write to them of my final change in plans. I've now forgotten where I was at that point and have no clear idea as to where my *New Yorker* is being sent. Also—I got to cringe as I'd go up to the steamship counter at American Express—and change my ticket. Cindy was with me through all that—in fact, it was during that period that she got to know me—and I must say she took it without flinching—though with a bit of wide-eyed wonder. First person in my life (or first woman, anyway) that I haven't completely thrown by being myself.

Please talk about me not at all in New York. Divorce proceeding at a very delicate stage—Jody wants annulment which seems possible—anxious not to add any little notes of hysteria. . . .

NEW YORK, 14 NOVEMBER 1958
LETTER FROM LEO CASTELLI

Dear Jon,

I never answered the numerous letters which you wrote me during the month of September. I felt that anything I could say would become obsolete the next day, but now some time has elapsed, and it looks like there won't be any more changes—or are there? Do you still plan to come back in January? Please let me know. Also, tell me about yourself, and your work.

The gallery is doing well. I have a show on now of the seven American artists who have had a one man show here during the past two seasons. You are represented with one of the early Scottish pictures, *October*. The show looks very important, and in spite of the extreme variety there is a sense of unity in it. Most visitors seem to be impressed by it.[72] Under separate cover

[72]Besides Schueler, the others in the Castelli group show (28 October-22 November) were Bluhm, Brach, Dzubas, Johns, Marisol, and Rauschenberg.

I am going to send you an announcement of this show and of the next one, which will be drawings of Esteban Vicente.

Hope we hear from you very soon. Ileana and I send you our best,
Leo

<div align="right">

ARCUEIL, 14 DECEMBER 1958
LETTER TO JAMIE AND JOYA

</div>

. . . Now—there will be various and sundry presents coming from a French Santa Claus, but I have no idea when they will get there—and they will be coming in separate packages and mixed-up packages and there won't be any name in them and that's how you'll know they are from me. I've been having my difficulties, and I just hope that they get there in time for Xmas and in remembrance of your birthdays—the French part. I hope that you got the Spanish part of the birthdays. There will be another package for Jamie that Alastair Reid had something to do with.[73] He's a good friend of mine and comes from Scotland

I am sailing for New York January 25 and will arrive Jan. 30 on the *United States*. And then I'm going to fly out to California—I hope in February. I can't wait to see you characters and to see how you've grown and to find out what you have been doing. I also want to get your sizes so that it will be easier to find presents for you.

Paris is cold and damp and is about the worst climate I've ever lived in. But my studio is big and the light is good because I have a big skylight, and I have done a great deal of work. But I'm going to be glad to get back home.

Hope you're happy and have a very merry Xmas—and if you have a chance, yell hello—loud enough so that I can hear you.

Love, love, and more love,
Daddy

[73] *Ounce Dice Trice*

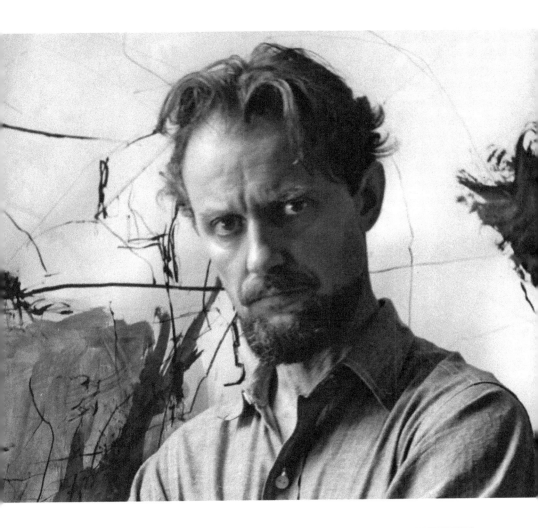

Jon Schueler at Yale University Summer School, Norfolk,
Connecticut, 1961, with a pen, brush and ink drawing of that
time. 60" x 51".

THE WOMAN IN THE SKY

.

Part two begins three months after Schueler's return to New York. The next five years were marked by financial difficulties, a number of turbulent love affairs and a new focus on women in his paintings. The need to write continually drew him into the troubling memories of childhood and the war years. His desire to return to Scotland served as a counterpoint to the seductions and frustrations of the New York art scene and the social whirl of East Hampton.

The title "The Woman in the Sky" refers to the image of his lost mother, who died when he was six months old, and to the poetic force he associated with the female presence, sometimes embodied in particular models. Although the figurative elements found in his paintings between 1963 and 1967 gradually disappeared, his landscapes would forever be informed by this motif.

NEW YORK, APRIL 1959[1]

Time has passed. I wrote in London. Then I went to Majorca, and back to France and painted in Arcueil. In January, 1959, I went to Switzerland to write some more, but I learned to ski instead and hurt my foot, and then I came home to New York. I have been here February and March and now a one-man show is coming up April 21.[2] In the meantime I shall try to write.

The other day I answered a questionnaire sent to me by the Whitney Museum for their files. They own *Snow Cloud and Blue Sky** painted in Scotland (February 1958). They wanted some information about the picture and some comments on my philosophy of art:

> . . . In early January I spent an afternoon on a peninsula jutting into the sea. The snow clouds, opaque, sometimes ghostly, sometimes full of fire and life as they reflected the light of the sky and the low winter sun, moved across the Sound of Sleat, pushing down to the sea like curtains, forming new horizons. Sometimes I would watch them as

[1]In March, Jody had gone to Mexico to get a divorce from Schueler (costing him $800).
[2]Despite the fact that Leo Castelli agreed to this show of the paintings done in France, Schueler rightly sensed that the dealer was losing interest in his work and that this would be his last exhibition at that gallery. Several paintings were sold, but a few months later they agreed to part.
*See color illustration 5. Also referred to on page 40.

they approached, finally engulfing me in snow driven almost horizontally at me by the force of the wind, so strong that I would have to take cover behind a hillock. Then for a while I would be blinded in the middle of the snow cloud—until it passed, suddenly and swiftly, and I would be in the clear air again watching new clouds form far away, slowly obliterating islands on the distant horizon, a horizon that could have been real. At one moment I turned and looked and saw the sun glowing dully through a snow cloud. In the following weeks I painted some snow cloud studies, and then some major works, of which this is one. I felt that the juxtaposition of sea, land and sky, of the cloud and the sun, all in motion against each other and reflecting each other, suggested the possibilities of infinite nuances of human emotion and of the emotion of time. . . .

I'm trying to remember my departure for Scotland.

Jody and I went up on deck, passing a short line near the steward's office where people were making their table reservations.

Jody: "I shall try to get to Scotland for Xmas. Or maybe after Xmas."

Jon: Yes, it would be best that you were with Tina at Xmas." This was all play acting. I knew damn well I hoped never to see Jody again, and certainly was not planning a little get-together at Xmas. From the moment I told her that she wasn't coming to Scotland, both Jody and I knew that things were practically at an end. Then she started pretending that a normal state of affairs had developed which necessitated my going over now and her following. I could only go ahead with the gag. But going ahead with the gag make it very difficult for me to keep in touch with reality.

Jody walked down the gangplank. She turned once and waved and I waved back.

The point is, I suppose, in this world, you either do or you don't. You fish or you cut bait. You shit or get off the pot. I did neither. I was still married. All right, I may have never felt married, but I was married and I had not really said the hard, firm word that would have dissolved the marriage, so Jody had every right to act any role she wanted. And I, from emotion to emotion, had no real feeling where I stood myself.

I took to Scotland a great need to be alone and to think. The confusion of life and painting had surrounded me: women and my children and my work and the picture itself, and all the ways in which one destroys oneself and creates the death of each day. Each day's dying. There is only one choice for me in each day: life or death. Life is to work, death is not to work. Too often I choose death. This morning I chose death for two hours and forty-five minutes. It is excruciating to die. Also very boring.

Too often the only way of moving out of death is through conversation, a woman, a meaningless rage, almost anything except the one sure joy that I know. I went to Scotland to think about this along with everything else. I wanted to watch the Devil come to me there. I felt that I could face him

more surely and recognize him for what he is. The city is too full, perhaps too full of wonderful things, wonderful temptations disguised as necessities, too full of necessities disguised as life. I wanted to go to the mountain and to meet my own thoughts and to meet God and to meet the Devil and see his face and tell him to go to Hell. The confusion of my life had been yearly compounded for forty years. A north wind blowing off the sea promised clarity.

I had wanted to live in the middle of one of my paintings for a year. I wanted to be in one spot and watch the painting change. I saw clouds menacing my mind's eye, and the rain shafts or the mist obliterating horizons and forming new forms with the clouds and land masses blending with the sea. I chose northern Scotland as my cathedral, because for my needs at that moment, it seemed the only church that would do.

Before spending August on Martha's Vineyard, Massachusetts with his children, Schueler visited his stepmother, who in 1955 had married George Fredericks and moved to Detroit.

DETROIT, 21 JULY 1959

It is now 10:45 in the morning of Tuesday, July 21, and I am in Detroit, Michigan. 19363 Lucerne Drive. Does the address speak of comfort? My stepmother lives here with her second husband, George Fredericks, and his son, George, Jr. The house is huge, like the Middle West, and comfortable. Many rooms, many chairs, many windows, many baths. Fredericks drives a black, 1959 Cadillac Fleetwood. Mother has her own Ford. The "boy," (thirty-five?) has his own Dodge. The maid has her own suite on the third floor, and her own Oldsmobile.

I wonder if the people in this house are happy. There is plenty of money to pay the doctors and buy the pills and the automobiles and to pay the dues at the River Club. Then there is the daily hate, which is so reliable. It comes out at any moment with such ease. Mr. Fredericks mostly hates the labor unions. He also hates the niggers, particularly all those niggers who came up from the South to Detroit just to live on welfare, which comes out of his pocket. He hates the Jews, too. As each person talked last night—Mr. Fredericks, Mother, Mr. Fredericks' brother, the brother's wife—I would be embarrassed for him, thinking the others must be terribly bored by what that person was saying, and I would almost want to interrupt to save the others the pain. Each would talk about the Jews or the niggers or about how much something cost. Suddenly I realized that everyone

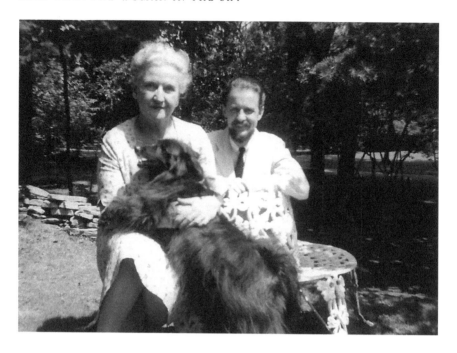

*Jon Schueler visiting his stepmother, now Mrs. George Fredericks,
in Detroit, July 1959*

was having a good time. That was indeed the way a conversation was sup-
posed to go.

I am now forty-two, almost forty-three years old. I did not get killed in the
war, nor have I ever attempted suicide. I think I know a little bit about creating
a painting. An oil painting, as Gertrude Stein would say. I am an oil painter
of oil paintings. If I start working very hard today, perhaps I shall truly create.
Also, if I don't work too hard, perhaps I shall love. In other words, in a year, a
month, a week, I could live a lifetime, which few people are privileged to live.
That's why I wonder about hating the unions and the Jews and the Negroes.
I wonder whether or not I hate them too. Or, worse, am I condescending?
Dave Myers is a Jew. He's very anti-Semitic. I used to be uncomfortable about
this, but then I got used to it. I got used to not being able to be non-anti-Se-
mitic around David, much less anti-Semitic. The best thing is not to ask any
questions, but to just listen to David being anti-Semitic. I wonder if he is go-
ing to be anti-Semitic towards his children who are not Jewish on their moth-
er's side, but are Jewish on their father's side. Or if he is anti-Semitic toward
Bob Friedman, who is also Jewish and who is my friend. Now Alastair Reid is
my friend, and he feels close to me in many ways that Dave and Bob do not. Is
that because he is a Scot and not Jewish? Well, yes, I suppose it might very well
be. But then Dave and Bob are close to me in many ways that Alastair is not,

and perhaps that is just as much because they are Jewish and not Scottish. In other words, the strangeness has to be there between one person and another, and the struggle is to get through the strangeness.

NEW YORK, 12 OCTOBER 1959

I have been reading Thoreau's *Walden* this evening. I am impressed by the clarity and precision of his thinking. The material "poverty" of the greatest of philosophers and creators. The burden and distortions of luxury. There are two sides to my nature. The side that affirms simplicity. I made it work in Mallaig. And the side I use to destroy myself, when I either revel in luxury or damn myself for not having it. *Luxury* is too big a word. But at times, I most certainly carry a burden of guilt for not having all the false things I have renounced and which I had been taught to have. It is strange. For example, when I am particularly poor, I feel guilty. This feeling deprives me of the very benefits of that state.

My last painting gives me great hope. I feel that I can take its message back to Mallaig. It is a blue painting with movements far more complex in their rhythms than anything I have done. I am more and more excited by it and by its implications.

I would like to go to Mallaig for a year—even for two. Live very simply. Do much work. Feel nature to the utmost. My one big financial need would be about a thousand dollars a year to have my children visit me. For this reason I would like a gallery. A sale or two would do the trick.

NEW YORK, 8 JANUARY 1960
EXCERPTS FROM "A LETTER ABOUT THE SKY" BY JON SCHUELER
PUBLISHED IN *It is*, 5 (SPRING 1960)[3]

When I speak of nature I'm speaking of the sky, because in many ways the sky became nature to me. And when I think of the sky, I think of the Scottish sky over Mallaig. It isn't that I think of it that nationally, really, but that I studied the Mallaig sky so intently, and I found in its convulsive movement and change and drama such a concentration of activity that it became all skies and even the idea of all nature to me. It's as if one could see from day to day the drama of all skies and of all nature in all times speeded up and compressed. I knew that the whole thing was there. Time was there and motion was there—lands forming, seas disappearing, worlds fragmenting, colors emerging or giving birth to burning shapes, mountain snows showing emerald green; or paused solid still when the gales stopped

[3]Edited by Philip Pavia, *It is* was a magazine primarily devoted to artists' writings and statements. There were five issues between 1957 and 1960 and one later.

suddenly and the skies were clear again after long days of howling sound and rain or snow beating horizontal from the sky. . . .

The sky. Father and Mother and Mistress, and the lonely mystery of endless love. Eternal Fact, felt through the emotion of its change, the weather patterns moving fast and slow across the sea and points of land, beating against one's face when the snow cloud funneled through the valley, pressing one relentlessly when the gale winds moved like a visual force through the day sky or the sky of night. The sky was multiform, as complex as all life. . . .

I found every passion in the sky—as encompassing and as certain and as fleeting as the intimacy of a night mist. This passion—this daily awareness of a mistress who is always there, who is there without fail even in the violence of some moods—this sensation of being was always the life behind any sudden glimpses of esthetic mysteries or any wanderings of the intellect across the horizon or past the shadow of the sea. Humanity was there; my heart was never so concerned with man, I like to think. The sky was not a substitute for man. It was an enlargement of man. And there was always the mystery behind the discovered. There was always a passion and a mind above and beyond that which one felt and understood. And therefore, in the mind of the artist, there was always a loneliness, a sense of reaching, of seeking, of never quite finding it all, of never having it all in his grasp, of never knowing, really, and then coming back to himself alone, to his work, to the canvas in the claustrophobic house, to his scratchings, to his effort, to his mark. . . .

NEW YORK, 31 JANUARY 1960

I thought today of writing, and I was very sad. Now, at forty-three, I would say that to communicate has been the primary need of my life. I feel that I have failed. Do I communicate in painting? Perhaps it is too abstract. I am so unhappy about the galleries, the museums, the average circumstances of the purchases and the collectors. I am more aware of the circumstances of acquisitions than of communication. A book, costing from one to six dollars, is within reach of everyone. Sometimes it costs twenty-five cents. Sometimes it is in a library—and free.

Talked to Friedman who had a monumental hangover. He and Abby entertained sixteen people last night and consumed five and a half bottles of Scotch, one and a half bottles of bourbon, and seven bottles of wine. Two of the guests didn't drink. Bob talked about my show[4], thought of people who should be invited, etc. He is very generous that way.

[4]The Hirschl & Adler Galleries exhibition was to open the next month.

Talked to the Israels[5] who have a month-old baby. They are very happy. Bob is fascinated by the child. At first he resented it. Now he feels a communion with life. A reliving of forgotten and submerged sensations of life and growth, of coming into being. Talking to Bob and Suzie was the bright spot of the day.

Where are Jamie and Joya?

NEW YORK, 21 MARCH 1960

Plan: 1960 to 1961.

March 22 to April 12, 1960: Clean up all affairs in New York.

April 12 to June 13, 1960: MacDowell: Write Mallaig Story.

June 20 to August 14, 1960: Yale, Norfolk: Draw
Show.

August 14 to September 5, 1960: With kids—to Martha's Vineyard or Cape Hatteras.

September 1960 to June 1961: Teach at Yale.

February 1961: Show.

June 1961: To Scotland with kids.
Mallaig. Explore all country around, and to the North.[6]

The Show at the Hirschl & Adler Gallery in New York took place from February 16 to March 5, 1960. Both the Mallaig and the Paris paintings were exhibited. However, only one small painting was sold, and by then the relationship with that gallery had disintegrated. Teaching became a possible means of support in the 1960's when Schueler was hired by Bernard Chaet for the Yale University Summer School of Music and Art at Norfolk, Connecticut in 1960 (and 1961). This would lead to future positions at Yale University School of Art in New Haven (1960–62) and at the Maryland Institute in Baltimore (1963 to 1967). The first summer at Yale Summer School was memorable for an intense love affair with one of the students, Sandra Pailet, and for a bout of hepatitis whose effects lingered for months. Schueler never drank again except for an occasional sip of beer, which inevitably left him with a slight hangover.

[5]The artist Robert Israel (b.1939) and his wife, Suzie.

[6]The plans to write at the MacDowell Colony, have the children visit, and go to Mallaig in 1961 never materialized.

NEW YORK, 17 AUGUST 1960
LETTER TO SANDRA PAILET[7]

My dearest—

Yes, I really do miss you—but the other loneliness I have spoken of isn't there anymore—even when you're away from me—and this is a wonder.

I talked to Abby [Friedman] today and she thought that you were a lovely girl, beautiful to look upon and a lovely person, too. I said that I thought so, too, and that I was planning to marry you. She: What did you say? A PAINTER. CHILDREN. WHAT ABOUT ALL THOSE THINGS YOU ALWAYS SAID? Bob called this evening as soon as he got home from work to congratulate me, God bless him. He said that he thought you were a very lovely girl, beautiful to look upon and a lovely person too. You seem to create a standard impression wherever you go—because that's exactly how I felt when I met you. Bob talked to me about the problem of Jewish families not wanting to admit gentiles and some of the possible reasons and about his family, etc. And he said that if your parents came up here that he would like to have them over, and that perhaps because he could show them that I had close Jewish friends that might somehow be reassuring. He also thought the combination of gentile, artist, and age would be just about impossible for a good Jewish family, and hoped that you wouldn't be put under an unbearable pressure. He wondered whether we were wise in waiting so long—that five months of pressure could do a lot of damage. But I said that although I didn't want to wait a day, I nevertheless felt that if there were any problems, they should be met head on before rather than after the wedding. Dear baby, you are the one who will have the roughest time for a while—family, taking care of the children without having this man around, making decisions. . . .

NEW YORK, 19 AUGUST 1960
LETTER TO SANDRA PAILET

. . . The studio is organized and I am ready to paint today. . . . I had a very bad dream last night, and when I suddenly woke up, I realized that I was back in New York with all the burden of the competitive art world on my shoulders again, all my feelings of envy for the successful, desire for recognition, feelings of rage and jealousy, and all the rest of it which eats at one like a cancer. Yesterday the ghosts—that I always encounter when I enter this studio[8]—

[7]Sandra Pailet, age twenty-six, was an art student and the mother of two daughters. She returned to New Orleans after Yale Summer School.
[8]68 East 12th Street.

Sandra Pailet and Jon Schueler, Yale University Summer School, Norfolk, Connecticut, 1960.

were so sneaky that they didn't show themselves—they just ate slowly at my entrails. But last night I could see them clearly, and today I shall let them dance about the studio at will, while I go about my business. It's a common disease for the artist—it killed Pollock, de Stael, Thomas

Wolfe[9] It comes with success or failure equally. There are various ways of coping with it—one is to be far away from New York. But for the moment I prefer to meet it head on to see if I can shake myself free once and for all. . . . Remember the long talk at night—wanting to make love to you—but talking of death and abandonment and guilt and war. Success and money are all part of the same fabric. Remember how you noticed that I, not you, was the one who seemed to talk of money constantly. I thought afterwards—it's true, the Milwaukee man trying to prove something—as though the painting doesn't prove enough. I used to try to separate painting from all this—but I think that it has to include everything, painting has to include the entire range and all the opposites, or it will miss something and won't be life. Or alive. Like the altarpiece at Clamart including the Passion of Christ and the passion of my lust. . . .

Tell your mother that there's no doubt that it's very selfish of you to leave her, but that on the other hand it's very generous of you to come to me. It has something to do with the theory of relativity. Also with the history of daughters leaving their families for marriage throughout time. Did they say anything about my being a gentile? Artist? Age? Northerner? Beard? Articulate? Talented? All these things are hard for any family to take. I'm not even kidding. Throughout the world I've found that mediocrity makes people feel safe, whereas particularly a creative talent brings on some kind of feeling of fear. Probably rightly so—particularly where a beautiful daughter is concerned. . . .

<div align="right">

NEW YORK, 20 AUGUST 1960
LETTER TO JAMIE

</div>

My dearest Jamie:

You sure didn't want to write that last letter very much! I don't blame you. You're probably mad as you can be that I spoiled your vacation—but, believe me, I didn't mean to! I kept arguing with the doctor over and over again that I just absolutely had to have Jamie and Joya with me, that I couldn't [cancel their visit]. Period. He won. I'm much, much better now— really, I think I'm practically all well, though I still have to take it a bit easy—and I'm not allowed to exercise or to drink anything stronger than ginger ale. But the blood tests (which tell the story) are all way, way down, and I guess that just about ends that chapter of the Schueler hepatitis saga. I'll be out to see you as soon as possible, and maybe we can arrange a really

[9]Jackson Pollock, a heavy drinker, smashed his car into a tree. The French painter Nicolas de Stael (1914-1955) committed suicide, while the writer Thomas Wolfe (1900-38), after subsisting on coffee, baked beans and cigarettes, died of a cerebral infection following pneumonia.

BIG summer for next year—which I must admit, seems a million years away to me. . . .

NEW YORK, 21 AUGUST 1960
LETTER TO SANDRA PAILET

. . . You may not know it, but you've changed very much in somewhat less than a week. The things you say are different now, as well as the way you say them. So—although I shall quite rely on your stubbornness—I shall also rely on your natural ability to take parental coloration and call it your own. Parents are our conscience—until we form our own. . . .

First of all age: Age difference is not an absolute or chronological thing—it's relative only to feeling. Your own true feeling will tell you if I'm too old for you or not. If you feel that I am, there is no amount of figuring or conversations in the world that will make me any younger. Women younger than you have loved me, and the question never entered their minds. . . . It never dawned on me that I might [be too old for you]—though a few times I have suspected you might be too young for me—mainly around the time when I said that you'd be ready for me after your next marriage had failed. . . .

And the problem of money: Again—objectively, there's no problem. I admire you for facing up to your feelings and not kidding yourself or me. Ultimately, again, you'll just have to obey your intuition—which will sum up all sorts of things for you—including a philosophy of life. (For God's sake, don't lay it on to the kids—it's too easy, and seldom if ever true. Jody did that bit constantly—and it was always just a projection of her own desires.). . . The very thing I offer a woman is a life of struggle—and I offer the same thing to children. I happen to believe in it, but whether I did or not wouldn't make much difference—because it's part of the deal. . . . Basically there isn't any money beyond subsistence. And certainly you shouldn't think of marrying me on any dreams of what might be—only on what is. Because I come from a goddamned bourgeois—all values in terms of money, price tags on everything every hour of the day—family, the rot is in me, and I can't dig deep enough to get it all out; sometimes you'll hear me getting more money-mad than the money madders, like the night when I started raving about leaving you pictures when I die. I'm just crying the Milwaukee blues at those times, yelling, "Look, you bastards, I'll outdo you at your own game." But I very well may not outdo them at their own game. At best, such as when I went to Scotland, I rose above their own game and forgot about it—and I hope to hell to do it again and again and again, and to base my life on it. . . .

I love you and I want you and I need you, and I trust you and I have faith in your love for me, and I have faith in the fact that I would be damned good for you. But I could only be good for you if you believed

that I could be—and for the second time, now, since I've known you, I must admit (you don't mind if I'm honest, too) I've lost faith in the possibility of your believing. I mean, in the immediate future. Perhaps in a few years, after you've gotten to know what it's all about, but there's nothing I can tell you right now, and if there was, it would be wrong to do it.

. . . For a time, I couldn't imagine our not being married. To save a certain amount of wear and tear on my nervous system (my emotions become terribly raw and exaggerated when I'm painting), I'm going to make my plans as though we're not going to get married—and then if you decide to accept, I can change what is necessary to change—whereas the other way around could be more difficult, and more bitter. . . . Sometimes this involves immediate practical decisions . . . such as settling in the country or the city. When I thought I was waiting for January, I wanted to stay in the city because I felt that I could stand the waiting better and could stand better the lonesomeness I felt for you. But if I'm not waiting for January, I think I'd rather plunge into the country because there is something that I want there, and the deep loneliness I lived with in the past will just have to come with me. . . .

About North and South, and about people in general: I now believe that lack of concern for human values, lack of sensitivity for others' feelings (everyone has lots of sensitivity for their own), and the willingness to show contempt for human dignity—these things can happen—against races, religions, helpless minorities of any kind, or from man to man, even from member of family to member of family—in the South, North, East and West and across the face of the globe. Also, human dignity can survive all over. I've met you: I no longer am willing to make generalizations about southerners. I do believe this: that hate and prejudice, as a foundation for loving, does more to destroy the haters than the hated—in part because they learn to support themselves by a facile contempt for others which must inevitably extend to their loved ones and finally to themselves. I also believe that when hate and prejudice and sadism become incorporated into law and the state—as has happened in Hitler's Germany and our own South—then man has reason to shudder. . . . Understand—I come from a family of haters—I was well tutored. And you can't get farther north than Milwaukee. . . .

<div align="right">

NEW YORK, 24 AUGUST 1960
LETTER TO SANDRA PAILET

</div>

. . . I can't let you go another minute without talking to you. I hope my last letter wasn't too rough on you—it isn't that I said anything new or anything that I don't mean—but you're going through enough now, without having me show a lack of understanding. This is no time for me to be hard on you,

(figuratively speaking). From this moment I shall develop patience—a quality for which I have never been noted. I shall wait patiently through minutes, hours, days, weeks, months, years (?) to know the outcome of your struggle. I shall be calm and gentle. My arms will always be open for you. . . . I shall find the way to be everything to you that I want to be. And I won't let the long silence and the long parting and the too hot fire of my imagination compound a witch's brew of strange poison. . . .

Conrad[10] has a fabulous new studio just around the corner from my place—in a four-story building—top floor de Kooning, ground floor a business, second floor Conrad—third floor still empty—and this morning I went over and looked at it and drooled. The building is being put in top shape—painted, new floors, everything one could want. Floor area of each studio is 40 x 90 feet. Try to imagine it. With very high ceilings. I nearly went out of my mind. Conrad has his place entirely free of partitions—just one huge room—where he'll paint in a big space again. $300 per month. Also one would have to put in bath and kitchen. I had a half hour of fantasies before I realized that it doesn't fit in with my income plus what I want to do. I guess what I want is a nice 40 x 90 pied à terre in New York, plus a house on the shore, plus a studio in Mallaig and another in Paris. Plus you and the L's[11] trotting along with me from one to the other. Plus Jamie and Joya whenever possible. Plus a couple of kids of our own just to add to the excitement. I'm going to ask Chaet[12] for a raise. . . .

I'll come down to New Orleans any time you want me to. But let's do some proper timing. I can't be coming down to prove to your parents that I'm something I'm not. I'll prove to them that I'm everything that I am—and they've decided (long before you were born) that they're against that. I have a hunch I shouldn't meet them until after you yourself have made up your mind—and I'm a fait accompli, as it were—which will permit both parties to relax more—even in the midst of disapproval.

. . . I won't run to Scotland for a while.

And when I do, I hope I have you running with me. . . .

[10]Conrad Marca-Relli, American artist (b. 1913), whose elegant and eloquent collage paintings of the 1950s were shown at the Stable Gallery and at the Kootz Gallery in New York. Conrad was also well known for his stunning studios. Throughout the years Schueler remained good friends with Conrad and his wife, Anita, seeing them in New York, East Hampton, Paris, and also in Scotland in 1971 when the Marca-Rellis visited Schueler in Mallaig.

[11]Sandra Pailet's two daughters, Lisa and Lori.

[12]The painter Bernard Chaet, b. 1924, Chairman of the Department of Art, Yale University School of Art.

NEW YORK, 25 AUGUST 1960
LETTER TO SANDRA PAILET

. . . You know—I've gone through, with my family in the past, everything you're going through with yours. In fact, they helped as much as anything to ruin my marriage to Jane—well, along with other things—but I had married Jane—they met her afterwards—then jumped all over me—"terrible girl", "would help me get a divorce", etc. I was so appalled and speechless I didn't talk or write to them for two or three years. (This, incidentally, just on the eve of my departure for Europe and combat—and they knew I was going.) In any case—these things never have anything to do with the arguments at hand—religion or no religion, it's always the same thing—some terrible possessiveness, some need for absolute domination, some focusing of all the growing hostility of years against the one person who won't bow to the will of domineering people. At least in my family, I now realize that it was so—that it was merely a culmination of what was going on before. Plenty of other people have disagreed with children's decisions (though you're scarcely a child, nor was I at the time), but have done so always leaving son or daughter with a knowledge of their loyalty, support, affection, love. I even got the disinheritance bit—in fact, I think I was disowned more than once. . . . In a money symbol family, it meant that they were telling me that I was rejected totally—that all love was cut off—unless I'd submit totally to their rather insane domination. I accepted the total rejection—but it hurt like hell—and, I suppose, it hurts to this day . . . It's truly amazing how absolutely similar our backgrounds are (it's one of the many reasons I feel that our common understanding is so great—and that our own marital success is assured)—and if your parents think that Gentiles can't be just as domineering and just as contemptuous of their children's dignity as Jews, they're crazy. In fact—even as to religion, they are practically identical. I see little difference between the synagogue twice a year—or the Sunday golfer, who grudgingly sets foot in a church once or twice a year—maybe. But my father was quick to scream about God when it suited his purpose—and he called me an atheist—when I now realize that I've plumbed depths of religious feeling that he never even suspected existed in his entire life. I also remember that—a few years after the war when I had been speaking my mind on some subject before his friends (I think the subject was prejudice)—he said, "If you'd be a good American, people would like you better." By that he meant—if I'd nod politely to a very sick, distorted, hate-laden cliché which passed for thinking amongst those god-fearing folk, then everyone would think I was an intelligent, obedient son who wouldn't utter an opinion that wasn't held by a non-thinking family. I looked at him open-mouthed: I had fought in a war, and was just then recovering—while he had manfully recouped his fortunes by a favored position he was in re automobile tires—plus a nice killing on the stock market. The only killing I had partaken of, was of my friends and the Luftwaffe.

Well—you see what I mean! If I fail for one moment in understanding everything you're going through—even if you would succumb—even if I'd lose you—I should be berated as a nincompoop, and your parents would be right in saving you from my clutches. . . .

NEW YORK, 27 AUGUST 1960
LETTER TO SANDRA PAILET

Dearest sweet one with a soft voice like bells in snow—

We should phone each other every night. Perhaps if I'd give up eating and rent out the studio. . . . It was so good to talk to you—I felt so at ease—perhaps next time I'll be able to talk for an hour. In fact, I can see where we could work out a perfectly satisfactory relationship this way—you could mull over all of your problems to the soft drone of mosquitoes, and I could paint pictures in the New York-filled silence—and then at times the telephone would ring and we could talk long enough to remind each other, subtly, of each other's person, of our exquisite denials of thousands of kisses, of that pounding emotion when your breasts are before my eyes, of me inside of you, close, and crushing you, of the sight of your head, dark upon the pillow in the middle of the night, of that most precious moment early in the morning when, still in sleep, we reach for each other. The perfect rack—better than any I could ever have dreamed up myself. Our puritan ideals come true—every sense of the flesh and every emotion of the soul twisted to the torment of frustration by the most simply contrived separation. We could go on like this for years—feeling, with each day's hell, that we were delightfully paying for any heaven we might long for at some increasingly far-off date. . . .

NEW YORK, 31 AUGUST 1960
LETTER TO SANDRA PAILET

. . . First—I'm going to phone you tonight to tell you not to cut your hair. DON'T DON'T DON'T. My God—we talked all about that when you were here, and about how much it means to me. . . . I'm angry and hurt just thinking about it and just hearing you listen to Theone[13] rather than me on the subject. Theone's not going to be looking at you every day, nor will she be waking up in the middle of the night just to look at you. Your beautiful long hair, soft and feminine, is just as mystical to me as the sea—it would be a desecration to wantonly destroy that mystery. . . .

. . . I had lunch with Neil Welliver[14], a nice guy who teaches at Yale, very

[13]Sandra's sister-in-law.
[14]The landscape painter, Neil Welliver (b. 1929) taught at Yale University 1955-65 and at the University of Pennsylvania 1966-89.

energetic, chases women, has happy home life, a house in the country which he just sold. He had a friend who was leaving for Europe November 1 until next summer who had a house for rent and we drove out to see it. About twenty-five minutes from New Haven and less than half a mile from the sea in some lovely Connecticut countryside, we drove up to the most marvelous barn-turned-into-a-house I have ever seen. The owner is an architect (De Forest Ribley) and he's had the place for seven years and has done all of the work himself. It's fabulous. . . . Well, I went crazy. It was like walking into the perfect solution. I could hardly believe it was true. . . . We shook hands, and November 1, I'll be in and I'll look around at all this peace and space and air and light and glory—and wonder what in hell I'm doing there alone. It's a place for love and a woman who likes to find her own seclusion once in awhile, and a place for children's toys to be scattered around and for people to be together or apart as much as they want. And the sea is near, with marvelous places for walking, and I shall see the sky and the water every day. I'll stay there until next June 15, and then shall go back to Norfolk[15] and stay there the entire summer. Thinking of all this time and all this beauty and the chance to paint again while touching nature and thinking of nature and dreaming of nature, I can almost cry for the need of you, knowing how full and rich everything would be with you and the children with me. I know also, that if I'm alone, there will be an endless sadness, because I know the sadness and loss I feel when I can't share such beauty—but at least it won't be the insanity and claustrophobia of the city.

Monday night I had a long talk with Bernie [Chaet]. He and I have reached a new stage in our friendship—easy and pleasant and lacking that touch of self-consciousness which existed at Norfolk . . . He told me some things about teaching—which are both good and bad. First bad: my situation at Yale is not as secure as I thought. On the one hand, he and Danes[16] think I am terrific. Chaet personally feels strongly—and said, "There is nothing I wouldn't do for you—you know that, Jon." On the other hand—this visiting critic thing was set up with the idea of constantly changing personnel. . . . I have a particularly good deal right now. $4,000 for two half-days' work is, in this racket, about top pay. . . . The same thing holds true for Norfolk—they don't want the same instructors year after year because they're afraid of becoming academic—which happens to schools.

On the other hand, he said that I can get all the jobs I want through Danes, who hears about them constantly from all over the country, and that because of my reputation as an artist and my abilities and references as a teacher I could get some of the best jobs in the country. He said also,

[15]Yale University Summer School in Norfolk, Connecticut.
[16]Gibson Danes, dean, Yale University School of Art.

that while teaching, it would be much easier for me to get grants to go to Europe or stay in Mallaig or whatever. And he said that some of the jobs are in interesting places that I'd probably enjoy. There are two ways of doing this—one can settle into one job some place, or one can "play the circuit" which lots of artists have done—David Smith[17], Clyfford Still[18], etc.—which means take, when needed, whichever job seems most interesting and which seems to offer more, and which fits into one's plans. Naturally, I like the latter for the moment, because I wouldn't feel tied to one school, and because there would be a bit more adventure in the offing. He said that I ought to be able to get the University of California job at Berkeley—perhaps next year—pays $8,000—and it would be near my kids. Erle Loran,[19] who hires, is out at East Hampton now, and I'm going to see about it this weekend. This is a job where they've been hiring New York artists, visiting on a temporary basis.

. . . Also—I plan to not count on my painting income, but let it be my chance for the freedom to travel or live in Mallaig, or whatever, so I shall try to, on the one hand, make enough money through teaching to live on, and on the other hand, live simply enough so that the money from the sale of paintings becomes the key to freedom. I'm trying to make this as explicit as I can to you—and then you can make up your mind. . . .

You cannot love and live with an artist on the same terms that you might with an industrialist or a doctor. . . . In this case, the income would never be large (unless my painting income should become large—but I think we should not burden ourselves with thinking about that . . . but it could always be adequate if we'd both cooperate and want to live the same way). We could always have four months off in the summer to spend as we pleased. We could presumably be able to take a year now and then to go to Mallaig or to France or to just work at home in a place of our choice. But, for the moment at least, we would have to have our roots in the world, rather than in one particular place. Perhaps someday we could find a place in the country—Maine or Vermont or whatever—that we could come back to. I'd like this. I am ready for this step on many levels—because I want you, Lisa and Lori as part of my life, but also because, as a result of much thinking last year, I want to free myself of something which I feel is happening in New York, and from the necessity to "operate" in the gallery area, which I detest. I'll put on my shows, and the world will find me soon enough. I already have many people who believe in me without reservation—and this has to grow. But I don't want to tie myself to economic dreams about it.

[17]David Smith (1906-65).

[18]Clyfford Still (1904-80), whom Schueler writes about more fully in part five.

[19]Erle Loran (b 1905), painter and writer.

• • •

May I make a suggestion? Figure it out for yourself. Don't talk it over with people—particularly parents. It's your decision involved with your feelings. Nobody else—even at best—can feel it the same way. And parents—when they want to be sadistic—can be unbelievable . . .

I spent last evening with Conrad [Marca-Relli] and Anita (had a wonderful time) and Jody dropped over and I took her home and talked to her. She had visited her parents a couple of weeks ago—and had had a wonderful week, and knocked herself out to get along and be nice. Then, on the last day, she had said to her father (fine, upstanding, monied, middle-class) that she felt that what she needed most of all was to be married—and he said (face contorted with a cold hate, I'm sure), "Jody, if you think you'll ever get married again, you're crazy! No man is going to want you at your age after three divorces, etc. etc. etc. No man wants a woman who paints, he wants a good housekeeper (she does perfectly well enough), and a good cook (she is excellent—but he implied she was hopeless) etc. etc. etc." It just broke her up, yet it's the basis of every problem she's had in her life, and why she's been divorced and why she's in analysis. But she really had been feeling better, and more confident—and by God, he was able to set her back a few years. . . . Well, her confidence was so damned shot, I spent an hour or so trying to build it up. You see what I mean? It's an endless repetition. God help me never to do it to a child of mine—no matter how old. IT'S ALWAYS DONE IN THE NAME OF LOVE. HER FATHER WAS TRYING TO HELP HER, I'M SURE. HE'D PROBABLY EVEN BE ANGRY IF SHE SAID SHE WAS UNHAPPY. . . .

I'm going to say one more thing about parents. You never get that callous toward them, no matter what. You always want their love and approval. What one has to figure out is whether one wants to destroy one's life for it, and still not get it. . . .

NEW YORK, 6 SEPTEMBER 1960
LETTER TO SANDRA PAILET

. . . I had quite an interesting weekend. I left Friday morning—reluctantly because my painting had been going rather well. (The one I left on the easel is looking very much alive—reds, oranges, earth colors—yellow and orange, and a blue form on the left working against an umber form on the right.) When I arrived, Conrad and Anita[20] were already at the beach, so I spent the afternoon reading and resting. . . . The party was huge—held outside—and it seemed that every New York artist was

[20]Schueler was staying with Conrad and Anita Marca-Relli.

there.[21] Most of them staying in East Hampton—the others visiting for the weekend. Afterwards we went to another painter's house for dinner. Saturday the sun was shining and we went to the beach for the afternoon—saw more painters, also Ben Heller, Bob and Abby [Friedman], and numerous other friends, characters, hangers-on etc. It's rather fantastic. The whole thing feels so unreal—seeing all of these people from New York suddenly in another setting—that I could not tell whether it was upsetting me or whether I was enjoying myself. . . . Everyone was so tanned that often I wouldn't recognize them—even Stephanie Tatarski (Salvatore Scarpitta's girl) who is very close to me, came up—and I didn't know, for a moment, who she was. Of course, she had also dyed her hair. Bill and Shirley King (who live upstairs)[22] have thoroughly succumbed—Bill has, for the first time in his life, devoted his life to pleasure—and just put work out of the way—swimming, tennis engagements, parties, etc. I took a rather long swim—and when we got home I still felt so invigorated that I skipped the necessary nap and went off with Conrad to a bocci engagement he had—when I proceeded to droop in true hep. [hepatitis] fashion—but could do nothing about it until very late that night. Because from there we went to dinner at a lawyer's house—and then everyone to a huge party at Ben Heller's—a kind of fabulous affair where the rich and the artists mingle—but this mixing up of things seems to have become the nature of New York and East Hampton—it's a little crazy—and then after that another huge party at Bill de Kooning's—at which Bill didn't appear. The rumor was that he had gone to Mexico to get a divorce from Elaine—a long time in coming—but yesterday I heard that this was not true. In any case, it was rather odd—and one didn't know whether or not to feel insulted, whether or not to feel sorry for Ruth (Bill's girl whom I told you about),[23] and whether or not to feel taken in by Ruth who apparently had known for a couple of days that Bill wouldn't be there—but threw the party anyway. Somewhere, underneath, I sense a touch of cruelty—or at least a strain of some sort.

When I awakened the next morning, I felt just as though I had a bad hangover. Obviously I'm not through suffering from the effects of the hep. as yet. Everyone had heard about my illness and much sympathy and advice was offered—along with harrowing tales of friends who had had the same thing—and how interminably it had lasted.

[21] The party was given at Hampton Water, East Hampton, by Barney Rosset, founder and publisher of Grove Press.

[22] The sculptor William King (b. 1925) and his wife lived in the loft above Schueler at 68 East 12th Street, New York.

[23] Ruth Kligman, former girlfriend of Jackson Pollock. She was with him on the night of the car crash (in which he died) in 1956. See *Love Affair: A Memoir of Jackson Pollock*, (New York: William Morrow, 1974).

I forgot to mention that Saturday morning we had visited Jim Brooks[24]. He and Charlotte do not party as much as the rest (all of this that I am describing is evidently the norm—not just a Labor Day exception). They have a lovely little house, and Jim has just had a new studio built—about 30 x 40 feet—two banks of skylights—quite fabulous. Charlotte has a little studio which used to be Jim's—it's very charming and has a nice feeling of the woods in which it rests. They're planning to stay out there until Xmas and work—which is a plan I can well understand.

Sunday noon—after all the partying of Saturday—there was a huge brunch at Zogbaum's[25]—at which one saw all of the people one had been seeing. The drinking continued (except for sober old Schueler)—Scarpitta[26] being in rare form, tossing down beers at an unbelievable rate—just to keep himself on even keel, as he had not sobered up from the night before. By this time Anita had collapsed, and didn't attend a single Sunday function. In the middle of the brunch it started to rain; half the guests moved inside—but many remained outside talking in the rain. Afterwards a bunch of them had a baseball game somewhere, but Conrad and I skipped that. I was absolutely exhausted and went home for a long sleep in the afternoon—and also read a very dull book about East Hampton and the artists—a gossipy book, presumably written by Harold Rosenberg's wife called *But Not for Love*.[27] . . . Then some place for dinner—I have no idea where—and then another huge party given by [Hans] Namuth . . . a rather well known and well-heeled photographer. Wonderful food and lovely women, and evidently the liquor was good, though I didn't taste it. Crowd somewhat different, though Bob and Abby were there, other people I knew, and a sprinkling of artists.

Monday noon, Conrad and I visited Kyle and June Morris[28]—and Ray and Denise Parker[29] who were visiting them. Had a pleasant conversation. Somewhere along the line Conrad and I had a great talk about painting—about some of the more basic problems facing the painter today. Went to the beach, but it was too cold to swim. We sat shivering on

[24]The Abstract Expressionist James Brooks (1906-92) and his wife, Charlotte Park (b.1918), also an abstract painter.

[25]The sculptor Wilfred Zogbaum (1915-65) and Marta Vivas.

[26]Salvatore Scarpitta (b. 1919) whose shaped, cut and bandaged canvases, and later the cars and sleds were shown at the Leo Castelli Gallery. The bond between Schueler and Scarpitta was strengthened by much talk and open discussion when their teaching jobs overlapped at the Maryland Institute, Baltimore between 1965 and 1967.

[27]By May Tabak (New York: Horizon Press, 1960).

[28]The abstract painter Kyle Morris (1918-79) and his wife.

[29]Schueler had been introduced to the artist Raymond Parker (1922-90) by Clyfford Still in New York in 1951. Parker knew many of the jazz musicians and played the horn. Schueler, who had brought his double bass with him from San Francisco, shared his interest and they saw a good deal of each other until 1964.

the beach, talking to those hardy souls who managed to make it down there. The sky was cloudy, but lovely, the beach almost empty and I went for a walk by myself. Every minute of the weekend I wished that you were with me. A lot would have been fun that wasn't that much fun—and the things that were great would have been twice as great. That night we had a small party at Conrad and Anita's—the Zogbaums, Scarpittas, and Kings came over—some kind of shrimp on rice which was terrific (Conrad's doing, I think)—and lots of dancing and gaiety and real fun because we were an intimate group who enjoyed one another. Again, I wish that you had been there. Scarpitta was in good form, and I managed enough energy to dance with fervor. Today I drove back, read your letter (that you wrote the night I phoned you) and looked at your photos and then slept the rest of the afternoon.

I had many mixed feelings as a result of the weekend—about East Hampton, New York, the meaning of all this frenetic activity, etc. It's an exciting place to be, in a way—if one is not working. All of one's friends are there, and they are all playing like mad—so that if one were working, one would feel everything as an intrusion. The beaches are beautiful, the landscape dull. There is a kind of madness going on amongst the artists—as though they're searching for something—some lost toy—like the wealthy and semi-wealthy of the twenties. The next thing—quite seriously—they'll be going off to Florida in the winters. On the more positive side, it made me realize how warm the art world can be, how many friends there are, and how I shall miss New York. With all the madness, I can still understand that frenetic search more than I can understand the regimented poker nights, etc. of the Yale-type artists. . . .

NEW YORK, 7 SEPTEMBER 1960
LETTER TO SANDRA PAILET

. . . I realize that I've been rather depressed since you left me and have never quite gotten over it. I feel better tonight, oddly enough, than I have for a long time. (When my kids left last year I plunged into a fantastic depression—it took me weeks to pull out of it.) The weariness from the hepatitis doesn't help—I somehow feel guilty when I'm not working up to full pitch. Yet—curiously, there are advantages to working slowly. The picture on the easel is maturing in a way that delights me.

. . . My main security, and ultimate chance for some decent money (in contradistinction to petty academic handouts) rests in my painting. Teaching is only a means to an end as far as I'm concerned. It enables me to paint for the moment, and will enable us to be married. But it should never interfere with the big output of canvases. And everything that is necessary for me to enlarge upon my idea—whether it be living abroad, or living in California, whether it be teaching or taking care of you and your children, or thinking my way through my book—these are the things we have to rely

on. . . . But if you do decide to marry an artist, you'll have to watch me gamble many a time—because the thing is done through gambles. It has been up to now, and it will be in the future. I know what I want, and I'm still out to get it. But I won't let you get into difficulties. I never know what the hell you mean by "having to buy things." I know, of course, that I won't sell my soul and my career so that you can buy things. . . . But—as I said—I don't think that this is really the problem. If it is, we're doomed—unless you can make enough money during difficult times to buy what you want. The artists' lives, which include marriage, that seem to work best are very cooperative affairs on a financial level—and by that I don't necessarily mean that all the wives have worked, though many have at one time or another—but they work together. Frankly, I think your only problem right now is not being with me. I believe in you, and I think that your values are much deeper than you sometimes let yourself believe. . . .

<div style="text-align:center">

NEW ORLEANS, 8 SEPTEMBER 1960
LETTER FROM SANDRA PAILET

</div>

Dear Jon,

Today Lisa was up at 5:30 A.M and dressed by 6. 00. Today was the first day of school, and she senses that she is on the brink of a big discovery—that of learning to read and write. And it is such a thrill to sense this excitement in that eager young body, and such inquiry in those bright eyes. I brought her into the schoolroom and she was for a moment very shy, but her teacher (who was a childhood friend of mine) soon put her at ease. And so Lisa is in the first grade. Lori and I went to do some shopping for you—on your birthday. Then we went to my father's store to pick some fabrics to have my sofa and two chairs covered

Now for the very basic thing. I loved you deeply this summer—I love you now. I'm proud of the way you've attempted to tackle future problems. I could have cried when I shopped for you this morning—just wanting to care for you. And if you're unwilling to accept or understand me on my terms and problems then to hell with you, Jon. And you'll always remain in my heart and perhaps I'll be that wonderful, poignant summer dream in yours.

I love you,
Sandra

<div style="text-align:center">

NEW YORK, 10 SEPTEMBER 1960
LETTER TO SANDRA PAILET

</div>

. . . I've finished a blue painting which is very tender[30]—and I've also finished painting the bathroom. The bathroom is so white—so clean—so antiseptic.

[30]Probably *Blue Near Mallaig* (67" x 72").

One could eat off the—well, not off the floor, but off the walls. One could be born there, live there, die there. One would be pure, hermetically sealed, never knowing evil. It is so clean, so white, so virginal, one can stop thinking, stop feeling, stop everything. I think I shall move in.

Kyle Morris (the guy who does the recommending for the California job) is having an opening Tuesday at the Kootz Gallery—which I'll attend. And I'll call him later in the week about the job.[31] The more I think of it, the more I'd like to have it. I think it would be fun to go back to the coast for a year—and what a kick it would be to be able to see my kids any time I wanted to and get the entire family together. . . .

NEW YORK, 14 SEPTEMBER 1960
LETTER TO SANDFRA PAILET

. . . But I'm so damned tired, darling. There's just no way of fighting it. And I don't sleep well in the city, which doesn't help the hep. any. Dr. Baldwin wants me to come in Friday for an examination and some kind of liver test— and I hope that we can make some progress. I'm taking therapeutic vitamins and am trying to eat carefully and I wash the dishes rather than rinse them and the bathroom is gleaming white and today I swept the floor, so you'd think I'd be full of vim and vinegar.

I wish that you had phoned me on my birthday. Even though the Myers took good care of me throughout the evening, I was quite low again by the time I went to bed. I was very upset by the death of my friend—I think I've mentioned him to you—Oscar Pettiford—whom I've known since 1944. He was a terrific guy, besides being an extremely creative man—one of the best—probably the best jazz bass player who has ever lived. He was in Europe when I was there—I saw him a number of times in Paris, thank God—and he stayed on after I left. He was sick of the commercialism surrounding music here, the very tough conditions, the cynicism, etc.—and he was heartily sick of a very impossible wife—while in Europe they idolized him—and he had decided to stay. Wherever he'd go in Europe he was treated like royalty. But around the time I left, he was in a bad automobile accident in Austria—he had been driving while drunk—and was laid up for some time. We seldom corresponded, so I don't know too much about what happened after, but I know he was playing all over Europe again, making his headquarters in Copenhagen—and had recently played in a jazz festival in Paris. They found him in a hotel room in Copenhagen, and the doctors won't tell the press what he died of—so it looks like suicide or else dope. I doubt the dope idea, because Oscar was never on it as far as I

[31]Kyle Morris had included three of Schueler's paintings in "Vanguard 1955: A Painter's Selection of New American Painting" which was shown at the Walker Art Center, Minneapolis, so Schueler knew that Morris respected his work.

knew—and I think I would have known. He drank a lot, and addicts seldom drink—and vice versa. The suicide possibility I can imagine in some terrible way. He was a man of tremendous tensions and conflicts—basically unhappy, even as he spread a lot of happiness around him—most of it coming from his tremendous vitality. He was husky and very strong and very proud. When he played he had a marvelous dignity about him, even as one felt his strength and a kind of almost animal magnetism (the thing one feels, I think, in the most vital art everywhere)—and women went crazy about him. He was Negro with part Indian which gave his features an unusual look. And he hated bigotry on both sides of the color line. I remember one time on Sixth Avenue (at eight o'clock in the morning after we had been drinking all night in an after-hours joint) he attacked another colored musician who made some race cracks about me that were on the edge of being insulting. It was rather fantastic—as the world looks strange enough when you come out into a morning rush hour from a night spot. The world shimmered crazily in the sun that was too dazzling for my tired, and I'm sure bleary, eyes. And the next thing I knew, this fight was going on, and another musician and I were trying to stop it, and finally we hailed a cab and everyone piled in and somehow I got home. I really miss this guy. We would meet in every possible city, as our paths crossed throughout the years—New York, Los Angeles, San Francisco, Paris—and it was always with that basic assumption of true friendship, and we'd pick up where we left off. I could never last too long—because Oscar was a night person totally—typically, in New York, he'd work until three or four in the morning, and then raise hell all night, and sleep during the day—except he was forever having to cut records during the day, too. He was only thirty-eight years old when he died.*

The little blonde, whose name is Linda Levi, is one and the same girl mentioned by your friend. She's also about the most aggressive little wench that I've ever seen in my life—and I've seen plenty of them in this business. She's a female *What Makes Sammy Run* character—and just cute enough in a slightly weird way to probably make a go of it. She amuses me just enough so that I told her I'd give her some introductions in the art world—so last night I took her to Kyle Morris's opening. Because Kootz closed the doors at 6:30, and those things usually last at least until 7:00—we were late, arriving just as Kootz, the Marca-Rellis, and the Morrises were coming out of the building—so we all got together for a drink along with Denise Parker and Shirley King—and then went down to Chinatown for dinner (a typical post-opening ritual). Scarpitta and Norman Bluhm and Ruth Kligman (de Kooning's girl) were down there, and after a fairly good Chinese dinner we all went up to Kyle's apartment—one of the most beautiful in New York—and had a party—a number of other people came—Ray Parker, Lutz

*See color illustration 24 for one of the paintings dedicated to Oscar Pettiford.

Sander,[32] the Zogbaums, etc. etc.—so by the time we were through, little Miss Ambitious from Los Angeles had really had her introduction. From now on she's on her own. I noticed Conrad making his pitch—so I'm curious. Unfortunately, I was terribly tired all evening, but hung on until 12:30 because it was the first event of the season—but also because Kyle had had a rather poorly attended opening—a lot of people aren't back in town as yet—and I felt that he should have plenty of company for the rest of the evening. We had a good talk. . . .

NEW ORLEANS, 15 SEPTEMBER 1960
LETTER FROM SANDRA PAILET'S MOTHER, MRS. MAX HALPERN

Dear Mr. Schueler,

This letter is not a sneak preview—I am writing to you with Sandra's knowledge of it—I am a very mild sort of person—a mother who loves her children and home and will fight like a demon to protect them if necessary. My husband and I were not born with a gold spoon in our mouths—we earned everything we won, so don't get the impression that we are the rich that want our way or else. We are a very prominent family here in New Orleans. My children, including Sandra, are looked upon with respect and are entertained by the nicest people here in the city. My three sons are highly respected citizens here and at school and in business. My daughter-in-law is also of a prominent family.

My three granddaughters are growing up in the same way—I do not intend to have you come here and destroy all this. We cannot pull up stakes and hide elsewhere in shame because of you coming to New Orleans. I will have you watched every minute of your stay in New Orleans if you do come—I can't stop you from coming, but I love my grandchildren too much to sacrifice them to you and your way of life.

Wherever you will go with Sandra, you will be noticed. She is that well known.

What you have done to my child in the short time you have known her is something I can't understand. She was more reserved before "J. S." You have several strikes against you. This marriage will never work out. You are old enough to be her father—when she will be in the bloom of life in her thirties you will be in your fifties. Secondly, Sandra has never worked in her life. You can hardly support yourself, let alone a young wife [who] likes nice clothes and also to give her two very young children a good education, food, nice clothing etc.—Her husband will cut her off to a minimum of $75 when he finds out what Sandra intends to do—he can do this by Louisiana law. I have also told Sandra that she will annihilate herself completely from her family as much as it will kill us to do this. We all love

[32]The painter Ludwig Sander (1906–1975)

her, especially my husband and myself. We want her to give herself a chance to find someone [crossed out in letter] to be sure of this next marriage. Men like you should never get married. You are of another world. In high heaven one moment and in Hades the next. You dream. Anyone breaking into your weird world will be destroyed in time, unless they have the strength to get out of it—like your former wife did—I am sure she was a fine woman. You haven't been a success with your first marriage, so please, I beg of you—don't add my daughter and her two babies to your belt. When Sandra will live in poverty, she will not be such a happy wife. She will not have family or children. There is a very good chance for her husband to get custody of the children— and I know Sandra will give them up instead of subjecting them to poverty. She is that honest—

Remember, Mr. Schueler, I am a desperate mother and grandmother. I will fight. I will employ the finest detective agency to have you watched. I do not trust you. You cannot understand love in a respectable way. You want what you desire over the bodies of whoever stands in your way. I am in your way. You suddenly came up from Hell to destroy a young woman and her family—when I saw your picture, you look like the devil; you have evil in your eyes. If Sandra can't see it now, she will in time. You're a sick man—leave human beings alone that never harmed you—please don't make me do what I never did in my life, be vicious enough to get to your level.

Signed: Mrs. Max Halpern (Sandra's Mother)

NEW YORK, 18 SEPTEMBER 1960
LETTER TO SANDRA PAILET

. . . I hate to see you going through misery on my account—and, because it's involved with your parents, there is not much I can do about it. I may or may not answer the letter from your mother—but I hope you trust me to do the right thing as I see fit. The fact of the matter is that your parents are going to have to get to know me whether they want to or not. . . . Remember, dearest— no one is going to shake my faith in you or my love for you. . . .

I had an experience Friday night which was a lot of fun. I went to a little dinner party at Virginia Gilmore's.[33] Do you remember her—an actress, probably before your time, who was married to Yul Brynner[34]—rather recently

[33]Virginia Gilmore (1919–86): the lead in *Dear Ruth*, a Broadway act in the forties, she made some forty films as a contract player for Twentieth Century-Fox, before returning to the New York stage in the sixties as Henry Fonda's co-star. Married to Yul Brynner from 1944 to 1960, she was the mother of Roc Brynner.
[34]Yul Brynner (1915–85) won both a Tony (1951) and an Oscar (1956) for his role in *The King and I*.

divorced? Well–there is a little group that gets together every once in a while: Ellen Violett (Pucky)[35]–whom I've told you about–an old friend, AA, writes for TV, brilliant and kind and tragic; Sidney Lumet–movie and TV director–who directed *12 Angry Men*, *The Fugitive Kind*–and a big TV show last year on Sacco and Vanzetti–and who is now doing O'Neill's *The Iceman Cometh* which will be on TV in two parts near the end of October. (Be sure to see it. He's having me up to a screening–so I'll be able to see it all at once–nearly a four-hour show!) His wife–Gloria Vanderbilt, of whom you've heard–she's acted, and painted, and is now writing–though she's always waiting for a part in the theater. . . . Lou Peterson–who six years ago was just a young, sensitive, intelligent colored guy who wanted to write–and whose wife (white) would complain behind his back that he goofed off most of the time. Well– he wrote (sometime while goofing off) *Take a Giant Step*, which was produced on Broadway–then the movies bought it for quite a sum. . . .

Theater people are . . . great ones for getting hysterically involved with things–games, parlor games, etc. Well–this bunch is now on *I Ching*–do you know the books?. . . The women have gone crazy on the subject–have become so absorbed that they do nothing but ask the books questions . . . so finally I decided to ask one. Virginia took me in the other room, and I very seriously and earnestly asked a question. (You write it down, put it in your pocket, and keep it well in mind.) I asked: "Will I find the path to the glory?" (You know what I mean by the glory–in regard to life and art–and vision– the highest vision–that will give meaning and life to the whole thing.) Well– the answers–long and complex, in part–and at the end, simple and direct– were fascinating. First–a lot of stuff under the general heading of "Youthful Folly"–which seemed to outline a good deal of the strife I've had in fighting through to the present. Then a section which seemed to suggest many ambiguities–yet the obvious moral choices involved so that one could attain a clarity and maturity of purpose–again lots of stuff I've been thinking about endlessly. And then–on the next throw–an absolute affirmation of success–because, it said, that I was a man who embraced humility and the idea of weakness, and that true strength lay in humility, kindness, and encompassed weakness, etc. . . . And there was even a lovely paragraph on a happy marriage–this, evidently, being somehow part of the realization of wisdom. (Which I firmly believe.) . . . When I finished, I said–"Fine–I have the definitive answers to the definitive question. . . ." So–you might as well relax. You can't go against *I Ching*–and you are part of my destiny. It is so written. . . .

[35]Schueler's friendship with Ellen Violett (b.1925) was grounded in their support of each other's work when his start as a painter and hers as a writer coincided in New York in the 1950's. When Violett was company playwright for the Touring Players, Schueler joined them for their summer season on Block Island in 1953, 1954 and 1955.

NEW YORK, 19 SEPTEMBER 1960
LETTER TO SANDRA PAILET'S MOTHER

Dear Mrs Halpern:

Thank you for your sweet and gracious letter, in which I have the pleasure of making your acquaintance sooner than I had expected. Even though we haven't met, we have so much in common that we should feel absolutely free to correspond with each other.

Certainly the main thing we have in common is the happiness of Sandra, the dearest, sweetest and gentlest woman I have ever known. I am touched by the tenderness of your concern for her, and want you to know that it is equaled only by mine. I can well see that you would never do a thing to cause her a moment's unhappiness or pain. Nor would I. I love her so totally and so profoundly that I am, have been, and always shall be ready to do anything in my power to make her happy.

So, it seems that you and I have absolutely the same goals in mind, and I see no reason why we should not be able to cooperate fully. If you'll just let me know your wishes from time to time—wishes, that is, that we both know will lead to Sandra's happiness—I promise you that I shall consider them carefully and do what I can to help you.

In regard to the biggest question of all, that of marriage, a man can do only one thing for the woman he loves: He can propose to her. And, as you probably remember, the woman's part is equally simple: She can answer yes or no. I have often told Sandra that I love her so much, that even if she thought that loving me would make her unhappy, or if she felt that she had to reject me for any other reason, I would still feel fortunate in having loved a woman as lovely and kind as she. I hope, therefore, that you are giving her all the advice that a loving mother should give a daughter, and if there are insights into my character and information about my life that you know and that she is not aware of, I hope that you'll share them with her so that she'll intelligently and maturely be able to make up her mind. Inasmuch as you said that you wrote with Sandra's knowledge, I'm sure you won't mind if I send her copies of our correspondence, for there might be information in it important to her. I have always tried to be absolutely open with Sandra, as I try to be with my life in general; but often others see you in a different way than you see yourself, and those opinions are important, too. I would never hide anything from Sandra.

I was pleasantly surprised to hear you say how socially prominent you are. Are you prominent throughout the United States and Europe, or just in New Orleans? Sandra had given me no idea, but had led me to believe that she came from a nice, middle-class family, and that her father was in the dry goods business. (I have an uncle in the dry goods business—in California.) But, naturally, a man in my position would want to know the background of the girl he loves in as much detail as possible, and I hope you'll tell me more. I never thought of hiring detectives—it isn't customary

in my circles—but it does seem eminently practical, doesn't it? You and my mother would get along beautifully: She has always said how socially prominent the Schuelers were in Milwaukee. (My father was in the tire business.) After my father died, she married George Fredericks who is in the ready-mix concrete business in Detroit. She now says she's socially prominent there, which I think is very sweet.

Please don't worry about Sandra and myself being noticed when I am in New Orleans. Being somewhat in the public eye myself, I am quite used to being stared at by the curious, so I shall not be embarrassed. In fact, I'm afraid that I have to admit to the human frailty of sometimes enjoying it.

Now, about the detectives: I agree it would be wise to employ only the finest agency possible, because at best, the sort of people who are in that line of work are—well, rather criminal types. (The other side of the coin, you know.) I promise you that I shall cooperate in every way possible. I suggest that they meet me at the plane, and perhaps I can hire one of them as a driver during my stay in New Orleans. (That type will take a buck wherever he can grab it.) In that way they could keep track of any deviations I might make from a planned schedule. Do they have a New York office? I could get in touch with them and give them a general outline of my plans. I understand that you are to have me investigated here in New York. Now, that is a very easy thing to do. Because of the nature of my work and my own character, my life is rather an open book—someday it will be literally—and I can guide the detectives to source material which will save them a lot of time and you a lot of money. My biographer, Mr. Alastair Reid, has intimate knowledge of all aspects of my life from the material he has been compiling. I never keep anything from him. Unfortunately, he is in Europe at the moment, but he can be reached through his publishers, Little, Brown and Co., Boston. I'll write and ask him to answer any questions which might be asked by you or your authorized agents. Also, Mr. B.H. Friedman (a very interesting man—business man, editor, writer) has been collecting materials on my life. He has hundreds of pages of manuscript, letters, journals, etc.—some of the most personal nature—and I'm sure that he'd be most interested in replying to your requests. His address: Mr. B.H. Friedman, Executive Vice-President, Uris Brothers, 300 Park Avenue, New York. Mrs. Nelson Doubleday and Mr. and Mrs. Roy Neuberger would be happy to answer your questions (though they might be a bit embarrassed by the detectives). They are socially prominent and you'd all speak the same language. Incidentally, I hope that you won't mind if I send on copies of our correspondence to Mr. Reid and Mr. Friedman, inasmuch as I give them access to my papers so that their writings will be as objective and accurate as possible. If I don't hear otherwise, I shall assume I have your permission.

I have just thought of someone else who might be useful to your detectives: Mr. Ben Heller, president of Wm. Heller, Inc., 1071 Sixth Avenue, New York, makers of Heller Jersey and other fabrics. I became friends with the

Hellers after they started buying my paintings some years ago. Mr. Heller is a very astute man, and could give much information of a professional nature. Insomuch as Mr. Halpern may know Mr. Heller personally, he could probably do some direct quizzing, and save on detective costs. Unless cost is no object.

In return for my cooperation, I wonder if you'd do me a favor? I'm sure that both of the writers, Mr. Reid and Mr. Friedman, would want copies of the detectives' reports for their files, and I would appreciate it if you would forward three copies to me (one for my own files).

About the intentions of Mr. Pailet: I'm shocked that he might be as cruel and irresponsible a father as you suggest. Certainly any man who would spitefully hurt his children as a means of hurting a woman can be no man at all. No wonder Sandra divorced him. From what you say, I think it would be better if Sandra, Lisa and Lori were getting no money from him at all, rather than to be mixed up with someone of the character that you suggest. I'm also rather shocked by the archaic Louisiana law, and I hope you write a letter to your congressman. The first concern of both California and New York law is for the welfare of the children, and not for the spite of the father. I look upon this with the same horror you do, and shall certainly do what I can to keep Sandra from being entangled with that sort of thing.

I think I have covered about everything you mentioned, except for my own qualities which I am too modest to discuss myself. I am reassured by your love for Sandra, for I naturally hoped that she came from a family which had a sensitive, human and wise concern for her daily happiness. There's only one thing I don't understand: In my circles, it's usually the men who carry on this kind of discussion, in a kind of man-to-man fashion, the women being more concerned with other matters, such as trousseau, etc. However, perhaps your customs are different.

I am looking forward to meeting you and the rest of the family (unless you have pulled up stakes and hidden). Inasmuch as we have Sandra in common, we inevitably must get along well—even though we might be observing each other somewhat critically. Believe me, Mrs. Halpern, I love Sandra with a deep and abiding tenderness. She is a very unusual woman (and I need a woman, not a child), with a sensitivity, warmth, kindness and femininity which one seldom sees. I can well imagine that these qualities reflect, in some way, her family and her upbringing. There is nothing I would not do for Sandra: all she has to do is ask—me.

Affectionately,

[signed] Jon

Jon Schueler

I shall take the liberty of signing my first name. Should you or the detectives wish to reach me by phone, I am at GRamercy 3-3175.

NEW YORK, 19 SEPTEMBER 1960
LETTER TO SANDRA PAILET

. . . There was something odd in your mother's letter, aside from its bad taste, that has been puzzling me all day, and this evening I suddenly realized what it was. Considering the fact that the threats are being made against you (for all practical purposes), what she is saying in the letter is that she is aware of the weapon the man has in a divorce suit in regard to child support and child custody, and that if you don't bow to her wishes, she will put a tail on me to provide evidence for Max Pailet so that he can get out of child support, and perhaps gain child custody. Obviously, putting detectives on me for any other purpose would be meaningless. What if they caught us sleeping together? All that would happen would be that some detectives and your family would know that we slept together—and they probably know that already. I can't imagine that a sane person would actually do such a thing, but a person who is destructive and self-destructive (and your mother is sounding a bit like a cross between Hitler and Lumumba)[36] can be counted on to do anything, because it's impossible to predict the limits of their fantasy. One thing I've found from experience is that it's the self-righteousness that you can't get past. They'll destroy the world and all the while stand there in a kind of calm martyrdom proclaiming that it was the other guy that did it. She could conceivably try to wreak havoc with you and your children and all the while demand that you pity her in her suffering. Would Max play this game with her? In any case, watch your step; don't let letters get into her hands—they're weapons if she wants to use them. (Evidence, if we talk about sex.) It's amazing how all that's beautiful in life can be made sordid by the touch of the mean and nasty minded. For myself, I'd like to tell them all to take their little green dollar bills and shove them way, way, way up where they'd be absolutely safe. I'm sure that there would be plenty of room for all the bills, plus any gold spoons lying around. (Do you think I'm vulgar?) I think that if you can keep a sense of humor about all this on the one hand, and a wary eye open on the other, you should come out of this without being hurt. After all, everything is going just as Bob Friedman predicted. Probably after we've been married ten or fifteen years, peace will be made. Particularly if we stay far north. Perhaps we should settle in Mallaig for good—I can get a herring boat—Jim Manson promised me one—and each week I'd bring home the herring. Can you and the L's live on herring? Do you even like herring? We could have boiled herring, smoked herring, pickled herring, salted herring, fried herring, baked herring, and herring with Scotch. I can think of a worse life. The boats go out on Monday mornings and fish all up and down the western coast

[36]Patrice Lumumba (1925–61), first prime minister of the Republic of the Congo, June–September 1960.

and out along the Outer Hebrides until Saturday noon. We'd make love Saturdays and Sundays and then I'd be gone again and you'd have five and a half days of uninterrupted painting. . . .

NEW YORK, 23 SEPTEMBER 1960
LETTER TO SANDRA PAILET

. . . In the morning I was up at seven and put the top down on the car and loaded on fifteen stretchers. It was a beautiful September day—cool, yet warm enough to be quite comfortable driving with the top down. I pretended you were with me driving along the Merrit Parkway through Connecticut. You would have loved it so. Of course, even were we married, I don't suppose you'd be driving off to work with me in the morning. Because of the time taken in loading, I didn't arrive until almost 11.00 A.M.—and of course Chaet remarked that I was late. Boy Scout leader. He's all tensed up again, the summer did him no lasting good. He's under some kind of terrible pressure at Yale. I think he's on the one hand very repressed (of necessity in that kind of a job) and on the other hand is always proving himself in some way. (Does that sound like jargon?) Anyway, I spent the day talking to students—many of them had brought summer paintings and drawings—and at four I went out to the barn. . . .[37]

NEW YORK, 28 SEPTEMBER 1960
LETTER TO SANDRA PAILET

. . . Your parents aren't the only ones you're talking very little to. You're also talking very little to me. You said over the phone that you were writing short letters because you're moving October 3. It turned out that for three days you were writing no letters—and I doubt that it had a damned thing to do with moving. . . .

Don't disturb your mother's silent suffering. That's what martyrs like to do. . . . My dearly beloved stop—rather, stepmother managed to create an exquisite martyrdom every week during all of my growing years. Sometimes long silences. Sometimes flaring tempers. Sometimes the endless whine of complaints, like sirens in the night. But whatever—she was always on stage with the most demanding act of all.

I've been painting a lot, and thought I was doing well. Today everything looks like hell to me—one of those days when it just looks like paint on a canvas, nothing more. I woke up with a headache. And I've been climbing up

[37]The Ribley house in Guilford, Connecticut, half a mile from Long Island Sound. When Schueler moved there in November, he was within easy commuting distance of Yale University School of Art in New Haven where he was teaching.

the walls—you can see my footprints on the walls, and the deep gouges where I've clawed at the ceiling. . . .

NEW YORK, 1 OCTOBER 1960
LETTER TO SANDRA PAILET

. . . This summer I knew why I liked to teach. Tonight I know why I don't like to teach. It has to do with painting. When I'm not painting, teaching is fun and uses up my energy. When I'm painting it's an interruption—and a very disruptive one. I tend to paint in large rhythmic sweeps (speaking in terms of time). It's as though I pick myself off the ground, or out of some kind of timeless slough, and the next thing a rhythm starts, and the pictures build and build, and finally I find myself (perhaps after many weeks) in the middle of the big rhythm, with ideas flowing and with sensitivities highly keyed. At that point any interruption is like a catastrophe that has to be laboriously surmounted afterwards. Wednesday I had worked up to a fine concentration. Then came Thursday and Friday at school. I wanted to paint last night (Friday) after I talked to you, but I was too fatigued. . . . The deeper I get into painting this year, the more I'll probably blast the little bastards at school who want to suck the blood out of me—particularly next semester when I start three days a week. It's a damned stupid thing for me to do—taking that extra day—but my finances are going so completely to pot that I have to do it. I got my Yale check yesterday—and the $400 ends up $325 after deductions! I don't know why I couldn't have figured that out before—but I seem to live in some kind of a dream world about money, and every once in a while I'm jolted awake—but not for long. You mentioned selling. Of course, I like to sell a painting—although most sales are basically disappointments—you merely see a beloved painting go someplace you don't want it to go, and just for a few bucks which soon disappear. And God knows I love money. But what I like best is when I don't think of selling or the whole damned paraphernalia of the art world, but concentrate on God, Nature, painting, pain, people, and whatever else goes into it. In Scotland for a time I was overwhelmed with the totality of an act and the totality of an involvement with nature. I just touched on the potential then—I know that there's a glory that goes far beyond what I experienced during those months, and, by God, I'm going to create it. And when I was in the midst of that, I couldn't have cared less about sales, collectors, museums, galleries, etc. . . . Then, last year, in New York, I spent as much time thinking about money as I had in Scotland about Art and Nature. . . . I consider it, with great bitterness, the most misspent year in my life. I feel as though I was living on the level of a pig with his snout in the trough—full or empty is beside the point. . . . Every time anyone comes to see paintings, every time I have a show, etc., etc., etc.,—it always means I'm going to pay in a good amount of time spent not painting or painting badly. I'd give anything in the world if I could have a dealer who could

handle my work without me having a thing to do with it. The worst way I can waste my time is to worry about sales when I'm not selling. That's even more debilitating than worrying about them when I am.

I know what you mean about losing touch with each other in some cock-eyed way. . . . On the day of your departure, I could feel you withdraw as you started, even in imagination, to embrace something else that was strange to me. Now—you're living a life that I'm totally unfamiliar with, and I'm lead-ing a life which you don't know. You're, in part, someone I create as I write a letter, or as I read one of yours. How real is it? And how real is your black and white photo of me? Do you think it will be a shock when we meet each other in New Orleans? Just the idea of New Orleans seems terribly strange to me. The heat, the mosquitos, the racial situation which must imprison ev-eryone, including a visitor . . .

NEW YORK, 3 OCTOBER 1960
LETTER TO SANDRA PAILET

. . . Also had cocktails with Aissatou Mansare, my little friend from Les Ballets Africains—and met some of the other members of the cast whom I had gotten to know when they were here about a year and a half ago. Achkar Marof, who used to manage the show and who helped organize it, is now with the Guin-ean Embassy here—and Achkar said that he'd get me a teaching job in Guinea should I want one. Now, there's an idea. At one time, as a matter of fact, I was thinking of going to Africa—thinking it was at the other end of the scale from Mallaig, Scotland. The members of the Ballet would give me plenty of contacts, and Marof himself said that he'd take me into the country and really show me Africa. Something to keep in reserve in case California falls through.[38]

The women are doing some of their dances with breasts bared this year. Last time they tried it (which is the custom in Africa—a strong point for going there), but the police said, naughty, naughty—and they got so much publici-ty that the houses were sold out. This year the police haven't bothered, and it's much easier to get tickets. There's a huge photo on the front of the the-ater of two dancers—one a young beauty, beautifully constructed—who turns out to be 14 years old! They're going to San Francisco, and I'm going to have the kids look them up—they'll be thrilled.

The Guineans have that wonderful pride that comes from being of a na-tion which has won her independence, and which is going strong. (Guinea was one of the first, and is a kind of leader—though, unfortunately, becoming

[38]The job as visiting artist at the University of California never materialized but Schueler continued to teach at Yale until June 1962.

rather left wing. At one point she turned to us for help, didn't get it, and so accepted offers from Russia.) I don't know how much the reverberations are being felt outside of the rest of the world and New York—but the Africans are suddenly very important—and are being wooed by everybody. Among other things, they have many, many seats now in the UN—nineteen new ones just the other day—and therefore are quite a power block. The result is that it suddenly pays us to be very nice to them. There's been a terrific scandal about housing difficulties, and other slights to members of African delegations. The worst part is that American Negroes have been some of the worst offenders! Like I've always said, poison spreads. The degree of our influence (and probably lots more) as a first-rate power can ultimately depend on such an issue as this. The pride of these people is something I've seen firsthand, and I doubt if it is to be tampered with. And I know, also, that they have no concept of putting up with the kind of stuff that's going on in South Africa any longer than necessary.

You ask how I feel after painting. Sometimes drained, sometimes hopped up, sometimes disassociated. Sometimes very much in touch. Sometimes very positive about things I should question. And sometimes very unsure about things I should feel solid about. Often rather strange and odd and floating. Right now I'm staring at a painting that I know is an excellent work, yet I've been questioning my entire position as a painter. It goes on and on. I wish it would get different, but it doesn't. That's why it's hard to live with a painter. How can two of them live with each other? The worst difficulty, I think, for the two—is that they try to understand each other in their own terms, and this is not possible. Everything is different from painter to painter, and certainly from man to woman. Conrad [Marca-Relli] can't understand my need for nature and the country—he not only doesn't need it but doesn't like it. Jody couldn't understand the fantastic inspiration I found in Scotland—it was just cold and wet to her—nor how I felt that I had done something akin to climbing Mount Everest. After I had discovered it, all she had to do was take a boat and a train. The painter who works every day at set hours can never understand the painter who works like a demon two months a year (Riopelle[39]), or who works in odd spasms when he can pull himself together (de Kooning) etc., etc., and vice versa. . . .

<div align="right">

NEW YORK, 4 OCTOBER 1960
LETTER TO SANDRA PAILET

</div>

. . . God, I was tired today. Just one of those days. It seems that about every third one is rough. But I managed to get some painting done. I have a

[39]The French-Canadian abstract gestural artist Jean-Paul Riopelle (b. 1923).

number of them set around right now and the room is full of color. I've almost painted enough for a show.

Yesterday I stopped by the Stable Gallery and had a long talk with Eleanor Ward[40]. Did I tell you about her and the gallery? Well, I had my first show there in 1954–and immediately after had a fight (about money!) with Eleanor–won the argument–and got eased out of the gallery. Around that time and for some years after, the gallery went great guns–was a very active avant-garde gallery. But ultimately, Eleanor pulled so many fast ones on so many people that most of her important painters left (Conrad, Jim Brooks, Tworkov recently, and many others). However, it's a beautiful space to show– perfect for me–and she is still in business, and has some good people–Joan Mitchell (who is a bitch to equal only Eleanor), Stankiewicz, Katz, Noguchi[41], etc. She also manages to take on too many artists, promising more shows than she can deliver. She's a bit nutty, very chic, bitchy in the grand manner. Birmelin[42] is going to have a show there. Anyway–we've been getting on in the past many years, and she's been most complimentary–and since my last show has been wooing me–and I've sometimes wondered whether I should go back with her. I could expect a certain amount of trouble–it's just her nature to do snaky things–but on the other hand I don't feel that she could bug me as she could in the past, and we might have a bit more of an understanding.

My problem is that Hirschl and Adler[43] are practically useless to me, as they just don't do any business in contemporary paintings, and aren't out to try. They make too much money doing just what they're doing. And yet there is no place for me to go. The only step up for me is to Kootz or Janis– and they haven't been around asking. I don't like the Kootz Gallery–but would probably show there–but I doubt if he'd like my painting anyway. That leaves Janis–and he might get interested if I'm a big success in ten or fifteen years. One other difficulty about Eleanor is that she's going to lose her building–presumably she has a year of grace before they tear the entire block down to put up another luxury something or other. However,

[40]Eleanor Ward, despite her difficult personality, was known for her commitment to contemporary American artists. Her gallery was in a converted stable at 924 7th Avenue until she moved it uptown to 33 East 74th Street. The famous Stable Annuals took place in her gallery. They were organized by artists, an indication of the collaborative and supportive efforts of the 1950's.

[41]Painters Joan Mitchell (1926–1992) and Alex Katz (b.1927); sculptors Richard Stankiewicz (1922–1983) and Isamu Noguchi (1904–1988).

[42]The painter Robert A. Birmelin (b.1933).

[43]Schueler had a one-man exhibition at the Hirschl & Adler Galleries, 21 E 67th Street, New York, earlier that year. The brochure contained a reproduction of *Winter Sunday*, 1958 (80" x 71") and a reprint of the article Alastair Reid wrote on Schueler for *New York School: Some Younger Painters*, edited by B.H. Friedman (New York: Grove Press, 1959).

she has superb taste, and would probably find something good. Well—I'll think. She's coming out to the barn to visit me Oct. 29. . . .

<div align="center">

NEW YORK, 7 OCTOBER 1960
LETTER TO SANDRA PAILET

</div>

. . . Incidentally, unless I'm able to sleep on the plane [to New Orleans], I may be rather exhausted when I arrive—as I'll be teaching all morning, then drive down to New York, grab bags, cab to air terminal, bus to airport, etc.— all of which would mean nothing to me normally, but I still get the hep. weariness to some extent—though not nearly as before. So let's not go dancing the first night. I'm glad you decided against seeing the family. Anytime you might ever want me to, I certainly shall—but if you don't feel the need of it, I'd rather spend time and emotion on you. . . .

<div align="center">

NEW YORK, 12 OCTOBER 1960
LETTER TO SANDRA PAILET

</div>

Dear old Sandra—

Outside of the fact that I'm wheezing, coughing, spitting, dripping, blowing my nose, pressing my throbbing sinuses, peering through bleary eyes, etc., I feel fine. It shouldn't take more than a couple of weeks to recover. I'm glad that the Columns is comfortable, as I plan to spend my entire visit in bed. I'm bringing along aspirin, anti-histamine, one-a-day cold tablets, vitamins, orange juice, Kleenex, nose drops, and Smith Bros. cough drops, just in case these items aren't sold in New Orleans. Also flannel chest warmer . . .[44]

<div align="center">

NEW YORK, 23 OCTOBER 1960
LETTER TO SANDRA PAILET

</div>

. . . It seems very odd to be sitting down to the typewriter again. And it seems that I've been away from you for ages—rather than just a few days. The plane was a little late Wednesday night—and Thursday morning I dashed off to New Haven. Chaet . . . said he's been getting more and more reports of my success with the students, and he says that it's phenomenal. He also says that if he possibly can, he's going to keep me on next year. Which would be a temptation—but I don't want to think about it now. . . . Last night with the Marca-Rellis in their new place. It is beautiful. And very expensive. He's already complaining of the cost, because he doesn't want to be tied to it. He

[44]The visit to New Orleans did take place. It was not thought appropriate for Schueler to meet Sandra's parents.

likes to be away—in Europe or East Hampton—for about five months of the year. But he's done a wonderful job—made tables, cabinets, etc., which fit into the place beautifully. . . .

NEW YORK, 24 OCTOBER 1960
LETTER TO SANDRA PAILET

My darling wench:

I received your lovely first letter this morning—and I wish that I could do justice in answering it right now, because you were very, very serious, and wanted some serious answers. This is noon, and I'm in the midst of packing and rolling canvases, have to store a lot of stuff at the warehouse, doctor's appointment at 3:00, etc., etc.—and I won't be able to write anything but notes for the next four of five days. But I'd like to sit and talk to you right now. Big Main Answer: I love you. I have no doubt at all that if we were in the same city we'd always be together and would gradually find solutions to our problems, or the problems would disappear. Apart, we both have problems to which we have to find answers—and I don't know where they are. Basically—I have a way of life which is oriented toward painting, and I don't know whether or not you could follow me and help me. And you have a way of life which, among other things, is oriented toward your children, and you don't know whether I could do for you and them what you want done, nor whether I could help you. The fact is, we don't know the answers, and all we can do is to live and find out. No matter what happens, I love you. At best, there is a great tenderness which flows between us. . . .

GUILDFORD, CONNECTICUT, 7 NOVEMBER 1960

. . . I am alone in a house that I have rented in Guilford, Connecticut.[45] The house is mine until the end of June 1961. By that time, I hope to have told the Mallaig story. I have tried to write it many times, but this is the first time that I have unwound sufficiently from the Mallaig experience itself to carry on a sustained piece of writing. And to look at the experience with any objectivity at all. Of course, both the sustained writing and the objectivity remain to be seen. Something will be lost, just because I am out of it now, but I'm hoping that something will also be gained.

[45]Sandra Pailet visits Schueler in Connecticut and New York in November of 1960. They went on a whirl of visits to friends and to openings but both evidently realized that the intensity of the affair was over. Pailet left New Orleans with her children in the fall of 1961 to begin her M.F.A. at Yale (where Schueler was still teaching). As good friends, they saw each other in New Haven, and on and off during the succeeding years.

I was pretty listless yesterday. By evening I had an unbearable headache. The country was lonely and dark and silent. Not a sound in the still night. It was a beautiful night, I know, but my loneliness was so oppressive that I couldn't see it. I slept for a while and then I finished reading Thomas Mann's *Death in Venice*, in which he told more about the artist in 150 pages than I shall be able to tell in twice that. But he wrote about an artist who was successful, fulfilled. I am an artist, and by design or chance my entire life became focused on Mallaig. I lived and worked in Mallaig Vaig, in a house there lonelier than this at first, under a Scottish sky, northern, which was my reason for being there and which illuminated my work and which has been in my mind and work each day since.

For a moment I am at peace. Most of the leaves are off the trees, and the sun pours through the woods, glancing off the leaves of the underbrush, shimmering like dancing waves. Hundreds of birds are around today and I put some crumbs out for them on the little feeding platform on the tree outside the living room window. I don't know that I have ever fed birds before in my life.

GUILFORD, 8 NOVEMBER 1960

I'm settling into the place. Yesterday was happier. I painted for the first time, and not badly. Worked most of the afternoon on a big, vertical sky painting I had started in New York. It's a red painting, glowing with a gentle mistiness to bely its color. An ominous gray moves down from the upper-right hand corner, barely penetrating this reddish world caught between serenity and passion.

I have spoken to no one for three days and am getting used to my own company. Tom is getting used to it, too. He's lying in the sun now, on the living room floor. He's beginning to act more like a dog and less like a martyr. And I'm beginning to accept the house. It is going to hold me for eight months. I'm going to work here, and now I almost welcome the solitude. I'm beginning to have the same feeling of adventure that I felt in Scotland. But what a difference in my physical surroundings! Here—a large house, fifteen-foot windows opening on to a gentle, tangled woods, which I can see from my typewriter. Forced-air heat that I can regulate easily for my comfort. Milk is delivered at my door. My car is parked on the property, and it's an easy drive to Guilford for convenient shopping. The sky is placid and blue. Though the temperature is in the twenties, I took a walk this morning without my coat and felt very comfortable.

In Mallaig, the sky may have been placid and blue, but never for long. Clouds, rain, storm, movement through the sky, never stopping, ever changing. The weather was always there, inside and out, pounding and buffeting. Cold and wind and rain and the deep chill. And the massive motion of the autumn sky.

<div align="right">

GUILFORD, 13 FEBRUARY 1961
LETTER TO BEN HELLER

</div>

Dear Ben:

I've been hoping to get into New York long enough to see you and per-
haps have lunch—but it looks as though it will be next month at the earliest
before I have a chance.

I was wondering if you had made any decision about the paintings. And if
not, whether you could lend me some money—perhaps using the paintings as
security. I need about a thousand dollars, or any part thereof down to twelve
cents, as I'm sinking fast and could easily go under within the next week.
You may have heard that I've gone with Eleanor Ward, should have a show
at the Stable next fall—and perhaps the gods who guard lucre will look upon
me with favor this time. Doing business with Hirschl and Adler was tanta-
mount to committing oneself to an undertaker. . . .

One of the things I was hoping to talk to you about when I had a chance
for some kind of intimate conversation, was to explain something about
the picture *Counterpoint** and in as much as I haven't had the chance, I'll
do so now. When you came down to my studio about a year and a half ago
to pick out some paintings to send to the Weismans[46] in California, I was
dead broke and had been for some time. I was reduced to bumming meals—
that kind of broke. Yet, it gave me a real pain to think of sending *Counter-
point* out to California to some people I didn't know at the time. A friend
of mine[47], who was there that afternoon, loved the picture, and when she
learned that I didn't want to send it out to California, she wanted to buy
it. I said no, but that I'd lend it to her. In the ensuing month or two, she
kept asking to buy it, and I kept refusing. However, the day that you called
and told me that the Weismans were going to wait until April before they
made up their minds, I was forced to sell it, which I did for $750. Later in
the spring, when you said that you were interested in buying the picture, I
asked her if she'd be willing to sell it, and she said no. I tell you all of this
mainly for this reason: Had I thought you were interested in the picture for
yourself, I would have saved it for you. I have felt your loyalty in the past,
particularly when you responded so quickly to my cry of need in Paris and
lined up some introductions for me, and would be only too glad to find a

*See color illustration 1

[46]Before his death in 1995, Mr. Weisman was to gift the major part of his collection
to Pepperdine University, Malibu, California, to be housed in the custom-built Fred-
erick R. Weisman Museum of Art. He also contributed significantly to the Frederick
R. Weisman Art Museum, University of Minnesota, Minneapolis, which, designed by
Frank Gehry, opened in 1993.

[47]Rosemary Franck, who later donated *Counterpoint*, 1953 (48" x 50"), to the Detroit
Institute of Arts.

favor to do in return. Incidentally—for various reasons which I shall tell you when I see you, I wish that you'd keep this *Counterpoint* story secret.

I hope all is well with you and Judy and the kids. I haven't heard any news of you as I've been quite isolated.

My best,

Jon

NEW YORK, 14 FEBRUARY 1961
LETTER FROM BEN HELLER

Dear Jon:

I know not where you are but I do want to advise you that I lent a painting for you to a museum show in Baltimore. These paintings were selected by me as part of a group show selected by collectors. The paintings are put on sale. I selected *Passion and Blue*[48] and put it on sale for $900.

Also, I want to arrange to purchase *Burning*[49] at some point. I would also like to discuss what it costs, if I know where you are, how you are, if you are over your illness completely and how life is treating you.

Sincerely,

Ben

NEW YORK, 16 FEBRUARY 1961
LETTER TO BEN HELLER

Dear Jon:

What a strange coincidence! I came home last night to see a letter from you and wondered how you could have replied to my note so quickly. You will probably be answering my letter while I am answering yours.

I am frantically busy today and am taking time enough only to send you a check for $500.00 to help out immediately for whatever your problem is. I will mark on the check part or full payment for Burning and/or other paintings. Then, you will let me know about the price for *Burning*, and for the big Scottish Mallaig winter scene.[50] If we can put together a package for around $1,000.00 of newer and/or older works, I will certainly try to do so. Forgive me for rushing and running. By the sound of your letter, you are feeling better. Will be speaking to you shortly.

Sincerely,

Ben

[48] 1958 (72" x 60").
[49] 1959 (71" x 79"). See color illustration 7.
[50] *Winter Sunday*, 1958 (80" x 71").

GUILFORD, 19 FEBRUARY 1961
LETTER TO BEN HELLER

Dear Ben:

I now definitely believe in extrasensory perception. Who talked first? Your letter, of course, first went to my studio in New York, so I didn't receive it until last night. Your second letter with the check (I'm your friend for life—what would you like me to do?) arrived this morning. The check solves the problem—which was that I had thirty-five cents in my pocket, nothing in the bank, and as I was driving home last night I was thinking, "What do I do next?" Now, what I do next is to pay up a bunch of bills, buy some materials, and continue to cater to an appetite stimulated by the country air.

Otherwise, everything has been going very well this year. The hepatitis after-effects are gradually disappearing. . . . It was a godsend hearing about this house in the country—with studio—guy who built it went to Europe until next summer. The country life has helped my recovery, and given me some needed contemplation for painting. I'm also enjoying teaching at Yale—where I'm visiting artist, criticizing advanced painting. I like to talk, and this way I get paid for it—except not enough to live on, so I've been on a financial treadmill going backwards. . . . (I think Eleanor may be having a group show soon, with a couple of my paintings. Have you seen her new gallery?)

I have to leave in a few minutes for an engagement—so I'll write in greater detail later. A few notes: Thanks for putting *Passion and Blue* in the show. I think Eleanor has a painting about that size priced at $1500, but if she doesn't hear about this, and I could sell it for $900 I'd be delighted to get the money. Prices on *Burning* and *Winter Sunday* (I always feel as though I'm standing on the edge of a cliff when I talk about money)—would you feel that a fair price would be 50 percent off the prices asked in the last Hirschl & Adler show—inasmuch as those prices were far below what other artists have been getting? I'll have to look them up—amidst a pile of papers in a box here, but I think the list was around $2,000 each.

Your quick, incisive responses never cease to amaze me. Thanks again. And I'm delighted that your perception machinery is so well tuned . . .

NEW YORK, 3 MARCH 1961
LETTER FROM BEN HELLER

Dear Jon:

I don't want to be in a position of taking advantage of you, but I do think it is fair to try to correlate price in some manner with the market. I just bought a Ray Parker. It is about the size of *Burning* and the list price is $1500.00. As you know, Ray is showing with Kootz, has had successful

exhibits there and has shows in Paris and Los Angeles. So, I think it is fair to say that's a reasonable guide as to prices.

Might I suggest then that we take one-half of $1500.00 rather than $2,000.00 and arrive at a price of $750.00 for *Burning*.

I, too, am embarrassed by discussion of prices, so rather than put anything else in this letter, I will leave it brief and to that point. Then, when you answer me and we are done with money, we can talk about other things more comfortably once again.

Sincerely,

Ben

GUILFORD, 6 MARCH 1961
LETTER TO BEN HELLER

Dear Ben:

I'm glad to know that you, too, are embarrassed to talk about money. I thought the affliction was confined to artists and poets. And I'm happy that you wouldn't want to be in a position of taking advantage of me—a situation which would make me also decidedly uncomfortable. As a matter of fact, because my back is to the wall at the moment, and also because I'm up to my ears in painting right now, I'd rather put off business discussions until a more convenient time. Fortunately, Yale gave me a substantial increase in salary this semester, so I should be on my feet soon.

Undoubtedly, the mutual embarrassment is caused by trying to mix business with the sentiments and obligations of friendship—which, for all I know, may be the main reason artists have dealers. I would suggest that we can easily get off the hook by each withdrawing his offer, both of which were made in an atmosphere muddled by sentiment, and start all over again on a purely business basis as soon as is mutually convenient, so that we can each take into account no other factors than those of the marketplace. In that way the more pleasurable part of our relationship can remain intact no matter how the negotiations end. Does this sound sensible to you?

Sincerely,

Jon

P.S. I'm delighted to hear that Ray is doing so well. If you see him, please give him my best.

NEW YORK, 7 MARCH 1961
LETTER FROM BEN HELLER

Dear Jon:

Thank you for your very nice note of March 6.

I full well appreciate what you are saying and trying to say. I don't think I was that far off on the business elements on what I was saying. If I buy a painting that lists at $1500.00 for $1260.00, for example, the artist gets $840.00

after the dealer's commission. Therefore, in business terms, buying a $1,500 painting for $1,000 directly means that the buyer is getting an advantage and the painter is giving up nothing which, obviously, he doesn't necessarily have to do.

I mean the above paragraph by way of clarification and not pressure. I will be happy to leave this ride until you want to discuss it further.

In the meanwhile, I am glad that your next semester plans are full of bigger salaries and more painting. The only further question is "Is there a sexual increase as well?"

Sincerely yours,

Ben

GUILFORD, 8 MARCH 1961
LETTER TO BEN HELLER

Dear Ben:

Fortunately, yesterday I had one of my hepatitis days, so rather than my back being to the wall, it was to the bed. This gave me that necessary time away from painting to contemplate all possible aspects of the marketplace which I might feel pertain to the pricing of *Burning* and *Winter Sunday*. I arrive at the figure of $1,500 as the net amount I would want for each of those paintings, to willingly part with them. By coincidence, this is the precise figure I had had in mind before I had let feelings obscure my judgement. It is also the precise figure at which I should be happy to receive the money, and below which I should feel I was selling out my two daughters, who will receive my paintings upon my death. Should I allow the paintings to be put on the market by the Stable Gallery, it will be with a corresponding mark-up to take care of the commission. I am extending you the same courtesy I have extended as a favor to other close friends. A dear friend of mine, with a keen understanding of human nature, once advised me to never make friendly gestures in terms of my paintings, as they would not be understood as such. I go against his advice at times reluctantly, only to this extent, and only in few instances receiving a corresponding appreciation.

I assume now that you will want to make your market analysis, and if the figure you arrive at equals my own, we have a sale. If not, I am still the proud and happy owner—and, as you say, "we can talk about other things more comfortably once again."

Sincerely,

Jon

GUILFORD, 12 MARCH 1961
LETTER TO BEN HELLER

Dear Ben:

Thanks a lot for your very informative note of March 7. I think we are doing a service for mankind, even if no paintings change hands. It has long been obvious that every time a painting was sold, both the buyer and the artist felt as though they had somehow been taken, on the one hand, or sold out on the other. I am beginning to see why. We live in different worlds; we have different fantasies, different logic. Your truths are absolute and beautiful to you, and mine are absolute and beautiful to me.

I'm completely taken by your logic by which my painting becomes marketable at almost a mandatory $750. In fact, I can get so enthusiastic that I find ways to extend it further—except that I might find myself in the position of having to pay you to take the painting while I threw in my sickly green 1953 Pontiac, as well.

Just for the sake of history—let me show you, in all seriousness and on business terms, how the artist's mind works. In the first place, he tries to figure out how much the painting is worth in money terms. This becomes very hard to translate. Let us say that a painting like *Burning* represents a month's work. (This is for the sake of argument—it represents much more.) I certainly feel, of course, that it is worth at least double that of—say—a young business executive. I don't know how much you make, for example—but I do know that after a month's hard work in which you have utilized laborers, clerks, secretaries, salesmen, factories, offices, billing machines etc., you end up with some pieces of cloth which will grace the forms of lovely ladies (and for this I am thankful) for but a short time before they are reduced to dust cloths, rag paper, children's costumes—even paint rags—and will finally disappear. On the other hand, *Burning*, with proper care, should last at least a thousand years, and will most certainly increase in money value, in contrast to the penny value your lovely fabrics will have within a comparatively short time.

Perhaps I should compare myself with an executive more my own age—say MacNamara before he left Ford. His product lasts longer than yours—but, let's face it, it's pretty sorry after ten years. Now, he made around $480,000, what with stock bonuses, extra services, expense accounts, and one thing and another. I think that would be a conservative estimate. So for a month's work he got $40,000. I certainly think I should get at least twice that—or $80,000. But immediately I suspect that I'm selling myself short. You and MacNamara at least produce something. But let me compare myself with an entertainer—keeping in mind our scale of true values—and I'm sure that you would agree that it would be an insult to both your dignity and mine, to both your intelligence and mine, if I didn't make at least twice as much for a month's work as, let us say, such an unsavory presence as Elvis Presley. That means that I should net around $200,000—which would make *Burning* list at $300,000.

My asking price, then, in my own mind would be $300,000. (More about "net" and "list" later.) Henceforth in the discussion you have to understand (and I'm speaking very seriously—not as pressure, but as clarification) that any lowering of price from that figure becomes, in my eyes, either compromise with or gift to the buyer—depending on how he is reacting to my gesture.

Now, being a realist (an attitude which springs from the belly) and having a sharp instinct for survival (because there are more paintings for me to make), I am well aware that I shall have to compromise. We have lost God. Or, more hopefully, we have not found Him. Our country's scale of values is such that the transitory material or the degenerative esthetic is grabbed at, slobbered over and rewarded—while the works of the visionary, without whom the country and man will perish, go largely or pitifully unrewarded. To the extent that the vision has meaning, the artist has given unmercifully of himself. He would gladly stop there. But he finds, quite realistically, that there are no businessmen to do business for him, and unless he uses a certain amount of his precious time, energy, and emotion pondering percentages, pennies and profits, he will most certainly die and prove useless to his ordained task of giving unmercifully of himself.

So the first step in my compromise is a major one: I shall look at what you and other collectors pay for other paintings. Van Gogh paintings have sold for at least $250,000. In his lifetime (living according to the practical realism of his collectors rather than the practical realism which should encompass the artist), he made a total of $80. I have yet to meet an artist who doesn't think that van Gogh should have had the two hundred grand, and not the profiteers in between. They have done nothing, he did everything. Or, shall I compare myself with Pollock—a more recent victim of man's distorted money values. Would one large major work of his sell now for $100,000? More? I remember and you remember and everybody remembers a very few years ago when peanuts were being generously thrown to him—a kind of teaser to keep the worry mechanism going. I have yet to meet an artist who doesn't think that Jackson should have had the $100,000. Or more.

But perhaps I should compromise further, and compare my sale with the petty sums being made by contemporary artists. (You see, I am arguing for you, rather than against you.) I understand (and rightly or wrongly: for the sake of argument, it makes no difference) that you recently purchased a few of Barney Newman's paintings.[51] I like Barney and I like his work—for precisely what it is—and I feel that it should be purchased. He probably got too low a price—and I know the prices he was asking in his last show. I also know that on the scale of values on which I am accustomed to think that his work is a kind of "gesture" painting—a flexing of the muscles which had its meaning historically and thus should be honored. Double the sum

[51]Newman was known for his "stripe" paintings, large fields of pure color segmented by the occasional vertical line.

for *Burning.* If you don't know that there is more of both painting and moral value in that work, then you shouldn't own it.

On the other hand (and I compromise again), I have to consider that Barney is of another generation, and I feel that a certain respect for age should be shown in this business. (An Eastern, and therefore foreign concept.) Perhaps we should consider Jasper Johns. A nice lad, and I'm all for him. Perhaps I should compare my prices to his—with suitable modifications for a number of factors, which I shall point out. After all, we were both of the same gallery. Johns is fifteen or so years younger than I, so I should make adjustments accordingly. Those who have purchased his work have proved themselves willing to foster a symbol of decadence. Paintings are moral statements. They mirror and make mankind. The green-tinted plaster genitals, and their targets are meant to underline and contribute to the degeneracy of an already sick society. Curiously, the final, bitter, Dada joke is the purchase of objects resulting from this distorted, amusing, talented, anti-moral activity.

Shall I charge less for good than one charges for evil? Less for light than for darkness? It cost me practically nothing to embrace hepatitis—a strong force, indeed, and I pay it great respect. It cost me anguish and insolvency to get rid of it and to rediscover my health, but anything was worth the price. Perhaps, as a service to man, you could buy a large Johns, the nearest available to the size of *Burning.* Purchase *Burning* at double the price of the Johns (I'm making certain assumptions about your moral integrity) and hang the two paintings side by side. An interesting battle would be fought out on that wall. Time the referee. The issue: Man. Do you make commitments?

You would be a man of unusual stature if you would accept the above challenge—as to purchase and as to price. But, having an insatiable appetite for food and Winsor Newton paints, and having two children who have their own demands, I have to assume the possibility that you won't—and therefore have another price in the offing. That slip of paper hidden in my sleeve, ready to be pulled out and presented at the last minute when all negotiations have failed—when the last bargaining has been done and the customer is leaving the room. On that slip is written (I shall let you in on a secret), $1,500. And in a few words I shall tell you how I arrive at that figure. *Burning* is a favorite painting of mine. When I consider the absolute end of the compromise, humiliation, and mockery that I would go through to part with it in exchange for a few moments more freedom to work, I arrive at the ridiculously low figure of $2,250.00. (I blush to mention it, but I must hide my chagrin in an effort to be practical.) The one-third off, is a gift to you, given out of sentiment, because you are my friend. (I do this even though I promised both you and myself not to mix business and friendship). . . .

So, briefly, I have given you at least a partial picture of the artist's logic on pricing a painting. It is just as real as yours. It is not, unfortunately, the same. I read your clarification with relief—and I hope you do the same with mine. Without knowing the inner working of each other's minds, you might think you were being "taken" and I might think I was being "beaten down"—when

in point of fact both of us are acting in terms of integrity and precision.

And on a more personal level—remember, as a friend, I love you. I admire you as a businessman. I get a kick out of your power and the way you manipulate it. And I like to feel that you're on my side out there in that strange world of presenting paintings where, one way or the other, they will have to reach men's minds and emotions. I'm willing to keep all that separate from whether or not you buy a painting, and I hope you are, too. The paintings are terribly important. I know you believe in them. The sale of them is relatively unimportant. The only times I've allowed myself to be eaten by bitterness were those relatively few moments I was not certain I could survive. This is not the case now. So we can feel free and easy and unabashed as we probe the working of "the market."

My best,

Jon

Sexual increase? Well, there are sweet young things about, and I'm searching. A bachelor's life is not for me.

<div align="right">

NEW YORK, 16 MARCH 1961
LETTER FROM BEN HELLER

</div>

Dear Jon:

I have just finished rereading your long and beautiful letter of March 12 and I said to my secretary, "It's about time we answered it," and she said, "Oh no!" But actually, I think both she and I are coming to enjoy these letters for they, as we both realize, have risen somewhat above the question of buying or selling a particular painting.

I think you must know that I am reasonably familiar with an artist's point of view and I think you must know that you are much more businesslike in many respects than most artists. Each time we do discuss the price of a painting, it is inevitably one of your favorite paintings and so the discussion is all the more crucial. Fortunately for me (if perhaps unfortunately financially), I usually get involved in favorite paintings. My position is such that I always understand and deeply sympathize with the creator's point of view. I feel in my own private heart of hearts that I usually end up paying more than the next fellow who has just come in and wants to buy at a certain price and bargains and if he doesn't get his price walks away from it. I don't find it easy to walk away from that which I love and need.

I think you do recognize that as soon as you begin to equate a painting with money, you are already in the Lewis Carroll area of logic; also, if you figure the time spent in making a painting, you are in some fallacious territory. In the first place, if an artist is fortunate enough to be able to do the same-size work in a day and another man in a month, should the more rapid worker get less than the slower? Or is it the day or month it took to make the paintings, or that many years the man has lived; or regardless of

all of these facts, isn't the real criteria the intensity of emotion, the conviction behind it and the ability to communicate it, which is the major element in establishing the price of a painting?

As I see it, painting prices are like anything else that is sold—very close to elementary supply-and-demand circumstances. This is all the more so when the creator is close in time to the work and usually less well off financially. The odd thing is that a de Kooning can well afford to make 10% less on a painting but is strong enough not to have to yield. You or those much younger and with less reputation are not in the position to financially give a penny, and yet circumstances make yours a lesser market position. Once paintings get beyond this first level, they move into a second level that deals to a great degree with insurance. By this I mean, if you pay $50,000 for a painting, a large part of the price is the guarantee that the painting is worth $50,000 to other people. At this level, elements of chic and fashion are quite often more important than the long term elements of quality, and while van Gogh got nothing during his life time and is worth a fortune now, I can think of many painters with whom the reverse is true whether it be Bougereau (spelling?), Gainsborough, or Ivan Albright.

In truth, high price is a very mysterious thing for why should anyone pay so much money for any work of art and yet, after all, what is worth more? As the Pollock prices have gone up and up, I was greatly disturbed for a certain period. At first, I considered what I bought was spent money, my own private passion, love and so on. At some point, all of a sudden, the paintings became worth so much they became real money, and I knew if I sold *Blue Poles*, I could create an annuity that would make certain that, regardless of what happened, my family would always have enough money to live on. It began to look like dollar bills on the wall. At these levels, my judgment and how good the painting really is is no longer my criteria. It has gone beyond me to the fads of critics, collectors, museums, and all kinds of little people.

Obviously, I understand what you are talking about; but I don't think you are being fair to younger or older executives, in that our product is not really so much cloth or a "Ford"—and let me interrupt here to say that I am last to feel philosophically identified with my work when it comes to a product. I enjoy work for its activity, for its patterns of change, for the chance to dream up an idea and bring it through to reality, but the essential product of an executive's time is, as I see it, food, clothing and shelter for hundreds of people—indeed, thousands of people—for whom he helps create work and wages. The better the executive, usually the more jobs he will create; the better an executive the better the working environment will be for the people who spend one-half of their working hours there; the better the executive, the more meaning he gives to his workers in their daily work and the opportunities in their after-hours to find meanings to their own lives. A lot of this is, of course, a tall order and many executives do not think about it. But do not think that work of this nature is not creative;

it is, of a different kind. It is not the lasting kind but, on the other hand, it helps bring babies into the world and I guess that is as lasting as anything.

It is right and necessary for you not only to compare your work to contemporary paintings but to feel good about it, and somewhere in there you do have to rustle up a yard stick for price, I agree. I don't know that I can agree that Jasper is an antimoral painter or that the original Dada or the so-called neo-Dadaists were and are antimoral, but I am going to accept your challenge.

Our paintings of the first wave, first plateau or first generation—call them what you wish—are going out on tour for a year and a half[52]. One of the reasons for this is because I think it is necessary for the rest of the country to see the real McCoy and not only ship our stuff to Europe. Another reason is that I would like to get out of all phone calls and visits of people who continuously come in from all over the world and want to see the stuff. Another reason is that I am jammed up on space, cannot bring in new things, and want to hang them up and compare them to see how I really feel.

Therefore, when they leave in May, I am going to take *Burning* home (my secretary just let out an anguished groan) to hang it up against the Johns, which he is lending me, and will have the challenge. Time will be the referee, as you put it, but, if you will, I will be one of the judges.

I would personally prefer to leave off financial discussions for a little spell as I consider it much less important than the letters we are writing, but if further crises arise SOSs can always be sent to this address.

Aren't you coming into the city soon and can't we get together for some talk if we have anything left to say?

My very best.

Sincerely,

Ben

GUILFORD, 30 MARCH 1961
LETTER TO BEN HELLER

Dear Ben:

My immediate reaction to your letter of March 16 was to shout "Bravo." Also, "Hurrah"—and whatever else one shouts in the silence of a room when one is immensely pleased. I had previously shown a copy of my March 12 letter to a friend, Bernard Chaet, who is head of the art department at Yale, and he had said, "Well, that's the last you'll ever hear from that guy." I had assured him that this was absolutely not the case. I knew that in my effort

[52]This traveling exhibition, *The Collection of Mr. and Mrs. Ben Heller*, organized by MoMA, N.Y., opened at the Art Institute of Chicago in Sept. 1961 and had its final showing in the Los Angeles County Museum in the fall of 1962.

to make a point, I had been a bit rough at times, but I was absolutely certain you were a man of stature, could understand what I was trying to say, and could come back at me if necessary. Faith is a wonderful thing all by itself, but it's a special pleasure to have it proved.

I'm going to try to make this short. I took advantage of spring vacation to go down to Washington for a few days last week to visit the National Gallery—my first trip there. I was overwhelmed. It was like making love for three days. I have been recovering ever since.

I have one small point to make, but before I do, I want to record a few more scattered thoughts on "price". In my March 12 letter, I was trying to use a kind of irony, pretending to think along business lines, to really suggest that price was a very arbitrary matter—particularly for someone in my position. I am delighted to have you think I'm so business-like. . . . I doubt that I really am. You merely see me at my best. That's because the idea of price is so impossible for me to consider that I just sort of pick a figure and then hang on to it with grim Milwaukee stubbornness. I can get just as fanciful going down to zero dollars as I was going up to $300,000. Imagine, for a moment, those days when I study my work and suddenly it looks like paint to me. Only paint. Nothing else. It's the most horrible feeling in the world. Because if it's no more than that (and there's always a chance that it is no more), then I've thrown a life away, abnegated responsibilities rather than assumed them, committed a crime against my children, and have been a fake and a charlatan, toward the rest of the world as well as toward myself. Ideals become lies, work becomes a kind of meaningless masturbation, the small heroics of a man's life (I mean those that are necessary to every man for decent, productive living) become grotesque posturing.

You mention children. When I walk into a home such as yours or any others where children are loved and properly cared for, and when I see my own children, I am always struck by the fact that here lies the point of life. The true creation. Inevitably, then, I have to feel this as an accusation.

Van Gogh, in a letter written shortly before he killed himself, questions the validity of the painting act—as he had understood it to be, as he had dreamed it to be, and as it had inspired him to keep going in the face of his terrible obstacles. He suggested that perhaps, after all, he had produced some pleasant decorations for a wall—and this was all painting could be. The emptiness of his life, at the moment he wrote this, must have been terrible beyond imagining.

So much for price. One other note—this about communication. Another bewildering area for the contemporary artist—at least for me. The need is intense, total, absolute. Again, I can scarcely believe in the act of what I am doing unless I can imagine and foresee the communication that will take place. Yet the painting, which has been formed as a result of the most intimate activity, and presumably holds in its structure the most intense feelings, the most personal visions—when it goes from the studio, this painting seems to land immediately, in this day and age, in the most commercial of

commercial enterprises. For the moment, the artist is blinded by the galleries, the museums, the success talk of artists (all of us acting vain, ambitious, with a braggadocio that would have been bad taste in the tire business), the curious needs of the collectors (if you will, for my point to be made). He started—somewhere, at some moment—with love. He ended with money. Or he didn't end with money—which is worse. He can no longer imagine the person whom the painting will reach. Where is that soul whose imagination will be fired, whose vision will be enriched, who will respond to a poetry wrenched from pain? The artist sees dealers haggling and manipulating, art historians playing their passionless games, intellectuals light-footedly pirouetting over one another's thin-iced minds, hoi polloi tittering in the museums, collectors—well, collecting! And other artists eternally picking everything to pieces. Who receives? When does the communication take place?

For some reason, as a result of this exchange of letters (and a few days after I received your last letter), the answer came to me very clearly—really for the first time in my life. They all receive—all those human souls, huckstering, or criticizing, or envying, or hoarding, or whatever human souls do. The intimate experiences of life take place in the drama of life, and the painting will have to take its place there, too. Curiously, every time I have seen a painting enshrined—which is different than being part of a shrine—I have been a bit offended.

My short letter is getting long. Let me say this: My main memory of the time you and Judy made your first visit to my studio was that I had finally met the "consumer," the person who lusted after painting, who involved himself with it, who devoured it, with a passion that I could equate with my own intensity in producing it. I have often mentioned this in conversations. I renew the memory now. I am glad that *Burning* is a favorite painting you have become involved with, and I hope that it is one that you love and need. Therefore, I would like it to be a gift to you and Judy and the children, with my love and affection, but also with my recognition of your part in this communication.

Rather incidentally, it will be one painting which you won't be overcharged for—and may it never become dollar bills on the wall. Also, incidentally, it gets us off the hook—for wouldn't you have been embarrassed to pay me less than $300,000 for it, and shouldn't I have been embarrassed to have accepted a penny less? And yet, who else should own *Burning*?

I want you to know that your offer in regard to an SOS is of inestimable value. The one thing that has always been the most difficult for me—as far as financing my career goes—is that there is no place for an artist to go to borrow money. I have always paid my debts—yet, when a crisis came, could not finance myself in any ordinary way. For the moment all is well; I shall pay back the $500 as soon as possible, which will include a delay while I organize myself sufficiently to get my children here for the summer.

I wish I were coming to the city soon. Next Tuesday, I'll be bringing some

paintings in to the gallery—on a trailer—but will probably have to turn right around and go back to Guilford. But I may get in again before the end of the month, and hope that we can get together for talk and a toast to your new acquisition.

By the way, what if it loses in the grand competition?

My best,

Jon

My sympathies to your long-suffering secretary. Is it Miss Lerner,[53] or someone I haven't spoken to as yet?

<div align="center">

NEW YORK, 31 MARCH 1961

LETTER FROM BEN HELLER

</div>

Dear Jon:

I am very deeply moved by your last letter. As I was reading along, I was struck by the beauty of your thoughts and the way they are expressed, and the need for me to keep communicating to you about the nature of the "struggle" and its meaning, which, while you well know it, does no harm to hear again. Then, in the last paragraph came the thunderbolt of your gift. At this point, I waver between being more moved by the gift or by the contents of the letter.

The gift is a most particularly generous act. In its generosity and in the appreciation of both our feelings, there is great beauty and purity; but the rest of the letter is—if anything—at the higher level which questions the meaning of what you do and its worth and appearance in this world of ours. Would it be ungracious, therefore, if I address myself more to these remarks than thank you for *Burning*; or is this my way of eluding the embarrassment of thanking— for I know not how to do so? I know what the painting means to you and I know that the "highest act" on my part is to accept it in the truest sense in which it was given and to bestow upon it the reverence and love that brought it into being. I think you are quite right when you say that "the intimate experiences of life take place in the drama of life." The world is raw and the miracle is that in that raw and brutal place we can somehow rise above it, or more truly, achieve what is there to be gained . . . its essential meaning which is not "above it" but "in it," in the life stream itself. I have seen so many times how people flock to museums on Sundays and how they stand there uncomprehending and somewhat aghast at what they see, laughing—even mocking—and yet they return again and again. They would be the last to admit it, but they need it. They need it at any time and in any life, but certainly as much, if not more, now than before. I think no one of us is satisfied with how he acts most

[53]Nathalie Lerner, who later chose a Schueler painting as her leaving gift from Ben Heller.

of the time in public. We wish we could have said something else at a crucial moment; we are sorry for having lost our temper or not having sensed underneath some facade a message which was trying to get through to us. In a way, we know that the only real "us" tends to be buried, to be touched upon only in moments of love and privacy. It is here that the artist fits. I am sure that each one I have known well feels that his truest expression of himself, his feelings and relationship to the world—and those that are the purest and most unsullied by the complexities and drives of living—appear on canvas or in print when he can reach into himself and pull out that body of raw substance which he is about.

To the degree, then, that he knows he plays, possibly, the same foolish games that the dealer, critic, and collector play, to the degree that we yell at our children or don't give them all the attention we wish to give them, he and we—all of us—are being human. The nicest part of being human is that we can drive through to our Shangri-las, and one of the gifts given to an artist is that he can, through his work, drive not only himself but the recipient to that special place.

With deepest thanks and friendship.

Sincerely,

Ben

<div align="center">

NEW YORK, 5 APRIL 1961

LETTER FROM BEN HELLER

</div>

Dear Jon:

In rereading your last letter and my response, I feel that whatever I said was still inadequate.

I want you to know that I thought quite some time about whether I could even accept the gift. I was both thrilled and disturbed by your gesture, but I finally came to the conclusion that anything but accepting *Burning* would be a mistake.

I want you to know that when I showed your entire correspondence to Judy, she was most touched; and as "I fed" it to her one at a time, she was hit by the same thunderbolt when she read of your gift. Truly, the drama of the letters unfolds gradually and it all has a tremendous impact when reread.

I wonder, also, if I spoke to you sufficiently with reference to the whole meaning of painting. I showed the letters to Judy out at her folks' house the night before last, which was her birthday. Subsequently, we got into a discussion with my father-in-law about the whole meaning of life and the meaning of the work we do within that life and the connection of the work to life.

He spoke of how he felt ten years ago when he was recuperating from a nearly fatal heart attack, how meaningless he felt his work had been, how little it had achieved for anything or anyone, that he had done no good and

left nothing behind him of any real value. In his personal life, he felt just the opposite, and he ended up with a feeling of some chagrin and disappointment at the difference between the two.

Perhaps in a way, it boils down to the fact that one can only closely reach a few people during a lifetime. We have few real friends of long standing, and if by conversation or by act of painting we can actually touch a few people, that is a wonderful thing. If through the permanence of the painting act, you can touch a few people in each successive generation, that is a particularly wonderful thing.

As to the validity of your own painting, I would like to talk more about this with you face-to-face some time, but temporarily my best answer is that I keep coming back for more.

Please let us get together soon and please accept my deepest thanks for *Burning*, for the correspondence relating to it, and for the sense of feeling that underlies this whole "affaire."

Sincerely,

Ben

GUILFORD, 12 APRIL 1961
LETTER TO BEN HELLER

... Note to your father-in-law: I feel as though I've failed totally in my personal life—which may be the more important of the two. In any case, I partake of the "chagrin and disappointment between the two."

I'm still dealing with dealers—but you'd be amazed at what a calm, gentle, unruffled man I've become. Perhaps Leo and the insanity of the Hirschl & Adler episode broke or matured my spirit—so that now I merely regard the incidents of my "remarriage" to Eleanor Ward with a kind of unruffled amazement—such as the other day when I took my new paintings in—I told her that I hoped some people would be seeing the work, and mentioned your name along with others. She looked at me with that sudden, cold fish-eyed stare Eleanor can assume so well, and said, "Jon, Ben Heller isn't interested in your paintings." I'll admit I became a bit red in the face, but believe it or not, I didn't say a word. The next night, Judi Noselson called me to report that she had gone into the Stable Gallery to see about getting paintings for the synagogue show she organizes each year. Eleanor listened to her entire story, fixed her with the above-mentioned stare—and said, "Why don't you write me a letter about it?" and dismissed the subject. Again—I resisted the temptation to phone dear dealer there and then. This is either a sign of maturity on my part or else of combat fatigue. Her main reaction to the fact that I brought in a dozen pictures was that they're too difficult to store. I'm thinking of opening a gallery of my own—in Mallaig. . . .

In 1961, Schueler taught once more at Yale University Summer School, Nor-
folk, Connecticut, where he worked on large pen-and-ink drawings. He also
met another Sandra: Sandra Levowitz (b. 1939), who was one of his paint-
ing students. For August, he rented an apartment/studio in East Hampton
on Long Island, New York, where Sandra joined him for a few weeks.

EAST HAMPTON, 22 AUGUST 1961
LETTER TO SANDRA LEVOWITZ *(not sent)*

My dearest:

It's the next morning after a sleepless night, and I want to let you know that
I have let go and have let go completely. . . . I feel that I should understand, but
I really don't—but I can't mistake the fact that you don't want me anymore, and
that you never expect to want me again. When you told me the first time—last
Tuesday night . . . I went around for days in an attitude of complete disbelief.
It reminds me of seeing a plane falling in combat. When it happened right in
front of your eyes, it was a total reality; there was no escaping the reality of the
crippled, falling plane, of friends trapped inside, of sensing somehow the ter-
ror, anguish, fear, death, finality—there it all was, right before you—and yet it was
a fiction. . . . You noted the time and place in your log, and couldn't believe it.
When you made the intelligence report back at the base, it seemed as though
you were posing, as though you were telling an untruth, or at least a fiction.
When the friends weren't at dinner, you expected them to come in. Then the
talk dribbled off, and you became silent and numb and non-thinking and not
believing or disbelieving anything, and you and the other guys went, one by one,
to the officers' club and ordered drinks, and stood around not saying too much,
scarcely noticing that you were drinking so much or that the colonel had or-
dered unlimited rations on whiskey that evening. And then the next thing, all of
you are talking a lot and laughing hysterically at crazy jokes, combat jokes, jokes
about death, and then you're loaded to the gills, and the next thing someone
starts singing, and you're standing around harmonizing, and the sound is sad:

Down in the valley
The valley so low
Hear that train blowing
Hear that train blow . . .

And the laughter goes out of you, you hear the voices of Goetz and Reber[54] and the other guys who used to harmonize with you, and you know that they are gone, that they are dead, that they are not with you, that they won't come back, and the only reason you don't cry is that you're putting all the tears into the song. And then you're singing hot songs and fast songs and happy songs and vulgar songs, and the next thing everyone is so drunk, they are falling all over the place, and finally you conk out after having kissed the executive of-ficer's WAF girlfriend, and that's the end of it. Until the next morning, and the day after, and the day after. And ten years after that. And now it's nearly nineteen years after. I can't believe it. I'm certainly too old for you. Today I feel too old for everyone in the whole goddamned world. . . .

And this morning I thought I was letting go—I was trying to be forty-four and mature and sensible and logical and facing reality and letting go of a woman who at a moment had been everything to me, who had given me love and adoration and affection from day to day with a warmth and intensi-ty such as I could only have imagined before, who had sensed the depths of my life, who had held my head to her breasts to take the suffering from me, who had touched me with fingers of unbelievable sensitivity and who had re-ceived my touch, who had made me laugh when I was angry, and who had cut through every crazy mood with a touch or a kiss so that at any moment I could be transformed from my little obsessions to the man who loved this woman, who in two days had made me feel loved and had made the gnawing loneli-ness of too many years fade into the dim memory of an intelligence report . . .

(The letter continues for several more pages.)

Goodby and I love you.

Jon

EAST HAMPTON, 29 AUGUST 1961

Right now, the letter which I wrote a week ago has become a strange doc-ument—as though it were about feelings which may have been mine, but which are only poetically related to feelings I have today. Right now San-dra is asleep in this house. She has been visiting for days. I have been hav-ing as much fun with a woman as I have ever had in my life—Sandra being quite impossible, very sexy, refusing to be practical in any degree, retiring from others on the beach, getting delightfully loaded at the parties, be-ing magnificent in bed, toying with the idea of marriage, of being a mis-tress, of never seeing me again, of going home to mother, of staying here, of finding me an apartment in town, of school, of quitting school, of what kind of man she needs. Like a jumpy poodle made into woman. The

[54]The pilots William Goetz and Ehle Reber.

house is a shambles; I have relaxed into imbecility, I eat irregularly—sandwiches of my own making—at any moment now I am likely to be interrupted and at a certain point will realize that the interruption was almost conscious. As though she can't really bear to have me work, as though her need to be onstage, center stage—with all my attention focused on her—never ceases. She shows off her breasts, her bitten fingernails, her bathing suit, her messes, her ability at finding me an apartment, her need to smoke continuously, her fantastic sexuality, her rejection. It's endless. All this to take the place of work and an ordered home life? So, for once in my life, having given up totally, as I did the day of the letter, I find myself relaxed, undemanding, watching, enjoying the moment such as I never have before. Perhaps out of this I'll find the freedom of mind to write this book, and to bring the confusion and profusion of word and idea which I feel is necessary to convey my idea.

Why the Mallaig story? Because I felt that in the work and adventure and effort and life of my seven months in Mallaig I found a moment of focus when all the contradictions and confusions of sky, image and life were brought into a powerful focus.

Why do I write in such apparent disorder? In the first place the disorder is only apparent, or only partially. In the second place I believe in the disorder. I don't know where to find truth except in the disorder. Unless I can weave my way through it, stating, questioning, looking, resolving, breaking apart, forming, destroying, deciding, undeciding, worrying, asserting, (this is the way I paint), I feel that I have lost contact and am creating an artifact. Or not creating.

Anyway, I am writing in August of 1961 and I am sitting in an apartment above a garage in a woods near the sea in East Hampton, and on the beach yesterday I said hello to June, who was the girl before the Mallaig story and who lived in my mind through the Mallaig story, and I talked for a half hour to Jody, who was the wife in the Mallaig story, and I went back and explained where I had been to Sandra, who is the girl with me now, who is making me feel more about woman, who fills and disorders my life, and who therefore is inevitably of the heat of the Mallaig story. Ben Heller lives next door, and he is important (his correspondence will appear), and Bob and Abby Friedman were at the beach.

It would seem, wouldn't it, that the Mallaig story is about women, or Woman? And my loneliness is because of woman, and my search is because of woman, and my failure exists in woman, and when I peer deep into the horizon of the sky and when the canvas forms and finds its heat and its mystery, it is the uncontrollable mystery of woman and of creation, of formlessness forming, of the un-understandable being felt, suspected, in part known—though never not being unknown. Mother died. Has there ever been a man whose mother has not died? Or whose father has not lived? Mine died—my mother, that is—when I was six months old. It's the total horror of everything becoming nothing, yet continuing to demand an existence.

It's warmth and no sustenance. It's the strange and painful gift of life and the condemnation to an endless search for life, but only through the search for the giver of life. As though the life that has been given doesn't exist because the giver is gone, as though it can be found only if the giver is found or absorbed or understood.

EAST HAMPTON, 5 SEPTEMBER 1961

Woman. Sandra. Frustrating, impossible Sandra, who has turned away from me so totally. She's out of touch with me, is not writing, is not telephoning. Is she thinking of me? I know that our relationship is nearly at an end.[55]

Back in New York at the end of the summer of 1961, Schueler decided that he must have more painting space. He therefore made his old studio space at 68 East 12th Street into an apartment and rented the top-floor loft in a commercial building on 19th Street as his studio. For his final year of teaching at Yale, he commuted from New York.

Between the last entry and the next one, he had been tragically involved with Judy Dearing (1940–95), a young African-American starting out in her career as a dancer and later costume designer in the theater. Their marriage on January 27, 1962, led to almost instant separation.

NEW YORK, 28 MARCH 1962

The Search is like a series of letters, like a series of lectures, like a diary, like morning thoughts, like waking up this morning at 6:30, somehow jolted awake too early, yet not feeling the absolute pain of tension that I have felt for the last many weeks. My mind for a moment was stilled. In the moment's calm, I started to think about Judy and how strongly I reacted to her delaying tactics and to her demands for money.

Judy leaving me (cold, two days after the wedding, walking out four weeks later).

[55]Before Sandra Levowitz met Schueler, she was involved with another man, who was also considerably older than she was. Feeling overwhelmed, she now retreated from both men. She and Schueler remained in touch in a friendly way. Early in 1963, Sandra meets Ivan Soll, whom she married in 1964. Schueler got on well with Ivan, and attended their wedding.

Give her some money. If all she wants is money, give her some money. Did I think that Judy's taking of the money would take something from me? Oh, yes, I did. I was afraid, and I felt the old terror as though something were going to be taken from me. There is nothing in the money. Fuck you, baby, take the money. You are young and all alone and you have nothing there and you are hurt, too. You are more deeply in the hurt that I am in the hurt because you are twenty-two. Twenty-two. Dear God, one hurts at twenty-two.

("Je t'aime, mon maître de ma vie," she said when we were married).

The Lawyer. The Law. Mr. Murphy is the law and Judy has arranged the whole thing so that I received a summons from the Domestic Relations Court to appear before Mr. Murphy and "give my side of the story". I loved Judy very much. If she had needed the money, I would have given it to her. But she preferred to get a lawyer and try to force me to give her money. Her shyster lawyer suggested that what she wanted was a thousand dollars but that they'd settle for $500 plus one $150 for him. Plus, of course, $1000 to get the Mexican divorce, plus $300 traveling expenses. So last year I finally got all my debts paid up, debts that had piled up while I was broke. 1959, 1960, broke as hell trying to hold the whole thing together, the disappointments, out of the Castelli Gallery, no painting sales, somehow getting along, and then the Yale job and paying back a couple of thousand dollars in debts, and then finally this year ahead enough so that I could plan the trip to Scotland, and I needed a woman so damned badly because I couldn't stand the thought of being alone there. So, sentimentally, I found Judy and the trip will go into the lawyer's pot. Dear, sweet, Judy. Lovely Judy. She's an artist, she says. She's very sensitive, is Judy. And do you know what? She really is.

Shall I describe Judy?

NEW YORK, 29 MARCH 1962
(The following two entries are placed here to continue the Judy Dearing story.)

Last October, Astrid[56] gave a party. She invited eighty people, and I went alone to see what I could see.

I see a girl talking in a small knot of people. She is laughing. She is a slim, buoyant Negro, black bouffant hair, almond eyes, medium-brown skin, eye makeup (no other), and a red blouse, toreador pants, pixie shoes. She moves and looks like a dancer. Long, slim hands. Lovely small figure. Her smile is unusual and I know that I have to meet her. Astrid introduces me and we dance and then we talk a bit. Who are you? I wanted to ask. Who are you and where are you going? At one point, she said, "I never want to hate anybody." She said it with great intensity. I wondered, What price do you pay? Poor baby, the hate within her, the slights, the white hate,

[56]Astrid and Dave Myers, friends since the 1950s.

Jon and Judy Dearing Schueler on the day of their wedding,
January 27, 1962

the man hate, the ugly, seething, sporadic hate rising and striking, ugliness
she couldn't comprehend and which she didn't want to see.

NEW YORK, 1 APRIL 1962

In Montgomery, Alabama, in 1941, in the uniform of an Air Force Cadet, I
stepped into a segregated bus. I put my change into the box, and I looked at

the white-shirted thug at the wheel, and the complacent whites in the front of the bus, and the passive Negroes in the back of the bus, and I didn't know where to go. I hated myself and I hated man, white and black, that could live in terms of an absolute immorality. They rode the bus each day, the whites by law degrading their brothers, degrading the human race, degrading themselves. I felt the slothful degradation in the warm, fetid air of the segregated bus. I sat in the front, feeling my whiteness with a horror for my skin that I have never felt before. Is the black feeling inferior to me because he sits in back? Do I feel superior because of my pale skin? Really, down deep where culture has formed me, do I?

Oh, Judy, you were so beautiful, not wanting to hate, wanting to cover all your hate. You must have been in the segregated bus. You must have hated me, and hating me you hated yourself. I, hating myself, did I hate you? Hate corroding and twisting and corrupting, so that when we finally reached out and touched each other with love, we killed.

Are you hurting right now? Are you wearing the wide jade wedding band on your dark finger?[57]

NEW YORK, 28 MARCH 1962

Will I watch the Search take form rather than decide its form? I shall form by watching the form.

My stepmother. Young, beautiful, clean, cool, white skin, black hair, beautiful face. Full breasts, soft. Driving in a car. I'm five years old and—is the car black? No, I think it is green, an old Franklin with a slanting hood. An unusually designed car for its day and for this. I'm five years old, or four, and my father has just remarried and it's my stepmother who takes me shopping in the car. She's cool and remote and beautiful, I'm wondering, sitting beside her. I don't know what I'm wondering about, but I'm wondering, and I'm looking at her, and then I'm looking down and wondering still. I'm looking down and sometime later, when I'm five and no longer four, I'm told that it's dirty, that there is dirt behind the foreskin, and that something about playing with it is dirty or the dirt is making me play with it, but I'm to go to the hospital to have my tonsils taken out. I'm in the hospital bed now, my throat is raw and painful and the sun is coming in the window. The room is bright with white, white light, white sheets, white spread, white bed, white clothing on me. I look down and the white bandage is red with blood, red, red encrusted, red bleeding, brown-red sticking to the wound, hard-encrusted like the cake inside one's nose after a filthy day in New York, red staining the white of the light and the bandage. I

[57]Judy's lawyer subsequently agreed to accept $600. Schueler flew to Mexico and obtained a divorce on April 25, 1962.

can't even remember the bandage coming off, the foreskin gone, the red encrusted scabs.

The red stain moving, growing, spreading across the sky, the red sky filling the canvas, the red reflection in the red water beneath the horizon. Death and the sky.

NEW YORK, 31 MARCH 1962

Last fall, I made my old studio into an apartment because I was so crowded for space that I was no longer able to paint there. And now the apartment: rather bare, white walls, two paintings on the walls, a double bed, some chairs left by neighbors, a wine-colored love seat and a maroon rug left by a tenant, some chests, more or less battered windows badly in need of washing, no curtains or drapes, but a couple of shades, one of which doesn't work, a large refrigerator which I found last fall secondhand (a separate freezer on top), a scarred round table loaned me by the Myers, the dusty components of a radio phonograph I purchased in 1949, a few records and books, about forty pipes, most of which I never smoke, old newspapers and magazines, the magazines periodically thrown out in the wire trash baskets on the corner of Twelfth Street and Fourth Avenue, the newspapers hoarded until I take them over to my studio on Nineteenth Street, where I use them to wipe my brushes clear of paint and turpentine. The apartment has two rooms and a bath. I vacuum the place once a week or so, and most things are put away. But underneath the apparent neatness there's quite a disorder. Books are not arranged. Papers, old photographs (those that haven't disappeared) are stuffed into boxes or envelopes and crammed on to the bookshelves. Clothes are quite neat—too many shirts, socks, underclothes. At the moment I have a lot of suits—for the first time in my life, really. One day last fall, I woke up so depressed at the loss of Sandra II, that I bit on a *Times* ad for Harry Rothman clothes, half-priced name brands, and bought four suits. (What the hell have I done? I asked myself an hour later, when it was too late to do anything about it.) Four goddamned half-price suits to add to the two secondhand suits and the secondhand Fenn-Feinstein jacket I'd purchased from Morris Widder in New Haven the year before, and the drab Sweet Orr corduroy suit, twenty dollars, from the Hudson Army-Navy store on Thirteenth and Third Avenue.

The apartment is a cell or shell. It's waiting for someone to make a home of it. At this moment, I doubt anyone ever will.

I am working on ten paintings right now at my studio. Or rather, I have been working on these paintings ever since last fall (some of them date well before that) and now they are coming to fruition. I can see it happen, and it's a rather exciting time—though fearful too, because any minute, any day I can lose the pictures. I finished one the other day, a large vertical, perhaps ninety inches high, in which the line is in the sky, red, tumbled surface, bringing me slowly back to Mallaig. All of the paintings are

fairly large*, the smallest of this group being about fifty by sixty, but most going upwards from sixty by seventy-two. They're up there now in the studio, some of them wet, some dry, waiting for me to work on them. I work from one to the other, changing sporadically—perhaps because one needs to dry before I can do what I want to with it, because while working on another I feel the tension closing in on me so that my imagination refuses to function within the picture, perhaps another because I cannot understand where it should go until I fight my way through other paintings. The one I finished Wednesday had been in an unfinished state—close to final stage—for months. Finally I understood it and understood what had to happen to it, and I finished in one day. It only raised more questions, though.

I have been painting since September in my new studio on the top floor of a twelve-story building on Nineteenth Street. I really don't like having my studio separate from my living quarters, but at the time there seemed nothing else to do. There are large windows clear across the front, facing north, overlooking a corner of Gramercy Park, and the steep buildings in the distance are like the other side of a valley. It's a good, open feeling, as city feelings go. At night it is eerie quiet and the lights glow in the opposite buildings, gradually disappearing as the night wears on. I like it up there, and I wish that I could stay. But I am not a city painter. Or am I? I'm in the city, so I'm a city painter. I'm painting the dream of nature, not nature itself.

NEW YORK, 3 APRIL 1962

I suspect that the artist separates himself from nature at his peril. The New York artists flock to the galleries Tuesday after Tuesday. I'm going to two or three openings tonight. There is no way out, and it's necessary to go in. Donati[58] is a friend. Yvonne[59] is a friend. I shall pay homage to my friends, even as they have paid homage unto me. And for a moment, saying small things to the many people crowded into the galleries, two hundred friends or more, I'll forget the loneliness and maybe the nagging pain of Judy will stop for those two hours.

NEW YORK, 5 APRIL 1962

The North. Last night de Kooning said that his ambition in life was to be a good painter. That he worked hard to make a good picture. That was all. He

*See color illustration 8 for a painting of this period.

[58]Enrico Donati (b.1909), whose paintings were being shown at the Staempfli Gallery.

[59]Yvonne Thomas (b. 1913), whom Schueler saw in Paris in 1958, and with whom he remained in touch. Predominantly an abstract artist, she was showing drawings at the Bleecker Gallery.

said he had no trouble working in those terms, and he was satisfied to have that as the extent of his goals. No big idealism, no searches, no mysticism, no power, no trying to be a great thinker, etc. Well, of course, he's succeeded, being one of the best and most successful living painters. I was impressed with the humility of the drive. Last night in bed, tension-tossed at three in the morning, I thought about Bill and I thought about my own drives—my mystiques, my talk of the North, my desire to have humanness and love in my work, my desire for "The Vision," my wanting to understand Nature, my wanting to touch God, or God and Nature, or God in Nature, my wanting the hand to be an expression of something more than the will. And I wondered if all of this was fantasy. It can sound pretentious, and the words can outshine the painting in importance. When Bill's humility seems profound to me, I wonder if the most plebeian goal doesn't best allow for the greatest spiritual transformation. Unburdened by any other conscious considerations than the considerations for a good picture, the artist is freer to work, and freer to express much that is more profound and far reaching than were he self-conscious in his yearnings. Perhaps he thinks best about woman (as Bill obviously thinks about woman) when not thinking consciously of woman. The answer for me is that the deep concern, the deep responsiveness and responsibility to an ideal, to God, to nature, to human emotion, to woman, to love, to man, must be there, consciously or unconsciously, or it can't make itself manifest. I can't help but think that Bill protests too much, and that even his conscious needs are greater. It's like the many statements denying competitiveness by painters which seem, in their very expression, to underline the need and force of competitiveness as a drive in the particular artist. Bill is certainly extremely competitive, and his modesty in this department always comes off as a shallow disguise. Pollock used to scream in drunken agony of his superiority to other artists. [Clyfford] Still labors through tortuous logic to prove his superiority to other artists. And so it goes.

The North.

I remember the memory of North. I remember summer vacation time in childhood, when the family would head North in the car for the big adventure. I remember the farms near Milwaukee, and then farther along, 150 miles or so, the ribbon of highway moving through the hills, the forestland, tall pines, shimmering lakes. I remember the fresh feeling of pine air, the brightness of sky and tree, and the deepening mystery as we drove North. I wanted to go very far North. When we would finally stop at a lake resort or at Fish Creek on Sturgeon Bay, I would suffer a disappointment, knowing that further on, perhaps only fifty or a hundred miles or so, would be the North I wanted to find, hard, cold light, true mystery, freedom, the Word. Everything would be large and wonderful and free in the North. Heaven and God would be there and adventure, and my heart would be able

to expand, my mind to float free. The prison of the family would break asunder, and I'd hike through the forests and move across the lakes and go further and further into a steel grey sky, toward the cool light of the horizon.

I was imprisoned in my childhood. (Am I still?)

The North.

<div align="right">NEW YORK, 8 APRIL 1962</div>

Bernie Chaet is a friend who shifts his ground from being a friend to being a company man—and right now is filling me with distrust, as I feel that he is edging me out of Yale under the guise of being my friend and helping me to get a job there. But I haven't as yet just said, Bernie, what the hell are you hiding? What is the straight dope? I finally had to stop seeing Still for that reason. His fantasy world was so great that I'd see through it constantly, and found that I had to agree to the fantasy or attack the fantasy.

Memories: As a small child I'm always looking, always silently looking. The words are a secret locked in me. I'm peering at the world trying to find out, trying to understand. In the meanwhile, I have to play their game. I have to be what they want me to be and I have to pretend that they are whom they want me to believe they are. If I don't do that, something terrible will happen. If the facade collapses—what will be behind it? Will it crush them or myself? Or, crushing them will I be left without anything? I don't know to this day.

More memories: Picking mint leaves in Grandmother Haase's garden on a sunny day. As a wedding present, my real mother's parents had given the bridal couple a house.[60] My mother designed the house. Next to it was a large garden, filling an ordinary sized building lot. And in back was a fence, with a gate linking Mother and Mother. I suspect a constant moving back and forth through the gate. I suspect now that my father was the enemy who was discussed. And then my mother died and Grandmother and Grandfather Haase moved into her house and it became their home.[61] My new mother took me to Grandma and Grandpa's house, where I was spoiled and loved, and where I followed Grandma Haase into the sunlit

[60]868 Hackett Avenue in Milwaukee, Wisconsin. It was linked with 867 Summit Avenue.

[61]After the death of Schueler's mother (Clara Haase Schueler), a nursemaid stayed on to look after him. She left without saying good-bye when he was about three. His uncle Fred and aunt Marie (Schueler) then took care of him until his father married Margaret Vogt in 1920 (when he was almost four).

Jon Schueler (left) c.1923, with his stepmother,
who holds his half-brother Robert (Bob), and his
father, at their house in Whitefish Bay,
a suburb of Milwaukee, Wisconsin.

garden and picked mint leaves, which we took into the kitchen to make mint tea. I felt very grown up drinking the mint tea. It was my ritual, my tea, my drink, to make me feel important, and I was loved and enjoyed the day. I remember kneeling in the garden path, picking the mint leaves, my grandmother, portly and kindly, looming over me, skirts to the ground. Profusion of flowers, blue sky, sunlight on the grass path, smell of fresh turned earth.

When did my black-haired stepmother quarrel with my grandmother and when did the visits cease? When I am nine or so, the big Reo stops as I am walking along Lake Drive on my way to Sunday School. Sunday after Sunday, the Reo stops, and I am driven to Sunday School by people I know and don't know at the same time. They are my grandparents, but I no longer know they are my grandparents. They talk of Mother, and I know that they are not talking of the woman I call Mother. Yet I don't know this and I

am filled with fear and curiosity. For at some point my stepmother had start-ed to pretend that she was my real mother, and I entered the lie. I had a guilty secret which no one knew, including myself. I forgot my real mother, or the memory that I had one, and I felt intensely curious about the mysterious game that was played by the elderly people in the big Reo on Sunday morn-ings. I asked my stepmother, "Who are those people who take me to Sun-day School in their car?" She said, "They are nasty people, and you shouldn't see them. You shouldn't ride in their car." I feel very small in the memory, and my face seems to me to be a face of innocence and candor. Not a flick-er of deceit to show my guilty secret. In a way, the lie was more truly hid-den in myself than in my stepmother. My grandparents acted as though they were my grandparents, driving me to Sunday School and talking to me of my dead mother. They acted as though I knew my mother was dead. But I didn't know this. My mother was at home, waiting to tell me that these people were strangers. My face was innocent, my eyes without guile, as I watched them. To this day I watch. I hide behind my open eyes and watch. It is only the sky that I believe in totally. When I look at the sky, I register the nuances of its mood, but I know that it holds meaning behind meaning behind meaning. I am not fooled by a cloud sky, yet I take it literally. The mist moves across the seas hiding the deep loch. And I accept the surface of the mist, and the depth of it, and suspect the endless loch behind it. I feel its mystery and its endless-ness, and I thrill to it. I am not afraid of it. I do not count the mist as decep-tion but only as reality which, in its hiding, reveals reality.

I must find my way back to Mallaig and to the Scottish sky and to the sea.

My mother died a second time when I demanded of myself forgetful-ness. And when she came alive again it was to bring bitterness and suspi-cion into my life. I was twelve years old. One night when I was in bed, I sud-denly wanted a drink of water. Instead of going into my bathroom to get it, I went out into the hall and headed down the stairs to the kitchen. The maid's room was off a landing, the door was slightly ajar, and the maid and the nursemaid were talking. I stopped to listen. Slowly, I realized that the nursemaid was saying that my father had been married before and that his first wife was my mother and that she had died when I was six months old. She told more, but I don't remember it. I remember creeping back to bed and lying awake with the new secret. From then on, I knew. I believed, but I still had to prove the truth. Every time I talked to my stepmother, every time she punished me, every time we had arguments, I looked for the proof or silently condemned her or put the truth to her subtly and watched for the lie. I'd say, You punish me but you are not my real mother and you have no right. I'd never say it aloud. I kept living the lie and hating her and yet needing her day after day, needing her just as desperately or more desper-ately than before. My life became tumultuous that year, and has never really

calmed down since. I remember going into the attic and poking through trunks and finding old love letters which my stepmother had saved. They told of my father courting her and they spoke of me, and they told of her family objecting to her marrying an older man with a child. Wherever I could find it, I would pick up an added bit of proof and file it away, evidence to support a case. It wasn't until I was in college that my stepmother finally said that she knew that I knew and had known for some time. She said that she had done it for my own good. She thought it would be easier for me if I didn't know about my mother's death. She took me up to the attic and opened a little box. There were a few pitiful possessions in it which had belonged to my mother—a ring or two and some photographs. I looked intently at the photographs, and it was like looking at myself. I can't describe this. On the one hand, I was looking at a very beautiful woman, young, with a lovely oval face, hair loosely piled on top of her head, a delicately sensual mouth. On the other hand, I was looking into my own eyes. As I looked at the sepia image, I felt the sadness in her, and an overwhelming sense of loss came over me, choking me. I started to cry. I couldn't stop, and sobbed. My stepmother, sitting there, looked away at first, then her face became more and more contorted, until she cried out, "What are you crying about? What did she ever do for you? I have done everything for you. I have worked for you and taken care of you and fed you and raised you. She did nothing."

I don't think we ever spoke of it again.

In April, Schueler took a hallucinogenic drug with Bob and Abby Friedman and had to be taken to Bellevue Hospital that night.

NEW YORK, 6 MAY 1962

How many weeks later is this? Three? It seems an eternity, yet I am just beginning to recover. I feel the blood coursing through my veins again. I have moments of good humor. I'm still a bit reticent about letting my feelings go for fear that the pressure will once again form in my head, but I laugh heartily once in awhile and when I'm teaching, I talk with a moderate intensity.

Of course, at the time of the mushroom, I was not in the best-possible shape. The following day, I was to fly to Mexico for my divorce from Judy. Abby had assured me that the mushroom was very relaxing, that there was no hangover, and that, to the contrary, one felt a peculiar sense of well-being

after the effects of the mushroom wore off and for the day following. This suited my mood. Because of my old bout of hepatitis, I have been unable to afford even the minor relaxation of a few drinks.

I arrived at the Friedman's around 8:15 on that Saturday night. Bob said it would take a half hour for the pills to take effect, that I might experience slight nausea, that I would be under their influence for about six hours before they would wear off. I'm not sure exactly what I expected. Bob had read me a couple of his reports, and I received an impression of heightened response to color, of heightened awareness to detail, of a kind of fanciful awareness and interpretation of minute events.

NEW YORK, 28 MAY 1962

It was the worst thing that ever happened to me. Right now I feel lethargic, fearful, lacking in drive and energy. I doubt if I have had a laugh or even a smile inside myself since that night—which was over a month ago. I feel myself wanting to retreat from almost every actuality, as though it holds more terror than the dream, and both psychically or physically I want to curl up and close my eyes against the pain of inactivity.

Right this moment, I feel the tingling in my feet which has been a sign of fear connected with every memory I have had of that night. Fantasies go through my mind that if I should continue writing and get into the experience, I shall once again lose track of reality and shall have to call Dr. Hogan. And perhaps not be able to reach him. He'll be too far away to help.

NEW YORK, JULY 1962

The first sky was a night sky. I have a memory, total, absolute, experience so lived and complete that it was devoid of thought or interpretation until the painting itself revealed the sky to me. The memory is that of my mother's death when I was six months old. The memory is of a night sky, an all-encompassing void of darkness, an infinity of loss, an eternal Nothing, which must have held all. Perhaps that was when the search began. That sky, so full of everything undefined, reaching beyond space and beyond understanding of space, was the world of my loss, then, and now has become the world of my search.

The sky over Lake Michigan, beside which I was raised: I remember pure blue sky meeting the lake waters, and I remember the yellow of summer heat, and the sun's colors across the clouds. I remember darkness forming on the lake as I played on the sand beach, darkness moving across each precious, held-on minute, until I ran in fright and exhilaration to my home. I remember the sand and the cold lake and winter blue and snow and the ice mountains forming for miles along the shore, creating new lines and divisions between land and sea, new dangerous ice caves to explore, new

footings in the snow. I remember looking into the night sky and feeling tears as I tried to see its impenetrable hue. Stars endless, remotely crisp in their infinity of space and number, holding promise of being beyond, being beyond being, until the very power of imagination which they evoked became a spiritual substance which brought a lonely companionship and comfort. I was a romantic then and am a romantic now.

I remember thunderheads forming over Lake Michigan, when I was a child, and later, one summer, when I stayed alone at my grandfather's farm on the edge of the lake near Sheboygan. I remember sitting on Judge Hedding's porch watching rainsqualls beating on the lake and the towering forms, black to me now, containing fantastic power, lightning flashes, crash and roll of thunder, wisps of rain against the screen. The power within the thunderheads, light, cloud, lake sky, beating and throbbing, waves pounding on the shore, sky mystery endless—I wanted to be sucked up into it and be a part of its power. Blue patches showing, red thoughts, the dark of thunder winds rushing through the tall trees.

STONINGTON, 7 AUGUST 1962

Make a mark upon the canvas. A red. I think of the Scottish sea and the Scottish sky. Right now I'm sitting in a little cottage on Deer Isle. It's located on a point of land from which, on a clear day, one can look out to sea beyond the Isle du Haut, or across the Penobscot Bay to the Camden Hills, resting on the horizon and forming a silhouette which reminds me somewhat of Scotland. In the evening from my little peninsula, I can watch the sun go down over the water and over some forty miles away, the mainland of Maine. Today is not clear. I'm surrounded by fog. On my left it presses in, merging with the sea, gently obscuring a small rock island. Before me, it outlines the pines and a hill in the strange white light of Maine; to my right it brushes the exposed rocks and flats of our little bay, naked in low tide.

A gull momentarily hangs in the mist.

Why, then, red? Red is my color of memory. I painted two reds in Scotland, large canvases with a red mass reflected, red cloud, red sea, and later in memory, red snow clouds. I took the red of rage with me to Scotland, and while I was there, I found it in the tortured sky and painted it. I painted blues and umbers and violets, but I also painted reds. Rage red in my heart, loud voice screaming to be heard, hurt world woman wanting, and I found her for a moment in the Scottish sky. I found there, looking out across the sea, watching the weather cross the horizon and the islands of Skye and Eigg and Rhum and Muck, torturing the sky and destroying the horizon, I found there the primal scream of nature forming.

I had sailed for Scotland in September 1957.

STONINGTON, 13 AUGUST 1962

I remember the crowded, impersonal train ride from Southampton, piling luggage into a cab, and the cross-London ride to King's Cross. It was the first time I had seen London since the war.

Was Bunty[62] still in London? Memory upon memory. I wish that I could write and write and write recalling everything. I wish that there were thousands upon thousands of sheets of paper. I have the most intense desire to bring back every fact and mood and sentiment that I can muster. I wish that it were possible to leave nothing out. A life on paper. And every life that I have touched. Bunty, slim, aristocratic in look and manner, yet delicate and feminine. Soft, glowing skin, brown eyes laughing, smart in tailored uniform of the American Ambulance Corps. I first met Bunty at a tea dance given for American officers at Grosvenor House (hotel) in November 1942. We had been given a two-day pass after three weeks of training and before our first daylight raid on the continent.[63]

We had a number of drinks and then left the dance and had dinner and more drinks. We walked through the blackout hand in hand, and acted rather foolish and skipped like a couple of kids. She pretended to climb a lamppost, and then I pulled her into a shop entrance and kissed her, in a spirit of fun and frivolity and the beginnings of desire. I saw her the next time I was in London, and the next and the next. We liked each other, and she wanted to introduce me to her friends. But then she became my mistress and we loved, and she knew that our affection for each another would show on our faces. I was married. And Bunty was married to a submarine commander. He was regular navy, had gone to sea in the first months of the war, and had lived through the destruction and loss of all of his comrades. He had finally been sent to America as liaison officer. She hadn't seen him for two years.

War memories.

I remember a day when, a few minutes late, Bunty came running along the pavement, flushed and out of breath. The most annoying thing had happened. She had left the ambulance at the garage and had been strolling along the street toward the bus stop when suddenly there was the most awful clatter, and the next thing a Jerry fighter was flying just above the street, strafing as it went. People scurried in the sunlit afternoon, glass shattered, bullets ricocheted off the pavement. Bunty had ducked into a store front. Really, so irritating. No one had been killed, thank God, but it had taken some minutes to get away from the place.

There was a meeting with Bunty when it was me who was late. I had phoned her from Molesworth the day before because we had been promised

[62]Bunty Challis.
[63]Schueler was based in Molesworth, Huntingdonshire (now Cambridgeshire).

a pass for the next day. Because I had been obeying security rules, Bunty didn't know that I was flying combat, but thought that we were still training. She was to meet me at the Ritz Bar at five o'clock. But at 2:30 that morning, we were awakened for a briefing and were on the flight line at 7:00. Takeoff was delayed half-hour after half-hour because of cloud cover over the target. Finally we got off the ground. The raid should have been an easy one—it was a factory complex at Lille—but as we flew in toward the city, we couldn't see anything but clouds. In the crazy, three-dimensional patterns of the air, a fighter seemed to be coming at us in a head-on attack, but he swooped under us and a ship in the formation before us fell, slipping to the left, slicing the fuselage of its wing ship in two and then plummeting to the earth. I watched spell-bound, as though we were watching a slow-motion film from the strange detachment of our Plexiglas viewing room. The powerful four engines of the second ship pulled its nose straight into the air and bodies start tumbling from the smashed fuselage. Chutes opened and sprinkled the sky like blossoms, but one of the chutes, released from the pack, streamed out like holiday bunting and failed to open, the guy trailing decorations as he plunged out of sight. The tail assembly, cocooning the tail gunner, dropped gently like a leaf, almost floating, slipping from side to side through the air.

That morning, a bunch of brass from Eighth Bomber Command had visited the field to watch takeoff. Roy Deadman, the command navigator, was among them. When he did the bit of "I wish I were going with you guys," the navigator and the bombardier from the lead ship got him a suit and parachute and bundled him into the ship which was flying in the vee to our right. Our single-plane bombing had been terrible, and today we were to try bombing off the lead ship for the first time. As we approached the vicinity of our initial point, the clouds became eight-tenths, and we could glimpse the fields and rivers through the undercast. When the lead ship opened bomb bay doors all the rest of us did too. I called Billy[64] and told him that I thought we were still about ten miles off target, but just then bombs started falling from the lead ship, and there was nothing for Milt[65] to do but hit his toggle switch. Bombs started falling from all the planes of our group. Back at the field, we found out that the whole thing had been a mistake, that up in the lead ship Deadman was trying to point out a check point to the ship's navigator and had accidentally knocked his elbow against the toggle switch, dropping the bombs which caused all the rest of us to drop. We also found out that we had blasted a little French village off the face of the earth—a village lying about ten miles out of Lille.

Anyway, by the time we were briefed and I managed to catch a train to London and grab a cab and get to the Ritz, I was about two hours late.

[64]Billy Southworth, pilot.
[65]Milt Conver, bombardier.

Miraculously, Bunty was still waiting, but she was hopping mad and didn't want to talk to me, so I finally found myself explaining that I had been on a raid that day and had been delayed. She didn't really believe me at first because she couldn't figure out why I had been silent about combat, but the next day when we were shopping together, I picked up a *Daily Express* and showed her the headlines, FLYING FORTS RAID LILLE. But by that morning, we were really in love, and it didn't make too much difference.

After a drink at the Ritz, we arrived late at a London Philharmonic concert. (Oh, Bunty, I miss you now, I cry for you.) By the time we got out it was dark. The night was clear, moonless. We started walking through the blackout looking for a taxi, but the air raid sirens started to howl and we ducked into a little pub. There must have been an antiaircraft battery awfully close, because every time a volley was fired, the entire pub would shake and the glass would bounce off the bar. The Englishmen and Bunty talked on as though nothing were happening, and although I was scared shitless and kept thinking we should be doing something—I didn't know what—I couldn't figure out anything else to do except to appear unconcerned myself, which I did. Bunty, I love you.

After the all clear, we went back out into the blackout again and finally found a cab, which took us to Chelsea, where she had borrowed the flat of a friend who was out of town. I remember climbing to the top floor and entering the apartment just as the sirens were sounding another alert. We could see out over London, and we turned off all the lights and opened a couple of the blackout curtains and sat together, watching, as close as I've ever been to a human being in my life. The area being bombed was in a distant part of town—I would guess around St Paul's. We could see the traces etching the night air and the flak explosions banging across the horizon. It had been a strange, full day, and the weird pyrotechnics were intensely exciting in a crazy way. Somehow, everything horrible was eliminated, and yet the full, blood-coursing intensity of war was pounding in our veins. No, I don't really feel it that way. I feel as though we were very quiet and very loving, and I can see the flashes on the horizon, and I can feel the pressure of Bunty's hand in mine, and I don't think that we said very much. Afterward, I kissed her and we were excited and went to bed in the cold room and made very beautiful love. We lay awake talking for a long time. She told me about the friend who owned the flat, a lovely and giddy blond girl, and about how she and some of the others would drink champagne while they were waiting for orders to take out their ambulances. I still had no sense of the reality of their job, and I responded in all of my best Milwaukee puritanism, making some crack about these society wenches being too giddy to take anything seriously—even the war—and then Bunty let me have it. It was probably the only time she was tough with me during the entire year that I knew her. She told me, detail after detail, what their work was like, about being among the first on the scene of a bombing, about the fires, about the wounded, about burned, broken, torn flesh, about

lifting bleeding, racked victims into the ambulances, about working night after night after night, nerves torn, until they couldn't sleep even when they had a chance. I later was to know this sleeplessness—I didn't do as well as the giddy girls. Bunty, I love you, and I hope that there will be a day—just one—when I shall see you again. How old are you now? How do you look? Do you have children? Are you in London? Where is Freddy?

She talked then about her childhood and she talked about her family. Her mother lived near Berwick-upon-Tweed on the Scottish border. She said that we would visit there someday. I asked her about the Highlands of Scotland, where she had often gone in the summers with her family, and she described the hills and valleys and the mood and color of the place. I can see now the strong visual images, the shapes and colors that would fill my mind as she talked.

We planned a vacation to visit the Highlands together, but we never made it. Somehow, crumbling, my war ended. I was sent home about the same time that Freddy came back from the United States.

STONINGTON, 17 AUGUST 1962

There are two things I want to paint about and two things I want to write about—Nature and Woman. Having been in Maine for a few weeks, I realize that the Scottish landscape is the only one that I have a real passion for. I love it here, and there is much to look at. But my very own is in Mallaig, and that is that. What's more, I find that I look forward to New York with great anticipation. I hope that I shall be able to get the large studio on 20th and Broadway. Suddenly, I want New York and people, and I want to add the dimension of people to my work. Before I left, I started a couple of canvases using the figure as a basis, and now I would like to really plunge into the figure theme. I want to get a number of models and do lots of drawings, watercolors, and other studies, and stretch up canvases large and small and see what I can do. I have always thought that because of my nature theme, there was nothing for me to paint in New York. Now I realize that Woman is in New York, and I can paint about that with as much passion as I painted about the sky in Scotland. I'll bring the two together. In any case, I'm now excited about the coming year and don't see it as some long wasteland before I finally extricate myself for the dream of Scotland. Moreover, I'm bound and determined to end the false dream of marriage, which I always have used as some kind of sop for my loneliness. The loneliness will have to remain and will have to go into the picture. I might as well enjoy myself knowing lots of women. I like to know them and I like to romance them, just as I like to look at the sky. But I sure in hell don't want to ruin my life for them. Let them become part of my picture.

STONINGTON, 29 AUGUST 1962

Let's face it, I've fucked this up to a fare-thee-well. I planned to write in a kind of mad fury when I got up here, and have done nothing of the kind. A few days of good work. Many days of retreat. And for the rest of the time, I've just been having a vacation. So once again . . .

Schueler moved into 901 Broadway, at Twentieth Street, in Octo-ber 1962. This rented space, which is where all the woman paintings would be done, remained his studio and living quarters until Decem-ber 1967.

He soon met Mary Rogers (b.1941), who had come to New York to train as an actress in the Neighborhood Playhouse. Although she was twenty-five years younger, they began a complicated relationship, which led to a brief marriage and a longer friendship.

NEW YORK, 3 JANUARY 1963

Last night Mary posed for me for the third time. The first time I used her was one night when Flo Ferguson, who has been studying with me, was painting from the model. I decided it was a rather immaculate start, not without charm, but without intense concentration and passion—possi-bly because it was the first with Mary, more possibly because of the inhi-bitions I might feel with another painter, particularly a student, in the room.

Perhaps a week later, one afternoon when Mary was away, I started a large painting from a memory of the night before: Mary in an attitude of aban-don, head thrown back, legs spread. It's still in its beginning stage, and con-fronts me in my studio, inadequate in the extreme on any painterly level, but containing a kind of robust challenge. A movement of red between the legs is like a flame, and the sensuality of gross size and abandon is there. When Mary returned late that afternoon, I held her in my arms and cupped her breasts, and said, "What's happened to you, baby, you seem so small." I had lived with the Mary image on the canvas throughout the afternoon— the fantasy image, expanding as in a dream from the nearness of my eyes to her body the night before. Breasts like mountains, belly massive, thighs huge plains of flesh, a landscape, red, autumn yellows, confused and con-vulsive. The breasts now in my hands, though full, seemed small in com-parison. The girl was a girl, a human being to be enfolded and sheltered;

Mary Rogers in Jon Schueler's New York studio, 1963–1964

the painting was a landscape, tempting and threatening, in which I would become submerged in my struggle to dominate it.

I was terribly excited. For years I had been dreaming of the woman in the sky, and in my mind's eye had been trying to discover when and how she would emerge. The form, the actuality, the human image emerging from the sea and sky. In no way did I feel sure of myself. But I felt on the edge of knowing. I realized that I would have to look at woman and try to paint her. For years I had tried to understand how I could include the woman, and this always meant somehow technically submerging her in my image. A few starts I had made had proved to be neither one thing nor the other. The woman would disappear, and the sky imagery would be divorced from its source. Moreover, I had had the idea of looking at woman, studying her, drawing from her, but not painting from the model. That night while

talking to Mary I conceived the idea of painting from the woman (from Mary?), looking at her, painting from her, yet embracing the struggle of freeing myself from her.

I had primed a bunch of canvases, among them one about 85 x 74 inches. It had been standing on end ever since, staring me in the face. Although I had not planned anything ambitious in regard to the figure until I had done a long series of drawings and had allowed a series of smaller canvases to evolve slowly without trying for completion, I suddenly found myself determined to paint Mary in a standing pose, filling the seven-foot canvas. I wanted to go all the way. To have her pose as often as necessary, to struggle with the canvas to its completion, and, in all-out effort, to discover my conception on that canvas.[66]

Mary: Paul von Ringelheim[67] called me early in October, shortly after I had moved into this studio, 901 Broadway, and suggested that I call Mary Rogers. She was, he said, the best friend of his girl, Marilyn[68]; had recently arrived from Boston where she had left a guy she had been living with; was young and beautiful, with a noteworthy figure, and was studying acting at the Neighborhood Playhouse. How young, I asked. Twenty-one, he said. I'm a bit older than that, I said. Don't worry about that. She's new in New York and wants to meet people and you can show her around a bit. Just take it easy, he said, because she's too used to guys making passes at her right off the bat. Don't worry, I said, that's not my style.

NEW YORK, 7 JANUARY 1963

Lying with my head on her breast. Feeling, for the longest time, the gentle pulsation of her nipple in my mouth, the warmth of her sustenance, my soul calm with the generosity of her being. When I had first held her breast and put it to my mouth, I felt hungry—an undefinable hunger, not for sex, not for food, yet for both. But as I rested and rested more, gradually the hunger was appeased and warmth pervaded my body and my loins. I wanted her, but for these moments I wanted only to rest and to draw into my being some part of the excess of her warmth and spirit, which she so lovingly offered, and which I knew gave her pleasure to offer. How strange that it should finally be like this. Can it ever be taken away?

NEW YORK, 17 JANUARY 1963

A few minutes ago, I sat in my studio looking at an unfinished painting. Small, for me (48" x 46"), the sea and the sky, unformed blues, greys, blue-

[66]*The Blue Mary.*
[67]The sculptor.
[68]Marilyn Wylder.

greys, alizarin greys, alizarins—deep and somber.[69] I looked out the window at the sun falling across the facade of the opposite building, ugly 1920s rococo, window hazy with dirt, and I felt the onrush of time toward death. It was as though the only way to stop it, even temporarily, was to make the time pregnant with work. God cannot help me; Dr. Hogan cannot help me; Mary cannot help me. I can only help myself. I always feel the cold hand of death before I set to work, death castrating, dehumanizing, dulling my feelings, sapping my will, draining my muscles of their energy, dampening my fire, depressing my nerve fibers, bringing down a grey, impenetrable cloud of fear over my mind. Yet if I can only summon up some lost energy, some vestige of will, I'll feel a rebirth.

I was a growing boy—was it in high school?—when I had the dream. I knew that someday I would have to do something. I would have to find the glory. There was a dream, which was the dream of poets and the dream of religious men. The dream of song and the dream of color. Once I told my mother that I was a genius without talent. By that I think I meant that I had caught a glimpse, not of vision, but of the fact that there was such a thing as vision. But I despaired of having the abilities to record. Now, more and more, I realize that the instruments of recording—words, sound, colors—are the means of thought, and the key to the vision. The very exercise of these instruments at least opens the possibility of vision, though I continually despair of my facility or technical ability. Often other painters will comment on some such thing in my paintings as "handling of space" or "drawing", and for a moment I will feel at peace, as though truly I might have the competence (funny, all I could think of was *confidence*) to realize my dream. But then I'll be looking at my work, and suddenly I'll become obsessed with the feeling that I cannot paint at all.

NEW YORK, 18 JANUARY 1963

This morning at breakfast Mary said that when we go to Scotland, she is going to quit smoking. I love it when she talks of going to Scotland with me, because it makes the next trip seem real and practical and close. Which, for the first time since I left in 1958, perhaps it is. Mary is the girl who could, in some ways, make it possible. I know that for a couple of years I was truly frightened of going alone, as though I no longer had the strength to bear the loneliness. Mary's care is unbelievably gentle, without imposition; it exists as unheralded love, and I feel the comfort of continuing affection. And I think that she would enjoy the challenge.

[69]Probably *Blue Snow Cloud II (Toward Mourning)*. See color illustration 9.

NEW YORK, 21 JANUARY 1963

Zero.

NEW YORK, 22 JANUARY 1963

Mallaig: I painted the walls white—two coats to cover the heavy green. And I bought pounds and pounds of crack filler. For the next few months, every time I would feel a draft, I'd trace it down and would spread filler across the cracks. Cold breezes blew through the cracks of the tongue-and-groove boards which lined the kitchen. Downdrafts from the ceiling, updrafts from the floor—one by one, I stopped them. They were like sly enemies to be watched for every minute, and killed when possible. I sealed many of the windows, and have often wondered whether they were difficult to open the following summer. The day I made doorsills for the gaping wounds below the doors, and lined the frames with weather stripping, John MacPhie and Jack Watson watched me from across the burn in disbelief. Finally they came over to inspect the job. When I showed them cracks filled, door sills, weather stripping, windows snug, they were appalled. Jack Watson laughed, but didn't say much, as though a mad American was beyond understanding. John said, "You can't do that, boy. You're going to suffocate in there. You won't have any oxygen and the heat will be unbearable. Besides," he said, "it's unfair to the wind!" He smiled, but I think he meant it, for he lived with the wind and fought the wind and sang with the wind and cursed the wind. But he didn't shut the wind out of his house and out of his life.

NEW YORK, 31 JANUARY 1963

I can't believe it. It has been nine days since I last wrote. Where have they gone? I don't even know what has happened or why it has been so long. I know that I have been very depressed for the last week, though I have managed to work on a number of paintings. Nothing finished.

NEW YORK, 2 FEBRUARY 1963

After breakfast, I felt the fatigue come over me again, I felt a million years old, and I thought, Will I ever have energy again—what is it, is it the city, is it my age, is it my health—or is it the battle going on inside me for and against my work? I decided (or did I decide anything?) that it was the battle, and I went into the studio and started working on a painting. As the morning moved on, I rapidly came alive. I worked on three different paintings, including

A *Shadow in the Red Sky Moving.*[70] Tonight when I looked at them, I realized that I had done some good work. I felt strong and whole again, a different man from the one I had been a few hours before. I helped Mary with a few things around the house, dressed, and went up to the Stable Gallery on business.

I think of what is considered obscene. Photographs. A few Sundays ago, I took a number of photographs of Mary. She was dressed in one of my blue wool shirts, and it was unbuttoned. Some of the pictures I took with the shirt closed, others partly open, others fully open. I can't say that the pictures were particularly good, although I caught a few poses which I thought were rather typical of Mary and rather beautiful. At one point we started to joke. She teased me in a way she knows I like to be teased, and which is indicative of our gentle intimacy and is a gesture of her generosity: She cupped her breasts in her hands and held them toward me. Twice I snapped the shutter, and I got two intimate and delightful pictures—one in which she is holding her breasts boldly, and has her head held back, laughing. Modern Age took great exception after developing them and printing the contacts. "Art photos" were all right, the man said. But no pubic hair and no suggestive poses. Suddenly my girl was obscene. And my picture of her was obscene. But in bed or around the studio or in a painting there is nothing obscene about a woman's pubic hair. It is one of the most delightful parts of a woman's body, and is delicious to paint or draw. It provides the most convenient accent, and is a wonder for rhythm and composition, as well as most telling emotionally, as Picasso proved so delightfully in his series of drawings, *The Human Comedy.* But in a custom-print establishment, designed for professionals, the pubic hair is obscene. And a woman holding her breasts is obscene. How very obscene it would have been had she been holding her cunt. How very, very obscene had she been holding my cock. Which would be more obscene—my cock hard or my cock limp? And yet, some of the most delicately beautiful and intimate moments of anyone's life are when a woman holds her breasts for a man, or her cunt, or his cock. Her hands become tender, her sensitivities are aroused; her face is concerned or joyous. But we must cover all of this in shame and we must agree to the obscenity, until all that is left for the world to see is the obscenity.

NEW YORK, 3 FEBRUARY 1963

I feel, really I feel, totally unreal about my children. When I talk to Joya over the phone, she sounds near and real, but the rest of the time she is a fantasy, which grows dimmer and dimmer. I no longer understand my relationship with my children, nor indeed if I have any. I find that from one week to the next I forget to send them their allowance. Last month, for the

[70]78" x 90".

first time I forgot entirely. Or rather, I forgot part of the time and for the rest of the time had no money to send. Tomorrow I shall send money for two months.

Sex. Writing sex. Feeling sex. Thinking sex.

NEW YORK, 5 FEBRUARY 1963

Yesterday I finished *Winter Sunset on the Sound of Sleat*.[71] I think it's a good painting. I don't know. In a way, I feel strange because of the show coming up at the Stable. *A Shadow in the Red Sky Moving* is changing from one day to the next. A black shape at the top has enlarged and turned to red. And now I see most of the painting as black. Shall I paint it that way?

Mary wanted to know if she should get rid of her apartment.[72] I didn't know what to say. The apartment has been a symbol of freedom for Mary. And for both of us, I suppose, a symbol of the fact that our relationship has been on some kind of trial, that we didn't know what was going to happen, and that we were not going to try to plan for the future. Suddenly, the nature of the question suggested we were involved with commitment all the way or catastrophe. It seemed a rather large question for first thing in the morning.

NEW YORK, 7 FEBRUARY 1963

Winter Sunset on the Sound of Sleat, which I thought I had finished a few days ago, has disturbed me more and more, until today I completely repainted it. I don't know whether I like it or not. Perhaps it's a good picture. Yesterday I worked all day on *Shadow in a Red Sky Moving* and finished around 7:00 P.M., though I was still putting finishing touches on it last night before I went to bed and again first thing this morning. I evidently got so lost in the painting that last night I couldn't relate to anything or anybody.

I wish I hadn't shown *Winter Sunset* to Mary just now. She didn't like it, so I find myself rather depressed. The goddamned reactions of an artist. It makes no actual difference whether Mary or someone else likes a work. But subjectively, one can never tell when a reaction will set in.

NEW YORK, 8 FEBRUARY 1963

Am I going to be absolutely, finally and irrevocably broke? I'm running out of money, and not a sale in sight. I've gambled $500 on my show, putting an ad in *Art International* and paying for a catalogue instead of using the usual announcement the gallery pays for. I've never sold well in my shows. In my last

[71]60" x 72".

[72]Mary shared an apartment with Marilyn Wylder.

show I didn't sell a single picture. If something doesn't sell in this show, I'm not sure what I'll do. Go down in a blaze of color and a torrent of words. As many pictures as possible, and as much of this book as is possible.[73]

NEW YORK, SEPTEMBER 1963

Already my mind whirls. I try to remember being born, but of course, though the memory is in me, there are no words, any more than there are truly words for the death of my mother six months later. Or words for my father's sperm splattering the dynamic patterns of conception in the dark red womb night that led to my being. In paintings, one way or another, I have tried to talk of these things—birth, life and death—and hope I shall again.

Schueler's visiting artist job at Yale had come to an end in June of 1962. As he suggests, painting was interrupted by financial worries until Eugene Leake, formerly a mature student of Schueler's at Yale, invited him to teach at the Maryland Institute, where he had become President. Schueler and Mary Rogers, who were now deeply involved, went in June to Deer Isle in Maine and then camping in Nova Scotia, before moving to Baltimore for the beginning of the summer term. Joya (then almost seventeen) joined her father for the summer and was with him for the second visit to Deer Isle (in August,) which was without Mary, who had gone to live in Boston where she worked for the production manager of the Charles Playhouse. Upon returning to Baltimore to begin the fall semester, Schueler managed to get two teaching days back to back, so he immediately arranged to move back to New York, thereafter commuting to Baltimore until June 1967.

NEW YORK, SEPTEMBER 1963

Last night I dreamt that I saw my mother (was it my real mother or the nurse or my stepmother?) and I told her that six months of my life had been destroyed for lack of money. This last six months. For the sake of a

[73]There was a blizzard on the night of the opening. Three people show up. However, at least one painting was sold from this 1963 Stable Gallery exhibition, February 19– March 19, 1963. Michael and Flora Irving purchased *Grey Snow Cloud*, 1961, oil on canvas, (79" x 73").

few hundred dollars, I pulled myself from my studio, moved down to Baltimore with Mary and Joya, and forced myself into a never-never land, which has practically totally dissipated my energies. I'm still out of my studio, and may not get back in until the end of this month. No real painting from March—the end of my show, when I realized that I was going broke and desperately cast about for a job—until now—when, after a Monday and a Tuesday of speaking with compulsive intensity about art to my students at the Maryland Institute, I am left with my head bursting and my jaw tight. I sometimes wonder if the way my head feels heralds a brain hemorrhage. It's as though everything inside my skull is swelling, nerve ends rasping, blood vessels pushing against the hard skull so that the blood ceases to flow. Yet, I know of no way to stop. If I am to teach, I can only teach all the way. If I am to talk, I can only talk all the way. God help me to paint all the way. And help me now to write all the way. There is so much that I have to say.

In the dream, I told my mother that I had been ravaged by lack of money. That my painting, which was so important, which came out of me, and which was of importance to the world, had been lost. Six months of painting had been lost to the world and there was no way for it to be recovered. She gave me some money, coldly, without emotion, without interest, and walked away.

Next I dreamt that I saw my father in the distance and I beckoned to him, wanting to speak to him. He answered readily and came my way. I tried to tell him of what had happened, and I was in a rage as I told him. "For the sake of a few lousy dollars," I said, almost crying. "Can't you see how it is?" He was very serious, obviously concerned with my welfare. He asked to see my paintings; he asked me if the two small paintings resting against the wall were mine. The question seemed to be whether or not the paintings were of recognized value. If they were, then, as I was in the midst of a difficult time, something should be done. If they were not, I should not feel bad. But I tried so hard to explain, looking at the two small paintings on the floor the while, that there was no way of telling and that this was not the point. I felt a terrible failure and frustration, even though I knew he loved me and wanted the best for me and did not want me to feel unhappy. Yet I could not feel that he was going to help me, because I could not feel that he was going to understand. It seemed more important than anything else that he should understand.

I know that this dream is very important, but I can't interpret it. I have no idea what it means. I had the feeling that I had been dependent on my mother, long after I was alone. Dependent on her and on Woman. But now, for some reason, I had given her up. I no longer needed her, because I no longer could see how I could bring to her a sense of my need. Not a need for her, but a Need. So, thinking back on the dream, I thought I was saying that I no longer felt dependent on women. I almost dismissed my mother with contempt. Which left the Need as something relating to my father.

There was not only the need of my life, of my inner core, of my life force, of my being, of my identity, past, present and future, but there was the necessity of that need being communicated to him. My father must be terribly bound up in my need. But I must free myself of him and of men, even as I have freed myself of my mother and of women, or I shall not have the independence to create for another thirty years and leave what I should leave to the world. My father was a good man, a moral man. He loved me. And he is dead. Did I hate him? I killed him. I know, because I killed him in a dream. I was responsible for the death of my father long before he died. I was responsible for the death of my father when my mother died, and when my stepmother came into the picture, and years later when I found out that my mother had wanted to die. If she had died because of him, then I wanted to kill him, and his death was on my hands and in my conscience. I know the power of my will and of my fantasy.

I killed him first by hiding from the rage of his cock. I knew my separation and I bathed in the juices of his love on many other nights. I was laved with his warmth, but I could not separate it from the heat that I was sucking from her. Time was a multiple of nine, and that was the time I spent killing her while I sucked at the stream of her body. I sucked more than I could hold. I was a fish sucking, a twisted monster, curled and kicking, struggling for the air. Memory told me of the aperture; I had only to find it.

Schueler and Mary saw each other only occasionally during the fall of 1963. However, their close relationship was resumed after Schueler visited her in Boston in late December. Mary then spent most weekends in New York with him. The woman paintings were underway, with Mary, her friend Marilyn, and professional models posing nude for him. Schueler was also drawn to the remote beauty and sadness of Neltje Doubleday Sargent, recently separated from her husband. Meanwhile, Schueler's daughter, Joya, to escape the alcoholism of her mother, arrived in January 1964 to spend most of that year with him, attending the Washington Irving High School for Girls.

Schueler had proposed to Mary in the spring of 1963, and then withdrawn the offer when he found himself overcome by anxiety. Now the question of their marriage reappeared, complicated by the presence of Neltje.

NEW YORK, 22 APRIL 1964
LETTER TO MARY

. . . So here is the favor I ask of you: Could you just please not do anything for the moment? Don't fall in love; don't get an apartment, don't run off somewhere; don't create a new confusion. How much time can you give me? A day? A week? Two weeks? Three hours? I'll force myself out of this dilemma one way or the other. I love you and I can't bear the thought of giving you up. I'm scared of marriage. I'll either propose or I won't propose—and it's possible that either way you'll win. In any case, you'll know that I love you, too. . . .

This next entry was written on the eve of his marriage to Mary Rogers in Lincoln, Massachusetts, where Mary's parents had a large family farm.

CONCORD, 19 JUNE 1964

I don't know whether or not I can stand what I'm going through right now. Well, of course I can stand it—but everything is going all wrong and not at all like it should. It is going with a typical Schueler ambiguity. The problem is this: There is Mary, and I asked her to marry me, and now I'm going out of my mind because I don't want to get married at all. Where is the reality? Mary. Neltje. Probably, knowing my mind, both. If I choose one, I have to give up the other, and for the moment I can't do that. Each step of this wedding program is like a step to damnation. I don't see how I can go through with it, yet I don't see how I can stop it. I don't see how I'll be able to go through the actual wedding ceremony tomorrow. I nearly flipped today when I had to sign some paper signifying intention to wed. Please God, give me a sign. Is there some way to do it without hurting Mary? No, there isn't. One thing is certain, at this given moment, Neltje can't be hurt—at least not much, because she is not that much involved—but Mary can be hurt.

Let me find some beginning. I was living with Mary last spring. One night we went to a cocktail party given by Madeleine Davidson[74]. I remember

[74]Schueler had met Madeleine Dimond (née Violett) during the late 1940's in San Francisco when both were students at the California School of Fine Arts. When Schueler moved to New York in 1951, Dimond told him to look up her sister, Ellen Violett, a writer, through whom he met Violett's mother, Ellen Doubleday, widow of the publisher

seeing Neltje approaching, tall and beautiful, dressed in black. She looked cool and untouchable, yet strangely lonely. I really can't say that I started waiting then, but I was aware of her.

After the wedding on June 20, 1964 Schueler was so overwrought that he and Mary had to stop at Massachusetts General Hospital in Boston where he was given tranquilizers. By June 22, he was in Baltimore for the start of summer semester at the Maryland Institute.

BALTIMORE, 22 JUNE 1964
LETTER TO MARY

Dearest,

Another sleepless night—or rather slept for a few hours after arriving here totally exhausted and then woke up at 4.00 in the morning. I know I have to go through with the annulment. I have to make the decision and I have to make it alone. If I talk it over with you, I'll somehow put it off onto you—like I did the other day, and then blame you for it. I feel appallingly irresponsible. I'm so sorry, darling—I'm so terribly, terribly sorry. I have done a terrible thing—to you, to your family, to your friends. Now I have to somehow keep from doing worse. You're so sweet and so beautiful and deserve so much better. I'm so sorry.

I love you,

Jon

NEW YORK, 4 JULY 1964

On Thursday I saw Dr. Hogan. Women. I make women so much a part of my life. I love them, need them, and am cursed by them. Now that I paint them, I need them all the more—although through the painting I am separated from them even as I am drawn to them. I think of painting Neltje Thursday night. Looking at her and being thrilled by the beauty of a line, a shadow. Absolutely thrilled. Like love should be or is in the books and dreams of adolescence. And feeling the exhilaration and power of my love. But I existed as a painter in front of the canvas. The only way to touch her was to touch the canvas with my brush. For an hour or two, it seemed to

Nelson Doubleday. By the time Madeleine settled in New York with her second husband, Raymond Davidson, Schueler had become friends with the whole family, including her younger, half sister, Neltje Doubleday (b. 1934).

me that this was the only love, or the love of which I was capable. I could feel my strength. I could avoid getting caught in the honeycomb of sentimentality and guilt and abrasion—which is probably life, and without which I could not paint. I felt very strong and positive and willing to accept the contradictions of life. Mary had left.[75] That afternoon I had called Neltje and talked to her for the first time since that terribly emotional afternoon a few days before I was married.

I love this small room at the back of the studio, which has been Joya's since February. Now she is in California visiting her friends. I love my studio. And I love my brushes, paints, canvases. Yet I spend so much time in depression, sloth, avoidance of work. There is a death in me which is inertia. The moment I am freed of it, it is as though I am freed forever—only to face it the following day or hour.

NEW YORK, 5 JULY 1964

Terrible day. Woke up full of energy but am still on dead center about working. Yesterday went to Sandra II for dinner. Ivan a most pleasant and intelligent guy, and will make her a good husband—whatever the hell that is. Mary went with me. I don't feel married. It is very strange. Nor do I want to be. Yet there seems nothing to do but keep going. I could love Mary so much more without being married to her. This feels like a kind of doom which I periodically arrange. Yesterday I enjoyed myself with her; I took her as part of me and as part of my life. By last night she was feeling miserable and lonely and insecure. She had a nameless despair. I have it this afternoon. The marriage, which was to have been the reassurance, has turned out to be just the opposite. As anyone could have predicted. I always said that any problem one was involved in before marriage would be magnified a hundred times after marriage. I love her and she's a wonderful girl and I have no idea whether or not I can go on with it. Patience. Where is Neltje? Where is my painting? Where is my book? Then, perhaps I'll know.

It is cooler today.

NEW YORK, 18 JULY 1964

I continue to be burned by anxieties. The night before last, I suddenly realized that I had no sexual desire. Mary wanted to go to bed and she wanted to make love with the mirror and her tasseled negligee and split panties, but I was utterly without sexual desire or sexual emotion. Last night the tensions disappeared, but I still had no sexual desire. This morning she said to me, "When you don't make love to me, I feel that you don't want me." Within minutes I was worrying about that.

[75]When necessary, Mary was able to stay with her actress friend, Marilyn Wylder, who had also posed for Schueler.

Now there are other things piling up on me. I'm running out of money. I have to go to Yale, Norfolk and lecture next week. I'll be in Baltimore Monday through Wednesday and Norfolk from Wednesday through Sunday and Baltimore again from Monday through Wednesday. On August 3, I'm supposed to go to Provincetown—Bob [Friedman] has arranged quarters for us as a wedding present. Can I stand all that? It will release me from my studio, because I'll have no chance, but, on the other hand, I won't feel whole until I'm back in my studio. The painting I have done over the last few months has been terrible. The painting of Neltje I worked on last week is lousy. In the afternoon I bought Mary a bikini for $32. Yet I wanted to buy her a bikini. A bikini meant a lot to her. Everything becomes crazy. I'm caught in a web of anxiety because I am married. And I'm married to Mary. But I want to make her happy, and I hate to cause her pain. It will soon end up that I'll scarcely be able to relate to her. She may become an absolute stranger to me by virtue of the fact that she is married to me.

I can only stop all this one way—by working.

NEW YORK, AUGUST 1964

Black glory. I'm thinking of the black snow cloud. Painting Neltje. This year when I would take her out, I'd often ask her to wear the black dress, and one night I asked her if she would pose for me wearing it.

Neltje came to pose on a Sunday. While I was preparing my palette, I thought of the black dress and a black snow cloud, a woman in the black snow cloud, the dress and cloud merging and being the same. As I thought of this, I became faintly disturbed. Beautiful Neltje. Neltje the mother of two children.

During the break, I said, "Someday I'll paint you nude, but I couldn't even ask you as yet." She smiled enigmatically—which in a way, is what Neltje does. I am never sure by her looks as to what she is thinking, or how she is responding to a given situation. Therefore I am always surprised at her words. They are crystal clear and unambiguous. Far less ambiguous than my own words or my own thoughts in any given situation. If I were to ask her to pose nude for me, she would answer me in the most clear manner one way or the other. But I can't as yet.

Yet, Neltje, seeing that painting[76] for the first time had a look of fear, almost of horror in her face. "Do I really look that sad?" she asked. "Is it really that bad?"

The black snow cloud. Death. She did not really look that bad, that sad, and yet she did. Her face, pathos, resignation, the pain of frustration, of bewilderment, of giving up. But more than that, the resignation of her body, hand hanging limp (she said I painted it like a claw), her other hand resting

[76]Day: The Black Neltje, (78 ¼" x 89 ½")

B.H. (Bob) and Abby Friedman with their son, Jackson, Provincetown, Massachusetts, August 1964

across her belly. The mother, dead and dying. Her dream was not with me. But when I looked at her, I entered my own dream of love and hate and death.

PROVINCETOWN, AUGUST 1964

Right now I should be doing etchings, drawings and paintings and I should be talking to Neltje. I feel as though I am out of communication with her and therefore it is hard for me to communicate at all. I shall write to her to-day, then hope that I shall be able to write my book. This closing in of silence frightens me. Yesterday I had fears of madness again. I can't remember what small sensations and observations the fears hinged on, but they were definitely there.

I don't think I can stand being married because I can't stand the secrets of marriage. No matter what. In this instance: Mary and I finally made a pact that as soon as possible we would get an annulment or divorce and she would get an apartment and a job. This freed me to relate to her. But gradually I feel that this can't be talked about. And I feel cut off from

Neltje. And I have to act out the marriage for the rest of the world, which makes me feel as though I'm acting a lie or a deception, and then I lose track of the truth. By God, this is what has been bothering me for the last few days. I knew that I was bothered being here in Provincetown, that something was wrong that wasn't wrong in Nantucket over the weekend. This is the madness. In Nantucket, we knew no one and so it was possible to keep our own situation straight in my mind. I could communicate with Mary and love her and joke about the situation and have a good time within the reality of whatever it was. Mary put her ring on the finger of her right hand and we pretended to be unmarried and it was all right and we knew what we had to do. Here we are meeting all sorts of people, old friends and new, have to accept congratulations, have to act as though we are married, and pretty soon I get the reality and the act entirely confused. Of course, we are married, and this confuses things all the more.

Paperwork for the annulment of the marriage between Mary Rogers and Jon Schueler was filed in October 1964. It was granted in April 1965 by the Commonwealth of Massachusetts, which did not recognize Schueler's Mexican divorce from Judy Dearing in 1962. However, Mary posed for him during this period, and they continued to see each other until the summer of 1965. While Mary was working at the Byron Gallery in New York, she met Christian Boegner. When they got married in 1966, Christian asked Mary to return the four paintings Schueler had given her as "alimony."

Douglas Day (left) and Jon Schueler with air hostesses Edith Jahnel (left) and Belén Abascal (right) in Palma, Majorca, summer of 1965.

Galilea is a small hillside village on the Spanish island of Majorca, where Schueler spent the summer of 1965 writing a new section of the book. The buoyant mood of the introductory letter is in sharp contrast to the more somber narrative that follows. Schueler recalls his troubled adolescence and college years, the chaotic time in California during his first marriage, and the tentative beginnings of his painting career.

GALILEA, 2 AUGUST 1965
LETTER TO DAVID AND ASTRID MYERS

. . . I received Dave's most welcome letter in the dim long ago and kept thinking I was going to answer it tomorrow, and when it was tomorrow, I was going to answer it the next day, and then when the next day finally came, Maynard and Flo Ferguson[1] wanted to rent my studio for the summer and I was so goddamned fed up with everything, I really needed to cut out, so I came to Majorca. Alastair Reid had purchased a house in the mountains last spring, which he had only seen once, and he said I could live in it if I wanted to, so I rented a Lambretta and scooted up the mountain, and here I am. Whenever I want to get into trouble, I scoot down again to Palma, but so far no trouble. A most miraculous summer. You both know better than anyone else that summer is always my time to create absolute chaos, and somehow I've avoided it up to now (I'm knocking on wood) in the Year of our Lord, 1965 and it's already August 2, so I don't see how one can really do anything outstanding in the remaining weeks to come. I met a Spanish girl [Belén Abascal] a few weeks ago, but she flies for a charter airline and is out of town most of the time, and besides—though she is beautiful and bright and personable—she is most properly Spanish and holds me off at twenty arms' length. The other night I was with a friend, Douglas Day, at a café in the Born and we saw a couple of French women who were most attractive and who in turn noticed us, and we were both too god-damned cowardly to go over and talk to them. Innocence thrives on this sort of thing. Douglas teaches English lit at the University of Virginia—but the occupation doesn't do anything to describe his character, which is such that I feel conservative. He had gotten an interlocutory decree from his wife while having a mad affair with a grad student and came here to work on a book about Malcolm Lowry (having written the first critical book

[1] Maynard Ferguson (b.1928), trumpeter and bandleader, and his wife. The latter, mentioned on page 136, had taken some lessons in painting from Schueler in 1962-1963.

on Graves)[2] and the night I met the Spanish girl, a TASSA hostess, he met her friend, a Brazilian-German girl [Edith Jahnel], also a TASSA hostess, fell in love with her for a couple of days, and she cried and loved him and was ordering him around in true German style and told him about her unhappy childhood and cried in bed, and so he decided to go back to his wife, who is coming over here on August 9 with their three kids. I just sit back and watch amazed and say to myself, So that's how it looks from the outside! Alastair and Douglas and I have had lots of good talk together. Now Alastair's son, Jasper, is here, and soon they are going off to Corfu, and what with Douglas's wife coming, I won't have a stabilizing influence. Or an unstabilizing influence. I have been working on my book and have written over 350 pages, but a couple of weeks ago I fell off my scooter and it shook me up a bit (just a bloody hand, as far as hurt is concerned) and for a week after I couldn't write, and for the next week I could write, but it was all terrible. I can't seem to get back in the groove. At the same time as the scooter accident, I started studying Spanish—trading Spanish lessons for English lessons with the local school teacher, Doña Francesca. And I wonder whether I'm jumbling my brains all up by such an activity. Does this seem reasonable? I haven't been married recently and if I'm lucky I'll keep up the good record. It's very difficult to stay unmarried. The idea of eternal bonds of moy and (I mean joy and) happiness and devotion etc., is all so intimately bound up in one's psyche that one can scarcely get an erection without accompanying images of eternal peace or piece, as the case may be. In any case, as nothing is eternal, least of all piece or peace, except for eternity itself, there is a certain madness about the whole thing. Anyway, the last time I saw you I was with Ronnie [Elliot], and then I started to see Mary [Rogers] and I was taking out Norma Jean [Katan] and a few others, and in that way I was safe throughout the spring. I got a lot of work done, but then I started to worry about galleries, thinking I should try to get in one, and that ended my work once and for all. Had some disagreeable experiences with a couple of guys who had purchased paintings and were giving me trouble about money. Became sick of women complaining. So when chance came to fly from the city, I took it. It has been wonderfully rejuvenating. . . .

SUMMER OF 1965

In Scotland, I have looked each day at the lonely horizon, at that line (or is it a line?) where the sea and the sky meet. I have tried to understand it and tried to know how to paint it and what the painting of it might mean.

[2]Douglas Day, *Swifter than Reason: The Poetry and Criticism of Robert Graves*. Chapel Hill: University of North Carolina Press, 1963; Oxford University Press, 1964. *Malcolm Lowry: A Biography*. New York: Oxford University Press, 1973 and Oxford, 1974.

I have seen light immediately above and I have seen light immediately below. I have tried to understand the shadow and the reflection upon reflection. I have seen everything definite, the line, the light, the shadow, the color, on a clear day, and I have seen everything disappear in the mist, the fog, or the passing of a cloud. After many days I had seen so much that I could understand nothing. Yet I had seen enough to try to paint. It would have been easier to paint—it was easier to paint—before I had looked. The sea and sky, thighs richly spread and leaving their lonely line between them. The massive lonely line of the endless horizon over the sea has seemed to me to be the loneliest line of all. Line is poetry. Line is song. Line is about reality. It defines or tries to define. It suggests or tries to suggest. It begins and ends—sometimes where it appears to begin or end, though more often at a point where it appears and disappears at the same time. The line, my line, could violate the very meaning and idea of that line out there in space. By destroying that which might be, I could more tell of that line, which can't be seen or understood. The lonely line of the horizon. The most lonely line.

. . .

My work had been going beautifully last winter and spring. Then in April I decided that I should do something about finding a new gallery. Eleanor Ward of the Stable Gallery (where I had had my first show in 1954, and then after a reconciliation, two more shows in 1961 and 1963) had taken one look at the women paintings when she visited my studio in the spring of 1964 and had nearly been destroyed on the spot.* The blood drained from her face. Her cheeks became a greenish grey as she looked at the big naked women sprawled in attitudes of love and abandon across the canvases. I felt sorry for her and put my arm around her and said, "It's all right, baby, you don't have to show them." That was the end of our relationship. Now a year had passed. The paintings had been forming and I felt that it was high time that I showed them and that it was also time I did something about my financial situation. It's always high time for me to do that, and every time I do anything about it, I make the situation worse.

One day, Ronnie made an appointment for me with Alan Stone.[3] I was there at four on the dot. He looked at me as though he couldn't figure out what to do with me and then said something about things being terribly rushed and that maybe next week would be better. I walked out knowing that next week would be never. Then I went up to talk to Leo [Castelli], but he had a lot of people there and I didn't want to interrupt him. I stopped at Cordier Ekstrom, where Ekstrom in his grey suit and transparent face was talking to someone. I hung around and nothing happened. I could feel the

*See color illustration 10.
[3]Alan Stone of the Alan Stone Gallery

anger and panic building up in me. Then I went to Terry Dintenfass. I had met her socially a few nights before, but now that I was to talk business, I wasn't sure that I knew where to start. The gallery was empty, but there was the sound of conversation in the next room. I listened for a moment, pretending to look at the paintings, and then suddenly cut out. From that day on, my work went to pieces and I didn't do any decent painting for the next month, though the drawings I did the very last night before I left for Spain (the drawings of Barbara[4] and Mary), I liked very much.

At the same time that I was involved in the selling business, I was also in the bill-collecting business. A year before, two paintings had been sold on time: one to Harry Macklowe, who must be a real estate con man; the other to Sy Evans, who henceforth introduced me as a genius. He seemed so warmly responsive to the painting he bought that I forgave him his gaucherie; and when he wanted to take two other paintings (another snow cloud, one I had painted in France, and a recent nude), I went along with the deal. I had squeezed every dime I could out of Macklowe, making phone call after call, carrying on idiotic conversations in which he'd try to con me and I'd pretend I didn't know I was being conned. Yet, we did talk, and I did get most of the money. The bill was now down to $400 which he had promised so faithfully to pay many months before. Sy, on the other hand, had only paid $400 toward the total bill, but had given me so much love that I continued to trust him more than I trusted Harry.

But summer was coming up and I had no money except for my Air Force disability retirement pay and I was going to have to get through four months somehow before my September teaching check was due.

I started phoning both Sy and Harry, Harry at home and at the office, but Sy only at the office because he had changed apartments and his new number was unlisted. Harry would always return the calls and make promises and nothing would happen and then I'd call again. Sy never returned a call. Over a period of a month, I made at least 20 calls and wrote two letters, and finally when the secretary said, "Yes, Mr. Schueler, we have your call", I blew my top and told her to have Evans send back the three paintings and send them fast. He sent them and I had to pay the freight bill.

The calls to Harry Macklowe continued. I tried to keep my temper because the issue seemed to be one of money, not of anything else. Bob Friedman had noted that had he been talking to the secretary, he would have told her to send the money, not the paintings. But then he wasn't getting paranoid about the work, having waking dreams that Evans was trying to steal it. So I was as nice as I could be to Harry. I said, "Harry, just put a check in the mail, will you please?" And Harry said, "I'll do that this

[4]Barbara was a professional model whose long and lean body was a perfect counterpart to the smaller and fuller figure of Mary Rogers.

afternoon." I'd wait a couple of days and no check. Then he'd say, "Oh, I forgot." Then the next time he'd say, "I put the check in the mail—didn't you get it? Well, I'll send you another one". No check ever came. Finally, I said, "We have been talking for six weeks about $400 which should have been sent last December. Please, please, Harry, put a check in the mail."

And finally an envelope from Harry Macklowe was in the mailbox. I found it there when I was leaving the studio with Mary one morning. We were walking toward the subway entrance when I opened the envelope, to find a check for $200. I screamed bloody murder. I screamed as though I had been stabbed. I yelled, "I'll kill him. I'll kill him. That son of a bitch, that lousy son of a bitch."

I rushed back to the studio and phoned Macklowe. "What the fuck are you trying to do to me," I said, my voice rising until it became a scream. "Are you trying to make a lousy bill collector out of me? You've been conning me for six weeks. You know it and I know it. Now what do you want to do, con me for another six weeks for another lousy $200? Is that what you want? Do you want me to make another fifty phone calls and go through another fifty promises. Do you want me to stop my work so that I can try to get another lousy 200 bucks out of you?"

"No," he said.

"Well, put that money in the mail today, right now, and if it isn't in tomorrow's mail, I'm coming down to your office and I'm going to camp there until I get it."

"I'll send it," he said.

And he did. And I haven't spoken to him since. And I'm not sure if I want to. Though, knowing me, some day it will seem amusing (in fact, it already does in a grim sort of way) and I'll even be able to joke about with him. On the one hand, I wish that I didn't have to have my painting in the hands of someone like that. I need the money so desperately that I can't afford to get the painting back and return the money. On the other hand, I recognize the mania that can take over people who buy paintings. It's almost because they love it so much that they don't want to pay for it. The same thing has happened with friends who have bought paintings of mine and then a few years later could no longer think in terms of giving me the rest of the money for it.

I was left with my head reeling for a couple of weeks afterward, as though my brains had burst and the swelling nerves and blood and grey matter were pressing maddeningly against the inside of my skull. I felt slightly crazy and I knew that I couldn't do anything anymore in the way of business and that somehow I had to get myself back to work. It was almost impossible for me to think. I tried to work. I tried to make plans. I decided to go to Scotland for fifteen months. I decided not to. I decided to stay in New York. I decided to go to Majorca and work on my book. I decided to go to Copenhagen and work on my book.

I finally gave the studio to Maynard and Flo Ferguson and made reservations on Pan Am for Spain (having canceled the reservations on Icelandic for Glasgow). Choices seemed to disappear from my smashed brain. I flew to Majorca and met Alastair [Reid] in Palma and found my way to this house of his in the mountains above the town of Galilea. I bought tables and chairs and set up my typewriter, and here I am.

. . .

When my mother was new I was four years old. I wore a white sailor suit and I followed her from room to room. She was only twenty-one and very beautiful, with dark hair and a smooth face and a white dress and soft body. I wanted her to love me. I went to the store with her in the old Franklin with the slanting front and I became a mirror for her wishes and her whims. I'm sure now that she came to love me, yet all our lives we played a strange game of tenderness and battle, seduction and jealousy, closeness and cold distance. We were both self-conscious with each other, but I had too much to forget to be the boy she wanted me to be. The responsibility must have been terrible for her, because she was so young and my father was at least 37 and not an easy man. I had to forget the first four years of my life because she wanted it that way. Which means I was born anew and had to try to form myself into something I had never been. I had to kill my mother and the nurse and Aunt Marie and I had to kill myself and then present myself as someone who would think what had to be thought, and feel what had to be felt in order to be loved. I tried not to get the white sailor suit dirty.

. . .

The war was my father. I was born in 1916, during a war, and when I was growing up, I remember a continuing awareness of the First World War. There was a large brown book with a brown cover and the brown tints of old rotogravure pictures showing a world of barbed wire and mud and men going over the top and huge guns pointing toward the sky and spiked German helmets and doughboys and bodies sprawled across the mud and slumped against the trenches. I paged through that book again and again as I grew up, and it is a horrifying tribute to the young boy's mind that this rotogravure impression of death and slime and horror brought romance and dreams of glory. It was my father fighting and going over the top and returning a hero with the parade up Broadway and the girls cheering. It was my father being strong and defeating the enemy. It seemed as though I'd never have my chance, but if I did, it would be just like the book, and we'd be singing "Over There" and defeating the Hun.

I was about twelve when I noticed a many volumed set of books bound in red leather, which had seemed part of the wall. *Documents of the First World War*. I pulled out Volume one. On the first page was inscribed my name. I felt a touch of glory that my father, in ornate script on rich paper, had dedicated

these volumes to me. The hero leaves his memoirs to his son. But my father was never in the war. The story, told a few times rapidly by my step-mother with eyes averted, was that he had just gotten into uniform when the war ended. Therefore he had never seen action. I suspect he was never in uniform. The fact is, when I was born, he was thirty-three years old, so by 1917 he was thirty-four had a dead wife and a living child, which was probably quite enough excuse to ignore battle and pursue one's career.

The Schueler Bros. became the largest tire dealers in the state. My father was just right for dealing. He understood books and the proper markup. And he was a natural born salesman. Although he had many salesmen on the road, he often went out himself. There was a time when every garageman and every filling-station operator and every tire shop in Wisconsin and Upper Michigan knew George Schueler. Even on Sunday drives or on vacation travels, George Schueler would stop at the gas stations and garages. He knew his customers by name and he asked about their families and children. Even when he was driving a Cadillac or a sporty brown Buick with a rumble seat, the garage men liked him and liked to have him visit. He was known for his honesty.

Dad was so successful in Schueler Bros. that he bought out Uncle Fred in the early twenties. The business became the George Schueler Co. and moved to much bigger quarters in a white loft building on the South Side. I remember the smell of rubber, the Red Arrow which was the Hood trademark, the big offices with partitions of brown wood and plate glass, the salesmen, and Al Kaad, the bookkeeper, and the secretaries. Row upon row of tires in the storage area, racked to the ceiling, truck tires and tires for Ford Sedans. And I remember the men gathering to admire the 1928 Buick with the spare tires in wells on each front fender, and the leather top.

．　．　．

Up until seventh grade I had always been rather a serious little student and my grades were uniformly good. Then, when I was twelve, everything went crazy. It was the year I found out about my mother and probably the year I really found out about sex, and it was also the year I was sent off to a private school, which helped develop that fantasy snobbery which was so much a part of our middle-class, Milwaukee morality. Money equaled morality. If you had money and knew the right people, you were moral; if you were poor, you were immoral, and you were poor because you were immoral.

By eighth grade, the stock market and my own fortunes crashed. I was yanked out of the private school and sent back to Whitefish Bay School, which I took as quite a punishment. I tried to hang on to some of the old feeling, and sentimentally rode back to the University School one time on my bike, but found that no one really wanted to see me. In high school, my grades and other fortunes went up and down like a roller coaster. I'd get A one month and D the next in any given subject. I'd fall in love and get into fights with teachers. Miss Magdanz, the English teacher, did more

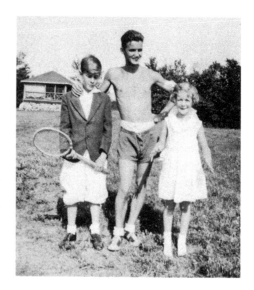

Jon Schueler, with his half brother and sister, Bob and Paula, when he was a counselor at a summer camp on Lake Any Belle, Wisconsin, c.1932.

for me than anyone else. She encouraged me to write, and I feel I owe her a debt. She was one of those to introduce me to the creative life. I wrote a number of pieces for her, everything screamingly romantic or passionate or idealistic or moody or sad or painful. I failed in football, in basketball, in track, in gym, in love, in class. My mother told me each and every day, "Well, Jack, I guess you'll always be a failure," and for all I know, it may have been with good reason. I was always starting with a bang and ending with a whimper. In college[5] the same. My freshman grades were quite good. In the beginning of the sophomore year, they were excellent and I was on my way to becoming Phi Beta Kappa. Then I got infectious mononucleosis. I spent weeks in the hospital recovering.

By the end of my senior year, I was really going down. Too many people, too many dreams, too much drinking, and not nearly enough work. I went home without my degree. Because I had dropped some courses when I'd had mononucleosis, and because I had flunked the accounting course, I was three credits short of graduating. Well, Jack, you've failed again. When I suggested to my parents that I go to summer school and get the degree, they were furious. Get a job. Learn about reality. I've been trying to learn something about it ever since.

In fact, my practical experience with the world had been limited. During the summer of my freshman year, I had worked for my father, changing tires and doing odd work around the shop. The next summer, I had worked on a rural line crew for the Wisconsin Telephone Company. Then in Madison, I

[5]Schueler started at the University of Wisconsin, Madison in 1934.

had waited on a table at Alpha Delta Phi and had worked in a YWCA cafeteria—first washing pots and pans, graduating to glasses, then to the automatic dishwashers in the basement, then to scraping and loading the dishes into the dumb waiter, which was as high as you could go.

I was a real goddamned whiz at every one of those cafeteria jobs. I was the best pot washer they ever had. I revolutionized the glass washing business and set speed records washing trays. I picked up the tray with the left hand, holding it under the splashing hot water, twisting it over, grabbing it with the other hand, slamming it on to the growing pile of clean, wet trays to my right. Always with a beat. Whichever job I had, I'd always do it in half the time that it had been done before, and would spend that extra time reading.

"You've certainly failed this time," Mother kept saying.

"I didn't fail," I said, struggling to explain. I was always trying to explain the obvious to her—as though she deliberately and with malice refused to understand.

I dashed around interviewing until I found a job at JCPenney. But all this activity was in a passive mood. It was a giving up inside: I had accepted the trap. At the beginning of the week, all the employees would assemble in the shoe department and the store's manager, and maybe some big-wigs from higher up in the chair, would give us pep talks—just like coaches before a football game, or the group commander before an air raid: Go team, go. Get out there and sell for dear old JCPenney. I listened. I was doing my good boy bit. I was neat and clean and I was going to do my best for JCPenney. I was always on time, or early, and I always worked overtime. I was eager. There is something about the half-assed jobs of this world (waiting on table, or washing trays, or stacking shirts and ties) that make me shine as a model of efficiency.

Despite the obvious recognition of my talent by the section manager and store manager, I was falling into a deeper and deeper depression. I did my job. I did little else. At night I would go home and eat supper, and sit around awhile and then go to bed. My depression must have been so obvious that it scared even my parents. Without even mentioning the subject, they suddenly announced that they had decided to let me go to summer school and get the credits necessary for my degree.

I became a new and different person, not only from the passive individual doing his duty at JCPenney's, but from the no-good who had been drinking his way through college with the boys only a few weeks before. I enrolled in three courses, a history course, a psychology course, and a philosophy course. I also met a girl who helped change my life.

Jean [Stafford] was two years older than I and undoubtedly much more mature. We talked about books and we took walks in the warm Madison evenings and we swam in Lake Mendota off the Alpha Delt pier and we drank beer in the student union. My studies went well and I read a lot. I remember that sex was a thing of beauty and great excitement.

School ended, I packed my bags, and on the appointed day my parents and my younger brother, Bob, drove up in the old 1926 Cadillac to collect me.

We were on the road less than a minute when I realized that Mother was sulking. But I felt so good that I didn't want to face it.

"Who was that girl?" she said.

I told her quite a bit about her.

"She's too old for you," she said. Mother was always right. Every girl was too old, too young, too brash, too shy, too far away, or too close.

"She's only two years older," I said. "We've had a marvelous summer and we get along very well."

"We didn't send you to summer school to be playing around," Mother replied. "We sent you there to work."

"But I did work," I said, trying to control myself. "I told you, I got two A's and a B+, and I couldn't have done that without working."

"We've been spending our hard-earned money for your education and all you've been doing is wasting yourself. You've failed again and you've always failed and I guess you're always going to be a failure."

I was getting terribly excited and I could hardly contain myself but I tried to explain. "I'm not a failure. I got two A's and a . . ."

"You failed to pass your senior year and graduate with your class."

"Mother, for Christ's sake—"

"Don't you swear at me—don't you say things like that."

Dad said, "You watch your language, young man."

"Mother, I've tried to explain, you don't pass or fail grades in college. I didn't fail senior year. I have a B average in college and I was short on credits because I was sick one semester and because I flunked a four-credit accounting course in another. I never wanted to take accounting. You wanted me to take accounting. I'm no good at that sort of thing and I never wanted to take it."

"That was your most important course, and you failed it. How do you ever expect to get anywhere? Every year there has been a girl, and this summer we sacrificed to send you back, even though you had failed in college, and now you've been playing around all summer on our money and you've failed again."

The rage in me was building up so great that I could hardly see and I wished that I could jam my foot on the accelerator and plow right through the truck ahead of us. I suddenly screamed, *"I did not fail, I did not fail, I did not fail."* I was screaming out of a terrible desperation because it seemed that because she was telling me I would always be a failure, that I really was doomed to be one. It was her words which would make me want to fail, so that I would fail.

For once Dad heard the anguish in my voice.

"Margaret, be quiet. Let him alone now."

When we returned to Milwaukee, I had to arrange to have Jean's letters sent to a friend's house. I didn't mention her name around the house. Once

more, something was becoming nothing by not talking about it. If I weren't careful, I'd kill her off, like I had killed off so many others.

When Jean came to Milwaukee, she had to stay with friends and I had to invent excuses and sneak out in order to see her. One day, we drove out into the country, parked and had a long talk. I told her about the adjustable lighting fixtures[6] and how I was going nuts and how I didn't know what to do. She asked me what I really wanted to do, and I told her that I would like to write but didn't know how I could earn a living doing that. When she suggested that I think of teaching, I said that I had considered the possibility of teaching English literature, but this was a problem since I had majored in economics.

"Why don't you get a master's in English?"

"God, I'd love to." The idea of using one's life for thought seemed unbelievably attractive. "But I have no money. I can get a job for meals, but I don't know where I'd get the rest."

"Can you borrow it?"

"Not from my parents. At least not for studying English literature."

"What about your grandfather?"

"Grandfather Haase? But, my God, I've never been to see him."

"Go to see him. He'll want to see you."

"I don't know if I can," I said. "It's been so strange. My family doesn't acknowledge him."

I keep thinking about Grandfather Haase and decided to go to see him. But I was panicked. There has always been a nameless, indefinable fear about seeing him and my grandmother. I knew that I had always wanted to and that he would want to see me. But it had been absolutely forbidden before.

For some poetic reason, I felt that I had to walk to find my grandfather's house. I seemed to remember the street as being Summit Avenue, and I knew it was not terribly far from where I had lived as a child in early grade school.

When I found the house, it was exactly as I had always remembered it, with the strange curving shingles roof and the low eaves. I walked up to the door and rang the bell. My grandfather looked at me strangely through clouded eyes, his parched skin taut across his face.

I didn't know whether to call him Grandpa or Grandfather or Mr. Haase. "Hello," I said.

"I was wondering when you would come," he said.

"I came as soon as I could," I replied.

"I wish your grandmother were here."

"She's . . ."

[6]Immediately after graduation, Schueler worked as a salesman for a man who had invented a new device.

"She died four years ago. She died of cancer. She was in great pain and all she talked of was you and how she wanted to see you before she died. You should have come."

He couldn't understand why I had not come before. I couldn't explain that I could have forgotten him and not known who he was and at the same time could have known but could have been afraid to know and could have finally been afraid to come and see him even after I knew

This house I was in now was the one to which my stepmother had brought me for visits; it was the house where I had spent happy days with my grandmother, making mint tea and picking flowers and being very spoiled indeed.

Grandpa Haase took me around from room to room showing me how everything had been kept the way it was when my mother was alive. The furniture was all of her choosing. He showed me unique ideas she had about design, which she had incorporated into the house with great attention to detail. It was a fascinating home. Its kitchen was most original, with a large, deep sink right in the middle, a built-in stove (unusual for that day) and all sorts of features that were different and yet functional, as well. Off the kitchen was the plant room: My mother had loved flowers and had also been responsible for the design of the garden. He showed me pictures of my mother and a notebook with sentimental poems she had written and some little watercolors which I can scarcely remember now. She was obviously a very sensitive and talented woman, whose major work was her house and garden. She had designed these and had them built and then had had me and had never recovered from my birth. She had been sick for six months and then had contracted flu and died.

I told my grandfather about wanting to get my M.A. in English literature, and he said, "Well, you should have enough money." I asked why. And he said, "Because I gave your father a thousand-dollar bond for you over ten years ago, so it should have accumulated quite a bit of interest by now."

I confronted my father the next day with my knowledge of the thousand-dollar bond, which I had never heard of. He had borrowed it, without telling me, to help restart his business in the Depression. I told him I needed the money now, and he was enraged and acted as though I were accusing him of stealing the money. He gave it to me, with a certain amount of interest—though whether or not it was 5% compounded over the years, I don't remember. With that money I started my graduate education and took one of the biggest steps in my life. It was a roundabout way of doing things, but I was on my way to becoming an artist.

• • •

I moved to Madison and got my old room at the rooming house and my old job at the cafeteria and plunged into work. Although I felt an unbelievable amount of guilt toward my parents, and felt sick that I was completely out of communication with my father, the breaking of the chains,

which had up until now doomed me to some kind of business career, and the suffocation of Milwaukee seemed broken.

The idea of plunging into such a reading program, covering all of English literature from its beginnings to the present, seemed like the most thrilling adventure imaginable. As thrilling as the decision I later made to devote myself to painting. I lusted after the books I accumulated as one might lust for women. Chaucer was a great discovery for me, and I loved the Romantic poets. I read all of Shakespeare's plays during the week that I was supposed to be studying for some other exam. Swift was an eye-opener, as was Fielding. The satiric sense appealed to me—and it has remained in my life as the one anchor to sanity that I can depend on when I have reached the depths of emotional despair following some harrowing life drama.

Most of all, during those two years I developed a growing sense of joy in poetry and in literature, in anything created, and a growing sense of disgust of the academic mind and the academic process. That is not to say that I didn't have some fascinating teachers. I did. But the activity of tearing things to pieces which so characterized graduate work seemed ultimately destructive, or, at minimum, to obscure the understanding of what literature was truly all about. Many of the graduate students bored me. They would have huge projects, which I classified as word-counting. The Germanic idea that the study of literature could be reduced to a science in which the microscope would be used instead of the soul, had taken over the graduate world. Whatever was talked about, it seldom touched upon the life force which was the power of art, or on the complexities of human motivation.

· · ·

Years later, in very different circumstances, I was again reminded of experts' determination to leave out all that is vital and unpredictable in human experience. There was a panel discussion at Yale on the implications of thermonuclear war with an admiral, straight backed and sober, a handsome, grey-haired Yale physicist who had done important bomb research (I like to say it that way), and a representative of Rand Corporation.

The Rand man spoke most lucidly, most practically, most beguilingly. He said that plans had been made whereby a war could certainly be limited. For example, we could let the Russians know that under no circumstances would we bomb, say, Moscow and Pinsk, in which case there was no doubt that they would spare New York and Detroit. With these tactics, most of the mutual effort would be spent hurling warheads at each other's warhead hurlers, with perhaps, (should the powers desire a wider conflict) some well-aimed shots at carefully chosen manufacturing centers. With this and other carefully considered and plotted controls, with a casualty predictability of under 20 million for the U.S. of A., the nation could indulge in warfare for purely predictable ends in the old-fashioned manner and could guarantee each other's survival at the end when both would kiss and make up.

I raised my hand. "I know that I have nothing of your experience, nor the

availability of your facts, and I never fancied that I had an analytic mind," I said, "so I hesitate to question your line of reasoning. But on the basis of my very limited experience in having fought in the last war and having some memory of history, it seems to me that warring nations have always done the unexpected, rather than the predicted, that destruction was always compounded far beyond the anticipated, and that the very science and weapons of war became more horrible in the act of war than they had been in the period of peace preceding it. In my simple way, I see no reason for that not to be true in the next war. I think a typical military solution to contain and warn the enemy and so to guarantee peace was the Maginot Line. The magazines and papers were full of it as I grew up, and I knew how important it was to the French: It was guaranteed to be an object lesson the Germans could understand. It was, therefore, a method of communication as well as an impregnable fortress, and well worth costs so fantastic that they almost wrecked the French economy. I also remember that once the Germans decided to invade France, they flew over the Maginot Line and drove around it. For some reason, these two moves had not been foreseen. May I suggest then, that a more challenging and perhaps a more realistic approach on the part of our guiding intelligentsia would be a search for every possible aberration of predictability; would be to compound projected casualty figures and then compound them again; and would be to concern their imaginations with the infinite vagaries of chance and change, rather than with the restrictive thinking of a charting room. What is frightening about the scientific mind to a timorous layman like myself is the fact that it always seems to deal with what it knows, and with a terrible arrogance assumes that what it knows today is what there is to know, when the evidence is that all it does not know, all that is unpredictable, is what will have the most profound effect on any future generation as the result of its arbitrary acts."

The experts looked at me in dumb amazement and with some distaste. The audience allowed a slight ripple of applause. The Rand man got red in the face and dismissed me as an artist. And the entire discussion went smoothly on.

• • •

I wasn't too far along in the first semester of graduate work before Jean started to talk about marriage. By the end of the summer, I had had love and I wanted to get the hell out. I tried to end the affair a number of times, but each time I tried, Jean threatened suicide, and I felt so responsible that I gave up and went with her for another year. Sometimes we'd have fun and feel very close. More often it was a miserable armed truce.

(By a chance conversation, Mrs. Stafford discovered that a very good friend of hers had known my mother and claimed to be her best friend. She told me that my mother had been so miserable with my father that she had wanted to die. After I was born, she came down with the flu and never

recovered.[7] It seemed as though she lacked any desire to continue living. This bit of information naturally made me see my father as an archvillain who had killed my mother, and for some time I was in a terrible, self-righteous rage. For one thing, it got me off the hook, because deep in my being I felt that I had killed her myself. Hadn't I killed her very memory?)

The time came for my graduation. My grandfather was unable to attend the ceremonies because he was not feeling well enough for the trip. I had sent my parents an announcement, knowing that it would be ignored. Jean would be there, and yet we were sinking lower and lower as I struggled once again to escape from our relationship.

The night before the ceremonies, Jean asked me again if I would marry her. I said that I couldn't, that I had no money, that I didn't know what I was going to do, and the main thing was to organize the next step in my life. I had been accepted at Yale to work for my Ph.D. and had received assurances from my grandfather that he would lend me money to see me through. She threw a tantrum, crying and screaming and calling me every name under the sun. She tried to cajole me; she tried to threaten me; she tried to make love to me; she tried everything. We never did get to the graduation party and she also decided that it would be too painful for her to go to the graduation the next day. We agreed to meet afterwards at 11:00 A.M. at her brother Mac's apartment.

The graduation ceremony went on and on. The heat filled the vast hall until it seemed the structural beams would melt. The black gown was a shroud. Words buzzed through the air like mosquitos. It was eleven o'clock and then 11:30 and finally almost 12:00 before the last word was spoken and I fought my way through the crush to the outer air and found Mac and we started for his apartment.

As he opened the door I called, "Jean!" There was no answer. At the same moment that I noticed she wasn't in the living room, I registered that the kitchen door was closed. Right then I knew. We smelled the gas and pushed open the door of the little kitchen, to see Jean sprawled half on the floor, half draped across the open door of the stove, with her head in the oven and the gas hissing like the hot drone of the commencement orators. Mac grabbed her and carried her into the living room, where he laid her on the couch. I turned off the gas and quickly opened all windows. When I came over to her, she opened her eyes and said, "Do you love me now?"

"Yes," I said.

"Will you marry me?"

"Yes," I said, and I held her in my arms because I was terrified and I didn't want her to be hurt in any way.

[7]The death certificate cites the cause of death as acute-broncho-pneumonia, with influenza as a contributing factor.

Mac carried her down the four flights of stairs and held her in the car while I drove to the hospital.

On the train back to Milwaukee, I looked at my watch. Immediately, I remembered that I had checked the time when Mac was locking the car. It had been 12:25 and we had been due at the apartment at 11:00. And then I knew I had indeed been an actor in a play and the actress playing the lead had been watching from the window for an hour and a half before we arrived in the car. And she had watched us park and lock the door—she had probably even seen me glance at my watch and wipe the sweat from my forehead—and then she had watched us cross the street, pausing while a convertible drove by filled with coeds, and then had timed our climb up the stairs, waiting, and had lit the gas as she had heard the key in the door.

My grandfather was rather upset and angry with me for breaking up with Jean. He believed that you met a girl, went with her for a long time, and someday married her. Moreover, by the end of the summer, he was less than happy with the progress of my German, a requirement for Yale. But his general disappointment in me was only made obvious on the very day that I was to leave for graduate school. He came up to my room while I was packing my bags and watched me silently while I folded my suits the way I had been taught by my mother, and neatly stacked the shirts, socks, hand-kerchiefs.

"I think you should find a job."

"I'll find something as soon as I get to New Haven."

"I've decided not to lend you the money to go to Yale."

I couldn't quite believe it—and yet I could. The madness of this kind of event has always seemed more natural than unnatural to me—sudden shifts and changes of plans, the bottom dropping out of carefully organized projects.

I pushed shut the bag, snapped the latches, and carried it downstairs.

"I am going to Chicago."

"To Chicago?"

"I know of a teachers' agency there. It's almost time for classes to begin, but they may be able to get me something. It is better to be there on the spot."

What I said probably made very little sense. I couldn't think of what else to do. He drove me to the station, and I waved goodbye. An hour later I was in Chicago.

. . .

I was never to see my grandfather again, though for many years he exerted a profound influence on me. It was the ghost of my grandfather who watched me manipulate money—or rather, be manipulated by the $50,000 he left me in his will a year later when he died. I never saw the money, but I felt its presence. The estate wasn't settled until after I joined the Air Force. Actions

that my imagination could not invent became possible. I could send for the stranger, Jane Elton, and marry her. I could buy a Vine Covered Cottage in the San Fernando Valley. I could go into psychoanalysis. I could help finance the beginnings of my career as an artist. The GI bill made the touchstone glow more brightly. I could get more than one divorce.

<p style="text-align:center">• • •</p>

1944:[8] Vine Covered Cottages. I had arrived in Los Angeles having been retired from the Air Force[9] and having found myself going nuts in a New York job doing research on cigarettes for the National Industrial Conference Board, and nuts in my marriage, and Jane pregnant with Jamie, and fixing up an apartment on Sheridan Square—having taken over a floor which had been a restaurant and making it into an apartment single-handedly, putting in bathroom and kitchen and all. I knew nothing about building, or I would never have tried it.

But then Uncle Buddy[10] made a drunken phone call, and said, "What are you doing in New York? Come out to Hollywood, the land of sunshine and honey, where it will be easy for you to make money, where you can get a job writing for one of the film companies. They are dying for writers, they pay a lot of money, and at least, if you can't find something right away, I'll hire you in the wholesale clothing business for (what was it?) $3,600 a year"—which was what I was making with the cigarette research job. Anything looked good at that point, and I decided to go, and I gave up the job and got rid of the apartment.

I arrived in Hollywood and bought a ranch house in the San Fernando Valley with two bedrooms, a thirty-three-foot living room, den, two fireplaces, large kitchen, lots of fruit trees and walnut trees, with a chicken run and thirteen chickens for $11,250. The reason it was so cheap was that the dry stream, which could become a raging torrent in flood time, was just across the dirt road. But it never did overflow its banks and ultimately the Los Angeles Flood Control fixed it. So I got a bargain.

We moved into the Crazy J. Ranch and bought some furniture, and through Uncle Buddy, I bought a retail mail-order clothing business for $1,000 and proceeded to make one comic mistake after another. And then

[8]Between leaving Milwaukee in 1940 and joining the Air Force in September 1941, Schueler worked as a will-call boy in a large department store in Chicago and then as a very junior newspaper reporter in New Haven; during the summer of 1941 he attended the Bread Loaf School of English in Ripton, Vermont.

[9]Schueler, suffering from combat fatigue, had arrived back in America towards the beginning of September 1943. Hospitalized on Long Island, New York that fall, he received a line-of-duty medical retirement on December 1, 1943, which was made official in February 1944. He and Jane had been married for two months before he left for Britain.

[10]Schueler's stepmother's brother Francis Vogt and his wife, Mac.

I pulled out of that and took a radio-announcing course, and then worked in Las Vegas and at a little radio station in Burbank. But I was flipping. I would get up very early in the morning to open the station at six on Sunday mornings and my mind would be so vague and fuzzy that I wouldn't know what I was doing and I would make all sorts of mistakes, and finally I was canned. Then I heard that you could make money driving soldiers to Chicago, and I had a big La Salle, so I went to the agent and said I'd take a load. I needed new tires, so he sold me some black-market airplane tires for $200 which was what I was getting for the trip, so I lost money right away. Anita O'Day[11] was singing in Chicago with Gene Krupa. She and her husband lived down Goodhill Road, near us, and had become friends. Anita was sexy as hell and had full breasts, and I always rather lusted after her. I remember her walking down Goodhill Road in the dust with high heels and a tight skirt and a white shirt pulled tight over her full breasts and no bra and her breasts moving voluptuously under the shirt and I squirm now to think of it. In Chicago, Carl was there as her manager, and they were practically splitting to pieces. He was an operator and living off of her. He had been a flying instructor in the Air Force and before that a professional golfer and now was just about nothing, as was I. He introduced me to a friend of his, Jerry, who was a broken-down jockey who was now afraid of horses and had had a night club called the Box Stall which had stalled somewhere along the way. Jerry was very short and thin and had lank blond hair. They talked about opening a club in the San Fernando Valley and asked me if I was interested, and I said yes.

It all seemed kind of crazy and wonderful. It was a dream and was getting me off the hook of reality for the moment, only I was playing it as reality. I had two buddies, Carl and the jockey, and they were my buddies just like in the Air Force and we were going into business together. They had the know-how and I had Grandfather Haase's money. And they sure in hell knew I had the money. Carl had Anita and musical connections. And the jockey had run a club and knew about kitchens and bars. I didn't know my ass from a hole in the ground.

Carl flew back to Los Angeles to make some advanced arrangements for the band and I hung around the Blackhawk, where the band was playing and listened to Anita, who sounded great. And then the jockey and two of the young band wives and a cocker spaniel and I drove back to Los Angeles in my La Salle, staying at motels along the way, the dog peeing on the rug in one of

[11]The singer Anita O'Day (b.1919), a member of Gene Krupa's big band (1941–1943 and 1945–46) before embarking on a solo career. Her account of the attempt to build the jazz supper club with Schueler is given in her autobiography *High Times, Hard Times*, New York: Proscenium Publishers, 1981, 1989. See John Shuler (*sic*). She had married Carl Hoff in 1943, who, as Schueler states, was also her manager.

them and causing a lot of trouble, and the owner of another trying to over-charge us in some little Arizona town.

When I eventually arrived home from the Chicago trip at 1:00 A.M., Jane wasn't there. Jamie was less than a year and a half old. The baby-sitter, hired to stay until 9:00 P.M. was furious. I went out of my mind wondering where Jane was. She had the Ford, an old car in terrible shape, which I was afraid to have her drive. About 9.00 in the morning, Jane drove up and I was so frantic, I took her in my arms, and she had some goddamned excuse and said that she had met some guy in a bar and they had sat up all night talking, and then I started to kiss her and I ran my hand up her skirt, and she didn't have any panties on, and I knew that she had been fucking and later I knew that somewhere along the line she and Carl had been fucking, though maybe not that night. I don't know. At that moment, I was in the dregs. I was at the bottom at that moment when I was at her bottom and knew that she had fucked another guy, and yet I was somehow at her mercy because I wanted her.

So we started planning the new Box Stall. We found an inexpensive piece of property, low, along the dry river in North Hollywood, in an off-beat lo-cation. But the trouble was that the place was not cleared by Flood Control. We forged ahead anyway. I got the maniacal idea that, by God, I wasn't going to fail in this venture. I had failed in the Air Force and I had failed in every-thing else and I was going down the drain, and now I was going to fight some-thing through to the finish; I was going to succeed.

I had to succeed with the Box Stall. And it was fighting through the mad-ness of the Box Stall and the madness of the next venture in Topanga Can-yon that pulled me out of my failure and my disintegration. So who knows? Who the fuck knows? And the two-bit drawing class suggested by a whor-ish, drunken, unfaithful wife. I pulled myself out of madness and started to create a life out of a shambles which was almost complete. Reaching under Jane's skirt that morning was the point of my final disintegration. It was also the beginning.

We forged ahead with the dream. There was to be a building designed like a barn, with a long bar and a stand for the music and a kitchen and tables. I would be Jon Schueler, one of the hosts, along with Carl and the jockey, and Anita would be there and she would be the music, and there would be great side men to back her up. I saw myself as making enough money out of it to support my family and then I'd be able to write. It was a grand scheme for avoiding writing.

I had the money and I kept writing to Steve Jaquith[12] and his partner in New York for more money, and they thought I had gone out of my mind and

[12]Stephen M. Jaquith worked on Wall Street as a financial investor in Model, Roland & Stone. He handled the money Schueler inherited from his grandfather Haase.

wrote letters trying to stop me. They had to sell stocks from their carefully planned portfolio, and I was doing everything haphazardly and from hand to mouth, but with a kind of mania getting things done. We bought that property which promised to be condemned by Flood Control and we bought a huge load of black-market lumber at a high price and then had to pay to have it sawn up, as it was rough sawed, not planed. We had it hauled to the property and then we had plans drawn up. We had a contractor, and the plumbers were out there working, and we were working, too, in the spring sun, and I had sold my house to get money and had the Topanga Canyon property instead, and everything was going at once and Jane was pregnant and at home with Jamie and kind of being one of the boys, and we were out there one day when the officials came from Flood Control with a notice that the property was condemned and we had to stop right then and there. We had pushed it as far as we could, and now we had failed, but somehow it seemed as though we had failed by an act of God and that there was nothing more that we could have done.

It was very hard to get building supplies, due to scarcities after the war. But I decided now to go ahead with the Topanga dream. Somehow fighting it out on the Box Stall, even though it had failed, had given me more courage than I had had for a long time. In one wacky moment (perhaps before the Box Stall folded), I had purchased a pre-fab house, which I was going to put up out there and then gradually add to it. Anyway, a friend said that he and I could build a house ourselves that would be much better than a pre-fab. And that we could use the lumber that was left over from the Box Stall and we could pull up the copper pipe and use that for the plumbing and at least salvage something.

I started right away, and for the next six months I worked my ass off building a house with the help of Jim Ames.[13] In order to put in the septic tank, I had to dig up hill from the house. My mania was so great that I insisted on doing everything by hand. A power digger could have done the job in a day. But I worked for weeks in the broiling sun, digging the ditch from the house into the side of the hill, and digging the huge pit that would hold the tank— it had to go down over twelve feet—and digging the drainage ditch away from the tank and down into the field toward the pepper trees. By the time I had dug down about a foot or less the first day, I ran into some kind of stuff that was neither sand nor stone nor earth—just something so firmly packed that the pick bounced right off it. Through sheer maniacal will, I clawed my way down. I think it was the absolute madness of this task, the inhumanity of it, the impossibility of it, that finally brought me back to health after the war, or at least the beginning of health. I was on my way to becoming a painter.

[13]Jim Ames had worked as a carpenter for the movies. But, a Communist sympathizer, he had been blacklisted.

By this time we had had to move out of the Magnolia Boulevard house [the Crazy J. Ranch] which I had sold for $24,500 making the only profit I've ever made in my life before or since, and we had moved into a little house on the property of Bob and Lois Dwan, next door to mine in Topanga Canyon. They had about four or five kids at the time. Jane would sit there all day long drinking with Lois and they'd bitch about their husbands. I would give Jane lists of things to buy and of important phone calls to make—to the plumber, electrician etc., and she'd never run an errand nor ever make a phone call. I began to feel that I was butting my head against a wall. She'd look me in the eye as though there was something wrong with me when I blew up. She'd always say yes to anything I'd ask, but just wouldn't do it. I didn't realize it then, but it really was mad. She was doing this more and more, and ultimately poor Jane was unable to do a thing—for herself or anyone else—except to blame everyone else for whatever was not done. But at the time she was my wife and I was trying to make this big heave to make everything work. She was pregnant with Joya and I was trying to pull myself together and somehow everything was hanging on this effort with the house. The house was a reality and a symbol and I was trying to remake myself, the family, our life, everything with it. What I did was to remake myself.

PROVINCETOWN, 19 AUGUST 1964
(This entry was written earlier but is placed here with the other material on Jane.)

The main thing I remember about Jane is the fact that the house was always filthy. I remember the vacuum cleaner. If only there were a vacuum cleaner, then everything would be all right. So we bought a vacuum cleaner on time. It was brought into the middle of the living room floor and assembled. I can't remember the time that it wasn't there from then on, except when I would put it away. Jane never felt like cleaning except in the middle of the night. Then it would be done more as a martyrdom than as a cleaning effort. She would snap on the vacuum cleaner when I came in and would look terribly woebegone and martyred and would push it around a bit, making a hell of a fuss and stopping often to light cigarettes or to get drinks. It was around this time that I found we were spending most of our income on alcohol. I must have been a dream myself. I see Jane in a dirty striped T-shirt and me unshaven and rapidly disintegrating. Our sex life had probably gone to pot. Little Jamie was somehow surviving and having a hell of a time with her bowels. She would be constipated day after day and would have a stool so hard, we would have to practically pull it from her. When Jane would change the diapers, they would be thrown on the floor of Jamie's room and would lie there, smelling, for days. The urine ate through the varnish on the floor and left it completely discolored. The bathroom smelled constantly. Dust covered most of the house, dust bunnies, of a size I have never seen before or since, growing under the beds and under the furniture. Filthy dishes spread their diseased sores through the kitchen. One summer's

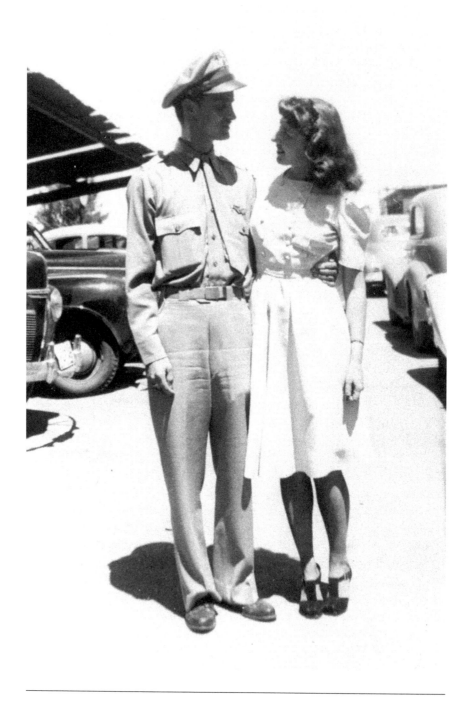

Jon and Jane (Elton) Schueler, at the time of their marriage in El Paso, Texas, August 1942, two months before he is sent to Britain as a B17 navigator.

day, I looked at a huge roast beef which had been left sitting next to the sink for days after it had first been cooked. It was alive with maggots. Laundry piled up all over the place. We had an automatic washing machine. And once in a while, in another display of martyrdom, it would be used and perhaps the clothes would be hung out to dry on a back yard line. For days, even weeks, they would stay there.

The woman in the sky. One day Jane came home and said, "I have joined a class at the People's Educational Center. Not at the center, really, but at a teacher's studio in Hollywood. It's a portrait-painting class."

"Portrait painting?"

"I decided I want to learn how to paint. We meet once a week for two hours." It sounded interesting. I asked who the teacher was.

"David Lax.[14] I'll want to use the car every Thursday night." Jane had that smug, bright smile she could assume when she felt she was getting the upper hand about something. Slightly conspiratorial.

"I think I'll go with you," I said.

Jane's face registered the passing of a secret cloud. She sulked for the rest of the night, and I had no understanding why. Years later, she told me that she had taken the course to try to learn to do something I couldn't do. It had been as though I was stealing something from her she had hoped to have as her very own.

We went to the class the following Thursday. I felt unbelievably inadequate. For some reason, I had been more hesitant about art than about most things during grade school. In drawing class, I had usually managed to get out of doing what I was supposed to do. When girls were doing fashion drawings and some of the boys were doing fair renderings of automobiles, I managed nothing but a scribble. After moving to high school, I had been spared the humiliation of continuing, and I doubt if I ever tried to draw anything again until that night in David Lax's class.

We left Jamie with a baby-sitter and I drove the 1940 La Salle sedan into Hollywood to David's studio. Jane brought a couple of drawing pads and some charcoal. She had been notified that we were to draw from the model for a few weeks before starting to paint.

David Lax was short, articulate, curiously even tempered for an artist. He and his wife earned a living by running a little gallery, giving classes, and selling his work. (Edward G. Robinson was a patron.) David had studied at the Art Students' League in New York and was aware of what was happening on the New York scene at that time.

When the time came to start work, I was in a sweat of self-consciousness. I had no idea of what to do. I looked around to see everyone busy working away with their charcoals, rendering the features, smudging the charcoal

[14]David Lax (1910–1990).

delicately to create illusions of roundness on cheeks and neck. Jane was working happily with the rest. I looked at the model and made some tentative lines. Terrible. I made some more. Tried to fill in some shadows by using the side of my charcoal. Each line or smudge I made had a blatant crudeness. The model rested. I took a fresh sheet of paper and made another drawing. You could tell they were heads, but they were dirty, vulgar, coarse, crude. I looked at Jane's and at the others and envied them their technique. The other students were doing what I wanted to do. As the evening wore on, I noticed David hovering over my shoulder as I worked. He asked to see a drawing I had finished. He tacked another to the wall. He called the attention of the students to my work. I had no idea what he was talking about. I was sincerely embarrassed by them and was afraid to have anyone look at them. I much preferred the slickly modeled work that Jane was doing, and only wished that I could relieve my embarrassment by doing something exactly like her.

Some weeks later, David said, "You have a strong line."

I looked at my messy drawings. "Why do you like them?" I asked.

"They are strong, forceful. What can I say?"

All I felt was confusion. I had no technique. I looked at the model and struggled to realize a line, a shadow. I know now that the struggle became the drawing and that this is what made them strong, within the limits of what they were. I worked the same way when we started to paint. I looked at the skin and saw a patch of orange. I put down orange. I saw a patch of violet, and I put down violet. They were crude, those first portraits, but I can see them still and can see in them the characteristics which became my later work. I still try to look; I still struggle to see and struggle to equate that line or that shadow. I respond very directly to color. The coarseness is still there, and so is the sensitivity. I have tried hard not to let artifact stand in the way of the possibility of response. This, perhaps, has been the cornerstone of my painting. Yet the demand on oneself to do something right rather than to feel something truly is very great. The guilt and sense of failure which follows an expression of feeling, for which there is no rule and no technique, is a curious paradox in most of my daily life.

David Lax was an idealist. He certainly was a kind and generous man and he did a great deal for me. His own paintings were not very much. At the time, they were competently executed clowns, with a certain amount of illustrative substance. Did I know that then? I probably suspected it. I don't think that at any time I wanted to "paint like him." But he had the generosity to recognize another man's talent. May I be that generous with my own students. He told me that there was strength in me, or something called talent. He gave me the feeling that there was something for me to work with. No more. He didn't exaggerate. When I asked him if I should take up painting, he told me that there was no way of telling, that painting was so much more than just this one thing, and that one could only find it and make up one's mind for oneself. He also made me aware that there was

something to art beyond what one saw on the surface, and he broadened my perspective by sending me to a Hans Hofmann exhibit. (This was possibly the first of the new New York painting, which later evolved into abstract expressionism, to be shown in Los Angeles.) I went to the show and was completely puzzled and demanded that he tell me what was interesting about it. Again, he answered that there was no way of telling. And this, too, I have discovered for myself. As for Hofmann, I never did become overly excited by his work, though I admire him as a man and as an artist. But the very fact of his paintings seen one day in 1945 when I was first moving a charcoal across a page made a profound impression on me. Or rather, it opened questions shattering to my ego and to too many of the values I had formed up to that time.

The house was getting done. I had time for nothing else. The painting classes with David Lax were over in the spring, and I had a handful of drawings and a handful of oils on canvas board. Yet they were the foundation of my painting career. I had made a beginning. They floated around in my mind's eye and plagued me and I had to think about them, and when I looked at the landscape around me, and later when driving up the West Coast, I was seeing everything through an eye which had painted, no matter how little. The landscape was becoming part of me in a way it never had before, and when I saw something of grandeur in nature, I would want to make it mine by painting it. I still thought of myself as a frustrated writer. But the painting was a mistress who was absorbing my dreams. I fixed the house under the pepper tree as a studio. I put in windows and knocked out the walls and had a large space there in which to work, and I stacked my few paintings there and my handful of materials.

Little Joya was born prematurely on September 3, 1946. She was a tiny thing. We named her Joya because Oscar Pettiford, my very dear friend, had been through Los Angeles that year and Joya Sherrill had been singing with the Duke.[15]

We were on the way to Portland, Oregon where Jamie was staying with Jane's parents just after Joya's birth. I don't understand what it is, but the fact of driving and the fact of going from one place to another seems to take me out of the tensions of existence and I become quite another person. If I could get behind the wheel of a car and just keep going for the rest of my life, I could be a contented man. Jane and I, who had been fighting and who really almost hated each other, and who had gone through so many horrors together, suddenly became lovers. Jane's eyes were flashing and dancing with that crazy, wicked laughter which was hers alone. She lit cigarettes for me as I wheeled the La Salle along the rolling highway. We were sprung, sprung from Los Angeles and all the sordid complicated mess of

[15]Both the jazz singer Joya Sherrill (b.1927) and the double bass player Oscar Pettiford were members of Duke Ellington's band at that time.

Jon Schueler's daughters, c.1949: Jamie (left) born in 1944 and
Joya born in 1946.

our life, unmade beds, dirty kitchens, messy relationships, insane struggles on my part to earn a living and make something of myself, all of my blocks about writing. We didn't have to hate each other and claw at each other and be suspicious of each other. We could touch each other and laugh and I could run my hand up her leg and move my fingers against the soft wet panties between her thighs and we could know we'd be free to love that night. We were a couple of kids and we had all our dreams ahead of us. I had remade myself by making the house and I was a man now and I felt some confidence running through my being.

I now thought that I wanted to get a teaching job to see my way clear until the next step. So I got out an almanac which listed colleges and universities and I wrote down the names of all of them in the area of San Francisco and wrote letters to them saying that I had heard they were looking for an instructor in English Literature and that it just so happened I was available.

Shortly after I arrived back in Los Angeles, I received offers from both the University of California at Berkeley and the University of San Francisco. I decided on the latter because it was in San Francisco, because I would not have to pretend to treat the job as a career, and because I would be able to teach advanced courses which would be more fun and more informative for me. The money was about the same—$3,600 a year. It was one of the smart decisions of my life.

I was to start second semester, which began the last week in January of 1947. By the time I had made this decision, we had lived for about two or three weeks in the new house in Topanga. Maybe a month.

Leaving Jane with the kids and the maid, I drove up to San Francisco on January 2, 1947 to get situated, to find a place for the family to live, and to prepare for my first classes. Jane was to sell the house and then join me.

The family stayed together until the fall of 1947, when Schueler moved out. The following summer, he began attending classes at the California School of Fine Arts while continuing to teach at the University of San Francisco. This job came to an end in 1949, when the Jesuit administration got wind of the divorce proceedings. He continued at the CSFA (now the San Francisco Art Institute) on the GI Bill until 1951, when he set off for New York.

The children stayed with their mother, who subsequently remarried and had two children with Alvin Sweetwyne. The family remained in the Jackson Street house in San Francisco, which Jane received as part of the divorce settlement. Around 1965, because of financial pressure, Jane's mother sold the house and helped them

move into a smaller one. Jane, a heavy smoker, died in 1974 of cirrhosis of the liver and throat cancer.

The following letter, although written in New York five months after part three, is included to suggest Schueler's ongoing awareness of the cost that his decision to leave exacted on his children, Jamie and Joya. His concern with his daughters' well-being continued despite the often long periods that elapsed between visits.

<div align="right">

NEW YORK, 13 JANUARY 1966
LETTER TO JAMIE

</div>

Dear Jamie:

You bring up enough material and questions in your letter to keep me busy for a week. I wish to hell we could get together. But I'll try to be more or less brief. In the first place, I'm glad that you're going back to school[16] If you try to touch upon as many of the great minds as possible—whether they be novelists, playwrights, poets, painters, historians, journal keepers, philosophers—whether they be cave painters or Velásquez, Freud or Sappho, Peter Weiss or Euripides, Toynbee or Boswell, Shakespeare or Blake, Cervantes or Socrates, van Gogh or Tolstoy—of the orient or the West—one will lead to an understanding of the other, and each will lead to an understanding of yourself and of life, of which you are a part, and will give you a sense of partaking of or creating life's richness. None of it is easy. The nature of the human condition ... is its conflict and its difficulty—but at these moments of ... its deepest pain, its foolish and ironic and idiotic joke, its most threatening catastrophe, it often reveals its most powerful emotions and deepest meanings—if you have developed the mind and laid bare the sensibilities to be aware

About Larry [Jamie's boyfriend]. That's a tough one, and really you do have to work it out for yourself, like everyone else. I will say this: Whatever you do in life, inevitably you will hurt someone's feelings. There is no way out. If there is something you really want to do and it demands your freedom, it will hurt the other person. ... And if you need your freedom and don't take it because you are succumbing to the complicated demands and blackmail of hurt feeling, you will hurt them even more some other way. There is no way out of that dilemma. So you might as well slowly figure out what you want to do and then do it. If you act honestly, the other person has to respect your move. You will both find it difficult and you will both hurt for the moment. There is no other way to move and to grow. Nature hurts. ... The child bursting from the womb hurts—himself and his mother. And then both grow and mature and maybe find knowledge

[16]In 1964, after two years at San Francisco City College, Jamie received an associate of arts degree. She then planned to attend the University of California at Berkeley.

and love—though not necessarily with each other. If you need your freedom, then you really need it, and there is no other fact in the world as important or as urgent as that. From that point on, you'll have to find out what that means by yourself. . . . When I decided to go to Scotland, everyone thought I was mad, and Jody thought I was doing it just to be cruel to her, and a million tortured words were not enough to make her understand. . . . Had I succumbed to her 6.00 A.M. tears, I would have hurt her unbelievably because my rage would have been a killing rage. . . .

The pain I have never even been able to think about rationally is the pain I caused you and Joya by leaving San Francisco, by leaving the pressure of a town and environment that had become crushingly small, a prison, to find an expansion of my talents in a more demanding and competitive environment. I know that without being and forming myself, I could be nothing to anybody, yet in finding and becoming, I had to physically leave you. I can't in my heart find the justification for the pain I caused you. I can only know the absolute necessity of the formation of myself and my work. So—I can only tell you about pain. I can't tell you what to do, what decisions to make, or how to avoid pain. I can only tell you how to feel it. In fact, I suspect that unless a person feels it and feels it deeply . . . to the point even that all feeling is gone—I doubt if he can really live, and certainly he can not profoundly create. Again I tell you: If you can find the instrument to help you understand life—whether it be dance or writing or painting, or scholarship or learning, or politics or social work, or whatever you might dream up yourself—by that instrument you can better understand your moves and the life in you and around you and give it form and meaning. . . .

Am I saying too much for you? I don't think so. I'm saying that you, my daughter, can be a dreamer and can feel the ideal, and can find a way to create your own ideal out of your life—no matter how simple or how complex that life will be—and that creation, whatever it has of you, will be beautiful. The only power that breaks the power of evil at any given time is the power of beauty. And beauty has to be created over and over again—each time anew—in the lives of the few that care. But I won't be able to tell you how to do it, and you might not know until it has been done. . . .

I'm planning to go to Scotland this summer—and perhaps to make my permanent studio there. I'm in a strange predicament now. . . . I, too, am trying to make decisions. You tell me how yours go, and I'll tell you mine. I wish I could see you.

My love to you,

Jon R

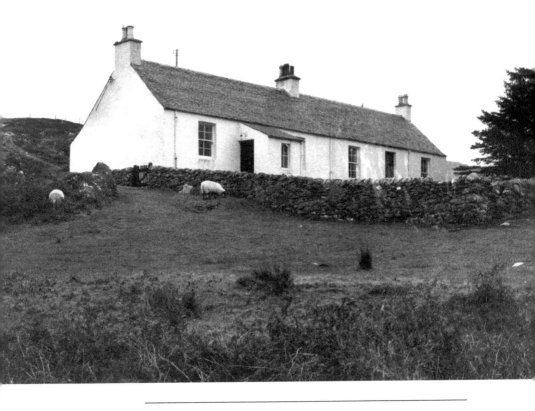

The old schoolhouse, called Romasaig, Glasnacardoch, Mallaig, which
Schueler used as his studio in Scotland from June 1970 onward.

DEATH AND THE MARGARET ANN

Five years went by before Schueler stopped painting to work once again on the book. The intervening time contained its share of Schueler dramas. In September of 1966, at a party in New York, he met the writer Elise Piquet, who was on the verge of being divorced. The two remained together until January 1970, when Schueler left for Scotland. Thus, Elise helped him with all the preparations for the large, retrospective exhibition at the Maryland Institute in spring of 1967, and she also accompanied him to Scotland that summer. They ended up living in a shack on the island of Skye, where Schueler painted his first series of watercolors.

Unable to find a place appropriate for the winter, they returned to the United States in the fall. Having rented out his studio, Schueler moved to Elise's house in Chester, Connecticut. From the fall of 1967 until June of 1968, he converted the garage into a fine studio, and the attic of the house into a workroom for Elise. Broke, and desperate to accumulate enough money to return to Scotland, he accepted the job of head of painting and sculpture at the University of Illinois, Champaign-Urbana, for the academic year 1968–69, but he returned sporadically to visit Elise and to use his new studio. During this unsettled period, he seems to have done no work at all in the studio that he fixed up in the farmhouse in Illini, Illinois.

By the fall of 1969, the relationship between Jon and Elise had disintegrated, and Schueler cut his losses, leaving for Scotland in January 1970. This time, he managed to rent the old schoolhouse, renamed Romasaig, Gaelic for "bay of the raven," a mile outside Mallaig, from its new owner, Archie MacLellan, a friend from the 1957–58 stay. Among the various women he met in a whirl of social activity in Edinburgh while waiting for Romasaig to be furnished was Magda Salvesen, then age 25, who was working at the Scottish Arts Council as an exhibition officer. Eventually, she left her job in the spring of 1971 to join Schueler in his life in the Scottish Highlands and later in New York.

Despite Schueler's growing confidence in the direction of his painting, his writing took on a somber note. Another excursion in the fishing boat the Margaret Ann, as well as the overpowering experience of a black June night, led him to confront and acknowledge the death and destruction in the sky. "My work." he decided, "must be a search and a requiem" for the dead mother, the deaths of friends during the war, and the deaths of artists who committed suicide. Schueler's respect for the skipper Jim Manson led him to

compare the passion and risks at stake for the fisherman and the artist. Having confronted his fear of death, he was finally able to write the story of the wedding night of 1941, which had long haunted him.

ROMASAIG, 13 NOVEMBER 1970

MAGDA![1]

How can I write if I have no memory?

How can I write if I have no memory of you?

Magda, Magda. The Woman in the Sky.

I have painted many black paintings. Images crowd my mind and words tumble into oblivion. I want to write of one cool fact, but there is no fact without death and emotion.

Romasaig is my studio, a schoolhouse built near the rock, sand and hill of the cove of Glasnacardoch, near Mallaig. I think I'm doing it this time. I made the studio and I've painted a great number of paintings and I have not yearned for home. I've blanked out on all of my friends, and when I do think of them, I try to forget or try not to feel or try to pretend that I'll see them tomorrow. I think I'm doing it. I was just going to say that I can't fail this time. But that's precisely what I can do. That's really what one does. So, again, I have to try to encompass that idea. But I've been here since February and I've been happy with New York as a memory.

Archie MacLellan[2] (owner of the West Highland Hotel), who helped me find the bungalow in 1957, bid for the schoolhouse at a sale and made the winning bid. Not having the money, I made a pretend bid of 3,000 pounds. It went for about 3,500 pounds. It was worth twice that to me. Or twice twice. Or twice whatever you can think of. It's mine now for as long as I can pay the rent of 600 pounds a year to Archie. Or for as long as I'm allowed to stay in this country. Why does this feel like a quicksand to me? Everything, except the sea and the sky and the painting itself, seems insubstantial. And even these, ultimately.

I've been painting as hard as I've ever painted before. I remember now the afternoon and evening in my studio at 70 East 12th Street in 1952 when I painted a night sky,[3] perhaps six and a half feet high, with white flecks coalescing in the upper right-hand quadrant, or upper left, and flecking, falling, an incomplete rhythm, to the bottom of the canvas, and out, and beyond.

[1] Magda Salvesen (b.1944).

[2] Archie MacLellan and his wife, Barbara, became closely linked with Schueler, and there were many evenings spent together over the years. Their eldest son, Archie Iain, photographed Schueler in the 1970s and 1980s, amassing a valuable documentary archive.

[3] Probably *White on Black*, 1952, 87" x 70".

It was the first painting, I think, that I knew for certain was a night sky and that it was the sky that I would be painting about. I remember the night this June when I thought I saw nature, Nature, NATURE divorced from my sensibility, my Romanticism, if you will, and I wrote this piece:

THE SOUND OF SLEAT: JUNE NIGHT

Last night I had one of the very important visual experiences of my life. It was late, 11:30, when I looked out the studio window and was struck by the somberness of what I was able to see. I went out, then called Raoul,[4] and we stayed for over an hour. Standing our small ground at the edge of the sea, we seemed isolated from the Sound of Sleat, the Sleat Peninsula, and the sky and cloud above it. The vision was intensely real, yet it was the most powerful abstraction—Nature a cold, stately presence, remote and unconcerned, beyond man's definitions, his identifications, his attempts at understanding, oblivious to his emotion. Man could only be irrelevant in the face of this implacable event, this dark and light of eternal death. Everything about the Sound of Sleat that I might have remembered, every color, shape, or form, the identity of sky, land or water was destroyed and replaced by those events, which I can only call the unearthly light, the dark, dark, rich beyond the black, the mass of grey, and the deep shimmering of a streak below, a presence more powerful, more beautiful, more seductive, more real than man's fantasies of poetry or joy or the damnation of his days.

There now have been three massive experiences I have had with the Scottish sky. The first, in March of 1958, when I had given up and, aching in my head and eyes and soul, I cycled from Mallaig Vaig to the white sands of Arisaig, where I watched the snow clouds moving toward me, implacable, from the sea. One passed over and through me, snow beating against my face. Then I turned to the south and saw the winter sun glowing in the snow cloud; strange image of light burning and dying through the shadows of a changing form. Though the sun was a winter sun, it translated itself in my mind to the most powerful and vibrant colors, reds, yellows, Indian yellows, or sometimes alizarin through blue.

The second experience was in 1967 when I was at sea with Jim Manson,[5] the day of the gale. A mist hung like a curtain to the sea, haunted by a subtle glow from the direction of Rhum. I pointed out the image to Jim, who said, "Yes, we call that a sun dog; it's the sign

[4]Raoul Middleman (b. 1935), American artist and close friend, who, living in Europe at the time, visited Schueler on several occasions.

[5]During the summer of 1967, when Schueler was in Scotland with Elise Piquet, he had, as in 1957, gone to sea with Jim Mason, skipper of the *Margaret Ann*.

The islands of Eigg and Rhum (far right), from the Sands of Morar, near Mallaig, Scotland, 1970.

The island of Eigg with Rhum (far right) 1970, from a point close to Schueler's studio.

The view of the Sound of Sleat and the Sleat Peninsula of the Isle of Skye from the gate of Romasaig, 1970.

of the gale." This warning of the storm that was to drive us from the sea was the most delicate sign, impossible to draw, impossible to define, impossible to understand except in the most exquisitely sensitive terms.*

And now, with Raoul, this vision of death, or of Nature beyond life, or of Nature as she must exist beyond that fantasy of life that we imagine. I wish that I could devote endless days and years to this cold and passionate truth. This noble, dispassionate truth. This frightening truth.

*See color illustration 23.

Jon Schueler with Raoul Middleman on the Sands of Morar, near Mallaig, Scotland, December 1970.

This abstraction of the sea and the sky and Sleat—I was possessed by it, wanted to walk into it, to disappear into it. I was exhausted afterwards. There was no color I could define: The greys were not grey, the silver was not silver, the blacks were not black. It was all light and all darkness. Believe me, I have seen eternity, and it is frightening and it is most beautiful, more beautiful and more powerful than any man or any woman or the works of either. I wondered, afterward, how I'd ever have the arrogance to paint again; yet it is now even less possible to do other than paint. I felt sad and sick and lost in loneliness, yet I was seeing the full glory, more than the glimpse I had sought.

The sky moved, the light changed, the vision faded, but I knew it had been there and I had been present. You must believe me. Raoul was there. I was not alone. This was more than a personal vision; this was a vision witnessed. A vision independent of my existence, yet one which has already changed my existence. Frighteningly beautiful. I don't know where to begin thinking about it in paint. It was so beautiful and true and real that it is impossible to hold in my memory. Yet it must be there.*

• • •

*See color illustration 14.

Death in the sky. 1942.
Death and the night sky. 1952.
Death and the night sky. June, 1970.
Is Magda like Death? Is this the melancholy beauty of my imagining?
Death and the November sky. 1970.

· · ·

Sunday, November 1. Contemplated sailing on the *Margaret Ann*. Preparing. Feeling the imminence of Death.

But before I remember that Sunday, I must explain about the misleading heading of "Romasaig". In small, it is this: It has always been very difficult for me to write where I have been painting. This time, when the writing was failing (I wanted the voyage in the *Margaret Ann* as the focus of my words) I decided to come to Edinburgh and use Magda's study for work and Magda's bed for rest. But there is no quick way to explain why it is a table in Magda's apartment.

Feelings of imminent death on that Sunday afternoon.
Fear of death before missions.
Fear of Death.

The curious quality of no word. She says very little. Does that intrigue me? Even when she talks, she does not reveal herself. I discover her only by waiting, and I have to wait a long time. I have to try not to jump to conclusions, to interpret. I'm nearly always wrong when I do. Intuitively I have been right about a number of things. I was right in recognizing her the moment I saw her. It was like recognizing Bunty or recognizing Death in the June sky or recognizing the sky and theme in the black painting in 1952. I knew that night of the black painting. Ever since, I have been struggling to understand.

ROMASAIG, 14 NOVEMBER 1970

This morning I said to Magda: The creative act is strange. Just before one starts writing or painting the mind fills with images so powerful or so subtle, emotions so tenuous and incapable of being rendered in either paint or word, that one is quite realistically aware of the impossibility of the task. He must accept the fact, the certainty of absolute failure from the beginning. Even before he starts work. But at the same time, he has to strive for an absolute reality. By the very fact that, looking, he sees more than he has seen, he knows that he has not seen enough: Yet his only solution is to look more, to see more, to struggle to understand more.

His only recourse is to work. More and more I've considered that working is the point of work, and that all else is incidental. Compared to the work in the studio, the rest of living is a passive act. Extremely passive. I say that advisedly. Looking at the sky, walking the moors, fighting wars, making money,

building houses, teaching students, all these are passive acts compared to the act in the studio.

The residue of the struggle is the painting or the poem. It has an existence outside of the artist, who can join others in contemplating it, feeling it, having it become part of the passive act of living. In his next painting, the artist might struggle with an impulse of nature, or with the impact of some past painting (his own or another's) on his mind. What questions are raised by the sound of silver-grey light outlining the Sleat Peninsula, or by the death of a mother, or by Magda's hand, or by a Goya drawing, or by a Turner sea and sun, or by *The Woman in the Sky, Red Snow over the Sound of Sleat*, or *Magda Series: June Light?**All reality, including the reality of the painting, raises unanswerable questions. The struggle to create an image as real as the idea (not an image of the idea) is the point of the artist's life. In this struggle, the artist creates himself.

Black.

The Night Sky.

Birth: From the womb into the night of day.

Death: Reaching up into black for the presence that must be there but which could never be found.

War: In the sky, the calm, work-a-day quality of terror and the exquisite beauty of death.

It was only a week ago Sunday that I could admit death and to a fear of death.

One time I was speaking to Ad Reinhardt,[6] who was painting his dark paintings, and he said that our paintings had something in common, though they seemed to be so different—mine so full of color, movement, a display of passion, the feeling bursting its way out; Ad's calm, static, color all but eliminated, the hand, feeling, the surface, nothing but the geometry of his dark pulse. I said, "Yes, we both speak of Death. There's something of Death in both our paintings." He refused to discuss it further. He is dead now, of a heart attack. I couldn't write to Rita (I was in Tokavaig, Skye that summer). I wanted to call her when I got back, but didn't. Rothko is dead, too, his veins slit, and Barney Newman of a heart attack. These three, with Still, were such close friends. Within a few years they were enemies, big men, but not speaking to each other.

Rothko, I had refused to understand, at least in part. I realized that when I read about his death this spring. He had a cutting manner and would suddenly or sneakily turn his contempt on anyone at hand. Once, in the early fifties when I had been visiting him in his studio, he pulled out many

*See color illustration 16.

[6]Ad Reinhardt (1913-1967), whose mature works of a black, cross-like structure within a dark, evenly colored square, were painted in blacks so close in value as to appear almost to be of one totally black square.

paintings and talked about his work. He said, "My work is nothing," and he ended the conversation on that note. The next day, excited by the many ideas in my mind, I tried to talk to him about that statement, but he passed it off. Later in a bar, I talked about my own desires in my work, my wish to say something that would hold the idea of life in it, and he said, "I'm not interested in all that stuff; I'm just trying to paint a picture." I became furious at the implied criticism, and I said, "Goddamn it, Mark, I'm not talking about your ideas now, I'm talking about mine." But now, with news of his death, I realize that he was trying to tell me something: His paintings were nothing. The essence of his feeling must have been that he was nothing, and the only salvation that his painting could offer, were it to be at all valid, would be that it was nothing. We were always coolly friendly after that; we'd try to talk but had not too much to talk about, me being wary and ready to thrust immediately were he to thrust. I'm sorry now. Why do I feel the seduction and the stagecraft in his work? I see his paintings and I think they are very beautiful, I thrill to the beauty of them and then, every time, I begin to question and wonder if I am falling for clever artifice. Will they become drab craftsmanship when the lights go up? Since his death, I paid a visit of homage to the Rothko room at the Tate. Huge maroon-and-black paintings, sulking mysteriously on the walls, the lights dimmed. An environment. The impact was immediate, and I sat and felt the work, and more and more I wondered. I found what I had always found in Rothko's painting. An undeniable mastery and beauty. Goya, haunting, haunted, brooding, bedeviled. Was this true, or only the mirrored image of another man's mind, or the thought of what a mind should be? What does nothing look like? How is it to bear the anguish of the idea of nothing? If the failure of nothing is to have even that turned to something?

Ad Reinhardt is dead, and Mark Rothko and Barney Newman. And Jackson Pollock (I didn't know him well) smashed his car and a girl against a tree in Long Island, and David Smith smashed his truck and himself against a tree in Vermont. The last time I saw David, I asked him how it was, and he said he was working and covering his hill with sculpture, but that he couldn't stand the loneliness. He felt desperately lonely, this gargantuan man, with his love of people and his many friends. He told me of a young girl holding him and being very kind, and how very much it meant to him, and how she understood his need and stayed an extra day.

And Franz Kline is dead.[7] One of the most beautiful men that I have known. No question about his integrity or moral earnestness. He was as open as a complex man could be. Words tumbled from his mouth over endless beers. Men were bound to each other by love for Kline. Looking

[7]Franz Kline died of a heart attack in 1962 at the age of 52.

at his photograph in Joan Mitchell's[8] studio recently, I found he was one of the few men who, contemplating him, could make me weep. He'd kid me out of that one fast, were he here right now. He loaned me his black Thunderbird for my strangely tragic marriage with Judy.[9] The last time I saw him was at Ben Heller's apartment. We were standing in the huge living room talking amidst the swirling sounds of a large party. He couldn't stop talking that night (he knew that he was dying, though only one or two people knew he knew) and he talked on to me about the work and about the empty sadness in him. Words free and associative, his meanings were always floating to the surface if one listened long enough. "What is it, Jon? What's happening?" He pointed to the walls. There were Rothkos, Klines, huge Pollocks. "They're not the same paintings that we painted. We had a force and a rebellion in us. We were angry and we wanted the paint to be sloppy and we wanted to break everything apart, and now look at it! It has become polite and refined and cultured. I don't recognize it anymore. The painting is not the same." And he spoke about what was happening to him, and how strange it was to face a work in the studio. He said that while working on a simple drawing, a flash of black across the paper, he could not help but know it would sell for $2,000. What did that mean? When he had painted the series of pages torn from the telephone book, because that was all the paper he had, the drawings were worthless and meant everything. In a way, art has to be worthless and must remain worthless in the artist's mind. I remember Bill de Kooning, on being asked what he got for his paintings, answering, "Well, two years ago I wasn't selling them for $400 and now I'm not selling for $800." The deeper unhappiness of his life began when they were selling for $15,000 and then more. Is it possible for any man to separate these things, the work and the price? It is no problem for me, nor has it been. So few paintings have been sold, really, that the price is always a fiction in my mind. The worthlessness of the work is absolute. Could I stand the onslaught of worth I so desperately need for survival?

When Joseph Beuys[10] was here in Edinburgh, I watched him standing before the black, rectangular board (the void? the grave?), his feet fixed apart, one hand hanging at his side, the other gripping the blood-tipped spear, hat firmly to the center of his head, eyes peering past all between him and the

[8]Schueler had visited the American artist, Joan Mitchell, in Vétheuil, France earlier in 1970.

[9]Judy Dearing, whom Schueler married in 1962.

[10]The gallery director, Richard Demarco, brought German artists and their work (Strategy Get Arts) to the Edinburgh Festival in 1970. Joseph Beuys (1921–86) performed a ritualistic act using fat, symbolic of his survival when he, a fighter pilot, had been shot down in World War II. The performance was accompanied by music of the Danish composer, Henning Christiansen (b. 1932). Schueler watched Beuys for hours on several occasions. Beuys, who was entertained by Schueler in Edinburgh, reciprocated in Dusseldorf in 1971.

distance. I watched him for some time, listening to the music from Christiansen's tapes and the idea formed that this was a requiem, a requiem for all the artists I have known. Artists dead and artists living flashed before my eyes. I scarcely paused, the thought was so like a painting existing to be discovered in its depth: a requiem for others I have known, for Billy Southworth and Jimmy Hudson, for Don Stockton, and for endless names forgotten now of those squadron friends of mine who were shot down, so many. It was a war memory, war in total; I couldn't see all the faces. And then I thought: For all the others, too. My work must be a search and a requiem.

My work has been a denial of death, an attempt to deny, and it has revealed death. Raoul said it frightened him to look upon some of the images forming in the grey paintings a year ago.

ROMASAIG, 15 NOVEMBER 1970

This is Sunday and I'm in my workroom in Edinburgh. The sun is shining. I've had breakfast and I've kissed Magda. Two weeks ago was the day before the *Margaret Ann* put to sea. I was in my Mallaig studio.

I was certain that I was to lose my life at sea.

I find myself wanting to leave the typewriter. I still do not understand what the facing of death has to do with my creativity—or the fear of it with lack of creativity. But it has been an ever-present fact in my life. I feel intensely now that to embrace the idea of death—more than that, to feel its reality, is necessary to the maturity of the artist.

That Sunday, I found myself thinking of Magda and finding no way to say good-bye. I couldn't bear that I had not made my will—to safeguard her and the continuity of my work. I felt curiously calm, and I spent the evening typing out the will, putting a copy in my desk and mailing a copy to Archie MacLellan to be kept in his safe. Although I was thinking of death, of my death, of my fear of death, I worked on a number of paintings—all different. A black painting, a grey painting, a black-and-mars orange painting. The day took on the quality of a celebration as I realized that this was the first time in my life that I had been able to truly feel and name what had been at times a nameless, faceless fear, and which had more often been blanked out entirely, or frozen. Emotions calm and dangerous. Knowing this, I wanted to think about it, feel it. What I felt was both specific in regard to next day's sailing, and general in that it had been the undercurrent of every trip or every departure I had known.

The vision of the Sound of Sleat on the late June night was not a void, except that it was separated from us by no possibility of understanding. It related only to itself. The void was in man, was man.

If there is anything in the painting at all of value and of meaning (of the meanings I need to say,) it is held in the image behind the image, in the illogical force of the paint itself and the movement of the hand at the point where that movement can no longer be defined. And yet the anguish of the artist is that very possibly there is nothing behind, nothing at all, an emptiness, a void, not even the void of death and nature.

One time I saw Norman Mailer at a party in Provincetown. (I had met him ten years before). After I realized that he was deliberately avoiding me and, after talking, avoided me again, I asked him, smiling, "Norman, I want to ask you something. Do you hate my guts?" Norman, smiling, "As a matter of fact, Schueler, yes." "Why?" "Well, I'll tell you. Before I met you, I'd read something you had written about your painting and was very much impressed by it." Pause. "And then I saw your work." Norman smiled. Schueler laughed.

But was this just a beautifully clever insult? It could have had a glimmer of truth. It could have been the whole truth. It wouldn't take a Mailer to pose this endless possibility. It hangs over the artist at every moment of creation.

. . .

Wednesday on the *Margaret Ann:* The fisherman and the artist, by what illusion are they driven? For the fishermen are driven men. Of that, I have no doubt. How else can a man exist for days without sleep, doing the most incredibly arduous and dangerous work, and then come back for more the next week and the next. The fisherman, to be sure, gambles the chances of a large catch and big money. But this isn't enough for the fire and passion demanded in the work. He talks of crans and prices, but he, like the artist, lives the urgency of the damned.

What happens when he kills himself—de Staël or Rothko?[11] What is the inner question, secret, and demanding of his life? His end is as violent as his beginning.

Pollock could not paint for the last three years of his life. Marca-Relli once told me that when he lived in Springs [East Hampton], he spent much time with Pollock. Each morning, Pollock would go to his studio and light a fire in the coal stove. Each day he did not paint. Marca-Relli asked him: "Why do you light a fire each day and burn coal when you are not working now?" Pollock: "I light the stove so that the studio will be warm in case this is the day that I can start to paint again." I'm reminded of that summer of 1967 when I went to sea with Jim Manson. It was a day of a gale, a much-predicted gale, and we were at the prawns off the coast of Rhum. The waves turned and twisted the boat and the net fowled and

[11]Nicolas de Stael was forty-one when he committed suicide; Mark Rothko sixty three.

twice we snared huge boulders but few prawns. It was next to impossible to fish, but the men worked away. Finally, I asked Jim: "Why did you come to sea when you knew there would be gales like this?" Jim: "You don't know if you can fish until you try, can you?" "No," I said, "you don't know."

This year I am very productive. I know enough about creativity to know that any day could be the last. I think that some of my productivity now is due to the fact that I have come home to Mallaig. Dear Bob,[12] I have finally done it. I really think I have. All these years, as you well know, since 1958 when I left Mallaig Vaig, I felt that it would be most important to my painting that I go back and work there again. New York was too abstract. I used to ask: "Where is my model? Where is my inspiration?" I provided the fantasy and demand and dream. It was one of the reasons for the woman and the model from 1964 to 1966, even though the woman had always been there. I needed her and I needed to look at her. New York, impoverishing me visually for what I had to see, created in me the time and the demand to stretch the woman on the mat beside my easel so I could look at her, look into her, feel her through all of my senses, to make her bigger than her life,[*] to form the sky of her, to destroy her as she became the sky and all idea and all emotion and death itself.[†] But I knew I needed the sea and the West Highland sky outside the door, to walk into, to feel each day, so that the pulse and beat, and tender line and light turned to light, would become my eye and thereby inform my work and dream alike. I was a thousand percent right.

When I visited Scotland in 1966 and 1967, there was no place for me to work, and Mallaig was retreating into a dream of home, but when I came back this time it was home. I owned nothing. I had a suitcase full of clothes and a couple of footlockers arriving with painting tools and sheets and towels and work clothes. That was it. My paintings, those not loaned to friends, were stored in a studio I had built on Elise's[13] property in Chester, Connecticut—and thank God, because safe storage was the thing which set me free. I could not have traveled with all the rolls of paintings and stretched paintings, nor could I remain and guard them. Were Mallaig not home, I would have had to invent another.

You guessed the truth about Elise and me when you saw my name go back to Jon from John (what a strange two-year fiction of identity). It was over and dying. Dead pain and immobility of spirit. It all died with us. My restlessness, the need to come back to Scotland right then and no other time, created a final anxiety and the real solution.

[12]Schueler's writing is often in the form of an open-ended letter to B. H. Friedman.
[*]See color illustration 10
[†]See color illustration 11
[13]Elise Piquet, with whom he lived from 1966 to early 1970. Schueler acquiesced temporally in her preference for "John" over "Jon."

Elise Piquet at Chincoteague, early 1967, where Jon was writing an introduction to his exhibition The Woman in the Sky, *which was shortly to open at the Maryland Institute, Baltimore.*

. . .

However, it was in my Chester studio that I started painting the small, grey paintings.* For years my work had been getting larger and larger until the 11 by 21 foot Woman in the Sky paintings of 1966. In 1967, I worked on the watercolors in Skye, and I think that these opened up the idea of small size for me. I don't turn my back on large size. It is a powerful experience to work over an area which is beyond one's control, which cannot be seen all at once, which seems like a huge landscape or like passing islands and lochs at sea, never quite being able to contain the complex relationships. But because I had been painting large, the idea of working small was a challenge, an invitation to adventure. Along with that came the challenge of working in grey. This went back to dreams of the early black paintings. But it was also a result of looking at the Mallaig skies and the snow clouds, and the fogs in Chester, Connecticut and seeing them constantly in terms

*See color illustrations 12 and 13.

of color. Color burned in my mind's eye. Now I wanted to explore the same thing in grey itself.

At first it seemed to mean slowly forcing color from the paintings. There were a few grey paintings with other colors, frank blue or yellow or green. Then there were those in which I pushed against the color or into the color with grey, using burnt umber, raw umber, or black. The very last paintings I did in Chester were all grey, using only raw umber. Snow clouds, mists, some with a light trying to be felt, some barely suggestive of shadows and the sea.

After I crossed the Atlantic this year, my first trips to the Highlands from Edinburgh were during snowstorms. I saw the very paintings I had painted in Chester. These and more. It was like a miracle of anticipation. Of no one's concern but my own, yet magic nevertheless.

When I worked on more small, grey paintings in the West Bow studio in Edinburgh,[14] I found myself facing something hard and intractable in the painting. I still don't know why that was. I had a hell of a time, really, yet there was nothing to do but go on. Something was forming, I realize now— but I could scarcely deal with it then. Finally a form emerged, which I rapidly dealt with as an arbitrary rectangle. It was as though, for one moment, it was necessary to see the birth of a hard, obstinate, dominating form behind the mist and cloud. It was the island of Eigg which rested on the horizon off Mallaig. It was a birth form.* It was a reminder of the Woman in the Sky.

Many of those paintings have been repainted in Romasaig, my Mallaig studio. In many cases the hard form has disappeared, only to be felt as shadow, or has shifted, become lighter, moved from the horizon higher in the sky.

When I started the grey paintings in Chester, I knew that I'd feel an urgency to bring color back into them, even as I'd try to assert a discipline to prevent it. This reminded me of painting the woman, having her lie before me, feeling, through eyes, her breasts, her thighs, her open cunt, her skin, her color, her repose, her passion, and knowing that she was to be pushed back into the sky, that the whole effort would be toward the paintings to be painted when she'd no longer be seen. I did one small painting in Chester where I touched the grey with color, a fine, alizarin wound along the horizon or base of the snow cloud. (It was sold a few weeks ago to Jack Thompson of Mississippi, who said he needed it. I wonder what it said to him that he needed it so badly. Was it the woman, felt, or the wound?) In West Bow I did some others, one full of color, reverting back, which was painted again and again and finally finished in Romasaig. Others in which the

[14]Schueler lived in Edinburgh from February–June 1970 while Romasaig was being renovated.

*See color illustration 15.

Magda Salvesen in Mallaig, Scotland, June 1970.

rectangle moved in color, sometimes in the sky. One had a blue shape poised at the base of a vertical canvas. Winter grey, all of these. A *Winter* Series, first struggle, before my heart was warm.

But I had met Magda. When I first saw her, she was kneeling, tying her shoe on the sidewalk. Three weeks later I met her at the Demarco Gallery, in March, at a private view in the large front room on the second floor. (The gallery seems a strange place to me now, held in abeyance, until it feels the life of my show scheduled for February. Only this memory is real.) She was tall and beautiful in a very personal way, and gave the impression of being an interesting woman without one knowing precisely why. Her skin was incredibly soft and glowing, yet firm and strong, and her voice was the sound of her, a music one could bathe in, yet with an urgency behind it. She gave the curious impression of being completely open and frank, yet hidden and elusive. She still does.

Were there any women of my past she might remind me of, they would be Bunty and Neltje. But her elegance was the elegance of Bunty in uniform rather than that of Neltje, encapsulated at the time in New York. I might include the one picture I have ever seen of my real mother. I've only become aware of this now, as I write.

From that night on she was evasive and difficult to see and get to know.

It is important that I try to understand—at least, those few surface

moments that I can grasp. And remembering the poetry, I can't. For there came a moment when I knew that I was pursuing (and I did pursue) two women, not one, and that it would be catastrophic if I did not separate them—in my emotions and in my mind. Now I am bringing them together again, although sometimes my woman Magda and I talk about The Woman in the Sky as though we both would like to understand.

ROMASAIG, 16 NOVEMBER 1970

In all my recent work, the work done at Romasaig with the reality of the sea and sky beyond the window, the painting has become more and more abstract, more defined, and, in becoming so, has become more real. It's what I had hoped for, but had no idea of how it would happen.

The idea of destruction.

The idea of the hand.

The idea of birth, life and death.

The hero destroys. But can the artist function unless he demands of himself this role? The hero is uncompromising. He accepts the demands he creates for himself and allows nothing and no one to interfere. He thereby becomes a monster. Antinature, antiman, antiwoman—in the sense that he doesn't see his life as the support of woman or society, to reproduce and house children.

The idea of the hand. I take responsibility for the hand, for its feelings and its movement. That moment's quiver, that moment's nuance, that caress of paint, that force or failure, that is the hand and is the music and the knowing of the hand.

I remember the thick paint, the knife, the pure, sensual joy of paint splashed upon my clothes, spread across the canvas. The sensual joy of the painting knife cutting, forming edges, destroying them. And I remember trying to make the knife do anything that the brush could do, and realizing the impossibility of this. In 1957, to better realize the infinite subtlety of the Scottish sky, I turned again to the brush. I'm with it still. The hand, the painting knife, the brush. The knife and brush are extensions of the hand, an extension of the sensibility, which is everything one has ever thought or felt or known in one's life. Sensibility thus defined is meaning.

Before, my paintings seemed to me to speak of the violence of motion and emotion. Now that motion is still there but quiet and invisible half the time.

These were the most beautiful words I have ever heard: "I'm longing for you," Magda said, timidly, across the long wire from Edinburgh to Mallaig.

1. *Counterpoint*, New York, 1953, 50" x 48" (o/c 53-2)
Collection: The Detroit Institute of Arts, Detroit, Mich., gift of Rosemary Franck
(Credit: The Detroit Institute of Arts)

2. *Night II*, New York, 1956, 36" x 40" (o/c 56-14)
Collection: Artist's Estate (Credit: Jeffrey Sturges)

3. *Emergent*, New York, 1957, 50" x 60" (o/c 57-2)
Collection of Donald Sherman,
Southport, CT. (Credit: Seth Goltzer)

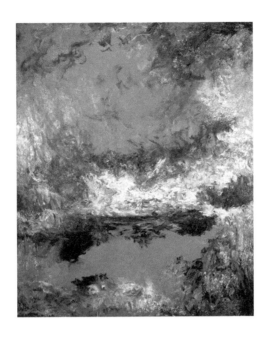

4. *I Think of the Open Sea*, Mallaig Vaig, 1957, 72" x 60" (o/c 57-52)
Collection: Sandy Gross and Anne Conaway (Credit: Oote Boe)

5. *Snow Cloud and Blue Sky*, Mallaig Vaig, 1958, 80" x 71" (o/c 58-13)
Collection: Whitney Museum of American Art, New York, N.Y. (Credit: Oote Boe)

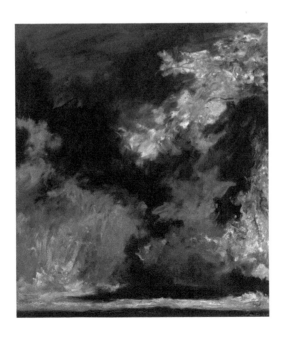

6. Co-editor Diane Cousineau with *La Passion et La Résurrection du Christ*, Clamart, 1958, 66" x 71" Collection: (Formerly) Les Prêtres Passionistes, Champigny, which she trackled down in the parish hall of the church of St. Lez-St. Giles, Thiais, France in 1998)
(Credit: Martine Oury)

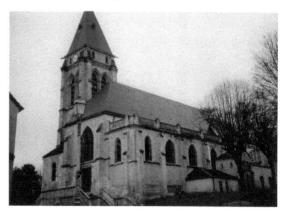

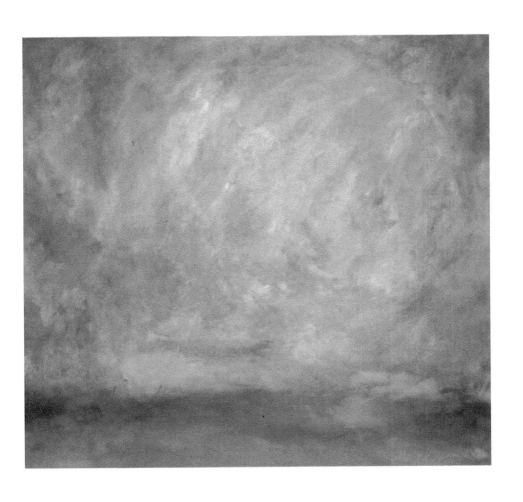

7. *Burning*, Arcueil and New York, 1958–59, 71" x 79" (o/c 59-2)
Collection: Deedy Heller Mishler, Sharon, CT.
(Credit: Dan Dragan)

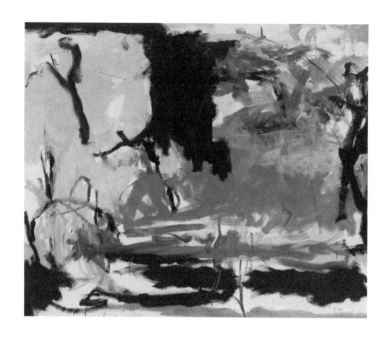

8. *Black and Yellow*, New York, 1962, 79" x 95" (o/c 62-6)
Collection: Artist's Estate (Credit: Jeffrey Sturges)

9. *Blue Snow Cloud II (Toward Mourning)*, New York, 1963, 48" x 46" (o/c 63-10)
Collection: Artist's Estate (Credit: Jeffrey Sturges)

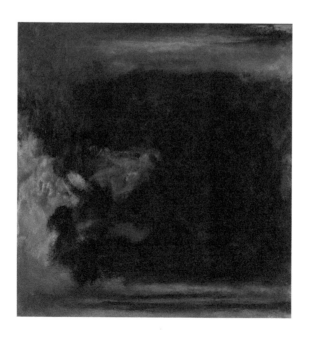

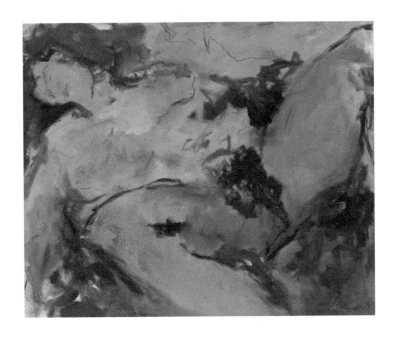

10. *Reclining Woman: Blue and Orange*, New York, 1964, 50" x 60" (o/c 64-7)
Collection: Artist's Estate (Credit: Jeffrey Sturges)

11. *Woman in a Morning Sky*, New York, 1964, 74" x 85" (o/c 64-28)
Collection: Artist's Estate (Credit: Jeffrey Sturges)

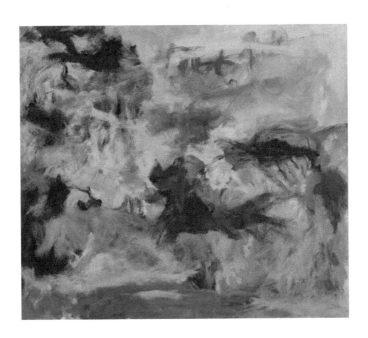

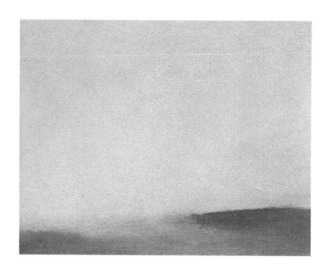

12. *Grey Sound*, Chester, CT, 1969, 8" x 10" (o/c 69-5)
Collection: Magda Salvesen (Credit: Jeffrey Sturges)

13. *Sun and Grey*, Chester, CT, 1969, 12" x 10" (o/c 69-26)
Collection: Joan and Richard Ziemann (Credit: Oote Boe)

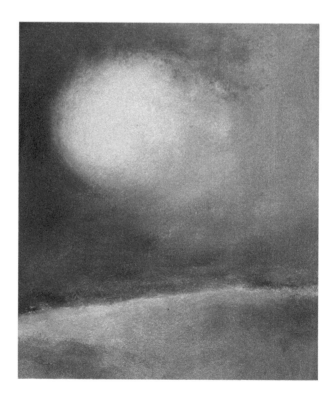

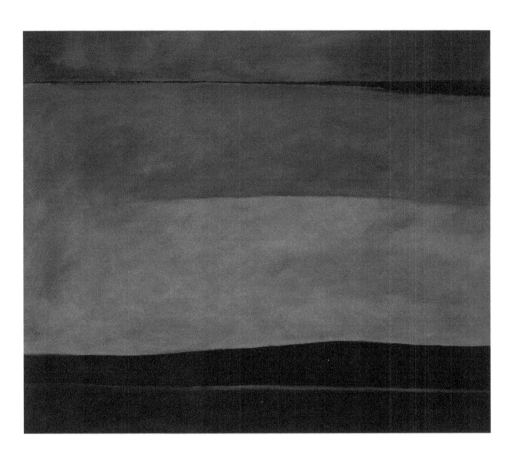

14. *The Sound of Sleat: June Night, XI*, Romasaig, 1970, 40" x 48" (o/c 48)
Collection: Scottish Nattional Gallery of Modern Art, Edinburgh, Scotland
(Credit: Antonia Reeve)

15. *Winter Series, 12: Eigg,* Edinburgh, 1970, 24" x 30" (o/c 69)
Private Collection: Buckinghamshire, England (Credit: Oote Boe)

16. *Magda Series, 6: June Light,* Romasaig, Scotland, June 1970, 28" x 36" (o/c 86)
Collection : Artist's Estate (Credit Jeffrey Sturges)

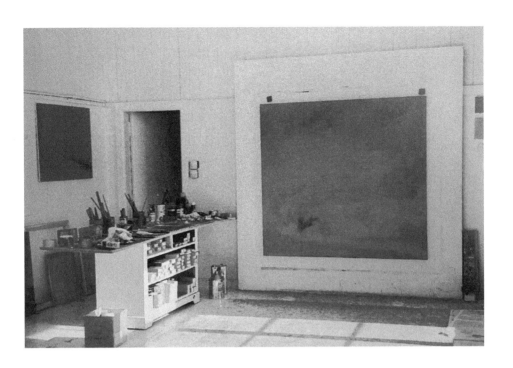

17. The studio in Romasaig, 1971
(Credit: Magda Salvesen)

18. Edinburgh College of Art, 1973
(Credit: Archie Iain McLellan)

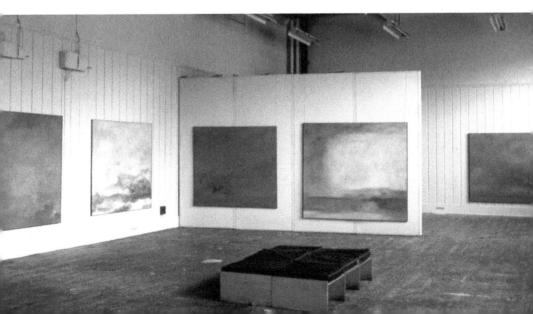

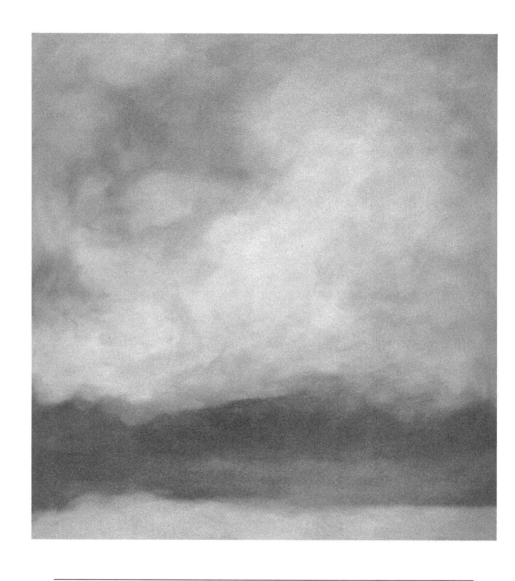

19. *Storm, Light and Black Shadow of Skye*, Romasaig, 1974, 79" x 75" (o/c 559)
Collection: Justin Scott and Amber Edwards,
Newtown, CT (Credit: Oote Boe)

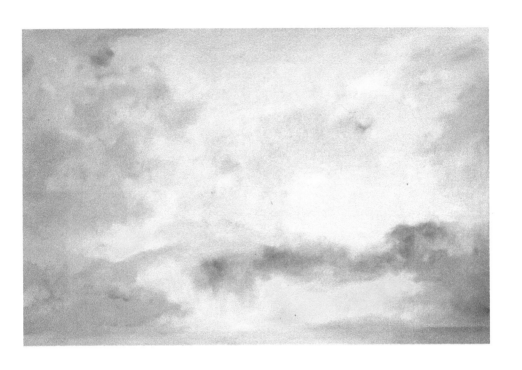

20. *Mood with Magda: September II*, New York, 1976–1981, 79" x 120"
(o/c 799) Collection: Justin Scott and Amber Edwards, Newtown, CT
(Credit Oote Boe)

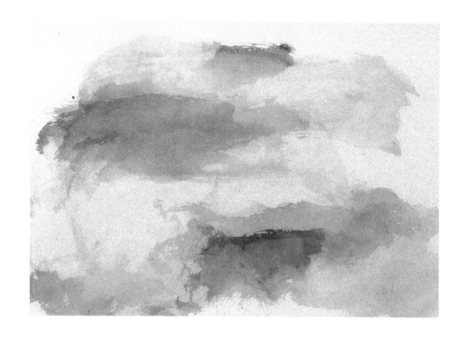

21. Watercolor #418, Romasaig, 1980, 10 ¾" x 14 ½"
Collection: Artist's Estate (Credit: Oote Boe)

22. Watercolor #491, Romasaig, 1981, 14 ⅜" x 21 ¾"
Collection: Artist's Estate (Credit: Oote Boe)

23. *Sun Dog Seen from the Margaret Ann*, New York, 1982, 36" x 51" (o/c 1254)
Private Collection (Credit: Oote Boe)

24. *Oscar Isn't Returning*, New York, 1984, 36" x 48" (o/c 1413)
Collection: Artist's Estate (Credit: Jeffrey Sturges)

25. *The Search: Bunty's Blues*, New York, April 1984, 79" x 72" (o/c 1411)
Collection: Artist's Estate (Credit: Jeffrey Sturges)

• • •

ROMASAIG, 17 NOVEMBER 1970

I think of this artist's life, in part, as a rending of veil after veil of self-deception. The romantic never knows whether he is creating the veils out of his fantasy, or is assuming, out of his fantasy, a truth behind the veil. As each dim shadow becomes defined, it can only be questioned as a cover for the next.

ROMASAIG, 18 NOVEMBER 1970

The Wedding night.

In September 1941, I boarded a train in Chicago under USAAF orders, heading for Maxwell Field, Alabama. The first day after I arrived, I was standing on the apron of the field, looking over the training planes. I happened to glance up and saw, maybe a thousand feet over the field, two small trainers approaching each other on a right-angle course. It was a beautifully sunny day, mellow and southern, and the light glanced off the wings of one of the ships. I watched as they slowly came together and one blew up and the other spiraled straight into the ground.

We were in a basic training program—six weeks to make military men of us before we were to be sent off to other bases for navigation or bombardier training. I was stationed at March Field at Sacramento, California. The T-11's, twin-engined, silver beauties, would buzz over the nearby highway when landing or taking off. They'd carry pilot and co-pilot and four of five student navigators lined up at desks and drift meters. I was so rigid about wanting to do everything right that for a while I was terribly slow at learning. But somewhere along the line, I got the sense of it and became a pretty good navigator and stayed that way. I remember one night marching with the platoon to a class, the platoon leader's cadence bellowing out against the stars, and I realized that for a moment in my life that terrible pressure to do something wasn't there, that all I had to do was move along where the orders took me, and that I was a free man.

All of us knew we were flirting with death from the moment we saw the planes. It was like the feeling at the beginning of a love affair, when all of the enticement is joy, yet one senses also the excitement of unknown possibilities, sadness, treachery, death. We started flying night cross-country missions—down the Sacramento Valley, over the blue lights of the valley towns, across the threatening mountain shapes through stars to Arizona and back. One night, a plane full of classmates didn't return. We learned later that it had crashed against the side of some high mountain mass. We'd hear death in the night as we'd hunch over our instruments in the droning planes, or on the field as we'd listen to the landings. We weren't dramatic about it. We tried not to think about it. I turned my face or closed my eyes or blinded my intelligence so that I couldn't see that the black sky which was my memory, was inexorably filling with images of death. There is no

way to say it strongly enough to give the truth. It is terribly important for me to understand, for without understanding it, I can't understand life. That's why, a couple of weeks ago, it was of such importance for me to tell myself over and over again, on the Sunday before sailing, that I feared death and that I felt the fear, and while sailing I tried to think of the ship floundering and of my going down with it so that I'd somehow know the feeling of the living image hidden beneath the abstract fact of steering through the waves.

ROMASAIG, 19 NOVEMBER 1970

During the three-week warm spell of this year's June, the haze formed over the Sound of Sleat, more intense each day. One late afternoon, I was walking down from Mallaig Vaig, looking southwest over the harbor and out to sea. There was no telling where the sea ended and the sky began; it was all a mysterious haze white, pulsing with the northern summer light. It was late Friday and the boats were coming in, and they emerged like formations of aircraft from the white sky.

· · ·

The implied horizon in my paintings is the horizon of altitude, as though one were flying and tried to understand the continuity of sea and sky.

In the war, my fantasy was that I would live.

In reality I must have known that I would die.

Living, I felt responsible for each man's death.

Death is a disappearance in the sky.

A B-24 becomes a puff of black smoke during a rendezvous over Cornwall.

A Focke Wulf slams a B-17 head on.

A severed tail section floats in the air like a leaf. Three parachutes open. A fourth, slim trail against the sky, drops streamlined swiftly, as though it were meant to be.

Two minutes before St. Nazaire, the squadron is seven ships. At St. Nazaire it is two. A winter sky waits, vast and silent silver, and the grey sea rises.

· · ·

We formed our group[15] in Boise, Idaho. Major Marion, our squadron commander, was probably a lieutenant. His was one of the five ships shot down over St. Nazaire. Billy Southworth was my pilot, Jimmy Hudson co-pilot, and Milt Conver the bombardier. I was navigator, crammed, with Milt Conver, in the Plexiglas nose of a B-17, the perfect place to fly. There has been

[15]303rd Bomber Group, 427th Squadron.

nothing like it in planes since. I remember skies blushing lightly in the atmosphere, descending brightly to a reddish earth, deserts below, escarpments, mountain ridges fading into the horizon light. A curious vantage point for living in the sky. Most of my paintings now, paintings of the sea and sky, are painted from an angle of view which I'm sure springs from those flying days.

Billy and I hated each other's guts. He was the cocky son of a bitch, the pampered only son of the manager of the St. Louis Cards. He had played ball himself, had been farmed out to Toronto, I believe, before he had become a pilot. Our backgrounds and personalities couldn't have been more different, except that we were both prima donnas of kinds. Billy was a hard-driving guy, very ambitious and driven to try to be the best. I probably have many of the same drives, but they're confused by the complexities of my being, fears of failure, depressions, impulsive responses to the world, inner contradictions. I think we disliked each other at first sight. When on one of our first missions together I had goofed in my navigation, Billy picked on it immediately, and was pretty well convinced that he had an incompetent as well as kooky navigator on his hands. This was not a happy prospect for a bomber captain preparing for combat. Jimmy, on the other hand, believed in both of us and had been trying to sell each to the other—without success. Jimmy was one of the nicest guys I have ever known. Large, generous face. Big ears. Sweet natured, competent, intelligent. He had been a newspaper man, and when he'd sit down for an afternoon to pound out some letters, the typewriter would move at a furious speed. His smile was as sweet and open as Billy's was sardonic. He was the kind of guy who liked people and showed it. Milt was another wonderful guy. The life of the party, full of good humor, he kept the crew laughing—often with good timing when tempers were at a high pitch.[16]

It was because of Jimmy that Billy and I became close friends. One day we went on a cross country flight to Chicago. We took off in perfect weather, but about two hours east of the base we saw a front rising in the distance. From the time we flew into the clouds, I navigated on dead reckoning—as part of flight training. I kept the radio silent. We climbed for some time, hoping we'd rise above the front. About two hours later we were still in total cloud; silver greyness pressed against the windows, opaquely glowing, holding us mysteriously. We couldn't get out of the stuff, though we finally climbed to about 24,000 feet. Billy kept calling to ask me where we were, in a voice which plainly suggested that I wouldn't have the slightest idea, and I was getting more and more enraged by the minute. Jimmy came down to encourage and to mollify me. Though I wanted to take the charts and shove them in any convenient spot, I kept working

[16]Schueler kept loosely in touch with Milton Conver (1916–92) and his wife, Jean, after the war.

and the line of the plotting moved steadily along the charts. The next thing I knew, the plane started flying all over the place. Billy was no longer following my directions, but had decided that we were lost and was trying to pick up the beam. There was nothing for me to do but track him. The line moved crazily over the chart until he picked up a radio beam and turned and headed back toward the base. He'd call up and taunt me once in a while, and finally he asked me for a position report. I told him we were about one minute east of the little town of C-, and by the grace of God, in one minute the clouds parted below us and there was the sweetest little town west of the Mississippi. I wish to hell I could remember its name—I'd like to immortalize it. I called Billy on the intercom and said, in as matter of fact tone as I could manage, "We are now flying over C-, and our ETA Boise is 15:36." "Roger," he said, and he didn't say one damned word more for the rest of the trip. When we landed, Jimmy stopped me and took my charts and told me that he wanted to show them to Billy so that he could see what had happened. I didn't wait for the demonstration, but walked past Billy without saying a word.

That night at the officers' club, I was sitting at the bar properly brooding when I noticed that Billy was standing next to me. He ordered a drink, and then he said, very quietly, "That was a great bit of navigating you did this afternoon." I said, "Thank you, Billy" and from that moment on Billy became one of the closest friends I have ever had. We worked together perfectly as a team, and we were constantly chalking up records in practice missions or, later, out of Muroc and North Island,[17] on submarine patrol over the Pacific. We established patterns and procedures, and we pushed our timing to an almost-finicky point of accuracy. Billy was concerned about everything. He'd lecture Jimmy about the weather and the dangers inherent in the terrible up-and-down-drafts of thunderheads. He worked over bombardment procedures with Milt. And he liked to scare the shit out of me over the Pacific by buzzing the waves until I could practically feel the spray of the whitecaps on my heels.

When half the group was sent to Alaska, new second lieutenants came to form crews, and the rest of us were suddenly senior pilots, navigators and bombardiers. Jimmy, our co-pilot, was given his own ship—on paper, because now the remaining B-17's that would fly were being reduced to trainers and were used by the entire group. He had a green crew, and I would fly with him at times for practice-training missions to coach his navigator. But, Billy, Jimmy, Milt and I remained very close. Our new copilot was a heavyset guy who had been an insurance actuary in Chicago. His name was John Dillinger and he hated flying. (Later, in combat, this became more apparent; he'd often fall asleep on missions. He would sit around in

[17]Muroc Army Air Field is now known as Edwards AFB, California. North Island was an aviation school near San Diego, California.

the evenings, after combat, and figure out our chances of survival. At one point, he had it down to the next mission. Billy got mad as hell when he heard about this. I think John lasted through ten missions and then one day when he was riding his bike on the base, he ran head on into a lorry loaded with bricks and banged himself up so badly, he was in the hospital for a year.)

Most of us fell in love in Boise [Idaho]. We were constantly being alerted and the rumor was that we were being sent to England. For a week or so after the bunch was sent to Alaska, it seemed as though our fragmented group wasn't worth sending anywhere, but then the alerts and rumors started again.

Mainly, it was all flying and fucking. This was the source of all our fantasies, but it became more complicated than that. There wasn't one man who wasn't thinking of death. Being trained for combat, we seemed to lose our hold on a feeling of responsibility for anything but flying. Yet the trappings of our life gave us an unreal aura of respectability and responsibility. We were a bunch of kids, ripped out of our ordinary ambitions, where we may have been starting, succeeding, or failing, like myself. We were clothed in uniforms and wore the insignia and returned the salutes of enlisted men and had good pay checks, including flight pay and the promise of allotments for dependents. We flew aircraft worth a quarter of a million dollars; drivers took us into town; we spent freely at the Deauville Club or went horseback riding or played golf. Some of us bought cars. Some, engagement rings. We played at Normal Living. At the same time, we felt we were hovering over some black void. Combat was a completely unknown quantity. We were being trained for it, so all of our urgency strained toward it.

We had been alerted to fly to England from Boise but had been sidetracked to Muroc and North Island by the Japanese submarine scare. Then we were sent to Alamogordo. I remember the dust and sand blowing across the runways, swirls and eddies, fouling the engines. Billy and I shared an apartment in town. We bought an old Plymouth, which we used for trips around New Mexico. We kept it when we were transferred to El Paso, Texas, for what was to be our final training.

By now we had very few Fortresses left flying in which to train. Many had crashed. Others were out of commission, waiting for parts. Some had become hangar queens. When we did fly one, we were never sure it would stay in the air very long. One of the pilots in our squadron, coming in for a forced landing with practically no engines left and God knows what else wrong, crash-landed between two hangars, and the crew walked out alive. Everything was getting rather mad. The patched-up planes, the dust-laden air over the runways, the drifting sand, the endless no-man's land of the desert, the tawdry little desert town serving our base, the lack of women, except for a bunch of whores who had taken over an old, beat up motel.

But even with the whores it wasn't enough, and everyone was writing

slushy letters and realizing how much in love they were with the last girls they had known in Boise. A bunch of Deauville Doves caught husbands that way, and every Boise girl was remembered in a kind of dreamlike haze that promised a golden life, settling down, building for the future, and living the American Dream. I had met Jane [Elton] in Boise, beautiful ass straining at taut riding pants, and high boobs dancing to a sexy beat as she posted on her mount, teaching me how to ride. I sent her a wire from Los Angeles asking her to marry me and talked to her long distance from the barracks at Alamogordo, wondering what the hell I was doing. I was strangely detached about it all, and too embarrassed to try to get out of it. In El Paso we were put on permanent alert and only allowed occasional six-hour passes. When Jane arrived, I managed to sneak off the base to meet her at the train. She looked a perfect stranger to me, though I dimly remembered her smile. War creates urgencies that look like life. I'd get into town once in a while to visit her at the El Paso Hotel. We'd make love in the afternoon or evening and then I'd drive back to the base in the old Plymouth. There was no way to get married, though a minister in the Episcopal church was alerted, because I couldn't get a six-hour pass.

In the meantime, I was flying almost daily. I was now a senior navigator and had to accompany the new navigators on cross country flights in the few battered B-17's left to the squadron. We'd often fly across Texas and back, and in the late afternoons the thunder heads would form over east Texas as high as forty thousand feet. One evening they were so thick, obscuring the mountains, that we had to fly low to escape them. I navigated by lightening flash to keep us from being swallowed by the thunder heads or smashed by the mountains rising from the plain.

On August 22, a six-hour pass was announced for the entire squadron, except for the members of Jimmy's crew and other officers posted to the ship, who were to fly to Boise. I had promised Jimmy I'd be senior navigator and work with his new man. I really wanted to go on the flight. My romance was getting sticky and dramatic with tears and complications and demands for proof of my true love. But I felt guilty. Wedding arrangements had been made, attendant upon the pass: license, minister, small diamond engagement ring from a credit jeweler. Solemn vows and promises. I asked Captain Marion if I could be taken off the flight so that I could get married. He said that the orders came from above and I'd have to see Colonel Walker. I saw Colonel Walker, who asked me what the hell I wanted to get married for. This brought out all the Schueler persistence. I argued and pled, until finally he said I could get married if I could find a replacement as senior navigator for the flight. He also said I could only have six hours. "One can't get married in six hours, sir." "Why not?" he said, staring at me grimly. He was West Point and had been married for some time, and possibly knew something I didn't know.

The only senior navigator left was [Leon H.] Shane whose fiancée was visiting him from New York. We'd never gotten on too well, though he was

smart as hell and way up toward the top in our navigation class at Sacramento, and I admired him. He'd taken a lot of shit from the guys because he was Jewish, which seemed to provide some kind of license to needle in those days. I stopped at the barracks and asked him to replace me. He said no, he couldn't. I started to put pressure on him. Other officers joined us. They were obviously getting mad at Shane because he wouldn't take my place, and soon they were giving him a hard time. I can see him now, lowering his head and obstinately refusing, until finally he couldn't stand it anymore.

Jimmy's flight was postponed because of storms in the area and predicted thunderheads, so most of the guys were able to come to my wedding. Billy was best man. Jimmy gave the bride away and Milt's girl, Jean, who had come to visit, was maid of honor. Afterward, we all went over to the hotel and had food and drinks. Quite a party was developing, but then a call came from the base that the Boise flight was on and the members of the crew and the other officers who were going as passengers had to leave. I could have gone by now, the wedding had taken place, and theoretically I was supposed to be back on the base in a couple of hours myself. But I had decided that I'd stay overnight, come what may, the romantic in me as unable to deny the wedding night as the wedding itself.

I remember that Jane and I sat in the hotel room self-consciously and had a drink and talked and eventually went to bed and made love. It was kind of forced and not as charged with illicit excitement as it had been the other tearful nights. Afterward, I woke up feeling unaccountably depressed and got out of bed and walked over to the window and stood there for a long, long time. The sky was black in the early morning dark. My watch showed 1:10 A.M. I saw flashes of distant lightening and thought I heard the slow roll of thunder. I've never felt so depressed in my entire life, except perhaps on that child night of my mother's death, when I felt alone beyond loneliness.

ROMASAIG, 20 NOVEMBER 1970

I lay awake that night beside Jane. In the morning, I left her and stopped in the hotel lobby to buy the traditional box of cigars to pass around at the base. At the gate I returned the MP's salute.

He said, "I'm sorry, sir. It was a terrible thing." Then he looked at me strangely. "You haven't heard?"

I could feel the black emptiness forming in me. I'd heard but hadn't heard. I knew but didn't know.

"About the crash, sir. Lieutenant Hudson's plane blew up last night."

I've tried to make it real over and over again. I don't think it is real to me now.

Already the bunks had been stripped, the blankets piled up, footlockers closed, equipment piled neatly on top. The large room was empty, the sun

shining through the windows, the beds of the living looking more dead than those of the dead, which had the look of departure.[18]

ROMASAIG, 24 NOVEMBER 1970

To go to sea on the *Margaret Ann* is to sail into my picture. The image is the sea and the sky and always, except when I am before the canvas or in my fantasy, I am standing on land and lifting myself forward into the sensation of sea and sky, of snow cloud and sun. To sail in the *Margaret Ann*, or to anticipate sailing—perhaps it's the imaginary event more than the real one—brings me deep into the painting. The storm takes place; the ship moves under me; the mist marries the sea. From the sea, the sky is even more massive, changing, subtle, incomprehensible, than from land. Yet, the emotions of the voyage itself are far more profoundly real before and after than during the days and nights at sea. Are the strange, deep, boundless emotions of death more or less real than the curiously defined events at sea? The fantasy, before and after, seems powerfully three dimensional. The emotions of the voyage have the two-dimensional quality of work, of action.

ROMASAIG, 25 NOVEMBER 1970

We were supposed to sail at 10:00 A.M., but Jimmy[19] was having some trouble with nets, so we waited until after 12:00 before casting off. By this time, I had more or less settled in. My lumpy mattress was drying in the engine room. Raymond had cleared the bunk of soggy books and papers, empty bottles, old oil skins. He threw the bottles over the side, one by one, breaking most of them in a haphazard target practice. More debris at the bottom of the sea.

The *Margaret Ann* sailed across a wind-flattened sea into a force-ten gale sweeping the Sound of Sleat. Then we rounded the Sleat Peninsula and entered Loch Eishort and Loch Slapin, sheltered from the gale. We fished late for sprats and had some luck, Jim always asking for one more try, one more try, and then finally, after two in the morning, we went to sleep.

The bell of Jim's alarm went off at 5:00 A.M. The engines were started and we cast off (we had been anchored near the silver shore and black hill) and moved into the night to search again.

We had tea. Breakfast. Dawn. We searched and searched, casting the nets, trawling, bringing in small catches or nothing at all. Alexander in the *Silvery*

[18]The plane blew up near Las Cruces, New Mexico. Seven men were killed, including Shane. Two were thrown clear, and although injured, parachuted to safety.

[19]The three fishing boats mentioned here were all run by the Manson family. Jimmy and Alexander were sons of Jim Manson; Raymond the son of Jimmy, and Tommy Mathieson, the son of Mary Manson, Jim's sister.

Sea was our partner. Jimmy in the *Crystal Sea* was still in Mallaig. We talked to him occasionally over the radio. Alexander jumping on to our deck excitedly, holding a paper scrap from his sonar, interpreting to Jim, demanding that there be fish. Finally by one o'clock, the *Silvery Sea* headed back to Mallaig with its hold partly full, and we left the loch for the open Minch on our way to South Uist. Jim went below. Tommy was at the wheel. I stayed in the wheelhouse with him. The others were also below, eating, trying for sleep. But quickly, we were in a heavy sea, the boat slamming against the waves, and finally Jim, unable to sleep, came up and took over the wheel. He had now been up since 6:00 A.M. on Monday, with perhaps three hours' sleep the morning of this day. We head-ed northwest into the wind, which was now blowing a gale—force eight, Jim said.

We started the hunt again. Jimmy and the *Crystal Sea* were on their way to join us. We moved back and forth across the water, Jim studying, learning where the herring were, watching the radar, the shore, the sonar, the weath-er, the many other fishing boats that were working the loch. Dusk, then dark-ness. All boats were lights. The *Silvery Sea* talks to us. We flash our light. Alex-ander spots us and sailing to us, starts to work with us. We cast the nets, the ring net this time, for herring. Once, twice, again. We cast near to the shore. Each boat, one casting the net, the other picking up the end with the flash-ing buoy, circles to come together. Each boat flashes its light madly against the shore and hill. The men all beat on pans, metal, rails, masts, anything, the light and noise scaring the invisible fish away from the shore and into the net. The night is black, with occasional stars. Lights of other boats as they move in toward us. They sense the fish. Erratic beat of the Scottish fishermen, hes-itant to channel their emotions into it. The boats come together. A rope is passed. Men jump from one to the other. The nets are pulled in, slowly, slow-ly, pulled in. Gulls form. They sit and rock upon the water, crying. Some are within the closing circle of the net, some outside, some moving, flying rest-lessly, sensing the fish. They all cry. At first they cry slightly, pleadingly. They cry to us, they cry to each other. One swoops for a fish. Another. One, resting on the wave, cries, suddenly sees a fish, too deep. The cry, the sharp sound no longer a sigh, no longer pleading, no longer a first moan. They cry shrilly, a beat increasing, an angry, hysterical, sexual sound, all of them crying, cry-ing at each other, screaming their excitement. I wait, sitting out of the way at the bow of the ship, listening to the sound, wondering at the shrill, ani-mal intensity of it, excited by death. The men, now hard working men, ex-cited, no longer tired, men who have been working all the night before, have sailed through two gales, have slept a few hours in their clothes, have repaired the torn nets, the men are now deep in the sky and sea, pulling the net into the glare made by the ships' lights which are now turned on, the gulls fad-ing into the shadows beyond the pools of light, gulls in the closing circle of the net, gulls crying of the men pulling in the fish, which will soon be sucked into the hold through a hole on deck, the gulls crying of this death and of

their own wish to kill. It is all the passion of the killing for eating, a gourmet lust to live, death and the sharp life, death and the beat of bars against metal and straining at the nets, and the abstract glory of the closing net, buoys bobbing, the pulse and beat of the throbbing waves and the scream-cry of the sex-food-death-maddened gulls. When the ring is closed the sound of the gulls quickly fades away, passion spent. Nets bulging with fish are raised to the deck, opened, and the fish slip and slide and slither into the hold.

The beat and pulse of death and life were in the Sound of Sleat, in Loch Eishort, in Loch Slapin, in the Minch, in Loch Boisdale of South Uist.

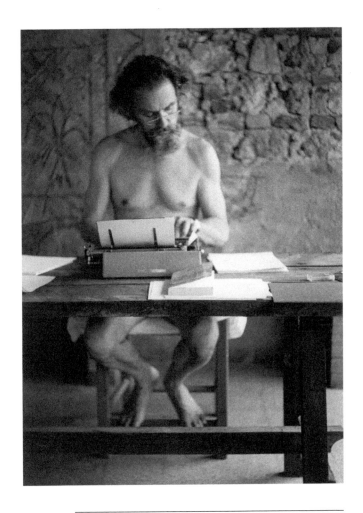

Jon Schueler in San Gimignano, Italy, summer 1971,
writing the piece on Piero della Francesca for the book.

MOOD WITH MAGDA:
REFLECTION

Schueler entitled this section "Mood with Magda: Reflection" (covering the years 1971–1974) because this period, in retrospect, appeared to him a quiet and untroubled time, free of teaching responsibilities and the distractions of city life. From 1971–75, he and Magda Salvesen used Mallaig as a base, living extremely simply, with few major expenses other than those of painting supplies. It was a very productive period as he could immerse himself entirely in his painting while Magda helped with the cataloguing and photographing of paintings and worked on all the preparations for shows.

Long work spells were punctuated by short stays in Magda's apartment in Edinburgh, trips abroad, including a three month stay in Paris to work on the book, and returns to the States in 1971, 1973, 1974 and 1975. Expenses for the American visits were covered by invitations to give talks at such institutions as Yale, the Maryland Institute (in Baltimore), the University of Manitoba, the Art Institute of Minneapolis, and the Cleveland Institute of Art.

This period brought unanticipated recognition and success to Schueler, although the details of these events will not be described until part six. Two important exhibitions in Scotland, a film made about him, and Ben Heller's decision to represent him in the States (resulting in extended sales and significant American shows) all took place during these years.

The opening section of part five was written in Italy on the first journey which he and Magda took together after she left her job and moved to Mallaig to be with him. After dropping in on his artist friends Raoul Middleman and Ruth Channing in Florence, they spent about a month visiting other Italian towns before taking the train to Germany to visit artists, including Joseph Beuys, whom they had met the previous year in Edinburgh.

The book was then put aside, while Schueler worked continuously in his studio, and was only taken up the following year in Paris when he circles back to his early years as an artist, both in California and New York; his instructors, especially Clyfford Still; and his immersion in jazz.

Then, back in Mallaig in 1973–74, Schueler would, for a time, set himself the arduous task of writing each day, in addition to painting, as he approached the most traumatic material of the war period and his Air Force career.

SAN GIMIGNANO, 12 JULY 1971

We have not stopped in the month since we left Mallaig: Venice, Burano, Torcello, Murano, Chioggia, Padua, Vicenza, Verona, Mantua, Bologna, Ravenna, Florence, Fiesole, Viareggio, Siena, Orvieto, Todi, Assisi, Gubbio, Urbino, Sansepolcro, Arezzo, Monterchi, San Gimignano. We are stopping now, for three days, and I am going to look at my typewriter and Magda is going to read novels, just as one is supposed to do on a proper holiday. I have managed to read some Berenson on the Italian painters and am more interested in a copy of Vasari's *Lives of the Artists* which I have hauled from place to place.

In Sansepolcro, we saw Piero della Francesca's fresco of *The Resurrection of Christ*. I hadn't known what to expect. I didn't remember the painting from reproductions, though now I know that I have seen it many times. We had just come from Urbino where I saw Piero's small oil paintings of the *Madonna and Child* and *The Flagellation of Christ*. They were exquisitely painted and the color was pure, the faces distant in their reality, and the architecture a cool perfection in which to contain the frozen drama of these lives.

In *The Flagellation* I remember the assertive, posed, poised figures in the foreground, and the delicately flaying rods or whips, a silent, almost secret drama in the background. Above all, I remember the Christ figure, his face depersonalized by a damaging mark across the panel, a wound so delicately wrought that it wove the Christ figure more serenely into the perfection of his surroundings than Piero could have imagined. These were the paintings that were in my mind's eye, these were the figures, when I entered the town hall of Sansepolcro. The fresco, on the end wall opposite the door, scarcely caught my eye. Sober colors, olive drabs, a Christ, a marble siding, some figures at the bottom of the painting. I went to the group of paintings on the right wall and studied the generous Madonna shielding many small figures with her cape. When I really looked at the resurrected Christ, I could not see Him. I could not feel the painting. I had to take myself away from it because I could not understand it in terms of the paintings I had seen in Urbino, so I walked through the second room and back again and then looked up and found myself confronting a man unlike any I had ever seen before. He was alone in a silent world, alert to his own being, assertive in his stance, erect almost to the point of being arrogant. But arrogance was not necessary. He knew. He knew his power. He knew the drama of his past. He knew of his own willingness to play the part in that drama, and he knew now that the first act was over, and the second long act would begin. No one else knew. Not a soul knew—but God, of course, whose son he knew he was. His face was filled with the infinite sadness of all that he had seen and all that he would ever see, of all he knew. It was the face of a man separated from mankind by the very force and magnitude of his human experience. But now, with incredible virility, he is saying, "All right, the suffering is over, the submissiveness, the meekness. We hold the crown of

thorns and the cross and the flagellation in our being. We hold all that experience that has been witnessed, the blood and the torn flesh and the weight of the cross and the kiss of Judas; and, containing that rich experience, we now have a power and a force of which the world has not yet dreamed." The erect body, the foot resting on the edge of his marble crypt, the arm so assuredly resting on his knee. The standard held self-confidently. The power would emanate from all that had been done. Man had created, under the guidance of God, a myth, which was now embodied in Christ's own person. He was relieved of all acting, and now only burdened with the knowledge of all he knew and of his own power arising out of that knowledge. The awesome sadness in his eyes is infinite. So He must know, from the very experience of his life on earth, the corruption and pain and intolerance and brutality that the wielding of this power will bring to man on earth. From now on, most evil will be done in his name. Yet, there is no evil, only knowledge and strength in that face.

Few artists have made me feel that they have so submitted to the idea as Piero did in this fresco. I was able to pause and appreciate his hand in it. The painting made me realize that the aim, the creative aim and driving force of generation upon generation of artists, was to decorate a space and illustrate a story. The story would be told, over and over. And the walls would be decorated. I have walked into cathedrals and churches where the walls and ceilings were so burdened with painting that I could only feel their weight, feel bewildered and depressed. Even the story would get lost in the bloom of abundance, and the incidents become sterilized and muddled by the interweaving of the decorative and architectural and symbolic and story intent of many ambitious artists. It's possible that the greatest artists surmount the burden of their time. And then, only in a very few paintings. Or perhaps they use those burdens. Piero's *Resurrection* was story and decoration. He had gone home to decorate a wall in the town hall before he died. The fact of decoration can no longer be seen. The hall is painted a white as pure as that of any modern museum or gallery. The fresco is isolated by the white, held in an arch—its only link with design. But at one point, it must have been part of more, and more surely diluted by the design and architectural scheme of the whole. Were there more paintings? Or more planned? Perhaps he died too soon to finish a bigger design, or perhaps time has so ravaged the walls as to leave, neatly, this one work.

The burdens of today, a burden I accept, is to paint without the impulse of decoration or illustration. The artist is challenged to face alone his invented world.

I am reminded of one other thought by this memory of Piero della Francesca's *Resurrection of Christ*: My friend John Francis,[1] who is making it his

[1]John Francis (b.1939), a former nuclear scientist, was, in 1971, the first full-time director of the Society, Religion and Technology Project sponsored by the Church of

business to study the possibilities for man's survival on this planet, feels that inherent in the Judeo-Christian philosophy is man's self-destruction. The idea of man being unique, apart from nature, a spiritual entity related to God and the Son of God, but master of the natural world (a gift by God to be exploited)—this spiritual fantasy has blinded man's essential understanding of himself as a part of nature, one that has to move and flow with nature, one that cannot exist outside of nature's very real time and presence. There is something about the Piero *Resurrection of Christ* which seems more knowing and more haunted by this knowledge than any I have seen. There is awareness of power, overwhelming power. But there is no joy in that awareness. The Last Judgment has been upon us from the beginning, doom enclosed in the very optimism of the Resurrection. The Last Judgment of Christian paintings, souls appointed for Heaven and for Hell, is in reality the Next-to-the-Last Judgment. It is the one which enables us to continue to believe in our very special presence on this earth and in a Heaven and Hell designed for our very own exquisite reward or sensual and egocentric punishment. The Very Last Judgment exists because we have the arrogance to imagine the one before: It takes place not in the mind of God, but in the movement of a lone, crucial tree felled in Earth's forest, or in the sensual motion of that special blob of oil on Earth's sea which will signify, long, long before Man can comprehend, that he has so changed the balance of nature that it can no longer support his presence.

· · ·

I am sitting on the terrace outside our room in San Gimignano. Without the sweat in my pores, all that I can see is as cool and impersonal, as still and as contained, as a great painting. The haze itself is flattened by the sun. Dotted fields on nearby hills form primitive vertical patterns. That which was primitive in the Italian paintings is more real than the perspective of Leonardo. Is, then, Leonardo a genius and benefactor of mankind for showing us a perspective which doesn't exist? What is the evidence of my eye on this heat-drenched landscape? Opalescence, devoid of temperature; light which can scarcely be named as to color, the palpable distance a broken haze of shadows; the abstract foreground as long away as the silver shadows, and as close; the planes and plains of plain demention or dimension, a gold, a light, an ochre, a green—or was it green? —lines etched and destroyed, sensual movement with rhythms that are as arbitrary and changing as time. I play with words to suggest the fantasy. The more I look, the less I can believe. So

Scotland. Later, he became director of the Nature Conservancy Council and worked in various departments of the Scottish Office. He and his wife, Eileen (a social-skills consultant), were to remain fast friends of Schueler, visiting him in Mallaig and meeting up in Edinburgh, New York, and elsewhere.

much is fantasy in this Mediterranean presence, whether it be the Salute and San Giorgio resting on the Grand Canal, the wonderfully heavy invention of the Palazzo Vecchio, the rain and cloud-swept Umbrian plains seen from the window of the Hotel Angelo, the hell-bent costumed Palio at Siena, the acres of Tintoretto at the Scuola di San Rocco, or the still, silent vision beyond the heat of our balcony—so much is fantasy that one wonders whether this was true for all men under its spell (and could any escape it?), or is it only because I come from the north, out of my own fantasy, that I fantasize what is here? I read recently a statement by the British scientist, J.B. Haldane, who said, "I suspect that nature is not only queerer than we imagine, but queerer than we can imagine." I look to the haze, the hill, the shadow, the gold, the brash light, the cool milk, the subtle line, the stalwart presence, the vertical field. Nature is before me, right now. It is in front of my eyes. In order to understand it, I have to rationalize it, give it words, colors, read ideas into it, feel frustration at having failed to touch it, and with each attempt, separate myself from it. The madness is no greater here than it is in the north. Yet I feel a difference in kind. Perhaps the sun and heat make it seem more rational, and therefore more misleading. Christ and the Mediterranean light misled man into a mad Renaissance, which is still spreading across the globe. It could never have started in Scotland. There the bewilderment of nature is so apparent that man must necessarily contain his vision and pretend to be sane.

It is all so very beautiful.

Berenson says, "Space-composition is the art which humanizes the void . . ." I find the statement haunting and one which I'm to think about for a long time to come.

. . .

It was in the Academy in Florence, standing before the *Slaves* of Michelangelo that I had another revelation.

The *David* is a piece of sculpture, all right, done by a man of tremendous talent. But it is all description and a good bit of show-biz, too. The muscles and the pose are like those of an exhibitionist weightlifter—he's tested them out at the mirror, and now he's down at the beach. It's a crowd pleaser, if you have the right kind of crowd.

But in the *Slaves*, Michelangelo is the artist few men can be. He is alone. He's proving nothing. He fights marble and the space as forces to explore and reveal and discover and disturb. The hand was nature and unfettered form, and a living edge moving through space. I find myself totally incapable of finding words to express this moment, but one has to try. I feel it when I see Turner's late paintings and his watercolors. I feel it when I see some of the oil sketches of Constable, though not to this extent. I feel it, in full grandeur, when I look at the late Rembrandt portraits—two of which I saw that afternoon at the Uffizi. A self-portrait and a portrait of an old man. In these the painting has gone beyond painting and has become nature,

the very fact and mystery of nature, and this quality is what I find in the *Slaves*. Deeply moving, unrevealing, except to assert their essential mystery. Michelangelo seems to let go of art, and to assert a presence by the very fact that the presence can't be defined. I consider the hands in the Rembrandt portrait. They *are* a landscape. I don't mean that they are painted like a landscape. I mean they are a landscape. They are nature and paint and the artist himself. In the *David*, Michelangelo is the brilliant, talented, successful sculptor. The work is successful. It would be hard to find fault with it. But the *Slaves* are the richness of time moving. The artist's integrity has become so great that he leaves a force and a pulse and a beat and a haunting strangeness which is like life, like the Sound of Sleat, like the face, if there was a real face, of Christ Resurrected, like the heavy, milk-white light of the Italian sky, like the ever-unanswered question of what a woman knows. I felt the force and intensity of the man, of his willingness to question and search, and I felt the power of all the questions he left unanswered.

<div align="right">

NEW YORK, 6 APRIL 1972

LETTER FROM B.H. FRIEDMAN[2]

</div>

... I'm glad you're going ahead with the book, not only because I believe in it but because I think it's something you must get out of your system in a shape you are satisfied with. For God's sake, don't think about publication while you're writing, any more than you think about sales while you're painting. There'll be time enough to face those harsh realities later. Even if the book isn't accepted commercially—and the publishing business is bad right now—you'll have done something you really want to do, something important to you and your friends. . . .

Schueler spent three months in Paris working on the book. Thus the account of his years painting in California and New York became interwoven with memories of earlier stays in France.

<div align="right">

PARIS, 7 JUNE 1972

</div>

I didn't think of Paris as being neutral, but I forgot the strength of the past. Paris is a mass on the horizon seen from a B-17 in 1942, and it is Hemingway dreams and Fitzgerald dreams before that. And without planning it or

[2]Schueler typed out this section from Friedman's letter and pinned it above his desk in Mallaig, Scotland, as he did later in New York.

thinking about it, I have repeated a cycle: Painting in Mallaig. Living with a woman there. Bringing her with me to Paris and the soft light, after the inner gloom of my work. In 1958, Jody. Now, Magda.

The sun shines over Paris on the edge of a silver cloud. Old, tortured roofs and chimney pots are across the rue St. Andrés des Arts, and the hotel sags like an old whore's belly, yellow wallpaper, corsages wilting, street sounds scratching the soft, cool air.

PARIS, 22 JUNE 1972

The California School of Fine Arts.[3] 1948-1951: I studied with David Park:[4] a funny, seductive way of talking, making a statement, and smiling his knowledge of your agreement, raising his eyes, popping them with his head tilted.

I studied with Elmer Bischoff[5] who walked through the class, looking at works on the tables, picking out ones that interested him and tacking them on the walls.

I remember the struggle to form a drawing. The naked woman would become distorted and her lines would move off the page. No matter how large the page. She was always larger. My hand would angrily break through the frustration. Dick Diebenkorn[6] talked to me about line. In his halting, inarticulate way, he made me realize that line need not define, but line could talk and breathe and have a life in itself.

Norman Woodbury[7] said, "You should hear this guy, Still.[8] He's something. Really. You should hear him."

I sat in. I was impressed. I signed up for Still's class in Space Organization. On the first day of the class, we waited along with fifteen others for Still to appear. Finally he came in. Tall, in a grey, double-breasted suit. Intense eyes peering angrily through steel-rimmed glasses. He stood on the platform and said, "The name of this course is Space Organization. (Pause.) I suggest that

[3]Now the San Francisco Institute of Art.

[4]David Park (1911–60), who forged a new figurative painting style in 1949 from his former interest in Abstract Expressionism.

[5]Elmer Bischoff (1916–91), an Abstract Expressionist at this point in his career who, like his friend David Park, became an important Bay Area figurative painter.

[6]Richard Diebenkorn (1922–93), whose eclectic Abstract Expressionist paintings of this period were influenced by de Kooning and Still, later became renowned for his gestural figurative work and his Ocean Park series of abstracted painterly landscapes.

[7]A student at the CSFA.

[8]Clyfford Still (1904–80), was a powerful presence at the California School of Fine Arts where he "taught" from 1946-50. His large, vertical canvases with areas of color appearing through the troweled surfaces were particularly influential on Schueler's development. Still, one of the founders of American Abstract Expressionism in the 1940's had an intimate knowledge of the New York art scene.

you organize space." Then he left the room and didn't appear again that day, and he never mentioned space organization again. What he did mention was one's obligation, one's responsibility. An artist, he said, made the ultimate demands on himself. He took on the responsibility for every move, every line, every color. Space, line, color, [that] was his statement. The way the artist organized space, the responsibility he took for it, that was what he had to say. I understood this. It left me with everything, and it left me with nothing. Everything had to be thought up, invented, destroyed, recreated.

ROMASAIG, NOVEMBER 1970
(Written earlier but placed here with the California School of Fine Arts material.)

However, trying for freedom could become just as contrived as trying for form. Many of us were trying to be as free as Still without knowing what he was being free about. Without truly understanding his discipline or his insights.

It was around this time [early nineteen fifties] that I said to myself, quite self-consciously, that I was painting about nature. Still, Rothko, Pollock, and others had broken through figuration and abstraction to feel the idea and freedom and power of nonobjectivity. I wanted to break through the restrictions of nonobjective thinking. But I wanted to use its freedoms. I wanted to include everything that might inform my mind. To include the marriage act, the dialogue between nature and this artist, as part of nature. I wanted to push through figuration into abstraction, and through abstraction into nonobjectivity, and to come out the other side. My "avant-garde" was to paint, not nature, but about nature. To recognize that nature informed me, that my fantasy and imagery and paint itself could only be as true and informing as my own intense response and subjectivity.

At this time there began to flower another rebellion. There was in the air a feeling that one should, to find new forms, deny not only nature, but other painters, living and dead. I could not stand such restriction. And it became important for me to forget chronological history in my response, to accept every painter, from caveman to the present, as a contemporary, to accept or reject them as influences upon my work, not because of their places in art history, but because of their effect upon my sensibilities and my mind. I also wanted to have the freedom to show this influence, when the idea of "influence" was as ugly and forbidden a word as "nature." It seemed that if one could deny the words "nature" and "influence," it would mean that these did not exist. I wanted the influence of Still or Turner or Monet or Goya or the cave drawing or Joya's drawing to very much exist. In 1954 or 1955, I painted some small paintings after visiting the Frick Museum in New York which I called *Landscape after Turner*. It was my public admission or advertisement of this idea, as well as homage to the excitement I had felt about Turner since seeing a portfolio of reproductions of late oils which Still had brought to class in 1948 or 1949.

When I saw the Turners through the years since and compared them with other work, it has seemed to me that he went further into nature and further into the sensation of nature in paint than any other painter. He, the stylist of incredible facility, did most to break down style, to destroy it, to find the possibility of paint talking as paint, as an extension of the most immediate perception and sensibility, so that it became most like nature. Not a painting of nature, but a painting most like nature. This is what I would like my painting to be. If I should succeed, I shall have gone further than Turner. But at any given moment in my painting, I don't know what that means. I can't.

Heroic figures: Clyfford Still. Jim Manson.

PARIS, 24 JUNE 1972

While at the California School of Fine Arts, I had a 1945 Willys station wagon, which gave me a lot of trouble. One time when visiting Mother in Los Angeles, I suddenly traded it for a 1941 Lincoln Continental, dark green, a classic car. I loved that car. It was a lot more than a car. It ate oil and it tended to heat up during mountain driving, but it kept going and I created the idiotic image of a guy in paint-stained clothes going to the art school, having to be careful of his money, wondering and worrying about the future, and driving a long, beautifully proportioned classic car. My fellow artists understood and got a kick out of it.

Lilly Fenichel, a fellow student, talked to Douglas MacAgy[9] about my work and, echoing my words, she talked about the rage, the brutality, the sadism in it. Black paintings, red. He said, "Schueler? Sadistic? Why, Schueler's work is some of the most sensitive and delicate I have seen."

When she told me this, I looked at the work again. It was with a feeling of fear and disappointment that I admitted it. I wanted the sensitivity, but I was afraid that without the rage and hurt, there would be no power, no pulse of life.

I had a house in Sausalito[10]. But I never did use it as a studio. I painted at the school. I had a piano which I had taken (it had been mine) from Jane's house (it had been my house) when she was away one afternoon. I found some guys to help and we grabbed the little piano (a Gulbransen) and dragged it from the house and put it on a trailer behind the Lincoln Continental and took it to Sausalito. I needed the piano for our jazz sessions. But I imagine that I could have bought another piano and left that one for the kids. Ultimately it went back. At the time it was probably part of my battle with Jane.

It was also Woody [Woodbury] who formed another important link for

[9]Director of the California School of Fine Arts from 1945 to 1950.

[10]After leaving his first wife, Jane, and the children in the fall of 1947, Schueler lived in a room in San Francisco, then Mill Valley, and finally Sausalito.

me. George Abend had studied music with Bartók in New York and then had come West and decided to be a painter and had studied with Still. He had a piano and he kind of dug the Dixieland we played in the Artists' Band.[11] But he was after something else. In painting then, we were talking about creation, about free creation, about starting from scratch, breaking with the past, destroying the past, destroying the demand of the past, of Europe, of the formal scheme of things, of the convention of painting, and now he wanted to do the same thing with music. The ideas were in the air, and it's possible that things were going on in New York music that I didn't know about. He liked my bass playing and tried to teach Woody drumming and we all three got together to just deal with sound. We tried to play music together like we were trying to paint individually, and at the same time to read each other. He was quite a creative guy, but he was too egocentric to be part of a group. He was creating solo work for himself and didn't really have the feel to play off another, to let the thing evolve as a whole. But I never forgot what I learned from him.

Jazz was very important for me. Still was not a jazz man. I'm not sure that he even liked it. He likes Beethoven and he plays the piano and knows classical music. But jazz had a special quality for me. Playing it was creating right now. Jazz was time and creating in time, feeling the exact moment and feeling it ride into the next. And jazz was also creating a mood that bounced off or became one with or was a dialogue between another man and his musical mood. If there were seven, it would be sevenfold. If I played a bass solo, I played off the drum and piano and they played off me, but the others were listening, and they might bring in a note or two and they would become part of it. They would hold the beat, a many-manned heart. The sound would move through the beating heart and come out a new thing, a creation in time. Besides the sense of dialogue right now with other men, there was an equal sense of immediacy in giving to an audience. If it were a dance, Dixieland music would move through us and into the dancers' bodies and souls and we would feed each other back and forth, the band and the audience. You could feel it swing, you could feel the air fill with it, rock and breathe like the beginning of time, the new creation, the Lord and the Universe pulsating and breathing, no time to think, only to feel and play and fill the next moment with a new and living sound. Through improvisation in music I tried to understand something about painting. It has none of the sexual give-and-take that playing music has when a dialogue gets set up between you and the rest of the musicians, and it has none of the sense of immediate communication that comes from having an audience riding along on the crest of the mood that you are creating. It's the

[11]The Artists' Band, later called The Studio 13 Jass (sic) Band, although organized by the faculty of the California School of Fine Arts, also included a few students such as Schueler and Charlie Clark.

loneliness that drives you mad. It's the loneliness that is almost intolerable. But it is the loneliness that offers a freedom which makes possible far more than can be possible in jazz. It makes possible contemplation; it makes possible the studied movement, the retreat, the reconsideration, the destruction of a moment past to recreate the moment of the future and to consider the moment of the present, to see it, to see that moment, to watch it take place, and seeing, to redesign it, to refashion it, to attempt to answer its questions or to still its voice.

It was Jack Lowe[12] and Elmer Bischoff and I who got together, chose ourselves out of the Artists' Band, to try to experiment in music. Elmer would prepare the piano, doing things to the strings. I would sometimes bow the bass below the bridge, tap it, create wild sounds with it. Screeches and quakes. The horn would beat or bleat and the drums crash through or tap and the piano would be a lonesome thing trying to marry the bass. We'd cut tapes so that we'd know what we were doing.

Clyfford Still left the school in January of 1951, probably one jump ahead of his notice. The trustees had been out to get him for a long time, and they were out to get Douglas MacAgy, the director, for having hired him. Clyfford left. Douglas got fired, as far as I can remember.

I don't really remember very well the spring that Still was gone from the school. The spring of 1951. But I think that things went to pot. We were still playing jazz—Elmer Bischoff on trumpet, Charlie Clark and Bill Napier on clarinet, Dave Park on piano, Bob Meilke on trombone, Jack Lowe on drums, myself on bass.[13] There were parties. I think Ed Corbett, Dick Diebenkorn, Hassel Smith were still teaching at the school.[14] The real collapse came that fall. Without Still, a major force was missing.

Clyfford came back to San Francisco in June to visit his wife and daughters. I saw him and asked him and Pat out to my house in Sausalito. Clyfford talked about New York and I became very excited. He talked about his show at the Betty Parsons Gallery and about the many things happening there, the many battles to be fought, many men to talk to, but above all the feeling of things happening, of an arena, of a place that I had to be in. San Francisco, that afternoon, seemed very much a small town. I made up my mind then and there that I'd be going.

PARIS, 25 JUNE 1972

I sold the old Lincoln Continental and the house in Sausalito. I put a lot of paintings in storage, and I put others in the attic at Jane's along with all

[12]Jack Lowe, a fellow student.
[13]Bob Meilke and Bill Napier were both professional jazz players.
[14]Diebenkorn left in 1950, Ed Corbett in 1951, and Park and Bischoff resigned when Hassel Smith was dropped from the school's faculty in 1952.

of my manuscripts and letters. Part of my life disappeared. All of the written material which might have covered the war years and the years of my marriage with Jane, the letters, the notes, the diaries, the journals, all were destroyed. By Jane, in about 1970. I saw her in San Francisco last year—a strange death mask of a face, the body stiff and twisted (she'd had a stroke), eyes unseeing, dead, but the reptilian calculation, the slyness still there as she told me she had burned it all.

In any case, I arranged for a moving van to pick up some belongings to be sent East. Then, I took the plane to New York and went directly to Clyfford Still's studio.

. . .

August 1951. Clyfford Still had a loft in an old building on the west side of Cooper Square—39 Cooper Square—$37.50 per month. Still invited me to use it while he was out of town.

Immediately, I was involved with many artists. I had met Mark Rothko and Ad Reinhardt when they had been teaching at the California School of Fine Arts. Still introduced me to Ray Parker, and took me to Barney Newman's house, where I saw some of the stripe paintings.

It was the Newmans who helped me to find a studio. They said to walk along the streets looking for LOFT TO LET signs. One had to try to figure out whether or not it was possible to live in the loft—inasmuch as loft living was illegal. Within a few days, walking the streets themselves, they spotted one on 12th Street and 4th Avenue, which became my first studio. Ad Reinhardt gave me a bed because he was getting a new one, and I moved in.

The loft was about 20 feet wide and 50 or 60 feet long. The main windows faced East. It smelled. It smelled of all the past, of sweatshop workers and urine-evil toilets, and of stale food and dishwater. The floor was filthy with the dust of a hundred years seeping from the cracks. A window at the back, just next to my bed, opened on to an air shaft. At the bottom of that shaft was the kitchen for a third-rate cafeteria owned by my landlord, Sidney Turkel. The first studio was $60.00 a month. A year later I moved next door to another building of his, where I paid $75.00. There I stayed until 1964.

My loft was painted white. I constructed an easel next to the large window which looked out on Fourth Avenue, and started to work.

Or tried to start to work. Whatever I had developed in San Francisco to make me think I was a painter seemed like the memory of a dream. I was starting from the beginning. I had had a show in Sausalito in about 1949 in which I hung student work, figure drawings, paintings of the figure, portraits, landscapes. Some people said that the drawings were particularly interesting, but I didn't know it then. I also had a show in 1950 at the Metart Gallery, a co-operative gallery of artists. We took turns watching the place, and contributed $5.00 a month to its rent and maintenance. (A bunch of us chipped in and paid for a show for Clyfford Still. I don't think he ever forgot

that.) In my show I had a number of large paintings, including oils on brown paper. Something was forming. Something was happening.

But when I tried to start to paint in New York, all of a sudden I had nothing. I stretched up some canvases about 50 x 60 inches. I bought cans of cheap oil paint used by house painters for tinting. I painted one canvas with a mixture of greys and blues, swimming in a glazed oil sea, lines scratched into the limpid mess. It had a peculiar quality. Still said it had the look of old oil paintings, glazed, color showing through color, a strange shiny surface. It was strange all right. It never dried. I finally threw it away. Another painting was all in blues. One morning I squeezed out long lines of red like spaghetti and ruined the picture. A red rage of ruination. I was wildly at sea, and I was moving madly from one idea to another, from one kind of surface to another. In a crude way, I was already establishing polarities, opposites, contradictions, which were to mark the nature of my work and thinking and process henceforth. But then I couldn't look upon this as a creative force. It looked only as though I didn't know what I was doing. Which was true enough.

I was away from school and away from the easy West, and I was suddenly in the powerfully competitive world of New York. I desperately wanted to prove myself, to be the painter I dreamt of, to be a Still, a van Gogh, a Goya, a Turner, a Gauguin. But I felt frustrated, impotent. I couldn't stay in the studio. I couldn't stay before the easel. Finally, I'd go to the easel and grab brushes and paint and just slam in, a sudden splurt of orgasm, a lashing out, a cry, a scream, a breaking through the wall of inhibition and opposition. And I'd have nothing but paint.

I tried everything. To finish one painting would have no meaning for me, so I'd try another, I couldn't follow through on an idea. I wanted to try grounds of different colors. I wonder now if I got this idea from seeing Newman's paintings. Yet, I soon had perhaps fifteen paintings showing the struggle to find a focus, an idea, an image so that I'd know what I was trying to do. I was left with nothing from San Francisco, except for one very important resolve: I would deal with nature and I would deal with the canvas in an organic way. Non-geometric. I was in this sea of primordial ooze, struggling toward form, *not knowing or aware enough as yet to just paint the primordial ooze and find the meaning of that.* So in a way, I had little to go on but the struggle and the inner agony. I had only my arrogance to sustain me.

Still brought Dorothy Miller[15] of the Museum of Modern Art to see the paintings. Later, Still called me from a phone booth. I asked him what Dorothy thought and he said that she would try to give me a show some day. He was just saying this to be kind. Yet there was an innocence and a trust at that time amongst certain people in New York, a willingness to look and

[15]Dorothy Miller (b.1904), Curator of museum collections.

consider—and perhaps I was being too cynical, too hard, too competitive in my expectations.

I would often get together with Still. He and Barney Newman and I went to some Yankee ball games. I bought a mitt and ball and Clyfford and I played catch in Cooper Square. We had lunch at McSorley's Bar on East 7th Street, or in the cafeteria on Third Avenue and St. Mark's Place that Clyfford liked so well. (It later became The Five Spot, where I heard many greats of jazz.) We'd meet Rothko at the Museum of Modern Art or at his apartment around the corner from the museum. We had dinner with Reinhardt, [Harold] Rosenberg, and others at an Italian restaurant on Second Avenue, where we talked painting, politics, anything. Much, much talk. I was introduced to the Club, presided over and organized by the sculptor, Philip Pavia, who published the avant-garde magazine It is. Besides Ray Parker, I met other younger painters—Joan Mitchell, Mike Goldberg. It was an exciting period.

The paintings were opening up in space. Large areas of black or yellow or red. I stretched up bigger ones—six feet, six and a half feet, seven feet. They had the feel of non-objective landscapes. I stretched a vertical canvas, about six and a half feet high. I opened a gallon of white. (Many of the artists were, for a short time, using a titanium white sold by the gallon at Kamenstein's Hardware—often with disastrous results, for it contained much drier and would soon become brittle and crack. But it was a luxurious feeling to dip into the gallon of rich white and smear it on to a canvas.)

The canvas was black and it was night and I was painting. Frustrated, searching, not knowing, but wanting. The black became the night sky and the white flecks coalesced near the top-right and then sprayed out, flecks scattered and shooting through space. I knew that I was looking into the night sky. It was no longer landscape. The horizon was gone. I was looking into the night sky, feeling the formations, the explosions, star upon star, floating, spiraling nebulae, the formation, the birth of universes. I recognized the painting as I painted it, and I knew what I was painting about.*

PARIS, 26 JUNE 1972

Still was doing powerful painting then. Huge paintings. Thick, forbidding blacks. Still mixed his own colors, using dry pigments and raw linseed oil bought from Kamenstein's. He applied the paint like plaster with a palette knife, as though he were covering a wall, but with exquisite sensitivity. A huge black canvas, with a white line descending like a crack into the future, with a corner of strange purple. What paintings! I remember walking into his studio one day and seeing an enormous yellow canvas. It was almost nothing, and yet it was everything. The drawing, the very way his hand

*See color illustration 2 for a slightly later Night.

moved, was always alive and to the point, always sensitive, loaded with meaning, a sharp expression of detail. The paintings were as material as concrete, with color as ordinary and immediate as Kamenstein's Hardware, yet they exalted the spirit. Their very physicality was a transcendent force. They were so determined, so much an uncompromising assertion, that they had an awful "Stillness" about them. They were set, frozen, final, absolute. A demand. To me, all the other painting I saw in New York paled by comparison. And I was seeing some superb painting: Kline, de Kooning, Rothko, Pollock, Phil Guston. A host of younger painters like myself who were struggling, fighting, full of energy and argument and drive, demanding, assertive, trying to make an original mark. Looking for the uniqueness of their souls on the canvas. Joan Mitchell, Larry Rivers, Stankiewicz, Rauschenberg. Ernie Briggs and Ed Dugmore and John Grillo from the California School of Fine Arts. Calcagno. I saw Reinhardt's work in his studio and often joined him for dinner. We'd meet Bradley Walker Tomlin or Dzubas or . . . the names of that family are too numerous to mention.[16]

The friendships grew. As in war, you were often friends just because you were there. You knew each other. You were in the battle, in a very small force which fought unaided. There were the artists, a few gallery owners, museum people, critics, collectors. Very few.

In Still's cramped apartment there was a long wooden crate containing rolls of his paintings. He would roll them up when New York was closing in on him, and he'd be ready to cut out at a moment's notice. He would unroll and stretch them again when things seemed more free and clear. The enemy was always present, breathing down Still's neck, and when the enemy closed in, one had to be prepared.

Pat was living with Still. His wife was in San Francisco, working as an executive secretary at the California School of Fine Arts. His daughters, Sandra and Diane, were ten or twelve or younger. While Still was at the school [1946-50], they would play in the court. Pat was in charge of the store. It was a long time before I completely understood the arrangement. When I started going out to stay with Jeanne Kewell,[17] I would often see Still's silver 1948 Jaguar parked in the street, and it would be there the following morning too. I looked on this as an amusing bit of scandal at first. I didn't realize that he was living a very complicated life, but in a very responsible manner. He had met Pat Garske when he was teaching in Richmond, Virginia in the forties, before he went to San Francisco. She had been a graduate student and they had fallen in love. The slightest suggestion of scandal would have

[16]Larry Rivers (b.1925), Richard Stankiewicz (1922-1983), Robert Rauschenberg (b.1925), Ernest Briggs (1923-1984), Edward Dugmore (1915-1996), John Grillo (b.1917), Lawrence Calcagno (1913-1993), Bradley Walker Tomlin (1899-1953), Friedel Dzubas (1915-1994).
[17]Friend who was a sculptor—she lived in Sausalito, California.

Pat and Clyfford Still with Jon Schueler in Baltimore, Maryland, c.1966

cost him his job. So, as he told me years later, he did the only thing possible: He had Pat move in with him and his wife and his two daughters. Later, in San Francisco, he organized two establishments.

Over and over Still spoke of the responsibility of the artist to his canvas and to himself. To fight his way out of fad and caprice. To fight his way out of history. He felt that the Renaissance was a misdirection of man's insight and energies into a path of trickery, deceit and pretension. Tricks of style and manner relating to perspective and representation. Away from the assertions of an individual man creating an individual image which represented or was his truth.

He hated the Bauhaus. He hated the idea of man annihilating himself on a grid of geometry. All these things I understood. The straight line was meant to kill. The organic line as birth to life. He spoke highly of Rembrandt, Goya, Turner. He tried to make me understand.

He scarcely ever spoke to me directly about my own painting. While a student, I had some work in an outdoor show in San Francisco's Union Square. While I was standing talking to a friend in the little bay which held a few of my heads and figures, Douglas MacAgy appeared and with him this austere, intense man, Clyfford Still, whom I had never met. He said, "Good work"—and perhaps a few more words—in a way which made

me feel that a communication had been established. He imbued this small meeting with a sense of strange importance. I could never forget it. When we studied under him, he said very little about any student's work. He would not look directly at it. At times, I'd feel a presence, and turning, would see him peering into the room. Even as I became aware of him, he'd disappear from the doorway. The work was our responsibility, not his. But we would talk, talk, talk. We would gather around the fountain in the central court, or talk in the cafeteria over coffee or in a North Beach restaurant over spaghetti and wine. Sometimes he'd tap a few of us on the shoulder and we'd meet him in a small lecture room where he'd show slides and talk for an hour or two. One time he took three of us into his studio at the base of the tower. He had hung four huge paintings, one on each of the walls. I had never seen anything like them before. Powerful images. Blood reds, scarred browns and blacks. A flash of color. Bumps and scourges, tensely violent, like the surface of life. I didn't even know if I liked them. I was breathless with the experience.

One time, after we had become close friends in New York, Still went to San Francisco to see his wife and children. Pat was left alone and I took her out for dinner. She told me of her love for Still, and how she had decided that he was a genius and that she wanted to dedicate her life to him and to his work. She knew it would be difficult and that she would have to find ways to adapt herself to his life. In some ways, he was unpredictable. Suddenly he would have to leave town; suddenly he would have to cross the country. She took a course in operating an IBM machine, a course she chose because it offered jobs anywhere to an efficient operator who would leave any place of employment with a good record and at least a month's notice. So she was never more than a month away from joining Still. But sometimes, she admitted, it was lonely. I think it was particularly lonely because she didn't want to complain. She gave herself solely and completely to Still. That night, she cried while admitting her loneliness.

Still has always been very generous with me, yet sensitive to my need for independence. We would talk for long hours in New York. He introduced me to anyone he knew. He became enraged at Rothko for accusing him of having a father relationship with me. Rothko was a vicious man and liked to probe for another's weak point and then strike—sometimes with a stiletto, sometimes with a broad sword. I often liked Rothko for his humor, but always, at a point when I was most trusting, I would discover that the humor was at the expense of my own dignity. For a while, Still and Rothko were friends. But Rothko, it seemed, could not stand Still's friendship with me. I realize now that it was complicated: Still the father, Still the master, but also Still the friend. He is the father, the master, the friend to this day. He shall never cease to be.

One time, Rothko became furious, telling Still, "Schueler thinks he's equal to us as an artist." Still passed these words on to me, and I said, "You're damned right I do. I'm younger, I don't paint as well, I don't as yet know

what I'm doing, but I'm an artist. I demand of myself that I be your equal as an artist. And I may be more of an artist than Rothko."

The arrogance was deep—fully as deep and deeper than the insecurity. Neither Still nor I will ever commit suicide, though we both know the idea of death.

One time my father said, "Had I taken your side, it would have been at the expense of my marriage. I had to choose."

Clyfford Still was on my side.

The following letter from Schueler to Still, although written in 1952, is placed here to enlarge on the previous entry.

NEW YORK, 13 AUGUST 1952
LETTER TO CLYFFORD STILL

Dear Clyff:

In my last letter I mentioned having some conversations with Mark Rothko about painting, and I would discuss them when you returned to New York. But since then I have thought about them considerably, and tonight felt the need of putting my thoughts into some kind of order. . . .

In the first place, I must mention that in no case was an exchange as extensive as even the shorter discussions that we have had in the past year. For the most part, I have listened to him talking to other people—a couple of former students down at the Cedar Bar, some others up at his studio—and more particularly a few exchanges with myself when I'd try to press a conversation beyond the point of clever toying with ideas and into a realm of serious probing and frank revelation. The very fact that these attempts were short-lived and frustrating is, I think, of some importance in my now reconsidering the matter as a whole.

. . . It's as though my own very serious involvement with my painting act was some kind of a threat, and the seriousness of it had to be denied. Only one time did we have a prolonged talk without rapidly degenerating into a series of attacks (or, more properly, defenses), and that was the day Mark came up to see my paintings. And even then, I realize in retrospect, it was because our talk mostly evolved around pictorial qualities.

At that time . . . I still assumed. . . an agreement as to the importance of the profound areas of the spirit and the forging and translating of that spirit into paint. I could then talk about form or movement on an intellectual level, even as you and I have talked about technical qualities or paint problems without feeling that we were reducing the understanding of our individual acts to a mechanical level.

But more and more I have come to feel that within Mark's thought

structure, we were talking about essentials, whereas within mine we were talking about quite secondary considerations. For example, he suggested that the forms I was using, as well as yours and his, somehow were allowed to us by the activities of the Surrealists, in that through allowing their fancies a kind of free play, they created worlds of free forms which broke away from the more standardized form concepts of traditional painting. Well, I had never thought of it, certainly never paid much attention to the Surrealists, feel that whatever form concepts I create come out of something quite different than a bowing to that cultural heritage, but was willing to probe the point for what it was worth.

. . . A man's emotional and inner spiritual drives can often surmount the intellectual barriers he constructs around them. Mark talks a great deal about picture making, and I'm beginning to wonder if that's what he talks about partially, which is quite acceptable to me, or whether that's what he talks about completely, which is not acceptable at all. I'm not sure whether this statement will be clear: I think that Rothko denies the validity of academic picture making or Bauhaus picture making or whatever picture making, only to set up a picture making activity of his own with its own tight structure of demands and characteristics. And these include such things (oft repeated) as the fact that no one can copy his pictures ("I've seen to that"), that no one can copy the edge to a painting that he has formulated, that he has seen to it that he will not repeat his pictures, that he is not involved with the spirit, with universals, etc., but is involved with some kind of additive, materialist conception (which I don't quite understand), that it is somehow wrong to place too much importance to the part played by picture making in one's individual life—because he is careful to underestimate the importance of it in his—treating it as an incidental occupation along with picnics and diaper-changing. Now, as I say, I'm not sure that he completely means this deep in his being (in fact, I don't see how he could), or that he even always means it consciously, but the fact is that this impression gradually comes out and takes hold of one. . . .

The other night, for example, I mentioned what I had mentioned to you, that this has been a good year for me and that the sum total of this year revealed itself in a handful of paintings. To paraphrase his reply: Painting did not mean that much to him; he painted because that's what he knew how to do best; that he didn't feel that paintings should take on such a religious kind of importance as an answer to all one's problems, etc., etc. The sum total of the reaction was, that by defining his lack of interest in the importance of such an act or the symbols of that act, he was also suggesting that such literally could not be true with me, and, in fact, there was a subtle implication that I was not telling the truth, or at the most was deluded. Now, what I am trying to describe is a whole area of feeling; the conversation itself was most civilized and polite—except that in an effort to project my feelings, I may have displayed what in a British drawing room would be vulgar emotionalism. Another time, I was feeling an

enthusiasm for the very size, the expanse, the challenge, and the freedom of large canvases (this while in his studio)—and turned my feelings into a joking remark that perhaps it was just as well that my studio had a low ceiling, or I'd find myself with the physical problems and expense of large canvases. He immediately jumped me with the statement that he thought that the size of canvas I am using it about right for the image I'm projecting—and the struggle to make useful conversation out of that was futile. . . .

Needless to say, I am looking forward to your return to New York and a resumption of those conversations which have held so much meaning and satisfaction for me.

Sincerely yours,

Jon

PARIS, 27 JUNE 1972

It was May and Mother's Day, 1952. I was invited by Pucky Violett to the Doubledays' in Oyster Bay for dinner. I got the Long Island train and I forgot to change at Jamaica. I'm not sure that I even knew about changing at Jamaica. So I got off at the next station and grabbed the next train back to New York and phoned Mrs. Doubleday and said that I couldn't make it. I went back to my studio and put a big, vertical canvas on the easel. I covered the entire canvas with black, soft black, the black of Kamenstein pigment and the Kamenstein oil. Then there were swirls of red and swirls of white—fragments moving off from a centrifugal point, black, red, and white. This was my Mother's Day painting.[18] More and more, I have been struck by the curious nature of inspiration.

After the Mother's Day experience, I painted a number of paintings—the flecks moving off, long runners of red, red flecks, white flecks. The satin black. For years—until 1958—I painted with thick paint, my instrument a painting knife. I took that from Still. And from him I understood the feeling of vast areas—of endlessness of space. I recognized this, like I recognized the lessons of Turner. They both showed me what I recognized, like an oft-remembered landscape. The thick paint and the knife made me feel the sensuality of paint, the killing power of the knife. I scratched at the paint and drew with the knife and tried to find my way through the paint into light and nature and, finally, the snow cloud. I was painting the orgasm, the moment of conception, the moment of truth out of which truths would form. These paintings formed the core of my first Stable Gallery show in 1954.

During the first year I was at 70 E. 12th Street, I gave a party and invited Mrs. Doubleday. She came in a rented Rolls-Royce with a chauffeur and brought champagne and baskets of delicacies. Lights were low. Everyone

[18]*Red and White on Black (Mother's Day)*, 1952 (90" x 70").

Jon Schueler's first one-man exhibition in New York: the Stable Gallery, February 1954. Center: Memory, 1952, 90" x 110", and right: Force of New Light, 1953, 90 x 80".

was drinking and having a great time when the cops came up because they couldn't figure out what a Rolls-Royce was doing parked in front of this grim, sagging loft building. They stayed and had a drink.

I liked Mrs. Doubleday. She was crazy mean, vicious mean, with superb psychological twists. She knew how to cause her children complete agony, just like dear old Mom. But because she was beautiful and *like* dear old Mom, but *not* dear old Mom, I could see her for herself and enjoy her and even feel sorry for her.

PARIS, 28 JUNE 1972

The sound of French children's voices in the playground. The Marais. Paris. A red tile roof glistening in the sun. My chair, cane-bottomed, with six foam-rubber slabs and a piece of grey rug over them bound to the seat with a pale blue nylon string. I want to be back in my Mallaig studio. What am I doing here? Does it really make any sense? Magda—do you want to see Clamart and the old studio? Would it make any difference? At all?

• • •

One day in the fifties, we went up the grey, paper-cluttered stairs to the very top floor under the eaves. Ray Parker opened the door. It was, if possible,

a worse loft than mine. It was filthy. Paintings stacked here and there were reminiscent of Ad Reinhardt and Bradley Walker Tomlin[19] in their work of this period. All sorts of things were happening in the paintings. Some of them didn't seem to work. But there was a direct poetry in many of them, like spring.

We were all derivative then. For us, the younger painters, there was no way to be otherwise. And the older ones were derivative of each other. They couldn't admit it, nor could we, because originality was the password. The difficulty was that we were not always what we said we were. I was derivative of Clyfford Still and later in some ways of Rothko and certainly of Turner. Ray was also derivative of de Kooning, and Kline and de Kooning were derivative of each other. Barney Newman of Still and Rothko. Still? I don't know. He was as truly original a painter as I have seen. Considering him now, this still seems true. He methodically wiped out, killed everything in his painting which seemed derivative. What was left was a hard core of originality. To the contrary I tried to include everything. Everything which to me was true. I tried to let Still, Turner, Monet, Cezanne into my work. Clouds and sun.

Brooks dug Pollock. Pollock the Impressionists. De Kooning the Cubists. Everyone dug someone. But, also, everyone was bursting out of chains, ropes, bonds, blindfolds. The most was wanted. The highest drama. The most beautiful. We looked at the torn billboard and said, My God, that's beautiful. Our lofts are beautiful. If you look, the rubbish heap is beautiful. Gulls on the rubbish heap. White flecks and grey shimmering sea and a mass of beautiful silver grey, smoke rising. The scratch in the paint, the paint dripping, the hand moving across the canvas, the precious memory of the hand, all of these things are beautiful. We want to see beauty. What is beauty, here in America? we asked. Phil Guston loved Piero della Francesca but he wanted his beauty to be of his time, and he was deeply hurt, I understand, when his friends, his brothers, his fellow artists said, you, Phil, with your figurative paintings, with your success, you are a traitor. You are selling out, you are not with us, you are not seeing. The story goes that he changed then. He started all over again. Depending on how you look at it, that was a very brave or a very weak thing to do. Or perhaps it was neither. At the time I didn't like his work, but I look back on it now and I realize that those sensitive tracks across the canvas were very brave even though they looked precious to me at the time.

In the very early sixties, a number of artists did an abrupt turnabout and said, Yes, abstract expressionism is dead and I was really on the wrong track all along. Mea culpa." Ray did that. He published an article in *It is* in which

[19]Bradley Walker Tomlin (1899–1953) whose work of thickly painted shapes was more lyrical and less gestural than that of Pollock or de Kooning.

he gave his reasons and outlined a new philosophy. Paul Brach[20] did the same thing. Ray started doing some very stark canvases, very calculated. On the white ground, two areas of color, one above the other. Again and again. He said that he would study for hours before shifting the shape an inch or so. I thought the possibilities were exciting. I could imagine the edge becoming sensitive and reaching for meaning. I could imagine the areas themselves growing and changing in light as he would begin to challenge and question the paint. But the challenges and questions never came—in my eyes. Instead, I thought I saw a device, a method, an arbitrary image, which led to very successful shows. Previously there had been a struggle and poetry in his work, springlike color with the aliveness of a garden somewhat tended but not thoroughly mastered or understood.

PARIS, 29 JUNE 1972

Clyfford Still talked of the plains of Alberta, Canada, where he spent his boyhood on a lonely farm. The endless horizontals of the long horizon created a sky vast and strong that seemed to blot out man. This enraged Still. He wanted to paint of man the courageous who dared to stand upright. Still never could countenance a horizontal in his paintings. But I was drawn inexorably to the horizontal. Why? Some of the San Francisco paintings would automatically form themselves to sea and sky. Black sea, red sky. Non-objective but to do with nature. A strong vertical movement would have been a forced gesture.

In 1954 and 1955 I found myself studying the clouds framed between the high buildings of New York. They would appear as a landscape, the horizon imagined in the clouds. In moving my vision from the abstraction of infinite space and the central, bursting image of those early fifties paintings to the horizon, I seemed to find myself closer to man and the loneliness of the human dimension. I remember now a large cloud painting, the flecks enlarging to form expanding areas of delicate color which foretold *Sun and Fog* [1955, 48" x 54"] and later work. But it was all sky. Neither the sea nor the land was there.

PARIS, 2 JULY 1972

Kline.[21] I was looking for a loft in 1951 and someone said, "go see Kline." I phoned and asked if I could come over. I went down to the East 9th Street

[20]Paul Brach (b.1924), whose imagery was subsequently to be informed by the deserts of the Southwest.

[21]Franz Kline's expressive abstractions of large black calligraphic strokes on a white ground, shown in 1950 at the Charles Egan Gallery, had established his reputation as an innovator.

loft building and climbed the tired old stairs to the third floor. Kline came to
the door wearing paint-smeared blue jeans and an old blue shirt. He was of
medium height, with a shock of black hair and a black mustache. He showed
me his loft. The main room was huge and all around were paintings stacked
against the walls. The space was grim, as yet unpainted, but in one corner
was a shiny new cabinet sink. By God, he was proud of that sink. He had al-
ways wanted a good kitchen sink, a cabinet sink with chrome fixtures. He
had just sold a painting and he was able to buy the new sink. He couldn't
have it connected yet, so he could only look at it, but it was the thing he liked
to look at most in the loft.

He was a hell of a friendly guy. I don't think I understood his paintings
at the time. I didn't see how good they were. Then one time, I saw them in
a show and I thought, God, these are strong paintings. He was one of the
men in New York with great integrity. After he became famous and after he
decided on Kline with Color, some were weak, some thinned out, but there
were still strong ones, like the New Year's Eve painting on his huge, homo-
sote painting wall, about 10 by 12 feet. He had come home late on New Year's
Eve, a bit drunk [1959-1960], and God knows in what kind of a mood, but
he suddenly attacked the painting wall itself and painted one hell of a paint-
ing, black slashes, huge, mysterious black forms looming, a strong painting, a
very real painting, the kind of a painting any man would want to paint. God
knows what was the basis of his work. People talked of Wilkes-Barre and the
black forms of the coal derricks against the snow, and they talked about the
forms in New York, and they talked about his line and about how at one
point he was doing figurative drawings where the line became thicker and
thicker and someone said, (was it Elaine de Kooning?) "There's the paint-
ing—those thick black lines." They became so thick, you could no longer see
the figure; the thick black lines became the painting and then they became
what the painting was about. I used to see him in the Cedar Bar, where he
loved to sit and drink and talk. He talked a kind of nonstop flow of words
and one was not always absolutely certain of what he was talking about, but
he was talking about something. You knew that: you knew he was talking
about something. He must have known everyone in the Village and everyone
in the art world. When he died [in 1962], St. Bartholomew's on Fifth Ave-
nue was filled to overflowing. Everyone who had known Kline came to the
funeral. Many of the artists resented the big church on Fifth Avenue. They
felt it was not Kline's kind of thing, so they held a memorial service for him
at the Episcopal church on 10th Street and Broadway [Grace Church], where
many people read poetry or eulogies or told stories from the past. He was a
great man, there is no doubt about it. He was a man with soul and he opened
that soul to others.

PARIS, 9 JULY 1972

The way I feel about a show like the Kassel Documenta 5[22] is that I'd rather go to a movie. Fellini says it better. He knows the comedy and tragi-comedy of this or any age. Next to him, the artists seem like hucksters. They marry the establishment and play politics with it and grovel obscenely before it, pretending to be independent and in contempt of it. Nearly every art object or art activity, the painting of a Volkswagen, a John F. Kennedy bust, Gilbert and George, the living sculptures, are camp and depend upon the show, upon showbiz, and upon a hip audience to laugh at the joke. During the fifties, I felt this decadence in such men as Rauschenberg and Johns (camp), or Michel Tapié (the neo-Dada power play), and at times railed against them. But I had no idea that the forces and power of camp would become Warhol and New York and Documenta 5, until the *Art World* was Camp, and the artists had truly gone underground.

For myself, what can I do? There is an eternal, ever-present demand for money, to earn a living. There is an ever-present demand to respect the integrity of my efforts. Evils: pride, lust for fame, lust for money, lust for a gallery for the purpose of identity, status. In that I am no better than the artists at Documenta who display themselves, the one who lay sound asleep in bed on a podium stating "I am ashamed to be here showing myself off for glory, so I have taken sleeping pills. Do not wake me," (*Herald Tribune*, 8 July 1972). Gilbert and George, living sculptures. I'd rather see the Marx Brothers.

I must take a stand alone. I have taken stands all these years—leaving the Castelli Gallery in 1959 and leaving the Stable in 1964, only to compromise my stands. It's not that I compromise by having a gallery. It's that I compromise by wanting one. I went to New York last October and took my work around to galleries. On the one hand, I became strong in doing so—because I did something that has always been impossible for me to do. And it made me face the primal fact: My independence rests on the sale of my work. There is far more of a threat in teaching and in any other way of earning a living.

Clyfford Still used to talk of the evils of the galleries and museums. He was right, as far as the artist is concerned. It took me years to realize it, but he is right. But the greatest evil exists in the heart of the artist himself. He is human. He wants recognition; he wants his work displayed; he wants pay for his efforts so that he can live and work some more. Out of that comes his lusts for the show, for the gallery, for the ability to say to any nonentity,

[22]Documenta, the international contemporary art exhibition held every five years in Kassel, Germany.

Yes, I have a gallery in New York. Yes, I'm planning a show in London. Yes, I'm making an impact at Documenta. Where do you show? I don't show anywhere. In my studio.

I was really wiped out in the sixties, and I think that this must have been a great boon to me, because I became tougher and tougher, until now I know that nothing can stop me from painting and having my say. I depend upon no recognition at all, because with no recognition and the destruction of any I had, I have painted more and more, until now I know that I could keep working if there were no one in the world to look.

· · ·

Jody was a very sensitive artist. Although I was willing to do everything possible to help her, I had no way of understanding the emotions that my very presence as an artist, my very demands as an artist, made upon her. Curiously, the passions of our relationship were more painful and more ravaging that almost any other relationship I have known. Yet, I feel more sentimental and loving towards Jody, more sympathetic, than toward most other women of my past. She was as irresponsible and real as a fresh breeze which turns into a force-ten gale. She was the Scottish sea and sky, forever changing, unpredictable, sentimental, loving, passionate, destructive. In a way, we were both sentimental children who nearly tore each other to pieces.

PARIS, 16 JULY 1972

I have truly nothing to complain about, except my eternal complaint that I never seem to work enough. Magda is a very independent woman, finds me amusing, at the same time that she finds it quite convenient for her own demands on life to have me work as much as possible. She's never suggested in the slightest way that I should depend on her for anything, yet the fact is that, quietly, she has been of inestimable help to me. She has a moral grandeur about her as well as her pervading humor. Both sustain me. I know she's *there*. She believes that I mean what I say. Before she had become involved with me, she accepted the fact that I was a very serious man, a serious artist, that my demands were total—either selfishly or as dedication to my work, depending on how one wanted to look at it. She doesn't seem to find it unrealistic, and I believe that this quality of mine serves her own purposes in life in some respects. I described her once as being devoted, and she was quite annoyed. What she is, is Magda. For me, that's something of a miracle. As profound as the Sound of Sleat, as mysterious as the snow cloud.

PARIS, 18 JULY 1972

Some of the paintings I did in Clamart [Paris] in 1958 are among my best. It was a curiously intense painting experience, and I think that it made me understand something about painting which I had only dimly recognized before, or had verbally acknowledged. I'm not sure I can find the words, but I'll try. It was a matter of carrying commitment to its greatest extreme. One day in Clamart, I looked around me at the bare floors, the one hard chair, the palette table, the easel, the canvases, and I said, My God, I have no life. I have only painting. No life. I felt completely cut off from life. I seemed to know no one, see no one; all I did was paint. If I did not paint, I was sunk in a kind of gloomy, dull detachment. When I painted, I came alive and everything—absolutely everything—went into the painting. (Not always, of course, but when the steam was worked up, when I found my attention and concentration total, when I moved all the way into the dream of my work.) I could understand, I thought, what van Gogh had gone through in all of his last work. The terrible loneliness which characterized the man but which enabled or compelled him to bring all of his forces, all of his mind, all of his emotions, to bear on the canvas. It must have been that which drove him mad. I ended my stay in Clamart when I began to feel that should I paint much more, I'd be painting myself into the canvas, and there would be no one left outside of the canvas to paint. It was a powerful and thrilling creative experience. In my imagination, I had not left people. They crowded my mind. My fantasy life was full of thoughts and feelings about friends, women, art-world figures. But it was all swirling together into an image on the canvas.

The one thing that feels wrong about this book is that the words always seem to have to do with the sadness and despair and tension and misery and loneliness of my life. But in fact, this has been counterbalanced with great ecstasies, happiness, laughter, humor, love, tenderness, friendship, affection, parties, travel, rare good times, deep and powerful friendships, loyalties, intellectual and creative stimulation and challenges in the art worlds of San Francisco and New York as well as in nature and in the studio. Even the studio has not been entirely lonely. It has been crowded with other artists, friends, women, music, dramas, models. It has smelled of turpentine and the walls have been stacked with paintings and there has been the thrill of the physicality of all that work. The fact is, when I am in the midst of working, painting or writing, I feel a quickened pulse; my imagination surges. I can feel ecstasy or euphoria. Perhaps the surge and urge of work takes me into difficult inner battles, forces tough decisions, taps uncomfortable passions, poses imaginative threats and resolutions: All this becomes the excitement and the drama of the painting and of my experience there. It is not a "bad" feeling; it is the drama of work, and I live for it. For this, to be sure, I often pay with a feeling of let-down, of discomfort, perhaps even of a black despair. But it is a small price to pay. I have been spared

many, many of life's difficulties. Although I have been broke at times, and have constantly worried about money, I have never really been impoverished. I have not been hungry—which must certainly be the supreme test. I did live through the war. I was not injured. My work had been respected and many have responded to it and many have said that it brought them warmth and joy and meaning. I have a wacky sense of humor, which just doesn't function in writing, or, for that matter in painting, where I am always deadly earnest. But in life, the humor saves me over and over and over again. I can joke about the worst things that happen to me, sometimes even as they are happening. I could be in an extreme of psychic loneliness and misery (which happened in Clamart) and yet someone could come in the room and, more likely than not, I would soon be in full communication, talking, complaining, thinking, making plans, trying to understand—and finally joking, turning everything upside down, seeing the wild irony in the dance and rhythm of life. Without a sense of this, my book is false, because these are life-giving forces. My strength lies in my humor, in my flexibility, in my ability to laugh, to rebound, to start all over at the beginning after the worst disaster, my eternal optimism, my belief in my powers, the possibility of a communion between myself and nature. Moreover, my strength is my ability to perceive the connection between that which makes life most exciting and meaningful to me and that which makes it most difficult. I respond to many women with a sensitivity which often is all too much for me; and possibly for them, too. I don't even know what I respond to. I feel the death in some of them, perhaps—death or tragedy or loneliness that they don't even know is there. Or the rage or the destructiveness or the tenderness or the warmth. But I can't predict my reaction. Sometimes a woman will seem to draw from me a hurt, which on the surface neither of us want. Or a demand for protection. (Whores affect me this way. I sense in a whore some deep inner person who has been lost from view.) I can't tell you exactly what I mean. But when I feel the sky or when I feel the black despair in Neltje and I paint the black sky or the black Neltje, I am painting something which is so much there, so much a reality beyond figuration, so much a pulse of life and death, that the understanding of it is beyond me. And this is part of my power—if the paintings have anything to say at all—part of the joy of my life, part of my ambition and desire. At the same time, it has led me to many women, so that I have had a range of experience and I hope a range of understanding which I treasure. Sometimes the worst have been the best. Withal, I have never become bored with women; I enjoy them; I still search them as well as the sky and man's thought for the mystery. It's all life, and it's all lust and feeling and laughter and power and thought, and I wouldn't miss any of it.

. . .

The paintings done in my studio in Clamart (4 rue de L'Ouest, Cité Boigues) were full of light. Many yellows, warm yellows, Indian yellows. Pale white

skies. A brightness of life. A loveliness, a sense of beauty, of romance. One would think of most of them as joyous paintings. The Scottish paintings had been darker, brooding; the reds had been deeper, bloodier, the feeling of the north, a weight, a challenge. These paintings of Clamart were of another climate, softer, bathing one in a promise of spring. Optimistic. The blood was transformed. I think of the sun, the idea of the sun; I think of spring. I think of Turner. I think of the sun-washed garden outside my pavilion. All of these things were outside of myself. But something inside myself was responding to them, even though I was going through the most awful inner moments of my life. Perhaps that was why. Perhaps my sensibilities were then most receptive, the nerve ends blood-raw with feeling. I painted the red Jody, *La Mère*[23] and an early Clamart painting, which at one point I called *Passion and Blue* (the red of passion and the blue of sky and hope),[24] and I painted a number of yellow paintings, and pale whites with a surge of red at the sea. The yellow paintings (the most ambitious was called *My Father is the Sun*[25]) were about the light. The sun was behind the storm, burning through the storm, irresistible, the source of life which would refuse to die, refused to be smothered by the storm. These must have been some of the most optimistic paintings that I have ever painted. Père Pierre, Père Roch, and others of the Prêtres Passionistes thought they were very religious in feeling, and it was for this reason, I believe, that they asked me to paint an altar piece for them.

On one of the first days when I was walking back from the Mairie de Clamart along the tree-lined lane which was our road, Père Roch stopped me with a greeting. He said that he'd heard there was an artist in the neighborhood. Later he visited the studio to ask whether I needed anything. And a day later he came back with a small record player, a dictionary, and the records and book of *Français Assimil*. He brought Père Pierre (the *père superior* of the seminary) to see my paintings. When word got to the priests that I had finished a painting, they would all come over to see it, instructors, seminarians, all.

One time when Père Roch was looking at my paintings, he said, "Last September the "Père Philosophe" came to us, and now we have you."

PARIS, 19 JULY 1972

Les Prêtres Passionistes. A poor missionary order. They wore rough cassocks and heavy leather belts around their middles. The priests had wanted a painting of mine as an altar piece. All they asked was that I read Mark

[23] 1958, 40" x 31".
[24] 1958, 72" x 60".
[25] 1958, 79" x 73".

on the passion and resurrection of Christ* before I painted it. The painting would be in my imagery, the sun, the snow cloud, and the sea.

Père Pierre said that he would personally pay for the materials. I said no. They were my friends, and I felt strangely honored by their request.

I read Mark. Then, fascinated, I read the entire New Testament. It was a story that I knew, but now looked at for the first time. It was the story of man, man's condition, the human condition. It was the passion and the resurrection of man. The Passion and Resurrection of God. The idea was already in my work. I had painted the huge yellow painting, *My Father is the Sun*. And I had recognized the pun in the title. My father, the son. The sun, the light of truth; the sun, the Resurrection; the sun, the mind of God knowing he was creating the idea of the Resurrection. Reds and yellows. The passion, the rage, the agony. Reflection. Reds reflected in the sea.

When it was announced that the painting was finished, a time was arranged for viewing it in my studio. Everyone from the seminary came over. The Père Philosophe and Père Pierre were seated before the canvas. Père Roch stood beside Père Pierre. A young priest who spoke English stood beside the Père Philosophe—he was to act as translator when I did not understand. The others ranged on either side in a semi-circle. The Père Philosophe studied the painting for a long time. Finally, he said, "I am now going to give my reading of the painting as I believe it reflects Schueler's interpretation of the Resurrection and the Passion of Christ. He said that the red in the sky was the passion in the mind of God and this red was reflected in the sea. He said that Schueler saw the Passion and the Resurrection as one. That both existed in the eye and mind of God as they existed as events on earth. God knew all the anguish of his own terrible testing of the sun. Of the son. The pain he caused, the passions unleashed, the grinding down of a man's spirit to a moment of total defeat. Therefore, his knowledge, even in the blooded truth and glory of the Resurrection, was a shadow: It held the light of creation and the shadow of the knowledge of death; all was one." My very flesh thrilled when I understood the Père Philosophe to say that Schueler had chosen the moment of "My God, my God, why hast thou forsaken me?" as the moment of Christ's supreme agony. It existed in the passivity with which I had painted the red reflection. Everything else in the painting moved. This paint was quiescent, without struggle or search or hope. I realized when he said it, that this was the first time I had thus used a red in my work.

In the summer of 1966 I visited Clamart. The chapel had burned down some years before, and the only thing that had been saved was my painting. It was now on the wall of the Father Superior's office, smoke-blackened, the paint blistered.[26]

*See color illustration 6. Also referred to on page 41.

[26]In 1998, Diane Cousineau, coeditor, tracked down *La Passion et la Résurrection du*

PARIS, 7 AUGUST 1972

Margo. Margo.[27] Briefly a Woman in the Sky. She was a White Goddess for Graves. She was a fighting mistress and inspiration for many of Alastair's poems. And for a day, she lay in my studio, dreaming, while I worked on three huge canvases. I could do no wrong. Something in her reached me. I wanted her posing, so that I could look at her and feel the painting in me and watch the painting move across the canvas, watch it grow and become. There was no reason, no words. I asked her to stay in New York. I didn't want romance—in a million years I didn't want Romance. She still had a close friendship with Alastair. More than that, I could imagine her as being very destructive. Or I could imagine her as the rock, the knife, on which a man could destroy himself. But as the Woman in the Sky, she was magnificent. Very much Woman, very much Person. There was nothing particularly voluptuous about her or, for that matter, striking or unusual. She gave herself to the dream passively. Yes, passively—that's it. She easily fell into the pose I had determined long before with the series of models I had used to paint the Woman in the Sky. Reclining, legs spread as in love or birth. But with her, I allowed some pillows under her head for comfort, which made the pose more passive. I worked on three canvases.[28] All of them very large—seven feet or more. One was aggressive and sharp in its drawing, passionate, hard, next to cruel, but beautiful. Reds and dark blues and blacks. Another was soft and frivolous, gay, spring, love in the spring, hopes blooming, a joyous sentiment, laughter, a touch, magic and love. The third, the largest, was very sparse—I never really finished it. It was a few lines and strokes and spaces on a large white field, suggestive, abstract. It was the most abstract canvas and therefore the most intellectual. Three sides. Three forms. Three beings. God, how I wanted to keep on, for months, for a year. More. This should certainly be the woman to paint. There were endless facets of her being that would touch endless facets of my own. Painting upon painting, painting growing out of painting, painting growing out of mood.

I talked to her about it. She understood. She said, "I know that there is something unusual happening. I know that you see deeper into me, to a woman that I know exists but who is hidden to most people. I know that the best thing I could do with my life would be to work with you now and to become part of the painting. But I can't. I have to go to Paris."

Christ (1958), 66" x 71". Restored, it is on loan to the parish hall of St. Lez-St. Giles, in Thiais, a Paris suburb.

[27]In 1961, Margo Callas, the White Goddess, the poetic muse of Robert Graves, left him for Alastair Reid. Reid, who had previously worked very closely with the writer on the translation of Suetonius' *De Vita Caesarum*, was now no longer welcome in Graves's house.

[28]Two of these paintings are *Margo on Monday*, 1965 (90" x 96"), and *The Patea Margo*, 1965 (102" x 125").

Galilea. In the summer of 1965, I was living above Galilea in an old farmhouse, loaned to me by Alastair.[29]

Douglas Day and I decided to go to the Robert Graves poetry reading—the first event of the great man's seventieth birthday celebration. We learned that everyone was going to be at the reading. Graves's wife was at the table, as was his White Goddess, a rather pretty, quiet, and very young girl from North Carolina. But he was waiting for still another woman of his entourage: his Black Goddess, who was to have flown from Mexico for the event.

Ruthven[30] was also invited to the big picnic that would be held the following Saturday at Graves's house. Douglas had written a note to Graves telling him that he was in Majorca, but had received no reply.

Alastair, of course, couldn't go. Since he had run off with Margo, the White Goddess, Graves had not spoken to him. Graves hated him. He also hated anyone who had anything to do with Alastair.

I remember riding out to Deya in a convertible driven by Douglas. Ruthven was in the front seat with his bottle of lemonade, and I was in back. As luck would have it, when we pulled into Deya, we saw a tall handsome man in shorts and a huge straw hat walking along the road. It was Robert Graves. We stopped. Ruthven introduced us. I had met Graves in Deya and in New York during the previous seven years. Douglas had been in correspondence with him about the book. Graves completely ignored us, talked only to Ruthven, told him he hoped he'd come to the reading. Then he walked away. Douglas and I were disturbed at the snub but decided that Graves must have found out that we were often with Alastair. We drove on to the hotel where we had booked rooms.

We had a swim and walked around the village and went to our rooms for a rest and shower. Then we went to the terrace of the café for a drink. Graves came up (it was almost dinner time) and sat down with us, treating us most cordially. He now told us that he hoped we were coming to the reading, and asked us to a small dinner party being held beforehand in the private room of the inn. When it came time for dinner, we went with him to the dining room, where there was one long table, and one small table set apart. Ruthven was seated at the main table; Douglas and I were seated at the small table with a very boring Englishman.

[29]Schueler frequently rode his motorcycle down to Palma (about twenty-two kilometers away) to join Alastair Reid and Douglas Day who were sharing a house that summer.

[30]Ruthven Todd, poet and former husband of Jody, who now lived in the village of Galilea, about thirty-eight kilometers from Deya.

Graves had enlarged his original White Goddess theory, and now had a Black Goddess, an important inspiration for the poetry he must write. She was a bitch goddess, a tormentor, who used a man mercilessly. I was anxious to see this Black Goddess of Robert Graves.

After the dinner, we went to the Arts Center. The reading was delayed, but still the Black Goddess didn't appear. The room was packed and hot. Ruthven had a seat downstairs, but Douglas and I were up in the balcony, peering around some supporting pillars to watch the poet. And he was worth watching. He read a number of poems, beautifully, solemnly. He was, at seventy, a virile and energetic man, handsome, with grey curly hair. I was deeply moved at the very idea of his long productivity.

After the reading, everyone went to the terrace of the café to sit in the warm night and talk. Everyone except Mrs. Graves, who went home. Graves seemed distracted and unwilling to talk. I thought it was a natural aftermath of the reading, but someone whispered to me that it was because of his hurt and anger at the failure of the Black Goddess to appear for this celebration.

Suddenly there was shift of mood and motion. Everybody was alert. There were whisperings and warnings. Graves stiffened. Douglas whispered, "I think the Black Goddess has arrived." I turned and saw a woman in a white dress just stepping onto the terrace. Just as I saw her face, she saw mine.

"Jon!" she called.

"Cindy! My God, Cindy!"

I jumped up and we threw our arms around each other. She was absolutely exuberant. Her hair was short, though not as short as when we had had our affair in Paris. Her eyes danced with mischief. Immediately, I was aware of Robert and Cindy and myself. I tried to propel her towards Graves. She was yelling with delight. "How are you? We have to see each other." Finally, she greeted Graves, and then she took Douglas's chair and sat between Graves and myself. She wanted to know everything. She had been in Mexico (wonderful time!) and had missed her connection in New York because she had stopped to see some friends there. But had taken the next possible plane.

"A shame you missed the reading," I said.

"Yes, but how are you? God, you look wonderful. Are you coming to the big picnic on Saturday?"

I said, "No, not really."

"But you're invited, you must come. Isn't he invited, Robert?"

Graves, his face silent and dark, pouting, said, in a voice I could scarcely hear, "Yes, he's invited."

I said, "Well, thank you, Robert, I do hope I can come, but it's most difficult. I'll be in Galilea." And I knew that I would not come to the picnic. It most definitely would be the wrong thing to do.

When I was living in Paris in 1958, I called Joan Mitchell. She was living with Jean-Paul Riopelle, whom she later married. They took me to dinner at an ice hockey rink. Riopelle was totally self-engrossed. I didn't know how to reach him. But he was my host. Short, dark, determined. French-Canadian. Aggressive paintings, thick paint spread on with a knife. Short, tight strokes. A cleverness in the way in which the form and color evolved, like a system of killing.

I met Joan in New York in the early fifties. Joan and I were in the art world together. Everyone knew each other. She admired de Kooning. She was a friend of Ray Parker. We were at the same parties. We talked. We had an affinity, at the same time that we were ready for battle. She was one of three very aggressive women—Grace Hartigan and Helen Frankenthaler were the others—who fought to become known as artists rather than "women artists." She was a good painter, an aggressive painter. One night we were to appear on a panel together at the Club discussing the woman artist. Before the eve of the panel, I remarked that the creativity of woman was in the womb—and all hell broke loose. Joan got Grace and Helen to join the panel, and they raked me over unmercifully.

They were three female musketeers. They roamed the streets together. Helen did very fluid stain paintings, very much after Pollock, but also very much her own. Hers were the most feminine paintings of the three. She lived in an apartment on West End Avenue, spread her canvases on the floor of one of the rooms, and poured the paint. For a while, she went with Clement Greenberg.[31] After they had broken up, Clement got into a fight with her current boyfriend at a Stable opening. Helen screamed that she couldn't stand it, and everyone had a marvelous time. When she married Bob Motherwell [1958], she and her paintings became harder, firmer, more handsome, more forceful, whereas he and his paintings became softer, less defined, less certain, and influenced by some imagery in her work.

Joan has always dressed in rather shapeless clothes, and I was amazed one night, when I made love to her, at the beauty of her breasts. We had gotten together at a party at Phil Guston's studio. Later, we went to my studio. I felt warm and tender toward her in her St Mark's Place studio a couple of days later, but she made me understand quite definitely that there would be no more loving. We had enjoyed that, and now we would be friends.

I didn't see her much in Paris in 1958, at first because I just couldn't see anyone, and later because her life was so different. She and Jean-Paul hung out at a New York style bar and drank a lot. I just didn't like to drink that

[31]The critic Clement Greenberg (1909-94). He championed the work of Pollock, Newman and Rothko, and later the Color Field painters Morris Louis and Kenneth Noland.

much. But I did call when I was here a couple of years ago and she asked me out to Vétheuil, where she owns a lovely house. We had a warm and friendly afternoon. We had some drinks at the local café and then went up to her house, which is on a cliff overlooking a beautiful bend in the Seine. It is Monet country. Outside of her studio is the field Monet painted (a hill with poppies and two figures). His water lily pond is in the neighborhood. We talked about all sorts of things and looked at her paintings, which I thought were beautiful. She looked at slides of my paintings and wanted to buy a small one, and later I sent her two so that she'd have a choice. She bought both.[32] Then when I knew I was coming to Paris this summer, I wrote and told her. She was one of my reasons for coming. I thought we had developed a friendship through the ups and downs and complications of these years and would want to see each other. When I arrived, I called her and let her know. Then I called again. And I sent notes. But I never heard from her. Finally, I called once more and she said I "could" come out—as though I were begging some kind of favor. Were it anyone else, I'd not go, nor would I bother much anymore. I'm not really looking forward to tomorrow when Magda and I will drive out to Vétheuil to have lunch with Joan.

PARIS, 15 AUGUST 1972

Last Saturday, Magda and I drove to Vétheuil to see Joan. She had asked us for lunch, which we ate in a restaurant in the village. Jean-Paul was in the café but didn't come to the table until we had nearly finished eating. Joan twisted everything that Magda or I might say. I was quite miserable and wished that I were out of there. Joan seemed to be deliberately baiting me or attacking me, putting me down in every possible way. She suggested that I was getting deaf. She suggested that she didn't like my "Abstract Expressionist" paintings, as though she had no awareness of the continuity of my work. Everything was a put-down. I had the choice of getting enraged or of abruptly leaving. I no longer like to do such things. I just don't enjoy battles with women. I sat through it. But after lunch, we admitted that we had both been upset by the other. I had felt puzzled and insulted or rejected by her failure to call and invite us to Vétheuil. She had felt the same by the fact that I had not called and said that I was coming out. But of course, I had called a number of times, and had written a number of notes. Yet, we went back to her house and she showed us pictures of her show in Syracuse, New York, and transparencies of her paintings, and we visited her studio. The show and paintings were impressive. I felt happy for her. But Joan looked like a memory of someone I knew. She had tinted glasses, quite dark

[32]*Night Sky: The Sound of Sleat I*, 1970 (6" x 8") and *Sunday: The Sound of Sleat*, 1971 (12" x 14").

and very strong, so that her eyes looked like huge eggs swimming in dark
liquid.

*Neltje, a friend and important inspiration for the 1960s Woman in the
Sky paintings, appeared in Paris, prompting this circling back to even earli-
er times.*

PARIS, 22 AUGUST 1972

Fragment.

Neltje was to be married to John Sargent. I asked her to my studio to show
her paintings. In a cab afterwards I told her I'd save her from the marriage:
She could marry me. She suggested that I come to tea sometime.

*After writing in Paris for three months, Schueler drove back to Mallaig by
way of Brittany to visit the German World War II submarine pens at St.
Nazaire and Lorient, and then to Molesworth, England, his former air base.
It would be six months before he could bring himself to write about the pain-
ful war experience that follows here. Thoughts of that period inevitably sum-
moned up the image of Bunty Challis and their war time love affair. Her
"disappearance" was evoked through memories and later by titles of paint-
ings, Night Sky: Bunty, July 1973, or The Search: Bunty's Blues,* 1974,
but as he continued to write and talk of her during these years, he increasing-
ly gave himself over to the possibility that she might be found.*

MALLAIG, 13 JANUARY 1973

How strange it would be if the book or my paintings would come to Bunty's
eye. What if I had a show in London? Would she see it?

I think that the reason I can't look for her is because of my burial of the

*See color illustration 25.

past. The same reason that I couldn't look for my Grandfather Haase. I felt guilty. The same reason that I can't write and uncover the past.

22 NOVEMBER 1943
LETTER FROM BUNTY CHALLIS

My dear Jon:

For ages I have meant to send you one of my unreadable notes, as I didn't even wish you "bon voyage" before you left. So sorry.

I imagine you and Freddie passed in midocean, as he eventually returned about the middle of September.

What a party that was! The night he arrived in this country was complete Chaos at Lewisham—I almost wrecked the place, got wildly drunk and left in a cloud of dust. Since when I have been a civilian, and we have had lots of fun tearing madly from one place to another.

I hope you see lots of Jane and that life is very gay for you both. It must be such heaven for you being back home again. You must write and give me your impression of America after this war-scarred blacked-out England. I should so love to be able to rush along Broadway, instead of having to stagger on Piccadilly, bumping into everything!

Italy still looms ahead, much to Freddie's "disgust", and he is very successfully managing to postpone it at the moment—but not cancel.

In the meantime, I have been offered a driving job by the U.S. Naval Attaché in London—and he doesn't know quite whether to approve of that or not.

Actually!!! I am not at all keen to do any work for a long time, it is such heaven being on indefinite leave.

What are you doing now? Are you perfectly fit again?

Life is good, and gay, once again for me—I only hope it is for you, too.

Heavens knows if this letter will even reach you, 'cos I can't read your address.

Love,

Bunty

MALLAIG, 15 JANUARY 1973

What do I remember? I remember getting more and more tense and nervous and irritable and unable to sleep. Mostly I remember being unable to sleep. Billy[33] had been sick, had a terrible cold, was off flying. I had a cold, too, and was off flying, but I wasn't in the hospital. We were called upon for a raid and we could only get a few ships out of the group in the air—because of lost ships, because of badly shot-up ships, because of shortage of personnel.

[33]Billy Southworth, pilot of the B-17 *Bad Check*.

Either shot down or sick. I volunteered for a raid over St. Nazaire. I flew with another pilot. Afterwards Billy said that he was furious to hear this. He felt that it was a bad thing to do. That was the raid in which we headed in a steep descent down to the deck from 20,000 feet after dropping our bombs, and the pain shot through my head like I had never before imagined. That was probably the beginning of the deafness in my right ear.

MALLAIG, 18 JANUARY 1973

I couldn't sleep. I slept for an hour and a quarter before the last raid over St. Nazaire—the raid with the 120 mph headwind on our return. I started to feel guilty, responsible for every death. I was afraid, not sleeping, that I'd make errors and cause the death of many. It could happen—navigation errors, pilot errors. Ending in death. Planes falling, planes shot down. So many were dying and I felt responsible. But I felt more responsible for those who might die, who would die.

I was a good navigator. Billy raved about me, bragged constantly. We could sense each other. He depended on me. And I knew he was a terrific pilot. I would be able to pinpoint our position minute by minute, pinpoint the target, lead us on an accurate path away from the target, across France and the sea, across England and home. I'd be in the nose of the ship, hunched over my drift meter, making calculations, keeping mental averages as we flew evasive action, grabbing the machine guns when the fighters started to come in at us, checking, always checking position.

But then I failed. It was one of the biggest failures of my life. I still feel accountable. There is no way to rectify it. There is no continuum.

Is the continuum in the painting? It must be there. The loneliness of each man in the sky, the sound of the engines—MmmmmmmMmmmmmmm-MmmmmmmmMmmmmmmm. The sky blue. The undercast of cloud. The B-17's each alone in its formation, the men in the bombers, each alone at his station. We were connected to each other by wires, the wires of communication strung through the ship and ending with our headphones. The throat microphones. Navigator to Pilot. Navigator to Pilot. Go ahead, Navigator. We are approaching Boulogne. About five degrees to port. There is supposed to be a high flack concentration. Over and out. Roger, Navigator.

Who was the group flight surgeon? I went to him for sleeping pills. I said, "I can't sleep, I can't sleep and I'm feeling foggy in the plane, and I was afraid yesterday that I couldn't concentrate." The 120 mph headwind meant that we were traveling across France at about 134 mph and it seemed endless, as though we could not move. I see the clouds now, the clouds building up so that we couldn't see the ground. We had no sign of movement, the B-17's standing still and the Focke Wulfs and the Messerschmitts coming in to meet them, coming in to knock us out of the sky.

And for a moment, for a long moment, I was not navigating: I was watching the planes falling, the head on crash of a fighter into a B-17, the exploding,

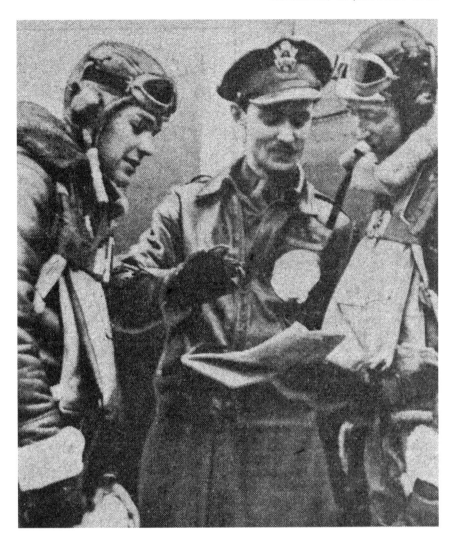

Sgt. W.W. Fleming, Lt. Jon R. Schueler (center), and Sgt. E.J. Doughty at the U.S. Air Force Base, Molesworth, England, November 1942. This photograph appeared in the Milwaukee Journal, *February 8, 1943*

burning, war-torn falling planes, all too often no chutes in sight, the lonely men, held to their seats, to the walls, to the roof of the plane as it twisted and fell, sometimes with machine guns blazing, and a spume of smoke trailing from the wing. Did I cause all this? I was bemused for a long moment. It seemed endless. It seemed as though we would never get back to England. I was looking out the window at the endless blue sky and white cloud beneath us. We waited for the Focke Wulfs and the Messerschmitts and we

watched the Fortresses fall. Falling Forts. I wanted to hold them. I wanted to go down with them. I wanted to go home. I prayed. I prayed, please, God, I'm bored. Please don't make this go on and on and on. It's boring, it's en-nui. I can't stand the boring repetition. Please, God, get us out of here and get this over with. I was probably frightened, too, although I was seldom scared while actually flying.

We'd be awakened at 2:30 A.M. and we'd dress in the cold of the room and slog outside into the rain and the muck and we'd have our breakfast and then we'd go to the briefing room.

"ATTENTION".

We'd pop to and the colonel would stride down the aisle and mount the plat-form and announce the target. "St. Nazaire"—and we'd groan and laugh at the same time. But from then on it was business. We'd be told the time of takeoff, the time and place of rendezvous, the point of crossing the Channel, the initial point, the target, the procedure and route back. And then we'd go to individual brief-ings, navigators' briefing, gunners' briefings, pilots' briefings, bombardiers' brief-ings. All night long, the bombs were being loaded and ground crew was work-ing on the planes. We could hear the engines being revved up. We could hear . . .

But that resistance I felt when we were out on the pad. Strange. Some-thing has just come over me. That resistance: We would go out to the ship. And as long as the momentum of activity was going, everything would be okay. I felt the excitement; the blood coursed through my veins. We would start the engines revving and I'd lay out my charts and have everything ready, oxygen mask, parachute. Check all the dials. Computer, pencils, Weems plotter. Milt Conver would be making wisecracks. We could feel the plane being readied; we could feel the vibration of readiness of men moving back and forth, at their dials and controls and guns. It was when it all stopped that I became immobilized. When we had word that the mission was postponed for a half hour, an hour, an hour and a half, two hours, two and a half hours, continuing until 11:00 or 11:30 A.M., when it was too late even if the clouds opened up. If the momentum stopped—the engines turned off, and every-one leaving the plane and sitting around on the pad talking—then I found it hard to think about starting again. A great lethargy. The same lethargy which comes over me when I stop typing. As though it is impossible to start again.

I wish I could make this clear. I cry to think of it. The morning, the grey cloud-covered morning. The endless flat of the air base, and all around the perimeters are parking circles. The B-17's are scattered around the field, and it is 7:00 in the morning, the first dim light of day. The first dim, grey, sil-ver light, mists rising from the fields. And then you hear engines starting here and there, some close, a roar, and then rrrrrrrmmmmmm, ready on one, ready on two, contact, ready on three, ready on four. And the four en-gines of the B-17 slowly throbbing, vibrations increasing, a spitting and grum-bling, a lust for the morning air, a waking from the dead, a waking from the

night, a waking to life, the life of the new day, of the throb, the heart-throb of the plane, four engines beating, four propellers whirling, engines revving, echoing one another across the field. The big, olive drab B-17's would slowly move, brakes screeching, the ground crew watching, one of them helping to guide the plane around the circle onto the tarmac path to the perimeter track. One after the other lumbering out onto the track and then all of them, single file on each side of the field, two files moving, lumbering slowly toward the takeoff point at the head of the runway. All of them, engines growling and propellers whirling. The nose of the B-17 in the air, the body sloping down to the rear tail wheel, already in an attitude of urgency, of wanting to rise into the grey morning sky. One after the other after the other. Because of the morning light, because of the vast, flat stretch of the field, the planes loomed larger and more powerful than they actually were. The vision was large as the very poetry of the act. It really was beautiful, beautiful in many, many ways, and the strange paradox of my life is that I feel sad and frustrated that it cannot be re-created, that I cannot see it again. I have no lust for war. I have no lust to fight. But that moment, that very moment, 1942–43, I wish I could have it again. I want to see it, I want to feel it, I want to relive it. I want to taste of the whole thing—except for my own defeat, and that I want to make right. I want to re-create that defeat, and turn it into a victory. I've tried to turn the painting into a victory, and I'll try to turn the writing into a victory, but I can never again try to turn my combat experience into a victory. I could be a total pacifist. I could be politically ignorant and know nothing about the war, the rise of Hitler, the meanings of the war. And yet, the fact of the men, of the moving together in the planes, of the search, lonely and together through the sky, the accidents, the quest, the blowing up of ships, the death and the life, and the pure visual beauty of the aircraft on the morning field—these live or were alive. This has nothing to do with man's hatred or rages or the diabolical machinations of politicians. It has to do with men doing something together, faced with great risk. A heightened sensibility. I don't know what it is. Yet, I was there. The nobility of the men, of the planes, was beyond compare. But I left.

Ifs. What-could-have-beens. I sometimes wonder if it would have been better if I could have felt the fear. Had I been able to feel the fear, call it that, name it, I might have been able to feel the rage. Had I been able to feel the rage, I could have poured out the machine gun fire, I could have slammed bullets into the sky, into the waiting Focke Wulf. I was always aiming carefully, aiming too high or too low, never hitting a plane. I really—underneath—couldn't stand the idea of killing. I couldn't shoot skeet; I couldn't win the game. And now here was a new game that I wanted to win, but I was shooting short. I could not call upon my rage. Yet, it is my rage that I've often had to depend upon to get things started, to find my way into the heart of the painting, into the sea of emotion that would be the painting. It saved me in Mallaig Vaig in 1957 when the skies

and nature were too much for me, when my painting was becoming senti-mental. But in combat, I could not feel the fear or the rage and therefore the love, the love and excitement of what I was doing. I was quite cool in com-bat. I'd always be so goddamned busy with charts, mental averages, counting and noting falling ships (time and place). I was a cool cookie. And I lost ev-erything in my cool. I lost my way. It took years to recover, to find myself in the heat of the emotion and to make something of it.

MALLAIG, 19 JANUARY 1973

The flight surgeon gave me sleeping pills and talked to the group commander about taking me off combat for a while to rest up and get my weight back. I had lost twenty pounds or more and was skinny as a rail. They needed an operations navigation officer, and I was made that, in charge of preparing the navigation flight data for the raids. For a moment, I breathed a sigh of relief, but then I felt myself sinking into guilt and confusion. We sent out as many of the planes as we could muster on a mission, and instead of being on it myself, I was left on the base. At the end of the day, I was on the tower, looking to the sky, watching for the returning planes, counting when they appeared. One, two, three, four, five, six, seven, eight—Is there another? Where are the others? My God, there must be others—there, there they are, nine, ten, eleven, twelve . . . twelve . . . twelve. . . . There are no others, there are not others. We look anxiously. Scanning the sky. But then the planes are flying in low over the field and moving around into their landing patterns. And then there is a flare from one and he's moving right down the runway without permission. He's floating down, landing, another flare de-noting wounded on board, and the ambulance is rushing toward the plane even as it rolls to a stop and the side door is opened and the orderlies take a fli-er from the plane. Another plane is coming in—this one wasn't in the flight—he has three engines out, and somehow he manages to bring the plane in. And still another has radioed in to the base that he has a flat tire on one wheel, but the plane moves gracefully as a bird, the pilot bringing in the ship lightly, soft-ly, leaning just a bit to port, the side of the good wheel, the plane contacts the runway; it glides along smoothly, slightly tilted, softly, softly settling, there, final-ly settling on to the bad tire and then lurching, turning, twisting off the runway into the soft ground, swinging around on the bad wheel, and coming to a stop. Others land with wounded. The group is badly shot up. One plane is missing.

In no time at all, word came that I was to be transferred to 8th Bomb-er Command Headquarters. Col. Walker, our original commanding offi-cer, the one who had given me such a hard time when I asked permission to get married in El Paso, was now Command Operations Officer at High Wycombe. He had heard that I was temporarily off combat, and know-ing my reputation as a navigator, and needing an assistant to the com-mand navigator, he called me down. I flew to High Wycombe. The place

was loaded with brass. This was the hub of the wheel, where missions were planned, where major decisions were made, where everything started, and where all responsibility lay, and the damages, the planes lost, the numbers, the constant numbers were fed back to the generals for more decisions, for more action, for more change. I was to be part of this.

After the mud-slimed walks and roads, the cold quarters, the impossible little coal stoves, the scrounging for coal, the weight of combat, the mood of combat held in the grey clouds hovering over the field at Molesworth, hovering over our lives, this coming out into the glare of civilized living, of comfort and cleanliness and order, this seeming ordinariness and peace, was like coming into a strange dream, stagelit, impossible to understand or relate to. I was shown to my quarters in Wycombe Abbey, a girls school, and before that a huge mansion. I had an attractive room, with a bell and a neat sign that said, RING FOR MISTRESS. I was introduced to the officers' club—quiet officers drinking and talking, rows of slot machines. The meals were superb. Food must have been flown in from the States.

Shortly after I arrived, the offices for the entire headquarters were moved into an underground structure which had been dug into the side of a hill. It was air-conditioned and entirely lit by fluorescent light. I had my own office next to the Command Navigator, Roy Deadman. Roy and I would work out the navigation timetables for prospective raids, and then, when it was time for the general to make his decisions, we would meet in the briefing room, huge wall map, everyone at attention when the general entered, formalities, just like the movies, but totally unlike what I had known at Molesworth. It seemed more like theater. Everyone was speaking in formal tones. The general looked thoughtful, was silent, made decisions, asked questions, shot out abrupt questions and answers, and we said 'Yes, sir" and "No, sir" and we carefully and formally played our parts. I would work out the problems, all in terms of predicted winds, and the alternatives. I seem to have been important, but in some way my mind was out of things. I was still with the men at Molesworth.

I felt dead amongst the living. I felt weak, washed out, through.

Within three weeks of the time I arrived, I came down with mumps. First I had them on the left side of my face, then on the right. Each took a week. I thought I would have a week's rest and then go back to duty. But then I had them in the right testicle. I was swollen many times my ordinary size and was in great pain. At the end of the week, I was a wreck. The doctor announced that I would now leave the hospital. He said that the Army rule was three weeks for mumps. When I left the hospital, I could hardly walk up the hill to my quarters.

After a couple of days, the flight surgeon at Command took me aside and said that he was worried about me, that I looked like hell and that I needed a rest. He told me that there were rest facilities for flying personnel where I'd be able to just eat and sleep and walk and play games and—did he say swim? I don't know. I wish to hell that I had said, Okay, you're the boss.

Where is it? I'll go—I sure need it. But instead, I said, "Okay, but not yet"—I was getting a little strange. I remember that I got so that it was nearly impossible for me to make a phone call, so I would call in person on other departments when I needed information. One day I absentmindedly walked through a door ahead of a general—I didn't even see him—I didn't know where I was—and he dressed me down on the spot and, I think, reported me. I doubt whether he had ever been in combat. I think he was a shiny-assed general. But nevertheless, I was in the wrong in a silly way that wouldn't have happened before.

I was looking worse and the flight surgeon said he wanted to speak to me again. He asked me questions and I started talking to him, telling him the story of my life, thinking that if he had as many facts as possible, he could remake me into a healthy human being. He now thought that maybe rest was not enough, that maybe I was in some kind of anxiety state, an anxiety cycle. There was a new experiment being tried in a hospital near Salisbury [perhaps Odstock Hospital] and he thought maybe I should be sent there and try it out. I think that when he said this to me, I took it almost with relief. I felt so goddamned guilty about being sick. So when the doctor said, "Look, you're in trouble; you really have been under a terrible strain; you really do need help," it was as though he relieved me of the guilt and of the thinking of it. For a moment.

MALLAIG, 22 JANUARY 1973

Cold. Yesterday snow. Today clear, and the island of Rhum is snow-covered down to—I should guess—about four or five hundred feet. Striations of rock through the whiteness. The ground below snow level like a deep mist or heavy, sullen cloud.

•　　•　　•

At the Air Force Hospital, I had about a half hour's talk with a doctor. In typical Schueler fashion, I was terribly earnest. I had some dim notion of psychiatry, about the fact that to resolve present weaknesses, one had to dig into the past. So, I just didn't talk about combat, nor was I asked about combat. As at Molesworth, I tried to say as much as possible to be helpful, because I wanted to be well—I wanted to gain weight and I wanted to stop the wild combat dreams (I flew at least one mission every night), and I wanted to be able to sleep, and I wanted to end the constant twisting sickness in my gut. Then I'd be a whole man again and then I could go back. By the very fact that Major Hastings had sent me there, I felt that I was at least justified in feeling the anxiety. Because I not only felt guilty about everything else, about the death of men and abandoning the squadron, but I felt guilty about the anxiety itself—as though it was wrong for me to have it. I told the doctors about the other time that I had felt

upset and depressed and anxiety ridden—following the suicide attempt of Jean Stafford and my trip to New Haven and the writing job there.

So, I gave them—quickly—something to hang on to without bothering to think about my combat experience. You had a choice of shutting up or of talking more and more and more in an effort to explain, to communicate, to find the word which would bring you together where you were both discussing whatever it was that was real. You felt your sense of survival had been strong, that you had made quite a bit out of a very eventful and complex life. And you wanted to unravel it and make even more of it, make it work. But for the others—gradually over the months, it became apparent that they were gathering evidence—and they were satisfied with a very small amount of evidence, and were willing to create conclusions out of a few chance words and incidents.

Anyway, the decision was made to give me the narcosis treatment. I think the same decision was made for everyone who came into the hospital with that ill-defined, but definite malady, "combat fatigue" or "flying fatigue". The planes became tired. The men became tired. They developed odd, unpredictable stresses and strains, hairline cracks in vulnerable places.

If I am not mistaken, this was the treatment: We were taken to a ward of sleeping men. We were given an overdose of sodium pentothal/amytal, enough to keep us asleep for about eight hours. At the end of eight hours, we would recover enough to be fed and taken to the toilet by the orderlies, but I don't think we would really become conscious. After eating and excreting, we would be given more sodium pentothal/amytal, to repeat the eight-hour cycle. And again. And again. For three days. At the end of that time we were placed in a special recovery or withdrawal ward.

I started to come out of it in the middle of the night. There was a night nurse in the ward and an orderly. I started talking with them and soon I was talking more and more and more. I couldn't stop. Then I'd blank out. Sleep. Then talk again. My world was the dark ward, the shaded light at the nurse's desk, the other men sleeping.

In the morning, I was taken to another ward. I don't think I slept. I was always awake, possibly twenty-four hours a day. When I closed my eyes, I'd be in a waking dream. Unbelievably real. Sometimes a million images would click before my eyes—like photographs, terribly clear, one after the other in rapid succession. One time, I was aware of another officer far down at the other end of the room, in the row of beds opposite mine. He is sleeping. Perhaps he is a bombardier. Then he is a bombardier and we are in the nose of a B-17 and we are being attacked and I'm at my desk hanging on to the gun, and suddenly the nose of our ship is shot to pieces and I can see the destruction now—twisted silver metal, webs of wires in every direction and oxygen lines blown out, wrecked. He is dying. I can't help him. I hear a terrible yelling filling the ward and I look down to where my bombardier is in his bed and I wait for the nurses and orderlies to go and help him. I can't seem to move. No one comes. But then I hear running

and they are at my side, holding me down, trying to calm me. I am the one who is yelling, I'm hearing myself yelling, I'm not there, I'm in the plane, I hear it, and it takes me a while to stop.

At one point that day, a young soldier came in to see me and said, "You are right in everything you said, and I'm going to read the books you wanted me to read." He was so serious and so thankful that I couldn't tell him that I didn't know who he was or what he was talking about. It turned out that he was the orderly from the recovery ward, and evidently I had been lecturing him on politics and economics, some rather left-wing ideas taken from Harold Laski, whom I had been reading in the summer of 1941, before I joined the Air Force.

· · ·

Our dog Millie is in the other room, quiet now, though she was crying when Magda left for the village to do the shopping and to pick up the mail. The room is a silver grey from the cloud light. My feet are cold. I'm surprisingly awake, considering the fact that I couldn't sleep last night and finally got out of bed and read Freeman's *The Mighty Eighth* until four o'clock in the morning.

· · ·

I remember moving to another ward. I was supposed to take off my uniform and to get rid of my footlocker. For some reason, I didn't want my footlocker to go into storage. It was very important for me to have it with me. It became an issue between myself and the Boston nurse, whom I liked very much—the nurse with full breasts and the good sense of humor. Somehow, she was the one who had to get me to remove the footlocker, and I kept putting it off, and pretty soon she was ordering me, and I got mad and lost my temper, and some officer had to dress me down about it. This was one of the first bad things that happened. This went on my record. This defined me.

MALLAIG, 23 JANUARY 1973

Now I was to be further defined because I became depressed. I know more than I used to about my own reactions to things. I always react very strongly to drugs. Undoubtedly, three days of overdose of sodium pentothal/amytal left me depressed. Was the narcosis treatment necessary? It was from then on that my hospital life was hell.

I never really talked to a doctor after that. I was asked what I wanted to do. I repeated that I wanted to go back to my unit. But I wanted to gain weight and feel fit again first. I was put through a regime of daily massage. I remained terribly tired and depressed and wouldn't come out of it. Then I fell sick. I had the chicken pox.

Move to another ward. Fever. Wild dreams. The fever lasted for days.

Then suddenly it dropped to subnormal. This worried the doctor anew. But finally it seemed to even out and I was exhausted and limp and very thin indeed, but the sun was shining and I was no longer depressed. Had the long, very high fever broken the depression created by the drugs? Long years later a doctor explained to me why this very well could have been the case.

I was asked again what I wanted to do. Once more I said that I wanted to get well and go back to flying with the 427th. This became part of the evidence. What man in his right mind would want to go back to combat?

It was eventually decided to send me back home. I was warned by the doctor that it would be a tough ordeal and that I would have to be very strong indeed. I could not know what he meant. But I was to find out.

Up until this time, I was surrounded with kind, well-meaning people. My dignity was intact. It was far from combat, but still connected with combat, and the remnants of the combat experience I had been through still existed in their thinking. We would have passes to go into town—sometimes in the evening. The doctor talked to me once again. He told me that the Air Force had no hospital service for sending men home; that this was done through the Army medical service; that I'd find it very different. The Army service was much less modern that the Air Force service, he explained, and regulations forced him to have me accompanied to the transit hospital at Exeter by an enlisted man. I'm getting sick thinking of this. He told me not to worry, that I was obviously perfectly sane, perfectly capable; I had been on a pass to London, and to Salisbury, etc.; that I was a combat fatigue patient and that they felt the strain of more combat would be too much.

I was going home.

Exeter. We entered the hospital and, after waiting, I was admitted to an office. A doctor in uniform remained seated and didn't look at me. He asked me a number of routine questions and then asked for all of my valuables, keys—in fact, to empty my pockets—and then to take off my belt. I was appalled. I said, "There is no reason for that." He said, "That is our rule." And he said it angrily and contemptuously.

Then I was taken upstairs by an orderly. I found myself in a locked ward.

Every door in that hospital was locked. We were herded around like animals. I remember high ceilings, tile walls. Cold, barren. Cold, barren nurses. The beds in long rows. Everything done by the bell, as in a reform school. We were without rank. I was now imprisoned.

There is nothing which will instill a greater feeling of rage in me. Yet I had to be under complete control. At first, I really wasn't. I told the nurses what I thought of the procedures. I didn't feel that it was necessary to degrade the patients. I took up the cause of one or two men whom I felt had been treated unjustly.

There was a particular ward boy who seemed to get on my nerves. In fact, he got on everybody's nerves. One day, this ward boy was particularly snotty

and I blew up at him and ticked him off, and the next thing I was sent before the doctor—the first time I had seen him since the day he took my belt. I tried to explain what had happened and what the other officers were beefing about, and he told me that I'd better be careful or else all of my privileges would be taken away and that I'd no longer be allowed on the walks that we took, accompanied by nurses.

I spent my days reading or talking or playing cards.

As I remember, I was in the hospital at Exeter about three weeks before we were alerted for departure to the United States. We were constantly made aware of the fact that there was something wrong with us and that we were prisoners, but nothing was done. We were being observed by nurses and ward boys and everything was being reported and our identities were being formed. If one talked or read too much, it was hyperactivity. If one didn't talk and didn't read, it might be depression. There was a subtle balance that had to be worked out.

I think it was in September [1943] that we were alerted to leave on the following day. The next afternoon we were given back all of our belongings, belt included, and in the evening were taken to the railroad yards and put on a hospital train.

MALLAIG, 24 JANUARY 1973

We traveled all night through the black countryside. Finally, the door was opened and we were told to disembark. We were in Glasgow at the side of the *Queen Mary*, which was to take us back to the United States.

Before we had left the hospital at Exeter, each officer was given a yellow tag, which he was told to tie to the top buttonhole of his coat. But then there was a slight commotion amongst the staff and I was told that I was supposed to have a green tag, not a yellow tag. On the yellow tags were the letters, in black, *Pn*. On the green tag were the letters *Pp*. We were not told what the letters meant, but I began to have a horrible feeling that they stood for "Psychoneurotic" and "Psychopathic," respectively. And now as we disembarked from the hospital train, I noticed that a colonel had a green tag. He and I were the only ones.

I only remember the confusion of leaving the train. I couldn't find my cap—searched quickly, but was hustled out, across the concrete ramp, and onto the gang plank. I felt naked, exposed, vulnerable. I was being stripped further of my rank.

On board, there was suddenly a moment when the colonel and I were separated from the group. The others, officers and enlisted men, were taken to an upper deck. The colonel and I were led aside, then taken down, down, down into the bowels of the ship, far below the water line, into the very bottom where we stood before a cage until the door was unlocked. Then we were shown into the cage, the door was locked again, and we were left alone.

The wall (at least the wall which contained the door) and the door were of wire mesh—like heavy duty fencing. There were two cots and two chairs. That was all. There may not even have been the two chairs, for I seem to remember sitting on the bed all the time.

I now was certain that I knew the meaning of the green tag. Psychopathic. I was a mad man.

But I didn't feel mad. I felt sick in my gut; I felt that I was trapped. I felt that someone at the Exeter hospital must now be having a hearty morning laugh.

I think it was a day or two before I finally got a message through to a doctor and he came to see me. I told him that I had to know what was happening to me. I asked him about the green tag. He said, yes, it labeled me as psychopathic. I told him I'd been in combat and that I'd been a staff officer at Eighth 8th Bomber Command and that I had been in the hospital at Salisbury. At no time had I received this kind of treatment. He talked to me for quite a while. Then he went to see my records. He returned and said, "There is nothing about you that is psychopathic. By something that is noted here, you must have had a row with someone at Exeter." I said that indeed I had and described the occurrence to him. He said, "Well, someone is getting even with you. There is nothing that I can do. You'll just have to put up with it until you are in the States. But I can get you up on deck for some walks." I said, "Thank God." But I also told him that having talked to him, I didn't mind as much. He said, "You must be incredibly strong; you must have a very strong core—to have gone through all you have gone through and still be sane." I have always remembered that statement of his, and it has held me in good stead when I have been involved with some of the subsequent crises of my life.

We arrived in New York. Once again, I was without my cap. The returning hero. Taken from the bowels of the ship, escorted down the gang plank by an orderly, and capless! Red Cross personnel were waiting to give us coffee. I can't remember whether or not I wanted the coffee, but I was home. Actually, I can only remember feeling somewhat estranged. England, wartime England, England with combat had become my natural habitat, and immediately this land, those faces, this activity felt strange.

We were driven out to Queens—and now I was back with my old friends from Exeter. I was no longer in the psychopathic ward. My doctor friend from the *Queen Mary* had evidently done some good. I was in a large green ward—unlocked—I think we had separate rooms, or two to a room. But we had no idea of what was going to happen to us.

I had called Jane's number several times throughout the day. Now I called again. And again. No answer. I called the next morning. A man answered. He said, no, Jane wasn't there. I said I was her husband and to have her call me. He said that he was the telephone repair man, and just happened to be in the apartment, but he would leave a note.

The hospital was conveniently located. The staff seemed very human and

I began to feel relieved and almost ready to be lighthearted. But it seemed that I would not immediately be rid of my green tag. The doctor told me that he could not reclassify me, that because of the green tag, I would have to go on to another hospital, the Mason General Hospital at Brentwood, Long Island. But he said that he agreed with the ship's doctor, that I was not psychopathic and he would escort me personally to Brentwood and would speak to the doctor in charge there.

The next morning, he and I left for Brentwood in a command car. It felt quite ordinary and dignified. Two officers being driven across the countryside in a command car. Except that one did not wear a cap. And both were probably rather self-conscious about the situation. We both knew that this was an interim of sanity.

I had wanted wings. *I Wanted Wings*.[34] At the hospital I was told to undress and my clothes were taken from me and I was given pajamas and a robe. Some of the men were locked in rooms. Some were strapped down to their beds. The rest wandered around aimlessly.

MALLAIG, 26 JANUARY 1973

I had a hell of a headache, and finally found a nurse. "I wonder if I could have a couple of aspirin?"

"Why?"

"I have a headache."

"Aspirin has to be prescribed by the doctor."

"Where is the doctor?"

"You can't see him now."

"When can I see the doctor?"

"You'll be called in to see him. Perhaps within the next two or three days."

I could not sleep. At times the night air was slashed by shrieks and yells. One man—I thought it must be the black soldier I had seen strapped to his bed in a straightjacket—moaned constantly—in a blood curdling manner.

The next morning, I found another nurse. "I must see the doctor."

"You'll have to wait your turn."

"I have a terrible headache, and I must see him right away."

For some reason (normal, logical behavior was becoming suspect), I was taken to the doctor's office, where I waited for about twenty minutes to be called. I was finally admitted to a small office. A rather young doctor was seated behind the desk. At first, he didn't look up. Then he said, "I understand you want some aspirin. Why?"

"Doctor," I said, "I want some aspirin because I have a headache. And I have a headache because I am in this hospital. And the reason I tried to see

[34] A film with Veronica Lake that romanticized patriotism and flying.

you was not to complain about a headache, but to tell you that if you want a real madman on your hands, you'll keep me in this ward for another twenty-four hours."

He looked up, startled. From that moment on he paid attention to me. "What do you mean?"

"I am a combat navigator. I flew in B-17's until recently. I was in a hospital where I was given narcosis treatment. But at that hospital, I was not treated like a prisoner or a madman. I went into town on dates and to movies. I went to London. Then I was shoved into this homecoming procedure. I became angry twice—once at a nurse, once at a ward boy. The doctor—who had scarcely spoken to me—threatened me. Without warning, I was given a psychopath tag when it was time to be shipped home. From that moment—not before—I was separated from my fellow patients. I was shipped home in a cage. The doctor I talked to on board said that I was not a psychopath, that I had probably been so labeled for stepping out of line, and that he admired my strength. He said that he'd try to straighten it out but that he had no power. Then yesterday, the major who brought me here from the Queens hospital said also that I was no psychopath, and that he would report this directly to the head of the hospital here. Now, once again I am being treated like a psychopath."

"Everybody goes into this ward for observation. After that, you will be diagnosed and sent to another ward."

"How long does that take."

"At least a week."

"Then I can only warn you. If you want a definite madman on your list, you'll keep me here one more night. I can't tell you how serious I am about this. I have been through a great deal. I have been able to take everything up until now. But I cannot take the utter insanity of this procedure."

I spoke to him as intensely as I felt, looking him straight in the eye, trying to communicate by the force of my look, in case my words should fail to get through.

He listened to every word I said. "I'll see what I can do," he said.

About three o'clock in the afternoon, I was approached by an orderly and given my uniform and taken out of this ward and down to the fourth floor to an open ward.

For the next few weeks, nothing very much happened. I started a big reading program and also began a journal—but very quickly found out through a friendly ward boy that I was considered to be hyperactive. The idea was, they told me (just as at Exeter), not to be too active but to do enough. To smile, but not to laugh uproariously. Not to complain, but not to be too satisfied. To be agreeable but not to suck up. Above all it was necessary to agree with the doctor, Captain. Simon, who they said was a real bastard.

But this became even more complicated. I was no longer in a psychopathic ward. I was in an open ward for psychoneurotics, combat-fatigue

patients, whatever you wanted to call them. But combat fatigue was no longer talked about. Combat was no longer talked about. Now it was neurosis or psychosis. And there the patient was faced with a dilemma. In order to prove himself sane (and the burden of proof was on him), he had to agree with the diagnosis. But my diagnosis now was that I suffered from a manic-depressive psychosis. I was faced with the curious contradiction that I had to admit (like a criminal admitting to guilt) to being a manic-depressive psychopath in order to be freed from hospital.

Jane came out often from the city. We'd wander around the grounds and talk. She'd bring me books and periodicals.

Mason General Hospital. Fourth floor. The day finally came for my preliminary exam. 8 October 1943. Pompous, fat little Captain Simon started asking questions. Very quickly I felt that this was an interrogation. With pre-conceived ends in view. All the discussion seemed absolutely divorced from reality. He asked me something about being "nervous" and "highly strung". Again, it was an accusation. I suggested that one could very easily be a bit nervous after a plane had crashed on the night of one's wedding, killing many friends and a navigator whom one had talked into going; after seeing planes crash head on; after losing most of one's squadron; after watching friends shot down; after aborted missions day after day. That I hardly considered that a "manic phase". At the same time, I could quite agree that it would be rather depressing to watch the officers' mess dwindle down to almost nothing; to wake up one day and realize that nearly everyone you had known in the group had been killed. Yes, I agreed, I had been both depressed at times and nervous and high-strung at times.

Later, the sergeant who had been taking dictation came up to me in the hall and said that he had to warn me about something—that he felt that it was only fair to do so. He said that after I had left, Captain Simon was livid with rage, that he had vowed to get me, that he had put in the record that I was suffering from a manic-depressive psychosis—and that it was aggravated by combat rather than caused by combat.

I don't know how it happened, but a young lawyer from the adjutant general's office heard about the case. He was horrified at what had happened and told me that I was entitled to legal representation. He offered to represent me if I wanted him to, even though he would be sticking his neck out to do so. He looked over my entire record, talked to me for a long time, and suggested that what Simon was doing was clearly out of spite. Simon knew that he could not get a non-line of duty discharge—my combat record was too obvious. Therefore, he could not kill my chances of pension or retirement pay. But, the lawyer told me, he was doing the next best thing—an "aggravated" by duty as an insult to my record. It could be no more—but it was a matter of principle—with him and with me. We decided to fight.

MALLAIG, 30 JANUARY 1973

1 December 1943. Meeting of the retirement board, composed of five line officers and four doctors. Verdict: line-of-duty medical retirement.

Lt. Jack W. Fox was counsel. I would like to thank him. He understood the importance of fighting for a man's dignity.

Years later, in 1948, I was going to a civilian psychiatrist in San Francisco. His name was Dr. Diamond. It turned out that he had been the assistant to Captain Simon. He didn't remember me, nor the case, but he now said that I had never been manic-depressive, nor had I suffered from a psychosis.

After completing this last section, Schueler put the book aside and wrote few journal entries. However, in the December 5, 1973, letter to B.H Friedman, he told him, "The ms. is laid out, part by part, on a board eight feet long which I bought especially for the display. I keep stealing glances at it. Someday, impatience, daring, affection will all combine to prompt me to move. Something will happen. I hope it's soon." But 1973 was particularly eventful in other ways. There was what he described as "a siege of work" before he and Magda went abroad for the month of April—"I really went to Morocco kicking and screaming. But Magda is in charge of diversions and felt that I needed a holiday. I couldn't imagine camping. . . . It was one of the most exciting trips of my life And now I've started a series of large oils (for the moment based on the Morocco experience)—and I'm starting to answer three months correspondence." (Letter to B.H Friedman, June 1, 1973).

The paintings in Mallaig from this period ranged from 6 x 8 inches to the largest size he could conveniently get out the studio door, 79 x 76 inches. A great deal of time was also spent preparing for the exhibition in Edinburgh during the 1973 festival. In the next section [p.344-347], he would write about this show and Ben Heller's decision to buy several paintings, which was the beginning of a new dealer/artist relationship. Finally, a visit to the States in the autumn took up six weeks.

MALLAIG, 7 MAY 1974

Magda and I returned to Scotland from our U.S. trip around November 15 of last year. I had a huge work period after that, finishing over eighty

paintings and as many watercolors. Ben [Heller] said to Magda, "When did he sleep?" I said, "I'll try to do better during the next period." I was joking, but kidding on the square. I meant it. I'm lusting to work. The paintings I've been doing have, as usual, only opened all the questions concerning those I want to do. Yet, in this next period I must, I absolutely must, work on the paintings and the book. Something I've never been able to do before, but I feel ready for this now. I'm now working on the book. My goal is to have something, no matter how bad, that starts on page one and continues to the end, finished and ready to take with me to New York in September for Bob [Friedman] to read. I want to hand him a book.

David Pirnie[35] arrived on April 4 for a two week stay to talk to me, study my papers, etc., for his book about my work. Ben and Patsy Heller[36] arrived on Friday, April 12, to make their first visit here and to see the paintings. It was also the first time Ben and I had gotten together since the New York trip when he became my dealer. They had a very packed day and a half and then on Sunday left in a helicopter for Prestwick and New York. Ben was thrilled with the studio, the landscape, the sky, the work. He said, "The work is absolutely masterly. I haven't seen so much work of a masterly quality in one studio since I was in Mark Rothko's studio." I was delighted, of course. Ben is my dealer. Ben is my friend. Ben is ruthless with himself when it comes to art.

But how strange that so often I should be linked with Rothko one way or another. Perhaps this was the reason for the rage which I so often felt in the past. Perhaps his world and mine touch more intimately than I expected. Perhaps my rage against his work and my distrust of his work was my rage against and distrust of myself. I'd find his paintings beautiful and seductive. Ultimately, I would not believe them. I'd question them. But one does this with paintings which move one deeply and which seem akin to one's own work, or the dream of one's own work.

Magda was superb. She made everyone feel at home. She fixed marvelous meals. Her own presence and help and activity made everything go so easily. I had promised her a trip to the Orkneys and Shetlands after these visits. And, as usually happens, the benefit was mine.

MALLAIG, 22 MAY 1974

Whenever I read the letters and journals of past years, I feel a deep sadness and sense of loss. I've been trying to understand this. I seem to feel sad that I didn't appreciate, wasn't sufficiently conscious of, at the time, the sheer

[35]David Pirnie subsequently changed jobs, and his plans for a book were dropped, but the friendship deepened. He and his second wife, Sue, were regular visitors in Mallaig, Edinburgh and New York.
[36]Pat Heller, a therapist, Heller's second wife.

Pat and Ben Heller in Jon Schueler's studio, Romasaig, in Mallaig, Scotland, April 1974, choosing the paintings to be sent to the United Sates.

range of experience I was having. It is as though a conscious celebration of the wonder and complexity of life should have gone on in my spirit, at the same time that I lived through the relationships with many men and women, and fought the battles of the spirit within myself.

But now the present has not ceased. There is even a deeper and more subtle range of experience, in some ways more surely and intensely felt because of the power of the past and the depth of a present reflection. Life has a range and a power and a drama which is beyond all belief. It is almost too exquisite to contemplate. The very thought, for example, of the power that my failures and past confusions have played in the forming of my art, which now seems to many so ordered, so masterly, so austere, so single-minded and logical, this thought gives me pause for silent celebration. The spiritual quality, if it is to appear in my paintings, can only continue to be the manifestation or realization of the strange, exaggerated moral imperative which has dominated my life. A moral imperative to obey and the moral imperative to question, inexorably locked as one.

Today, finally, the thirty-eight paintings for Ben were picked up by Dawsons Ltd., and should be at Prestwick late Friday, ready to board the first plane available. Tonight, as has always been true when I have had to move or ship paintings, I have felt tense, restless, somewhat removed.

I am fifty-seven years old. I know enough about my painting and am free enough with words so that this should be the beginning. The foundation has been laid. Perhaps part of the scaffolding has been raised. Real work is to be done.*

*See color illustration 19 for a painting of the period.

Jon Schueler in his studio in Mallaig, Scotland, 1977

BLUES IN GREY

The title "Blues in Grey" suggests the ambivalent tone that characterizes the last section of the narrative, written between January 1977 and August 1979. The five-year Mallaig period ended abruptly in June 1975 when Magda decided to leave Schueler to go to Moray House in Edinburgh to study for a teacher's certificate. Schueler, though continuing to rent Romasaig, returned to New York and sublet a loft on Jones Street in the Village. In July 1976, after what Schueler called "Magda's sabbatical," she rejoined him in New York and in order to assuage the immigration officials, they got married on July 29, 1976. In November of that year, Magda started teaching at the Day School on the Upper East Side, which brought about a new pattern of spending the academic year in New York and the summers in Mallaig.

Although this section begins with evidence of success—the renovation of a large loft on 22nd Street in Manhattan—there is often a note of discomfort and irritation. In the initial New York entries, this is in part due to the inconvenience of living in the Chelsea Hotel and trying to deal with the work to be completed on the studio. In the later Mallaig journals, frustrations are related to the difficulties of adapting to short three-month summer stays in the studio in Scotland, where Schueler, older and less buoyant now, sees the images tinged with sadness, Blues in Grey. Most significant is that Ben Heller's efficacy as a dealer has diminished, and Schueler feels that he is without representation in New York. An invitation for a one-man show at the Landmark Gallery in November-December 1977 (New York after Mallaig: Light, Space in Change) momentarily lessens the anxiety, while another at the House Gallery in London brings about the uncanny discovery of Bunty, the much-remembered and longed-for woman of the war period.

In Hanover, New Hampshire, for the summer of 1979, where he had gone for the purpose of writing, Schueler, circling back, picking up threads, expanding on events already mentioned, reflects on his career as an artist: experiences with galleries and exhibitions, dealers and academics, the times of intense satisfaction and the periods of extreme neglect. Although that section of "Blues in Grey" ends with the excitement of unanticipated recognition for his paintings, the last note is less jubilant: the account of Magda's departure in 1975 and the closing of Romasaig.

NEW YORK, 19 JANUARY 1977 (CHELSEA HOTEL)

Mood with Magda. Moving with Magda. We've just moved from 10 Jones Street, where I've been working for a year and a half.*

NEW YORK, 20 JANUARY 1977 (CHELSEA HOTEL)

The new loft at 40 W. 22nd Street: on the top floor of a twelve-story building, facing north. Windows all around flood it with light. Self-service and freight elevator. Forty-one hundred square feet of floor space. Eleven-foot ceilings. Under construction are a new bathroom and kitchen and lots of walls and a network of electric outlets. About two-thirds of the space is directly related to painting—a large studio space, a watercolor space and study, painting walls, hanging walls, etc. There is a bedroom and Magda's study. Everything will be painted white. The tiles on the bathroom floor and in the stall shower will be cobalt blue. Chosen by Magda. The floors will be sanded. Those in the living area and passageway and watercolor room will be coated with polyurethane. The floors of the oil-painting studio and storage area will be painted white—to reflect the light and for ease of upkeep. When they get too dirty, I'll roll on a new coat of floor enamel.

The building is a co-op. I bought my floor for $32,500. The renovation will cost close to $30,000. All of my savings are being used up, and then some. But, for me space is thrilling and liberating.

I'm at my typewriter in a room in the Chelsea Hotel. We're living here while the new studio is being built. We have two rooms—a large living room where I have my work space[1] and a large bedroom where Magda has her desk. There's also a small kitchen.

On Tuesday night Alger Hiss[2] and Isabel Johnson, and Oliver Lundquist[3]

*See color illustration 20 as an example of the large paintings from that period.
[1] Schueler worked on the book while waiting for the renovations to be completed.
[2] Alger Hiss (1904-97). A member of the State Department, his highest post was as Secretary General of the San Francisco conference which set up the United Nations in 1945. Accused in 1947 by Whittaker Chambers of having transmitted documents to the Russians in 1938, he was indicted for perjury, found guilty, and sentenced to a five-year prison term (he was released in November 1954). The Hiss-Chambers case polarized American opinion during the cold war. For Hiss's enemies, he became a symbol of communist infiltration in American government, while his supporters saw him as an innocent who had become the target of a political plot. Alger Hiss and Isabel Johnson (who became his second wife) were often dinner guests of John and Judith Stonehill—where Schueler came to know them.
[3] The architect Oliver Lundquist (b. 1916), had worked for Alger Hiss at the 1945 San Francisco conference, being in charge of overall design, photographics, and recording. His friendship with Schueler stemmed from the mid-sixties; Wanda Eliot's from the seventies.

and Wanda Eliot came here for dinner. Alger talked about the legal work that he is doing now that he has been reinstated at the bar. The tragedy of this brilliant man's life. Yet he is never bitter, never accusatory. He has incredible depths of understanding for people and processes. He said that his work, for many years with the office-supply concern, was too important for him to give up. Both because it supports him more surely than legal work will ever do (he said that his clients are inclined to be without money), and because the friendly associations have become too much a part of his life.

NEW YORK, 24 JANUARY 1977 (CHELSEA HOTEL)

Why?

I can't concentrate. I know I shouldn't make any calls now. I should work on the book. But I had to call Lane Altshuler, the contractor, and Ben about money. About a year and a half ago he said that he'd like to borrow the roughly $25,000 he owed me[4], and that he'd pay interest. Then, a few months ago, when I was considering buying a loft, he said that he couldn't pay me back. I didn't know what to say. But I now absolutely have to have the money. I have a feeling that I'm facing some complicated times financially, unless some paintings sell soon. All of this because of the new studio. Yet—what can I do? I was kicked out of the Jones Street studio, as the landlord wanted to turn the whole building into studio apartments. I had spent between $5,000 and $10,000 on that loft, adapting it for my work. I had thought that I'd get at least three years of use out of it. But then . . . if I had rented another loft, I could have gone through this hellish waste of time and money all over again. So I've purchased one. Once it is fixed up, I should be in good shape and without new pressures.

While Still lived in New York, he always treated the studio as a temporary haven—a tent or a cave—that would give him primitive shelter as long as he needed it. And I've tried to do the same through the years. It is one of the reasons that I feel threatened by the very excellent studio that John Stonehill[5] and I have designed and which is half-way to completion now. Yet—when I have had money to fix a studio the way I wanted it (this has only been in recent years), and—more important—have been able to buy all the materials I wanted without counting the cost—I have been very

[4]After shipping over two consignments of Schueler paintings from Scotland, Heller had made some substantial sales. Having sold William Heller, Inc. to Uniroyal, he was now running a small cutting-edge, computer knitting design firm and investing in new ventures.

[5]In return for the painting, Blue Sky Shadow, 1976 (50" x 60") Schueler's friend John Stonehill, of the architectural firm of Lundquist & Stonehill, interpreted all his requirements and drew up the plans for the new loft, formerly a small factory in a twelve story commercial building.

prolific. The more I could prolong the act of painting, the further I could go into paint, into the imagination, into the vision. To look into nature, into the dream, was also to look into the physical actuality of paint and the surface of the two-dimensional canvas, which offered the possibility of a poetry of space and light.

The size of a studio can shape possibilities. My studio in Mallaig is very small, the oil studio being perhaps 18 x 22 feet.* As I work, it grows smaller because finished and unfinished paintings are stacked against the wall, along with newly stretched canvases. I can actually feel the pressure, as though I'm being squeezed into a corner. On the plus side, there is a certain intimacy about painting a large painting in a small space—or a small painting in a small space, for that matter.

Right now, I have stretched canvases waiting for me in Romasaig (my Mallaig studio) along with rolls of canvas, bundles of stretcher bars, tubes of paint. Probably over $5,000 in materials alone. And the same will be true in my New York studio. This makes me feel liberated and is actually a stimulus to work. It's as simple as that.

NEW YORK, 26 JANUARY 1977 (CHELSEA HOTEL)

Christ. Within minutes, I have to call Ben and try to get the money that I loaned him about a year and a half ago. My bank account is getting low—about $1,700—which goes fast. I have about $10,000 in the Chester [Connecticut] savings account. And that's it. Assets: $11,700. Renovation still to pay: $15,000. Ben has paid me back part of the loan, giving me his commission every time he makes a painting sale. He probably still owes me around $18,000—though, typically, I don't really know how much. I'm sure that he hasn't figured out the interest—though that can be done any time. It should be around 5½ percent compounded quarterly.

I loathe making this kind of call. And because Ben can be rather strange about money at times—I'm sure that he can't be all that broke—I hate to get into a discussion about it with him. He's been absolutely fair with me, and it is because of his efforts that I've been able to make some money, afford to be in the United States, could even think about getting a studio here in New York. Most of the matter is in my head. One just has to state one's position.

· · ·

Five minutes later: I called Ben.

"I was wondering if I could get the money you owe me?"

"I'll look into it and will call you back."

And that's all there was to it.

*See color illustration 17.

<center>• • •</center>

Now I have to get in touch with David Oreck.[6] About a year ago when David and Paula Oreck were in the studio preparing to buy a painting, David suggested that should I ever want to trade a painting for appliances, I should let him know. We now have researched the stove, refrigerator, washing machine, dryer, dishwasher, and TV set we need. It's a deal to the advantage of both of us. Yet I feel hesitant about calling, as though I were asking some kind of favor.

NEW YORK, 27 FEBRUARY 1977 (CHELSEA HOTEL)

I am going now to have brunch with John and Judith Stonehill. There is a painting that John so loves that every time he came to visit me in my studio at 10 Jones Street, he wanted to see that painting and that painting alone. At least three times he cried while looking at it. What is touching him so? I think I "know"—but I can't say what I know. It's in the painting; it's a memory in me, a memory of loss and loneliness which is man's condition and which we each feel in our own particular way. But I don't really, really know what the painting is about. Or, at least, I don't know what it is about for John Stonehill. Or for anyone else. I must let it be about what it is about for them. I must watch them and listen uncritically. Only to know that they react. Not to analyze the reaction.

NEW YORK, 29 FEBRUARY 1977 (CHELSEA HOTEL)

Mood with Magda. Blues in Grey. Long, slow Blues. Blues in the night. Lovely, soft, loving Blues. Soft, warm greys of loneliness and love and death. A woman told me that she wanted to live in my grey paintings. The grey of peace. She wanted a roomful, and to live in the room surrounded. Another woman talked about how the paintings suggest the peace of one who knows he is going to die. She said that she saw this constantly, because she was a nurse who worked in a terminal ward. There was a time before dying when a feeling of peace came; a look of peace came over the dying, which was like no other mood or emotion in life. Mood. Blues. Blues in B flat. Blues in B Flat minor. Minor Blues. The blue of grey. The grey of blue and the grey of red. Salmon red. Cadmium red. Red blues. Red and blue blues. Black and blue. Black makes the grey blue. And umber makes the grey green. And yellow forms and greys and yellow greys, mood with grey.

[6]At that point, David Oreck was president of McDonald Sales Corporation, an RCA and major appliances distributor. He became the president and C.E.O. of the Oreck Corporation which specializes in vacuum cleaners.

MALLAIG, 27 JUNE 1977[7]

Magda and coming North into yesterday.

Bunty 1942. Magda 1970

The last time I was in Mallaig—April 1976—Annie Manson, Jim's wife, had a stroke. I did not find time to go and see them.

Now Annie watches Hamish Smith[8] while he speaks to her. He talks, he rattles on, trying to move past the discomfort until he can leave, and Annie, unable to reply, looks at him with hate in her eyes. The inability to say is rage.

In 1958 I waited for a bank draft so that I could pay for my departure and for the fares on the freighter which would take Jody and me to Italy. I needed 300 pounds. Jim said, "Why didn't you tell me, boy?" He told Annie to get the money for me. She disappeared into the bedroom and came back with the notes. They trusted me, an American stranger, who had been in their midst for little more than half a year. I had sailed on the *Margaret Ann*. Jim was a hero of mine. I went to sea and survived and somehow took the helm and steered the boat. I came back thinking I had now won. I had re-fought the battle and now I was flying through the gale and flack and could meet Billy and say, Billy, I am with you. It is okay. You can trust me and you can count on me. But Billy is dead. He dumped a B-29 into Flushing Bay. The navigator died and the bombardier died. It took over a month to find Billy's body. Each day Milt and Billy's father would go out on the boat with the men who searched for his body.[9]

MALLAIG, 28 JUNE 1977

I started painting yesterday. We arrived from Edinburgh Saturday evening, cleaned up the place on Sunday—Magda doing a heroic job in the kitchen and living area—and I started writing and painting on Monday. I want to feel the old excitement in me—but I seem to carry a dull weight. A weight of memory? Or the weariness of the past five months in New York, which were so painfully taken up with the renovation at 40 West 22nd Street? Always one should work. No matter what. The very pain and agony and disruption caused by the contractor were life. They were life as much

[7]This was the first summer in Mallaig since Magda's "sabbatical." Subsequently, they spent three months there almost every year, until Schueler's death in 1992.

[8]Hamish Smith, a cousin of the Mansons, and thus related to many Mallaig families, often dropped in to talk to Schueler. Smith, who runs the Smith Brothers carpentry business in the village, and his wife, Joan, lived close to Romasaig, Schueler's studio.

[9]This accident took place in 1945 when Billy Southworth attempted an emergency landing at New York's La Guardia Airport. Fortuitously, Milt Conver was not in the plane.

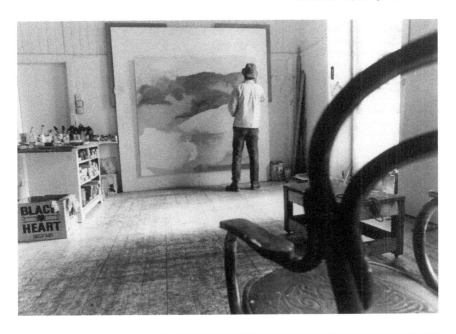

Jon Schueler painting in his studio in Mallaig, Scotland, 1977.

as love. They were black rage and red inertia. The few paintings I created out of that frustration were beautiful. One can't wait for the perfect moment.

Yesterday's paintings are greys—brown greys, silver greys, fierce black shadow in the light of Skye.

Magda.

I feel hemmed in by the past and future. I want to break something. Only a huge canvas will do. 79 inches by 20 feet. There is one stretched and waiting in the New York studio.

And now I am in Mallaig. The schoolhouse is filled to bursting with old canvases, the last finished in April 1976. The extra bathroom is piled high with smaller canvases, stretched, waiting. The storeroom also. Along with many smaller ones painted. And the studio and halls—big canvases hugging the walls, crowding me, stifling work.

Magda.

I spent over five years here working. Restricted to the far north, viewing Skye, feeling the gale, living with Magda, reading in the night. Magda in her rocker. Day after lonely day.

Coming back, there is the strangeness that one feels upon returning to a place that one knows well. It is brighter and flatter. Its mystery was in the past. There is something golden that has gone out of it. My nerve ends refuse to make contact. Or perhaps the contact they make is more real than the dream of the past. The dream, romantic, I lived in from 1970 to 1975.

Or from 1957. Or from Bunty and the war. Or from the very beginning in Clara's room.

I mean *womb*.

The Wound of Sleat. Of course, I meant *Sound*. But I like Wound of Sleat this morning. I scratch at the wound, wanting to feel the pain, wanting to see the blood flowing.

The small paintings are very beautiful. I am glad that I have painted them. And I shall paint more. But they are too small for me to work on right now. My feeling is so physical. Too physical for watercolor. Too physical for the small paintings. I have to work harder, drag the brush and push it over impossible surfaces. Distance. Distant space. Inside the space. My nose right up against the canvas, losing sight of the edges, of the limitations, trying to feel the lack of boundary, even as the boundary forms the limitless space.

I treat my friends badly. I didn't write to Bob [Friedman] while he was in the hospital with viral pneumonia. Terribly sick. Miserably uncomfortable as he fought the onslaughts of his doctors. And I withheld myself from view as I tried to get through each day. I was a little mad then. I couldn't seem to contain the anger I felt. I wish that I had turned it into more paintings.

· · ·

Magda.

The Woman in the Sky.

Where are you, Bunty?

The war storms through memory in grey.

MALLAIG, 14 JULY 1977

Note which I left on my typewriter last night: "Battle for memory."

The words are from Doris Lessing's book *The Four Gated City*.

"Battle for memory". I lose, constantly lose, the experience, the fact, the moment. I have a feeling that the memory must be there, encapsulated. But it is not available to me.

It seems to me that it is only in Mallaig that I am afraid. I stay in the house, usually working. But when I'm not working I can't get the relief I need by going outside. I feel imprisoned here. I dream of being with American friends. I think of Bob and Abby on the Cape. I would have no trouble at all talking to people there.

Suddenly—a rush of death images. The little boy hit by the motorcycle while chasing a baseball from our schoolyard, his body thrown into the air like a bundle of rags. The workman being carried into the school, leaving a trail of blood—he had fallen while working on the new auditorium. Dad, my stepmother's father, killed, not an hour after I had said good-bye, by a car barreling along the highway.

The sky was the death of my mother.

Loving Magda, I don't make love to her.

Wanting the dream of Mallaig, I am afraid to penetrate the dream. I only know how to stay in the studio and paint.

I want the past and I am afraid of the past.

. . .

Four black orderlies in white suits descending upon me, beating me up. Nearly throttling me. This was the night before I was to fly to Mexico to divorce Judy. I took the Mushroom and got scared. Dr. Hogan, whom I called, said I should go to Bellevue Hospital.

I hate the damned doctors. I distrust them. Why then do I go to them so often? Black night in Bellevue. Dr. Hogan came over and got me out. No one wanted to believe that the black orderlies beat me up. A patient came up to me and said that he saw them giving me a going-over the night before. And that they had almost choked me. I had the bruise on my neck. It was worse than combat. It was a truly horrible experience. Combat has a humanness about it. It also has a terrible dignity.

Most of the men in my squadron were killed except Milt Conver and me. I never got over the war. With all that happened, all the death and destruction, all the tragic stories, the most insistent of my memories and my feelings were of my failure in the war. Escaping with my life and with my limbs intact was my failure. Others died. Theirs was the success of war. Billy died. Jimmy died. Stocton died. Goetz died. Reber died[10]. Stocton's co-pilot, Mackin, died.

BATTLE FOR MEMORY.

This is the combat. This is the combat I have feared most in my life. This is my painting. This is the book. It all will fail, but I must feel that I have tried. I must see the evidence, the paintings, the pages. And, if possible, I must know the response out there, so that I shall know that the combat has been real. That I have plunged into combat. Not that I have fled combat. Not that I have been expelled from combat. Not that I have been helped from combat. Not that I have slid from combat or wriggled out of combat. But that I have entered combat and kept entering further and further and further and further until all the fear was there and the shadows beyond the clouds. That I have struggled to see, even though I couldn't see. The blackness of the death of my mother and the blackness of Mallaig in my memory. Fear-driven shadows which I could

[10]Billy Southworth, Jimmy Hudson, Don Stockton, William Goetz, Ehle Reber, George T. Mackin.

never find. Night Light. Light Night. My battle is the battle for memory. In the painting, it is finally in a nuance of the brush stroke, in a disturbance of color or the suggestion of line. The moment's space. It is in the poetry about the poetry of paint. That is the area of combat, that is the contrail, that shows where I've been and what has happened, for that is the happening. In the writing it is something else again. In the specific memory? Is that it? The symbol. The word is only a symbol, an echo of what happened rather than the happening itself. Or even the thought about the happening.

When I was in Paris in 1958, I wanted to come back to Mallaig for Christmas. I wrote to Betty MacPhie. But it was impossible. I could not have faced the darkness I saw in my mind. The darkness unto death.

In 1965, I was writing in Galilea, Majorca. I thought, inevitably, of Mallaig and wrote of Mallaig and wanted to go back there. Again I felt the fear, and saw the darkness of the memory.

MALLAIG, 15 JULY 1977

Yesterday in the afternoon, I started working on a large canvas, 72" x 79". I had the idea of doing a night painting, the idea of huge night shadows and a glowing white. The painting started forming itself, blacks and reds, until—when I looked at it later—it became in feeling and in illustration the womb sky and the opening and the entry into the sky of the world. As though I had wanted to create in paint the sky images I had been writing of yesterday. Bursting from the womb into the sky. The womb itself a sky. And what about before that? An atavistic sky image, so impressed in me, so much a part of me, me so much a part of it, that the painting, when spontaneous, touches the source for everyone.[11]

· · ·

After working on my manuscript for a few months in 1972, Magda wanted to take a tour of Brittany. It meant leaving Paris a few weeks before I had intended to leave. But once we were talking about it, I entered into the planning with enthusiasm. We set off in the Mini, headed south and west.

Our course is set—but I keep feeling the need to alter it. I find excuses as though everything in me wants to avoid St. Nazaire. I want to head more directly west. It isn't the danger of St. Nazaire; it is the memory which frightens me. It is a sunny day; the weather is perfect. But the memory of St. Nazaire is black and deep greys and sudden violets and alizarins, just like the memory of Mallaig. What do I expect to find there? My fate?

[11]*Mourning Mass: Blush of Red.*

I expect to find the accusation. A hundred pilots, co-pilots, navigators, bombardiers, engineers, radio operators, gunners, dead hands on the controls of the guns, dead hands sadly by their sides, no pointing, no look, nothing. They are not there. I am alone there alive, going down to the deck, going out to sea, passing the Brest peninsula, finding my way to Land's End and across southern England to Molesworth and the mess and bed and dreams and hospitals and an ever-changing home.

But now I am at ground altitude in the tan Mini with Magda by my side and we were entering St. Nazaire, seeing the sun-drenched buildings. I see them as white, light. But I am going along a straight street and I want to turn toward the harbor, which is at my left. I know that the harbor is at my left and the submarine pens are there, but I am truly afraid to turn, and I keep finding excuses to turn right and to leave St. Nazaire without having searched for the submarine pens. I didn't recognize St. Nazaire. This place has nothing to do with me. But Magda said, "We're here, you've come all this way. Why don't you just turn left and see what happens, see what you can find." So I turned left and suddenly I was on the edge of the harbor, a concrete pier leading out to a massive block of concrete, another huge mass in the distance across the water of the harbor. Powerful monuments to death and the Devil. I recognized them. But at the same time, I didn't recognize them. We got out of the car and started walking toward the nearer mass. Brute form. Powerful. Relentless. A fisherman was about to step into a small fishing boat. Magda asked him if these were in truth the pens. They started in on a conversation. I listened, straining my French. And then she told him that I had been in B-17's and had been on the St. Nazaire air raids. We shook hands and introduced ourselves and he told us that he had been in the Resistance during the war and had helped American fliers escape from the country. He had been at the receiving end of the bombing of St. Nazaire. The city had been flattened. The sub pen stood, undamaged. Nothing could penetrate the ten-foot reenforced concrete. Nothing. One bomb twisted the massive metal gates of a pen, but the Germans had repaired them in a week.

We spent an hour together. He took us into the pens—showed us how some were used now as winter harbors for small craft like his, some used for storage—for grain storage, wine storage. They were there. The pens were there. They would be there until the end of time as we know it, like huge rocks or mountains. They were impervious to our time.

I had one more stop after St. Nazaire. (No, there is still another one. I must find Bunty.)

Molesworth.

MALLAIG, 17 JULY 1977

Romasaig is well filled with visitors. Judy[12] has been here for a few days. On Thursday night the American Girl[13] arrived. And two days ago, Charlotte Carstairs[14] arrived from St. Andrews. I now found myself in the position of being one man with four women.

I love women. I like to look at women. I like to feel them and touch them. I wish that I could find the way to feeling and touching them, to making love to them, without disturbing Magda, but rather, with, in some way, including her in the joy, in the looking, in the touching, in the talking, in the friendliness, in the passion. Far, far more than ever before, I realize that the pleasure is so much greater as one begins to sense the idiosyncrasy of male, of female. Of their differences. Of their peculiarities. I think I was always that way. But I think also that the chase was too compulsive and important for me. And the marriage would always finally spoil it. Spoil. Marriage. Magda and I are married now.[15] I'd like to make this work toward freedom rather than toward restriction. I think it is possible.

Why is it so joyous? I've looked on flesh a thousand times. Girls I've taken to bed. Girls in my studio. Yet it is always new, always exciting, always a joy. I feel more receptive now than ever before. I'd like to see old bodies, young bodies. Large and small. Tiny breasts and huge breasts. Everything. It's like the sea and the sky.

Today we had a wonderful walk with much joking and teasing about my particular joys.

MALLAIG, 20 JULY 1977

In the past when I was with one woman, I closed my memory to the other women I had known. I drew down a shade. Pledging to one woman, I killed all others. And I could not bear this. Pledging to my stepmother, I killed the memory of my real mother. I mean, literally killed it. And when I did remember her, as a horribly guilty secret unmasked when I was about twelve years old, I could not contain my secret. I didn't tell my stepmother. I was afraid to. I didn't tell my father. I was afraid to. So I stayed true to my stepmother, constancy, frigidity, rage. I had to remember and more than

[12]Judy Norwell, Magda's friend. They met every summer to do some walking in the Highlands.

[13]Sara Paretsky, mystery writer, whose female detective, V.I. Warshawski, solves the crimes. Paretsky was a friend of Magda's sister, Katrina Turner, and stayed in the neighboring Bed & Breakfast.

[14]Charlotte Carstairs, at that point a lecturer in the English Department of the University of St Andrews, had been introduced by Alastair Reid to Schueler and Salvesen in 1973, the beginning of an ongoing friendship.

[15]Schueler and Magda Salvesen were married in July 1976.

remember, to know. But I couldn't. Each time I have been married, I have gone through the same thing. A shutting of the door on memory. Locked. Closed. Impervious. And I didn't know why I was so desperately and ragingly unhappy. If I don't know the life of the women I have felt friendly toward, I kill them in memory and coldly. I can't stand the death of them.

I am sixty. I feel myself bursting into a fullness of life. I think I'm beginning to understand something. This last year has been a tough one. Psychically. We were married. If I hadn't married Magda, I might never have seen her again—just because of the problems of visas—or I would have had to live in Scotland. So I wanted to marry, and we did marry, but it was very, very difficult. Even as before, perhaps more than before because I know more about myself—I found myself placed in some ravaging emotional dilemma. But I couldn't really share this dilemma without making Magda feel unwanted. And she was wanted. Besides, I didn't understand enough to make her or anyone else understand. I think I'm only getting to it now. It is the cutting off of communication—completely cutting off of communication—that I can't stand. That is the blankness before the typewriter. That is the impotence of love. The cutting off of memory and people and communication that I seem to feel that I have to do if I am to pledge myself in love. Fortunately with Magda, I knew I had to suffer through this. But now I talked to Charlotte and watched her bottom swinging as she ran through the shallow water of Loch Scavaig. And I watched the telling movement of Sara's breasts and unashamedly studied the sad contemplation of her eyes when she was asked a question. Somehow, I knew that Magda was not jealous. I was doing whatever was right not to make her jealous, so that she was part of the experience, part of the flirting, of the knowing, the excitement of human beings being together and enjoying themselves through an awareness of each other.

I'm so afraid that I'll destroy by even wanting to know. By wanting to communicate. I have a dark, inhibiting sadness about wanting to communicate with Bunty. I can't just let her rest in my past without letting her know that someone has loved her and thought about her, and without letting her know how much she was a part of my dream and of the paintings. Her description of the Highlands stayed with me along with memories of the war. I needed her. She was very beautiful. But I couldn't take from her the bravery that I wanted to have. She excused me, but she must have separated herself from me in doing so. It was her husband who was brave.

Between the end of August 1977 and June 20, 1978, Schueler worked in his New York studio, producing a group of twenty-four watercolors and thirty-seven oils. From 1975 onward, he had a part-time assistant to stretch canvases, wrap paintings, and

help with photography and other studio jobs. Alan Young was succeeded by Hans de Hollosy, Wayne Toepp and, lastly, Michael Byrnes, all young artists at the time. Seven large paintings ranging from 79 x 228 inches to 70 x 63 inches were shown at the Landmark Gallery in SoHo in November-December 1977, the first New York show since 1963 (other than the small Whitney exhibition in 1975).

Immediately after Magda's academic year had finished, they took off for two weeks in Italy, wandering in Umbria and Tuscany, and visiting artists Piero Dorazio and then William Bailey.[16] After a round of meetings with friends and Magda's family in London and Edinburgh, they finally, on July 12, reached Mallaig.

MALLAIG, 21 JULY 1978
LETTER TO JOYA[17]

Dear Joya:

... I'm enclosing a check for $1,600 to get you started on your immobile mobile home. I'm terribly sorry to hear about all the bad luck you are having lately, and I hope that it takes a turn for the better soon. In any case, the immobile mobile home should be an adventure of sorts.

Life constantly plays its tricks—a good share of them not funny. I arrived in Scotland ready for an important work period when (1) my back gave me trouble (remember in New York!), but fortunately not for long. For a few days I saw my summer going down the drain. Then I cracked a tooth—and had to go all the way back to Edinburgh to have it fixed. I think I have things in order now. Besides the writing and painting I'm planning to do here, I'm preparing for a show which opens in London[18] on September 14. Have to choose paintings, wrap, arrange shipping, etc. All the work will be from this studio.

I'm going to dash off this letter to get it in the mail. But let me mention a few things first. (I try not to burden you with advice—but I think you could use a little now.) Above all, don't fall behind on the payments, rent, etc., for the mobile home, or you'll lose it. If you're in difficulty, write me or Gaga[19] or get social service or whatever. Try to anticipate so that you can write rather than telephone.

I think you ought to bend every effort toward finding work in your

[16]Schueler knew William Bailey (b.1930), meticulous painter of still, still lives, and figures, and his wife, Sandra, from his Yale School of Art teaching days in the sixties.
[17]Joya was trying to support herself and two daughters, Dawn (b. 1967), and Alana (b.1970).
[18]At the House Gallery.
[19]Her maternal grandmother, Florence Elton.

field—dental assistant. The immediate pay might be less than working as a waitress, but in the long run it will be better. You took the course to give yourself a skill. The more, and the more steadily, you work at your skill the better you will become and the more valuable you will be. It's the unskilled who have a really tough time these days. You should try to work constantly and for a good length of time for any one employer so that you get good references. Your life will be more interesting and more stable.

. . . Write to me and let me know how things are going.

Love to the children and to you,

Jon

MALLAIG, 26 JULY 1978
LETTER TO MRS. GEORGE FREDERICKS, SCHUELER'S STEPMOTHER

Dear Mom:

July 21 has come and gone and the Whitefish Bay High School reunion was held without me. I wish I could have been there! I wish—at least—there was someone to write and tell me about it.

Have Bob and Josie[20] told you about Joya's predicament? I wrote to them yesterday. Joya has had just about everything bad happen that could happen in the last couple of months, and finally called me the other night—in tears— as though she was just about at the end of her rope. I think I got her out of the most desperate part of her dilemma, but I wished that she had someone there to turn to and talk to until she can get things straightened out. I didn't want to burden you with problems, but at the same time I wanted you to know—so I wrote to Bob and Josie and suggested that they pass the word. . . .

Life is so strange and contradictory. Of my two daughters, Joya is the conventional one, Jamie the rebellious one. All Joya has ever wanted was the most simple and ordinary kind of life. She loves family, a house, children. She likes her children to be attractive, to be nicely dressed. And she likes to make a nice home for them. Her very innocence seems to make it difficult for her to put the whole thing together. Jamie, on the other hand, is complicated, rebellious, has highly imaginative ambitions, is a kind of "active dreamer" who—even though her life is complicated—somehow seems to be making it work out.

Neither of them has ever had the benefit of feeling the solidarity of family, of getting to know you and the rest of the family. Part of that was due to the divorce—inevitably the children had to go Jane's path and not mine. Part was due to Jane's ways. And part was most certainly my fault—bound up in the inner and outer complexities of my own life. Anyway—there

[20]Schueler's half-brother and his wife, who lived in California, not far from Mrs. Fredericks.

it is, and there they are. I'd like to help Joya get through this difficult situation. And for one thing—I thought it would be good if she could at least feel that there was someone nearby that she could talk to, so that at this moment she won't feel absolutely abandoned.

It's almost mail time. I'll write again soon. Magda has just returned from a long weekend visit with her mother, three sisters, and all of their children—at a beach in Northumberland. She sends her love. You should see Scottish kids playing on beaches in this cold climate. One can hardly believe it—you'd think it was the tropics.

Love,
Jon

SANTA MONICA, 7 AUGUST 1978
LETTER FROM MRS. GEORGE FREDERICKS

Dear Jack,

So sorry about Joya's problems. Her background, as you suggest, was indeed far from stable and now she is over thirty—she hasn't chosen a proper husband, but is inclined to choose immature boys, who aren't good for anything.

She knows where I live—but do you think if she wanted advice, she would come to me?

She must have old friends and in-laws whom she has known over the years. Surely her husband's parents must have an interest in her and the girls.

Too bad we were not better acquainted, but I know you always elected a philosophy which was not ours—so we did go separate ways.

Well, you probably have given her what she needs for the moment.

Hope your summer has been a success and that Magda has enjoyed visiting with her family, and you come home all rested.

I had surgery on my foot in June and it still bothers me—curtails my walking a little.

My love to you both—
Mother.

Romasaig, as the following entry suggests, had no guest room, so what was perfect for two people became cramped with more. The former school room was Schueler's studio, and off it was the bedroom. The kitchen was also the "dining room" and the "sitting room." The watercolor room, with light filtering in from two sides, contained the table laid out with Schueler's watercolor materials. Jon and Magda's desks were also in that room, and against the

wall were two lightweight beds stacked one beneath the other. When these lat-
ter were pulled out for visitors, they took up most of the available floor space.

MALLAIG, 5 AUGUST 1978

They were so fucking insensitive—the whole crew of them.

I told Magda over and over again. For the past year. For the past hundred years, it seems. When I am working on watercolors, when I am working on my writing, I am terribly vulnerable and I can't tolerate anyone being in the watercolor room, the writing room. I just want the room to myself without suitcases, brassieres, nighties, the very odor of other people's presence. I'm trying to find an odor, a presence of the past. (And the present—and this is the present! This is the odor of the present! So write about this!)

I wonder how I really feel about Magda's sabbatical.

I have been planning this summer for a long time. I left Mallaig last year feeling total failure. The book hadn't been finished. The guests had been here. The room had been taken. I had done a few oil paintings. One problem is that everyone else is on vacation. I am not. So I resolved that this year the writing, no matter how bad, would be done. If I had to sit there day after day doing nothing else. But, I said, I could not tolerate having someone else using the study. The effort is too painful to me at best. There is something about the intrusion which suddenly makes everything impossible. I feel myself withdrawing when the person arrives. I feel the time being wasted. I feel my resentment. But by then I have turned into a host. I have to be nice, kind, gracious. I want to be nice, kind, gracious. But, goddamn, why don't they listen to me? Why doesn't Magda listen to me?

MALLAIG, 6 AUGUST 1978

This morning I got up at 8:30 intending to be at work by 9:00. I carried my shoes into the kitchen, where I looked for socks on the drying rack. They were not there. I went back to the bedroom, hoping to find them in my dresser drawer, where I should have looked in the first place. Magda was sleeping. She always looks indescribably lovely in bed. She opened her eyes. Magda's eyes are brown, with an infinite depth, waiting. I leaned over and kissed her. I lay down beside her and kissed her. I reached into the warm nest of the bed and touched her body. I fondled her and kissed her and finally I took off my clothes and moved next to her and we made love.

So I was late in starting work.

But I have no anger in me, nor tension to spark the word—although I have the usual hesitation, the usual feeling of blankness and a slight despair that I shall not be able to begin.

Magda is very gracious. The most gracious woman I have ever known. She is more concerned about the happiness and comfort of her guests than she is about herself. Or about myself. She is automatically concerned. As though, moment by moment, there is nothing else to be.

In the kitchen, Magda sat on my lap and laughed.

"What are you laughing at?"

"I am laughing because I think it is so funny that you and I get along together so well, and that we make each other happy. It is so strange."

"It is strange." I kissed her.

. . .

I think Magda has found herself. She is superb with children: I have watched her and heard her.[21]

I remember taking Magda home from the medieval party in Edinburgh [in 1970]. I wanted to caress her. I had never touched her before, but we had had a good time and I felt a little less strange than usual with her. I went over to the couch where she was sitting. I stood behind her. I took her hand. She rubbed her thumb against my thumb, consistently, delicately, over and over, as though there could be no other caress in the world. Terribly sensitive, like a white mist that hides the shadow within it.

And now she has become used to me, lives with me, travels with me, entertains with me, and is perhaps, happy. I have given something to her. Perhaps I have given her New York. Her friend, Judy Norwell, says that our relationship—though unpredictable and unnatural to the point of being bizarre—was perhaps the only truly possible relationship for Magda. In Britain, all forces conspired to enclose her within her class. This American, New York, my friends, now suggest possibility and variety to her. (She did leave me in 1975, with the intention of staying in Edinburgh. She studied at Moray House for her teaching credentials while I had my mornings of depression and my evenings of excitement in New York.)

Yet I feel sad. Too many people are ill. Fourteen people died in Mallaig over last winter. Too many people are dying.

What happened? To be chosen by the Air Force, we had to have perfect health. We did have perfect health. We were indestructible. What happened?

. . .

Heroes.
Jim Manson.
Clyfford Still.
Turner.

[21]Salvesen was teaching in the Middle School of the Day School in New York.

MALLAIG, 14 AUGUST 1978

Last winter I went to see *Colored Girls*[22] in New York and, looking at the program, I noticed that the costumes were designed by Judy Dearing. Later Bernie Schürch and Floriana Frassetto, our Mummenschanz[23] friends, were in Los Angeles talking to some theater people. They were telling them of my studio and my painting, and suddenly one of them said, "I was married to that guy." It was Judy. I wish that I could see her. I'd like to give her a painting. I don't think I'd know what to say, but I'd like to see her.[24]

. . .

What I am trying to do in this book is to write about the man who lives, who suffers, who chooses to paint, who wants to have vision, who suspects more and more that whatever happens, it happens because of forces beyond him as long as he works. He must provide that one force: He must be a man working. The trail of his work will be the art, and this will define the artist. I think of van Gogh. I think of Clyfford Still. But Clyfford's writing remains self-conscious and posturing. It does not show him at his best, nor does it clarify his meanings. By the very posture he assumes, he obscures the man, and, obscuring the man, obscures the artist. Van Gogh, on the other hand, is so patently naked, that his writing has a great force and power. And this writing is all in the form of letters. I am struck by what Alastair [Reid] says about writing obedient to the event alone. I am also struck by the force of Delacroix's *Journals*. Therefore, I shall use any form or attitude when it seems most pertinent.

MALLAIG, 18 AUGUST 1978

When I revisited the Air Force base at Molesworth on the way back from France in 1972, I was thrust into a state of anxiety which lasted for months. While I was there, I kept trying to see, to see. I tried to see the barracks, I tried to see the officers' club and the mess; I tried to see the planes on the runway. I tried to see myself.

Well, Jack, I guess you'll always be a failure.

Where was squadron headquarters, where the briefing room? I need another briefing.

[22]*For Colored Girls Who Have Considered Suicide When the Rainbow Is Enuf* by Ntozake Shange was on at the Public Theater, in New York City, from 1976-77.

[23]Mummenschanz—the name of their mask theater group.

[24]Schueler never did meet her again. The *New York Times* obituary headline for October 4, 1995, was, "Judy Dearing, Costume Designer and Former Dancer, Dies at 55."

MALLAIG, 19 AUGUST 1978

We had an absolutely superb dinner last night prepared by Joan Smith. Hamish was in rare form. He is truly brilliant as a storyteller and mimic. He told endless stories about local people, his friends, people he works with. Brilliant. I wonder what he does when he is doing a take-off of me! The MacLellans[25] were there too. We all had a marvelous time. Didn't get home until about 2:00 A.M. Unusual for us to stay out that late.

Afterward, Magda pointed out that there is a life going on here that we don't partake of. We are the ever-present strangers who come and go. For that matter, I live outside the daily lives of Sal Scarpitta and Bob Friedman and Ben Heller. Maybe a New Yorker always lives outside the daily lives of his friends. And a Mallaig man is more enmeshed in the daily lives of his fellowmen. Maybe this is what I constantly seek in New York and never quite find.

Ben. In business with Ben, I am handicapped by the thought that I have to spare his feelings. Why? He is a tough, successful businessman. He is not embarrassed. I am embarrassed. I retreat. I hesitate. I feel that I have to do it his way.

Ben is a friend. Ben says that our relationship is that of close friends burdened with business. Ben is tall. Mysterious. Subtle. Crass. Ben is sentimental. Ben is hard as nails. Ben's feelings get hurt very easily. Ben makes many, many people feel rejected and unwanted. Even as he is introduced to them. Even as they set foot inside his house to see my paintings. Ben has a terrifying sense of responsibility. Ben wants top dollar. Ben is generous. Ben will make the maximum out of a deal with me. Both things are true. Sometimes I have played the part of the firm but friendly businessman with Ben. I have always enjoyed it. I think he did, too. Now that Ben is in retreat in regard to handling my work, we have had some warm conversations. Ben sees much, much more than I think he sees. He knows himself better than I think he knows. But I don't think he knows that he can be cruel. He works too hard. He is too ravaged by responsibility. He began to feel responsible for me.[26]

My moods change much more than I know. I present more faces than I know. Sometimes when I am acting concerned, I am at my most brutal. I have hurt Ben in a series of letters written when I was obsessed by the letter

[25]Archie and Barbara MacLellan who owned Schueler's schoolhouse, Romasaig.

[26]Heller never had a gallery, but worked as a private dealer/consultant from his Upper East Side townhouse. Although he doubled the prices of Schueler's paintings, the 50% commission he received was minimal compared with that from the Aztec, Pompeian, African etc., pieces he collected and sold at this time. Despite selling to his own clients and having been instrumental in organizing the Whitney and Cleveland Museum of Art exhibitions for Schueler in 1975, he now found it hard to interest a wider public in his work. He had, therefore, encouraged Schueler to look for a gallery in New York.

and thought that I was explaining things. I don't think that Ben has ever hurt me.

MALLAIG, 23 AUGUST 1978

Yesterday, I received a letter from Ben in answer to the one I wrote him a couple of weeks ago. He writes: "I read with great interest and disturbance about your gallery efforts. My disturbance is based on real disappointment and inadequacy of what I have been able to do about your work. Possibly, last year was my over-reaction to the unusual success of the first year. I certainly have been unable to give you either the sales or the public contact that you deserve. I find this a bitter pill to swallow. To recognize the truth of it, I must. It would be easier if we were not so close personally; it would be much easier if I didn't believe in your work."

MALLAIG, 28 AUGUST 1978

On Thursday, September 7, this cold summer will be over for me. I'll help Derek[27] load the van with the paintings for the show, and on September 11, I'll fly to London. The show opens September 14. On September 18, I fly to New York.

MALLAIG, 31 AUGUST 1978

God. It really was a mistake. I've spent most of the afternoon talking on the telephone to Jenny Stein who owns the House Gallery in London where I'm to have a show in a couple of weeks. She called in a spirit of mild hysterics. I was sending too many paintings. The number of paintings not for sale was disproportionate. There were not enough large paintings. She was afraid the show wouldn't look good. She was afraid of the prices. She couldn't sell at those prices.

I thought all the matters over and called her back. She had told me, before I decided to show, when I visited her in early July, that London was absolutely dead. Nothing would sell. Nothing would happen. Ken Dingwall[28] getting a lot of publicity from his show there and selling and being asked to join a prestigious gallery was a fluke. A one-timer. It wouldn't happen again. I had decided that nevertheless I would be willing to show.

[27]Derek Roberts (b.1947), Scottish artist and friend who often helped Schueler with the moving of paintings, and innumerable other practical details when Schueler was back in the States.
[28]Kenneth Dingwall (b.1938), who had shown at the House Gallery in 1977, was taken on by Mayor Gallery, London. It was Dingwall who had introduced Schueler's work to Jenny Stein, whose gallery had opened in 1976.

I would show for one reason alone. I wanted as many people to see the work as possible. I told this to David Kay, Jenny's assistant. I said, "All I ask is that you get people in here. Just to see the paintings. That's all I ask. I shall not expect to sell." Having decided that, I went through the paintings making a very careful choice. I paid no attention to whether or not they were for sale, thinking this irrelevant. As to price, there was no point in being afraid of my prices if, in fact, London was dead and nothing was going to sell anyway. We had talked in July about price, and they both agreed that I shouldn't mark down from my New York prices.

I think I calmed her down. I told her that I would speak to David on Sunday and go over everything.

I thought I had things beautifully organized!

Magda returned to the United States to begin teaching while Schueler went down to London to attend the opening of his House Gallery exhibition, Paintings from Mallaig, *on September 14, 1978. Although no paintings were sold from that exhibition and the gallery closed the following year, Schueler met at the opening Henry McKenzie Johnston, Magda's cousin, a career diplomat who was familiar with the system of War Office records and was instrumental in locating Bunty.*

LONDON, 30 SEPTEMBER 1978
LETTER FROM HENRY MCKENZIE JOHNSTON

Dear Jon,

My detective work is complete. "Bunty" is Mrs. Challis of Hervey House, Lynch Road, Farnham, Surrey, England; and she has agreed to my giving you her address. I am afraid that she is a widow, her husband, Capt. Freddie Challis, DSC, RN having died last year. I have not met her, having made contact through a third party in case she did not want to be contacted direct. But I have now written to her about you and Magda. So it is now over to you!

It was the greatest pleasure meeting you. I hope very much there will be further meetings—next time including Magda, to whom our love. She may like to know that we became grandparents for the second time a couple of weeks ago, when our daughter Stephanie produced her second daughter.

Yours very sincerely,

Henry Mckenzie Johnston

NEW YORK, 6 OCTOBER 1978
LETTER TO BUNTY

Bunty!

I have just this minute received a letter from Henry McKenzie Johnston saying that you had been found. And that I might write.

But in minutes, I'm leaving to pick up a car and then to pick up Magda for a trip to Lenox, Massachusetts, in the Berkshires. So I can only write a note. We'll be returning Monday night, and I'll be able to write on Tuesday.

But another rush: There is a show of my work on in London at the moment in which there is a painting dedicated to you.[29] I would give anything to have you see it. The show runs through Sunday, October 15, at 7:00. It may already be too late to reach you in time. The next day, the paintings will be picked up and stored in Edinburgh.

The gallery is the House Gallery, 62 Regents Park Road, London NW1. Phone: 01-722-1056. The head of the gallery is Jenny Stein. Director is David Kay.

The paintings were all painted in Mallaig (in the Western Highlands of Scotland) over the last few years. I'd give anything to have you see the show. Perhaps you will before you receive my next letter.

The paintings say more than words.[30]

I'm terribly sorry to hear of the death of Freddie. I must leave.

Love,

Jon

NEW YORK, 10-13 OCTOBER 1978
LETTER TO BUNTY

Dear Bunty:

I don't know where to start. The thought of starting at the beginning staggers the imagination. I'll start with the McKenzie Johnstons.

They came to the opening of my London show on October 14. And this was by accident. I had never met them before. Magda had made up a mailing list for the show and had asked her mother if she had any names that she wanted to add. . . . Mora Salvesen (Magda's mother) made out a list of family friends and relatives in the London area whom Magda had overlooked. Among these were the McKenzie Johnstons—Henry and Merrie. . . . I think she is an aunt[31] of Magda's.

I'd never met the McKenzie Johnstons, but when they appeared at the

[29]*Ode to Bunty: A Winter Dream Remembered*, 1976, (72" x 79").

[30]In a letter of 9 October 1978, Schueler asks Bunty to select a small painting for herself.

[31]First cousin.

House Gallery and introduced themselves to me I immediately liked them. She and I got into a warm conversation, in which she tried to brief me on relationships. Henry would leave the conversation to look at paintings, and would come back full of enthusiasm. We finally found ourselves talking at great length about the work. I was impressed by the intelligence and sensitivity of his perception. I mention this because it became the basis for my trust of him later on.

Shift to Magda's sister, Katrina Turner, who had planned to have me for dinner on Sunday, October 17, the night before I flew back to New York. She had asked me to include any one I wanted. I phoned her and suggested the McKenzie Johnstons. And she had already asked Mark and Peggy Turner, the parents of her husband, Chris.

At dinner and after, we found ourselves talking about the paintings and about Mallaig and the years I had spent there. At some point, Merrie asked me how it had happened that I had gone to Mallaig in the first place. I took a deep breath and answered.

Now you must understand that during the course of any year, I'm asked this question dozens of times. And have been ever since I first went to Mallaig in 1957. I'm asked it in Edinburgh, in London, in Mallaig, in New York. I'm asked it in intimate social groups, and I've been asked it when I was lecturing to large audiences—in San Francisco, in Santa Cruz, in Manitoba, Canada. I've been asked it in art schools, at openings, or in casual conversations. And I always try to answer it as well as I can. It's difficult, because the answer, were it complete, is the story of my life. It is also difficult because one can slip across the surface of the story, which has been told so many times. And it is difficult because one wants to say so much more than one is allowed, or even has time to say in a given circumstance.

So when I was asked the question at Katrina's dinner party, I warned them that the answer would be long. But they all insisted that I tell the story.

I told them that the story began during the war when I was a navigator in B-17's. I told them that the navigator and bombardier flew in the nose of the B-17, a Plexiglas nose, as though suspended in the sky. There, in combat and before, the sky held all things, life and death and fear and joy and love. It held—it was—the incredible beauty of nature. It was the storm and the enemy gracefully flashing by and the friend waving from the crippled ship. It was the memory of a beautiful woman.

11 OCTOBER 1978

I told them that at that time I knew a woman in London who meant a great deal to me. She was beautiful. She was brave. She had delicate wrists and patrician eyes. She drove an ambulance for the American Ambulance Corps.

She was English, but she loved Scotland. And, because she understood something very personal about me, she thought I would love Scotland, too.

Most particularly, she though that I would love the Highlands, and often she would describe them to me. I created the most powerful images from her descriptions. They were images of a sea and land and sky beyond mystery.

When I left England, the images stayed with me. Perhaps they grew in intensity. They were lonely, haunting images, possessed of the strange space of rain and storm. In some ways, they partook of the poetry of war, and may have been, in part, my memory of a war sky. In any case, I remembered. And through the years of the forties and early fifties, these images, formed from Bunty's descriptions, haunted me. I always wanted to go back and search for the reality, but my life became entangled with the present and it was impossible. But I talked of them. I was known for a kind of mad enthusiasm with which I'd talk about Scotland. I had never been to Scotland. I had never read of Scotland. I knew nothing about Scotland, nothing beyond the woman's words. Yet I talked as though obsessed.

I hadn't been a painter at the time of the war. I started in 1945. I studied first in Los Angeles and later in San Francisco. I went to New York in 1951.

There, in New York, the images that I seemed to be reaching for in my painting crossed or became those remembrances of Scotland described to me years before in London. In New York, as an abstract painter absorbed with the idea of Nature, I created glimmers of fantasy sea and sky, storm and fog, sun and land, which became the sky. More and more, I felt that I had to go to Scotland, I had to discover the Highlands in reality, I had to live inside my painting. Finally in 1957, I had a show at the Leo Castelli Gallery in which I sold some paintings, making enough money to go away for a year. In September I left New York on the *Maasdam* for London. I took a train from London to Edinburgh.

I rented a car in Edinburgh and headed west to the Highlands, searching for the place of which I had been dreaming. But which had become a living reality to me. I would describe it in great detail to whoever along the way would listen.

13 OCTOBER, 1978

(I've had the busiest and most disrupted week since we returned from Lenox. So I'm telling you this story in bits and pieces. I feel that it's all very disjointed. But I'll go on. The sun is shining. It's a lovely warm day—Indian Summer day. I wish that we were walking in Central Park and that I was telling you in person what I'm struggling to adapt to the whims of the electric typewriter.)

Anyway—I really did describe my destination—without knowing where it was—to anyone who would listen. Barmaids, filling-station attendants, hitch-hikers. A man in Edinburgh became furious—he considered me to be presumptuous. I drove down to Campbeltown and worked my way north. I was looking for a sea and a sky with a northern look, and I wanted to live at the edge of the sea in a rugged landscape, and I wanted a peninsula or an island in the distance so I could watch the sky move across that shadow of

land—sea, land, and sky in a constantly changing relationship. And if possible, I wanted to live in or near a fishing village, as I like to work in a workaday place. I met a woman in a hotel and I described the place to her. I saw her at breakfast the next morning and she said, "I've been thinking of the place you described last night, and I think you may be describing Mallaig. If you can stand the smell of fish, you should go there." So I headed north along the twisting one-track roads and as I headed west from Fort William into an increasingly strange landscape, I became more and more excited. At Glenfinnan, a crippled woman and her daughter were waiting for a bus to take them to Morar. I picked them up and they sat together in the backseat of the little car I had hired. As we went further and further into this increasingly mysterious landscape, I became more and more excited, and when I caught my first glimpse of the sea, and then of the Isle of Eigg, my Geiger counter went berserk. I think I was yelling with excitement—and my passengers would gladly have gotten out of the car and walked.

After you leave Arisaig, you are in constant touch with the sea and the strange mysterious presence of Eigg and Rhum and the Isle of Skye. I knew that I was approaching my place. When I drove into Mallaig, I had already settled this in my mind. The village itself was absolutely right. It was certainly workaday. And you could smell the fish. Some people think Mallaig is ugly, and in a way they are probably right. But I've always loved it, and find it strangely beautiful. The town itself.

I stopped at the West Highland Hotel. Young Archie MacLellan came out to help me with my bags. (His father owned the hotel.) While we were unloading my luggage from the trunk, I told him that I was planning to spend the winter in Mallaig (this was in September) and that I needed a house. He said that people didn't come to Mallaig in the winter—they left it. And besides, there were no houses available. I said that I needed something. I'd even take a room if I had to. But that I knew I was going to stay.

After dinner, Archie came up to me and said that he remembered a house in Mallaig Vaig—about two miles out of Mallaig, at the very end of the road. It had been rented to summer people and was now empty. It belonged to a Mrs. MacDonald. We got in his car and drove out to see it, though it was quite dark. The road was narrow and bumpy, curved around the bay, then up to a group of council houses, and then beyond them to an incredibly steep hill. As the car labored up the hill, I felt as though we were going to tip over backwards. At the very top we stopped. The road went no further. We looked down into a shadowed land which opened to the sea, and across from me was the powerful presence of the Cruaich, a rock-face hill which formed the opposite side of the valley of Mallaig Vaig. We could barely see the house Archie had talked about.

In the morning, I walked out to the valley and saw that it opened to the sea and in the distance was the Sleat Peninsula, which is the southern tip of the Isle of Skye. The valley was at the mouth of Loch Nevis, one of the most

beautiful lochs in the Western Highlands. There were six crofting houses scattered across the valley—including one that was in ruins. They were all stark and beautiful, except for the one I would be living in through the winter of 1957-1958 which was a rather ugly "bungalow"—called "The Bungalow"—which had been built in the 1930s. But it had a comparatively large room which had been an old-fashioned kitchen and it had a window which was larger than the typical crofting houses, so it was actually more suited to my purpose. I went to see Mrs. MacDonald, a taciturn lady indeed, and we made a deal.

I'm not going to write much more about this now. Suffice it to say that I did stay through the winter of 1957-1958. I painted forty-five paintings there. It was an incredibly cold winter with much snow for that area, but I learned how to keep warm. I made many friends, including Black Jim Manson, who became something of a hero to me. He was skipper of the herring boat, the *Margaret Ann*, and I went to sea with him and learned what it was to be at sea in a small herring boat in a force-ten gale. I could scarcely understand him when he talked—he'd have to repeat everything twice—but we became fast friends, and I spent all my time at sea in the wheel house with him. It was like sailing into my painting. Or into the dream of my paintings.

That period spent in Mallaig was one of the most crucial of my life. It was as though everything that I had thought about previously, every thought, every dream, was funneled into that period. And everything that I have thought about since has emerged from the drama of that incredible winter. What I saw and felt there was everything I could have dreamed of—and ten thousand, a hundred thousand times more so. It became the focal moment of my life and work.

And it exists only through you. It exists because of you.

Whatever it was that you were saying out of your own enthusiasm formed images in my mind's eye, images so strange and mysterious, images so full of meaning that I live with them to this day.

When I finished this story at Katrina's dinner party, Mrs. McKenzie Johnston said, "And what happened to Bunty?" I said that I didn't know. We had corresponded briefly, and then, in the mess of my life right after the war I lost her address. I lost the memory of her address, and I lost her letters, and I lost a photograph I had of her. But I didn't forget her. Because she became so much a part of my work and because the memory of her during that other stormy winter was so strong, she has never been far from my mind. Through the years, I made some unsuccessful attempts to find her. I felt that she might like to know that someone had thought that much of her, and that she had been so important in another person's life. During the seventies when I lived in Mallaig, and when I showed paintings in Edinburgh, I kept wishing that somehow she would hear of me or see the paintings. When I would lecture or give interviews on TV or radio or when I was written about in the Scottish papers, I would wonder, even as I spoke, if by chance she'd see or hear my words. As luck would have it, I never did

show in London until now, and it seemed less likely that Edinburgh publicity would reach her. Or that she'd see my paintings there.

Henry was looking at me intently. "Would you really like to find her?" he asked.

"I'd give anything," I said.

"I think I might be able to help you."

He did!

Now I'm going to stop and put this in the mail so that you'll hear from me and have an explanation. I wonder if you received my notes in time to see the House Gallery show and to pick out a painting. I wonder if we shall be able to meet soon. I wonder how you are, what your life has been. . . .

In receiving word about you, I learned of the death of Freddie. I'm sorry that I never met him. He was a hero to me because of what he did in the war. And I always wished I could have been of the same stature.

Do write and tell me about yourself. Anything. Anything will be news.

What is your telephone number? Complete with area code. And the zip code for your address.

I was in London twice last summer. Did we pass each other in the National Gallery?

In 1966, I was visiting a friend near the Borders, and I made a pilgrimage to Berwick-upon-Tweed. I remembered Berwick-upon-Tweed as part of an address. It was raining (appropriately) and I spent a good deal of time there walking the streets.

Love,

Jon

NEW YORK, 20 OCTOBER 1978

New York. New York. I've been in New York since September 20th and this is the first time that I've been able to actually start.

• • •

Bunty. Someday a letter will come from you. Will I be afraid to read it? Looking into the past can be so painful—and is not without danger.

• • •

This last summer, the weeks passed in Mallaig and I didn't go to see Jim Manson. I saw Mary[32] in the village and told her I'd be up to visit soon, but I couldn't make it. I was afraid. At first, I thought that I was afraid to see Annie. Hamish Smith had said that she looked at him with hate and wanted him to go away. Then I thought it was because Hamish told me that Jim was senile and one could scarcely understand him. But then I re-

[32]Jim Manson's daughter.

alized that it was the closed door I was facing again. The closed door against the dream that I did not dare open.

. . .

I just went down to collect the mail.

There was a letter from Bunty.

<p style="text-align:center">FARNHAM, SURREY, 16 OCTOBER 1978
LETTR FROM BUNTY</p>

Dear Jon,

I just made it! Your two letters arrived at noon on Saturday, so I changed my Sunday plans and dashed to London.

What a clever detective Henry McKenzie Johnston was.

And what a very kind thought, Jon, to give me a painting. I chose the small one of *Cloud and Sleat*.[33] As you wished to retain it, I do hope it wasn't for a really important reason. But I like the quiet muted colors, and having lived on the Isle of Bute and Arran, and walked for miles in the rain and sleet, it will remind me of those days.

I am so glad you are happily married to Magda—do give her my regards.

I feel highly honored to have a painting dedicated to me, Jon, and the colorings are quite beautiful.

As I am not an artist, I can't talk intelligently about painting and you must remember that I had no brains anyway. But I am very impressed by your paintings, and will think about them. And now I have one to look at.

I felt I should leave the painting until the exhibition was finished, but David Kay said as the exhibition was closing that I should bring it with me.

Thank you again and again.

Love from,

Bunty

Must dash to catch today's mail.

I always remember those wonderful musical concerts on Sunday afternoons.

<p style="text-align:center">NEW YORK, 24 OCTOBER 1978</p>

Bunty.

When I told Magda that Bunty had been found, she said, "How amazing. How very Schueler."

I think I always assumed that she would be found, even though I was completely unsuccessful in finding her on my own, and, indeed, was in some ways afraid to try.

[33] 1974 (8" x 10").

<div align="right">NEW YORK, 25 OCTOBER 1978</div>

I feel slightly ill. Slightly nervous. Slightly tense.

There is Bunty searched for and there is Bunty remembered. There is the Woman in the Sky. Bunty. Magda. There is the dark shadow behind the grey of death. Death of the memory. I can see, just barely see, her silent, sad smile. As though disappearing into a café or into a crevice in the wall. Bunty carries in her the scar of war. She is my hidden memory. When I see her stationery—the one letter which I found hidden in my USAF separation papers, and the recent note—I see a real person. Because I can see the surface. I can see the direct and unimaginative words. But without the letters, I have the memory, which goes deep and full, endlessly deep in all of its imaginings. I should not speak of Bunty to others. I should not. Not until I write it down. She is my private world, my memory, my hidden sadness of things past.

<div align="center">FARNHAM, SURREY, 26 OCTOBER 1978
LETTER FROM BUNTY</div>

Dear Jon,

I received your long letter this morning and will have to reply in bits—partly because I have friends coming to stay, and partly because I broke two bones in my wrist, and can only write slowly. . . .

Your letter was fascinating—I didn't realize I had talked so much of Scotland. 'Cept I had been working there, in Edinburgh, and knew it very well at the time. Freddie and I didn't forget the wonderful food parcels you sent to my mother's home, and there was a tiny note in one, saying it was your ambition to open a gallery in New York.[34]

I can't begin to fill in forty years. I planned to go to North Africa to join 8th Army, in the YMCA, about the time you left England probably, but [I] had a cable from Freddie saying "Please don't go. Am trying to return home." He did, in time, and I chased the wrong man on dark King's Cross station, as he had grown a beard. He had a short leave, and took another submarine back to Malta.

I then sailed for Italy, and had a "bun wagon" near Salerno. I refused to be in the back lines and by breaking all the rules, hitched my way with Hilary to Perugia, and then across the mountains, in thick snow, to the Adriatic coast. We worked our way north, to within yards of the front line. We saw a Senior Army Officer, who said, "You don't mean to say you will work here!" Within twenty-four hours, they had converted two large lorries

[34]This seems somewhat improbable. The remark was probably ironic, following a disappointment/disagreement with a New York gallery.

into canteens. Needless to say, I enjoyed the excitement, and had a bat-man-cum-helper, but I did all the driving.

Then we were the first Allied women to go into Venice and Trieste, and is-sued with an Army revolver (far too heavy). Then we went on to Vienna, to open the first canteen. And the Russians stopped us, but we got through the second time. . . . Anyway, I never talk about it. And I was cabled from Fred-die, in the Far East—saying returning in hospital ship with injury.

So I hitched my way to Trieste, where I had friends, and they took me to Calais, where I was the only female on a troop ship. I was sent for by HQ in London, expecting trouble, but quite the reverse.

Then Freddie was sent to the Far East, and I went and worked in Ger-many (Berlin), but didn't like it after the war—this is all old history, Jon. Since then, I have lived in fifty-eight furnished houses, and three of our own. New Zealand, Malta, Singapore, Paris etc. We bought and restored a tiny very old cottage in Provence—in the vineyards and olive groves, north of St. Tropez.

I may be busy for the next three weeks—perhaps two, when you get this. Because my younger brother—Harry—has been living in Rhodesia, on the Mozambique border—they can't sleep at nights, with bombing and houses being burnt down all round. They may come and stay, and while they are wealthy in Rhodesia, it is a question of how much money they can get out.

If you give me warning, Jon, I can give you a bed.

P.S. Trains run half-hourly from Waterloo—fifty-five minutes.

Jon, as you have such wonderful memories of me—mainly imagination, which I appreciate—I think you are going to be very disappointed if you see me again—forty years later.

So much has happened since.

Will I know you?

Have you grown a beard?

Love,

B

Schueler continues to gravitate between past and present. From October 1978 to January 1979, he worked on a series of paintings whose titles such as Memory of Love, Goodbye to Oscar, November Blues: Mood over Sleat, *often evoke remembered friends and landscapes, the source of his imagery. Meanwhile the present is filled with dinner parties, Thanksgiving and Christmas with John and Judith Stonehill, a regular flow of visitors staying in the loft, and openings—a convenient way of at least superficially keeping in touch with friends in the art world.*

NEW YORK, 24 JANUARY 1979

I am on the twelfth floor, the top floor of this building. From my desk, I look down on 22nd Street. Delivery trucks and cars nudge one another forward. The traffic moves slowly. Sometimes anger erupts into a spate of horn blowing. This morning a fire truck Klaxoned its way through to Fifth Avenue. Last night, four squad cars silently approached and parked before our building.

I think of my friends. Magda and I have so many friends—some hers, some mine, some shared—ultimately all shared—that it becomes almost a sorrowful and sobering thought. One can seldom see them. One can't catch up with them. One fails to contact, to write, to call, to talk. I would like to sit in the living room with one friend and talk. This seldom happens. Or informally with two or three. This seldom happens.

I'm constantly meeting new people whom I want as friends. Women and men. Then there is Bunty. I must talk about Bunty. I must talk to Bunty. She phoned me from England. She has not written since. Something happened.

She said, "I am scared to see you, Jon." And I tried to reassure her, but there is no reassuring.

NEW YORK, 2 MARCH 1979

Hilton Kramer in today's "Weekend" section of the *New York Times* gives Neil Welliver a big, rave review. Best landscape painter around. He really looks. He really knows landscape. Paintings are masterly. On front page, John Russell gives Alex Katz a rave review. A show of his cutouts at the Robert Miller Gallery.

How do I feel? I feel sad. Disturbed. I'm glad to see any artist get a good review. I'm glad to see any artist attract notice, have his paintings go out in the world, receive money for his paintings so that he can pay his bills and keep working. But at this moment, these articles drove home my own loneliness, my apartness, my lack of recognition in this arena of New York. As Patricia Hamilton[35] said, "You are an artist with many loyal followers. And you are an artist who is not nearly as well known as he should be." My gallery situation has become impossible. A few years ago, I was saying that if anyone offered me the ten best galleries in the world, or to be associated with Ben, I would take Ben. I felt that. I thought our relationship was warm, personal, and full of promise. I admired Ben's talent and his aggressiveness, and I responded to his dedication to my work. Now Ben and I have practically ceased to function together. He stopped working for me—the pressure of his involvement with antiquities, financial and otherwise,

[35]She had a gallery at that time.

meant that he couldn't turn his attention away from them for a minute. When he first took me on, he sold a dozen watercolors in weeks. Now he might sell one in a year. I mention watercolors because they are reasonable and he seems to be able to sell them almost at will. But it is not just a matter of selling (although it is selling that keeps me alive and working), but, rather, it is a matter of having no dealer working for me. There are no shows. No contacts being made.

NEW YORK, 4 MARCH 1979

My work has received very little publicity. Without the publicity no one knows about it. My book will be the publicity. Years ago, Bob Friedman said, "Wouldn't it be ironic if your paintings became known because your book was known." And now, Peter Rose[36] says, "The book is the key to everything."

NEW YORK, 7 MARCH 1979

The Hamburgers'[37] cocktail party last night was very stimulating to me. All the people. The sense of movement, of vitality, of human contact.

Even though I don't get a chance to really talk to Shawn, editor in chief of *The New Yorker*—I do enjoy meeting him. He is small and slightly bent—as though he is always ready to look away from you. His appearance is so unprepossessing that it is prepossessing! I mean—he looks as though he wants to fade from attention—and by that fact, one can't help noticing him. Particularly if you know who he is. Damn. I wish that party had gone on and on. I was just getting in stride, when there was a grand exodus.

I had a strange conversation with S. J. Perelman.[38] At first, I met him as part of a group. He stood upright and silent, occasionally responding to one or the other of the group that he knew. He had on very conservative clothes—a dark, single-breasted, three button suit. A vest or sweater-vest. Metal-rimmed glasses. He was shorter than he looked in some of the photos I've seen. In the middle of the conversation, he was spirited away. Later, I talked to Anna about him—and she said that he no longer talked, that it would be hard to get a response from him. But, for some reason, at the end

[36]Peter Rose, a private art dealer in New York, and his wife, Alexandra, had a number of Schueler's paintings on consignment at this time.

[37]Philip Hamburger (b. 1914), staff writer of *The New Yorker* magazine from 1939, contributing profiles, "Talk-of-the-Town" stories and many other articles. Nineteen of these essays were published as *Curious World: A New Yorker at Large*, (Berkeley, California: North Point Press, 1987). He and his wife Anna first met Schueler in the 1960's.

[38]S.J. Perelman (1904–79), eminent humorist. See: *The Most of S.J. Perelman*, foreword by Dorothy Parker and afterword by Philip Hamburger (New York: Simon & Schuster, 1980).

of the evening, I tried. He was crossing the room and I stopped him to talk to him. I wanted to say that it was interesting meeting him, just because he loomed large as a recurring figure in my life—those regularly filled two pages in *The New Yorker*. I can't imagine *The New Yorker* without him. So, even as I talked, I would see him this way. But it came out clumsily—I found myself using the word *institution*, which caused both of us to wince. And then I proceeded to tell him the story of David Lax[39]—and his answer to my letter that he only "dimly" remembered my name, but nothing else about me—which turned out to be a non sequitur, though when I started to tell the story I thought it was pertinent.

Oh well!

NEW YORK, 9 MARCH 1979

Lunch with Ellie Munro. She had just finished a long session with her Simon and Schuster editor, going over her book on women artists[40]. They have committed themselves to thirty pages of color, which bodes well for the book.

She had read "Death and the *Margaret Ann*" and evidently liked it. She felt it was too long. She thought editors were not eager to see memoirs. She asked me many questions about the form and substance of the book. She made an excellent suggestion: Finish the book before you do any more work on it. Excellent.

Once the book is finished, it can more easily be edited. There is a framework which helps the writer to make structural and other decisions. Otherwise, I can go on and on and on.

•　•　•

The telephone call from Bunty. Was she drunk or just frail?

NEW YORK, 10 MARCH 1979

I'm beginning to feel the way to pull this together.

First—write the end. Or an end. The end is part six. I'm not as yet sure what the end should be. But I can feel it. I will have been writing, among other things, about men. And about combat. And about failing in combat. The idea of age and destruction. Go back to Jim—now suffering, possibly a cancer in his leg. Go back to Billy—dead. Go back to Bob Friedman, his

[39]Schueler, in a lecture in the 1970s, had mentioned his indebtedness to David Lax, whose portrait painting class he had attended in Los Angeles in 1945. Afterward, a member of the audience gave Schueler David Lax's address in Red Hook, New York, where he had lived since the early 1960s.

[40]*Originals: American Women Artists* (1979).

great ability to work—and the disappointments in reviews, etc. Go back to the death of the father. Go back to war—and perhaps in this tell the Bunty story. The Bunty story could be the last story, the distillation of war and career and the movement of time. Part one has the Jody story—the turning of love and passion into destruction.

NEW YORK, 14 MARCH 1979

Bud Leake[41] came to town yesterday for a few hours. We went to the biennial at the Whitney. I liked the work of a former Yale student of mine best—his name goes out of my mind[42]—friend of Bob Mangold. It was warm and dignified. Seductive, yet formal. Three panels of two or more colors. That's all. But it had a pulse and a presence. What the hell is his name? Evidently, he's very much in the public eye right now. So is Mangold. They have been for some time. Strange. I feel as though I'm fading from the public eye—like the Cheshire cat.

NEW YORK, 5 APRIL 1979

I'll find my way back to Bunty. But not right now.

I must write to her. I wonder what she thinks. I have neglected her for a long time. But I have written to no one. I should write to (and send checks to) Jamie and Joya.

Poor Jamie and Joya. What a terrible father I was to both of them. I was always thinking about my own survival—as a man, as a painter. I didn't think too much about their survival. I left them in the hands of Jane.

NEW YORK, 7 APRIL 1979

Last night, Magda and I met at Yvonne Thomas's[43] cocktail party. I arrived around 7:00 P.M. Magda a little later. She came directly from the Day School.

At a certain point in the party, we were talking to an attractive young woman in a black outfit. She talked about how she had everything organized for her work. The main organization seemed to be to have her husband take on responsibility for the three children, two cats, and three horses. Also, it was up to them to realize that she was a night person and liked to sleep late in the morning—which she did. The husband fixed the children's

[41]Eugene Leake, president of the Maryland Institute of Art, Baltimore. It was Bud who had hired Schueler as visiting artist in Baltimore from 1963 to 1967.
[42]Brice Marden (b.1938). He and Robert Mangold (b. 1937) had both been Schueler's students at Yale.
[43]An artist, Thomas had been a friend of Schueler's since the 1950's.

breakfast, made their school lunch, and got them off to school. Mommy slept late. Besides, she was always in a bad mood in the morning, and it was best for everyone if she stayed in bed. She liked to get up later, when the house was empty.

For some reason, Magda started talking about the difficulties I was having working. But telling it in such a way as to suggest that I was inadequate to the task of organizing my day, taking care of the co-op business, etc., etc. I couldn't find the words to stop her. Worse yet, I got drawn into the discussion despite myself, trying to justify myself, talking about the telephone interruptions, describing the two-hour interruption that very day to deal with the plumbing problems at Bell Bedspread.[44] As usual, with every word that I said, I got less understanding and seemed to generate more ammunition for Magda and the Woman in Black.

When we left, I was quite depressed about the whole thing and became increasingly depressed as the evening wore on. I wanted to say something to Magda, but found myself inhibited from doing so.

I woke up this morning very early—before six—with this on my mind. I felt that my agonies and frustration, and the very intimacies that I had entrusted to Magda were now to be simplified, distorted, and used in a cocktail party conversation.

Finally, I told her that I was angry and that I didn't want her ever again to violate my confidences and use them for cocktail-party conversation. That I thought she would know how complicated and painful all this was to me. How I had been in creative difficulty for the last couple of years, and that it was far more complicated than not being able to deal with pressures developing because I was president of the co-op. She said that she was sorry. But I doubt if she understood. I never know with Magda whether or not she has a clue to my inner life. In a way, that is good—because it means that she is off my back, and doesn't get enmeshed in the complexities of my psyche and my creativity or lack thereof. But I think I would feel less lonely if I knew that she knew that an inner battle was being fought. It's like going off to war and having your loved one act as though you were off on a pleasure cruise.

NEW YORK, 9 APRIL 1979

Now. Can I wake up? Can I get organized?

By the time Saturday was over, I realized that Magda had done nothing at Yvonne's party. At the most, she touched on a sensitive spot—I don't like to talk about difficulties in working as cocktail party conversation. But Magda,

[44]This year, Schueler was president of the co-op which, at this stage, was run by its members without outside management. Thus there were constant interruptions and demands on his time.

being as sensitive as she is, is not likely to do something insensitive. The only time is when her need to be honest and to state facts gets in the way of her sense of discretion.

So what is interesting is not what Magda said or did not say, but rather, the inner rage of mine that was released as the fancied injury became more and more important in my fantasy.

NEW YORK, 12 APRIL 1979

I'm a little tired from entertaining.

Last night we gave a dinner party for Piero Dorazio and Juliana.[45] It was a lovely party. Magda was truly wonderful, as usual—creating a meal and an ambience of hospitality which couldn't have been better. And this after a full day's teaching. Plus a meeting. She arrived at the studio around 6:00 and didn't even have time for her usual cup of tea.

Flora Irving[46] came with Sydney Biddle. She looked a bit tired, but otherwise more relaxed and happier than she used to look before she took on the job of president of the Whitney. Her hair was cut fully and fluffed out and made her look warm and feminine. She seems less constrained and self-conscious than she used to be, and is more easily sociable. What a story! What a story in everyone. I have a feeling that all is not going well (to put it mildly) between Flora and Michael. Most of her life now is in New York. Most of his is in Rowayton [Connecticut].

Bernie Schürch and Floriana Frassetto were here. Lovely couple. They, of course, are two of the three Mummenschanz. They are going to stay on the houseboat at the 79th Street boat basin for another week or so, and then will tour South America for a couple of weeks.

NEW YORK, 13 APRIL 1979

This morning I looked at Magda sleeping and felt the sweet ache of love. Will I make her happy? Is she happy now?

She doesn't seem to be thrown by my ups and downs and contradictory concerns. Which both leaves me feeling free of pressure and, at the same time, can make me feel lonely and unattended.

Best this way.

[45]The Italian artist whom Schueler first met in Rome in 1958, and his young wife.
[46]Flora Irving, née Miller, the granddaughter of Gertrude Vanderbilt Whitney, and her husband Michael Irving, met Schueler c.1956, probably through their mutual friends, B.H. and Abby Friedman. Flora and Mike, who owned the large Schueler from the 1963 Stable gallery show, visited Schueler in Mallaig in the summer of 1973 and subsequently lent him their New York apartment when he and Magda visited the States in 1973, 1974 and 1975. Flora and Sydney Biddle married in 1981.

Best that she doesn't crawl into my own maze as some sensitive and exciting women are wont to do.

Women. Women. Women.

．　　●　　．

Galleries! I have nothing.

Last night Wayne Toepp[47] asked me what gallery I was affiliated with. When I told him that I was with a private dealer named Ben Heller, I felt false. As though I was lying. There is no Ben Heller! He is a figment of my imagination. We are no longer in business (nor have we been, really, for a long time). But it is necessary for me to pretend I'm in business. That I have a gallery. As though I would be admitting failure and defeat if I suggested that I had no gallery. But I do not have a gallery. That is the fact. The strength should be in the fact. Still made his position into a strength. But he had a gallery as long as he needed one. When the galleries needed him, he left the galleries. The facts for me: I do not have a gallery. Some individual dealers sell my work (Peter Rose, Ben Heller, perhaps John Stoller.[48] No one else. No one in Europe.) My career has practically come to an end.

What is positive about this? I could work passionately without the interference of gallery and shows. In the meantime, I seem to sell enough to get me through the year. Someday, some way, something would happen and the work would become known. I'd like to have the pleasure of seeing this, but it is not the most important thing in the world. Not if I continue to be productive. (The last couple of months have been very unproductive.)[49] Let's say, don't worry about galleries for a year. Have a year off. A year of solid work—like a year in Mallaig. There will be the show at the Demarco Gallery—if he gets a gallery—or at the Talbot Rice Art Centre in Edinburgh.[50] I want to feel the passion stirring in me again. The passion of painting. The lust of writing. It all has to come out of myself and out of my daily dedication. I feel as though I've been through some kind of nightmare—one excruciatingly painful because of its banality.

The stroke of paint. That is important. That is the one most important thing. It is more important than the word. I want the word to exist. I like it when it does. But it is not as important as the paintings.

Also in this year: Work passionately, play passionately. I tend to sacrifice myself in my work. Feel the work as an act of sacrifice rather than an act of celebration. I want to push toward the celebration. And at the same time, to

[47]The young artist, Wayne Toepp, became Schueler's assistant from 1980–1983.
[48]John C. Stoller, Minneapolis, Minnesota.
[49]According to the records, this seems to be true. However, in January, Schueler completed twenty-one smallish to medium-sized paintings.
[50]Schueler was never to show again with Richard Demarco, Edinburgh, but in 1981 he exhibited in the Talbot Rice Art Centre of Edinburgh University.

feel the pulse of my personal life. Fly to the west coast—see Mother, Jamie, Joya. See Pat Aherne and lecture at Santa Cruz.[51] Talk to Charlie Clark[52] in San Francisco. Visit Inez Storer at the Lester Gallery in Inverness, California. Drive through New Mexico with Magda. Stay in Mallaig an extra week or two or three if I feel like it. Go. Move. Feel. Create. Celebrate.

When I woke up this morning, I could not have guessed that I would have such feelings. I was holding myself together quietly so that the anxiety would not increase. It was there—but more like a shadow of itself. But I breathed deeply and I looked at Magda. Breathing deeply, I felt my body disappear from the breath itself. My eyes were heavy and I lost the count of one to six. I feel infinitely rested. I can do it again.

I painted yesterday.

I can write and paint. Why not?

NEW YORK, 14 APRIL 1979

Jamie and Joya are on the steps of the Jackson Street house. Jamie has on a huge pair of work or hiking shoes. No—they are paratrooper's boots. Really huge. I think that she wore them all through high school. Joya is feminine in a print cotton dress that is old fashioned and too long for her. Do they love me? Do I love them? Yes. But they have both had a most difficult life. Jane was quite mad by the time they managed to cut out. Yet somehow they have made their lives. They each have two children, and I think they would both want that no matter what. How detached I have often felt! There are four grandchildren. They quite fascinated me when I saw them, but away, I can scarcely remember their names. I know they exist, but they have little reality for me. I must write to Jamie and Joya. Jamie is in the mountains of Oregon living in her school bus. Joya is high in a mountain desert above Los Angeles, living in a mobile home. As far as I know, neither has a man living with them.

NEW YORK, 30 APRIL 1979

I've been painting for the last five or six days. Or maybe it's been the last week. A large horizontal painting—72" by 96"—a brooding, blue storm with blacks and reds and blues[53]. And some smaller works. In one—60" x 50"[54]—I

[51]An exhibition of small paintings had been shown, through the Inez Storer Gallery, at the University of California, Santa Cruz, in 1975. Schueler met the artist and instructor Patrick Aherne there, who invited him to return several times to lecture and show his 1971 film.

[52]Friend from the California School of Fine Arts days, when Charlie played the clarinet in the Artists' Band.

[53]*The Sound of Sleat: Blues.*

[54]*Reflection: Blues and Gold.*

try to create some of that subtlety of response that makes the grey one with its pinkish glow, in the dining room,[55] so strange and amorphous and so difficult to pin down. And on Sunday, I finished a smaller horizontal, 50" x 79".[56] And yesterday I had Magda help me move "Death of the Father" into place—on the large painting wall. This painting is 72" x 216". I finished it in 1976 while still in the Jones Street studio. But I was never satisfied with it. I found myself thinking about it during the last week, and yesterday I decided that I was ready to tackle it. It can be very difficult, emotionally, to take on an important painting—large, with much about it that is powerful and compelling. At first I was interested only in a few small changes, but as I was working on it, I sensed the implications of what I was doing, and felt that I might very well repaint a good part of the painting. It is already much improved—though fortunately, it is now in a truly unfinished state. I sense the possibilities. I feel, now, that much of the painting lies too close to the surface. There is a certain amount that is too literal—something that has to be expanded, wrenched, torn apart, and recreated. It may or may not demand a great deal of painting. Perhaps relatively few strokes will liberate it. It is already in the process.

<div align="center">NEW YORK, 1 MAY 1979</div>

Dick Ziemann[57] spent the night. We looked at recent work.

Momentum.

Right now, the painting is going beautifully. Works finished. Works unfinished. The studio has the look and the smell of work.

The writer Jay Parini[58] made arrangements for his friends Schueler and Salvesen, and also Alastair Reid, to spend the summer in Hanover, New Hampshire.

[55]*Magda's Dream: Summer Frost*, 1978 (72" x 120").

[56]*Summer Mood: Near Skye.*

[57]Richard Claude Ziemann (b.1932), printmaker and close friend of Schueler's. He stayed every second Monday during the academic year, coming in from Connecticut to teach at Lehman College, CUNY.

[58]Jay Parini (b.1948), prolific novelist, poet and biographer; professor at Dartmouth College, NH, in the 1970s, later at Middlebury College, VT. His friendship with Schueler, which stemmed from the early 1970s, was to be strengthened by Schueler's annual visits to stay with him and his future wife, Devon Jersild, in New England.

HANOVER, New Hampshire, 14 JULY 1979

Father. Dad. Resting on the side of the hill, Santa Monica sun warming the long-dead earth. I want him to see the view. A week ago when we were visiting the family in Santa Monica, Magda told me that Josie[59] had asked if I wanted to visit my father's grave. I felt a sickness and a fear in my stomach.

It was 1949. This seems like yesterday. But my mother has lived since then. And so have I. She has had another husband. Another George. That nine years of marriage was far more recent than the years of marriage to my father. Yet I can only think of her as the wife of my father, who, out of grief, had a momentary relationship with another man.

Blues in Grey.

I wish I had gone to visit him resting on the graveyard hill.

I remember that my mother, my stepmother, cried. And so did I. She said, "Touch him, Jack. Touch him." But I was afraid. He looked so much like himself that I couldn't believe he was not there. The flesh would be hard, none of it yielding or warming to the touch. I remember nothing after that. I do not remember the funeral or the burial. But I do remember the grave in the sun and the hill. And if I turn just a bit, I should be able to see the view. But I cannot turn.

HANOVER, 15 JULY 1979

What I really wanted was to have the entire summer in Mallaig finishing the book. Magda's school was out June 12, and I had hoped that as soon as possible after that we would set out for Scotland. We would stop in London for a few days and I would see Bunty.[60] And then we would head north to stay until the end of August. If necessary, I would stay on for an extra week or two at Mallaig.

Instead, we had the week's visit by Magda's mother. And then the trip to New Mexico. Then the visit to my mother in Santa Monica and to Joya in Rosamond, California. When we were planning all of that, I feared that a few stops in Britain on the way to and from Mallaig would chop up the summer disastrously, and I never would finish the book. I don't know if I will anyway, but this was the reason for settling on neutral ground in Hanover, New Hampshire. Alastair has given us his place to live in, while he has moved into Jay Parini's apartment just next door. So here I am with typewriter set up, paper in the machine, and I am so groggy that I can scarcely think.

[59]Josie Schueler, Jon's sister-in-law.
[60]Schueler would visit Bunty Challis in January 1980.

HANOVER, 17 JULY 1979

Alastair said that he had visited Robert Graves when he was in Majorca recently. Graves's wife said, "Robert, there is an old friend to see you." Robert gripped his arm and looked at him intently. He gripped his arm so hard, it hurt. He said, "Alastair." And then he released his arm and did not again recognize him for the rest of the afternoon. Alastair said that Graves did not remember a thing he wrote. He would not remember whether or not he had had lunch. Dear God, what hell. How did this happen? Robert Graves.

HANOVER, 23 JULY 1979

Out into the world. Showing. The image into the world. Supporting the painting.

It was right that I should leave the Leo Castelli Gallery in 1959. Things look slightly different today. But not that different. Leo said, "But I like his work." And this sounded as though there were others in the gallery who did not like my work. There *were* others who did not like my work.

So I put up the show when I arrived back from Paris in 1959 and sold a few paintings. Leo seemed disinterested. I was interviewed on the radio. He did not listen. He was talking to Jasper Johns. In fact, everything seemed to be about Jasper Johns or Bob Rauschenberg. I had the feeling that I was being totally ignored. And that it would get worse.[61]

The word *Pop* had not been invented as yet. But Pop was in the Leo Castelli Gallery. When I was in Scotland, I had got word from many sources that Johns and Rauschenberg had been trying to muscle me out of the gallery. Rightfully so. I was their enemy. Now that I was in the midst of things I could tell all the more. My gallery was the enemy camp.

I had a friendly conversation with Leo. I told him that I thought he was going in a definite direction rather than maintaining the eclectic gallery he had formed at the beginning. He agreed. And we both agreed that I might as well look for another gallery. Leo offered to help me. I walked out of the gallery a free man. Without any prospects.

Leo suggested that I talk to the director of the Staempfli Gallery who became Donati's dealer and who brought Park and Bischoff to New York. We had a friendly conversation. He was not interested. Clem Greenberg was

[61]Both Johns and Rauschenberg had their first one-man shows at the Leo Castelli Gallery while Schueler was in Scotland and France (September 1957 to January 1959). Johns's paintings of flags, and the targets with compartments of body parts, caused a great stir. Rauschenberg's "combines" (paintings and three-dimensional objects such as stuffed birds, beds, etc.) and *Factum I and Factum II* (1955), two "identical" paintings exhibited in 1958, seemed to mock the precepts of the Abstract Expressionists.

consultant for the new French and Co. Gallery of Modern Art. I was too shy to approach him directly, so I sent him a letter saying that I was free. It did not seem such a mad thing to do. He had once complimented me very highly on my work so I thought he might be interested. He replied with an insulting postcard.

Hirschl & Adler, 1960.

Who was that strange little man they hired to open a contemporary gallery? He approached me, as he approached others, about having a show there. It seemed like a strange situation. Hirschl & Adler had been, and still is, a conservative gallery dealing mostly in nineteenth-century art. They had decided to open a contemporary gallery using part of their space for shows. But they couldn't devote their time to the running of the gallery, as their regular business was far too demanding and they made more money off the sale of one nineteenth-century painting than they would off of a year's sales of contemporary work.

I should have known when the little man came to see me. He was conning right and left. He reeled off a list of names of important artists and said they would be showing in the gallery. He kept repeating Still's name—obviously aware that I knew Still and would be impressed by this promise. But I also knew that there wasn't a chance in the world that Still would show in this gallery. Or any other at that time. But I desperately needed a gallery and I desperately wanted a show. Leo had shown some of the work I had done in Paris in 1958-1959 but had shown none of the Scottish work. I had made the big (to me) gesture of going to Mallaig and creating the paintings that I hoped reflected some of the range and power of that experience. But nothing had been shown.

Very few people came to see the show. I went every day, not to see the show, but to save the painting. I didn't trust the little man. He was ignoring the Scottish paintings, playing them down. I had overheard him say, "The real paintings are upstairs"—where the Paris paintings were hung. By the end of the show, our feelings of antipathy were so great that I wanted out of that gallery as fast as I could. And Norman Hirschl and Sam Adler wanted to get out of the contemporary business as fast as they could.

Polarities. I was fighting my own battle between the paintings that had been done in Mallaig and those that had been painted in Clamart and Arcueil. At one end of the scale are paintings which have a rawness to them and seem to reflect an immediate passion. There is a strength of anger. The invention comes because of an impassioned immediacy.

At the other end of the scale is the endless softness of the sky. The mist and the cloud and the light absorb the raw edge. Some force is covered. It disappears behind layers of paint, or becomes the pulse—only suggested and

sensitively felt in a sky and sea and paint so gentle that it might disappear altogether.

I sold one small painting out of the Hirschl and Adler show.[62]

In the meanwhile, big changes were taking place in the New York art world. When I left for Scotland in 1957, it was a comparatively small world. Irving Sandler[63] has suggested that the entire group of the avant-garde—artists, a few writers and critics, a handful of museum people, and a handful of dealers—amounted to about two hundred people. Everyone knew everyone. The Cedar Bar and the Club could hold almost all of us. Very few paintings were sold. Sidney Janis had just taken on a number of contemporary painters—de Kooning and Kline from Charles Egan; Still, who joined and left the gallery practically the same day; Rothko, Jackson Pollock, Guston—thereby cleaning out the stable of that generation that had been showing with Betty Parsons. Betty didn't sell. Janis promised that he could. The Stable Gallery was presenting interesting shows, but money was illusive. There really was very little else.

By the time I returned, a number of other galleries had opened, including Sam Kootz. Works of art were selling, word was getting to Europe that something was happening in New York, and everything changed. Suddenly there was art all over the place. On 10th Street, the galleries would have openings on the same night and the street would be crowded with artists drifting from one gallery to the next.

When I was a few days off the boat from France, I was walking up University Place jingling lonely coins in my bare pocket, wondering how I was going to get along. I met Al Jensen.[64]

"How's it going, Jon?" he said.

"Just great, Al. Just great," I said jingling those few coins. "How is it with you?"

"Terrible," he said. "Damned awful. I just had a show with Martha Jackson and sold out and made $20,000 and now she wants me to have another show in the fall, and I've got to think up a new angle for that and paint the pictures. It's too much."

"That's rough," I said. "That's really rough. I feel for you. I hope it works out okay."

Once again, I was both in and out. I had shown my work at the Stable and

[62]Probably, *The Coast of Knoydart*, 1957 (12" x 18").

[63]Irving Sandler, whose books on American contemporary art track the main movements since the 1940s. See particularly: *The Triumph of American Painting: A History of Abstract Expressionism* (New York: Harper and Row, 1975) and *The New York School: The Painters and Sculptors of the Fifties* (New York: Harper and Row, 1978).

[64]Alfred Jensen (1903–81). Interested in color theories, he showed his complex, diagrammatic paintings at the Stable Gallery in 1957, 1959, 1961, and 1967.

at Leo Castelli. I had been in a number of group shows in the mid-fifties. My work was not unknown. But then I had left for Scotland to search for my place by the sea and had separated myself from the drama of New York. Two years is a long time in New York.

I felt separated.

I felt evil.

There is something about being broke that makes one feel guilty. I was definitely beginning to feel guilty.

Conrad Marca-Relli came to my rescue. He had been showing at the Stable and now was with the new Sam Kootz Gallery. His beautiful collage paintings had attracted much attention during the fifties, and now he was beginning to sell. He was visiting artist at Yale, traveling up every week for a two-day stint back to back. One day, he asked me if I would go up in his place for a day. He suggested that I go around and give crits to the graduate students and at the end of the day give a group criticism. He called Bernie Chaet—who at that time was chairman of the Yale School of Art—and told him that I'd be coming up. Bernie did a lot to set me at ease, introducing me around and suggesting that I take it easy. When I was giving the group crit—which was part lecture—I noticed Bernie appearing and disappearing at a door opening into a hall. Evidently, he had asked around, checking up on my work through the day, and had wanted to hear me himself. Out of that meeting came an offer for a summer job at the Yale Summer School of Music and Art, and another offer to be visiting artist at Yale for the coming year, filling the post that Conrad had decided to quit.

Bernie and Conrad saved my life. I was able to survive on what I was paid. In the end I taught summer sessions and regular sessions for two years—from 1960 to 1962. And it was at Yale that I met Bud Leake, who hired me as visiting artist at the Maryland Institute of Art from 1963 to 1967. It was during the rise of Pop. The teaching enabled me to keep working. More than that, it forced me to examine my ideas as I tried to penetrate art in my talks to the students. The lectures and conversations became a mirror in which I could see the blemishes and distortions of my thinking, enabling me to see and question my own paintings in another light.

I'd see Eleanor Ward at times. At her gallery. One time at Yale. And she visited me in Guilford [Connecticut] and saw the paintings I was doing there. We had managed to remain friends. There is something about Eleanor. She is one of the worst bitches I have ever known. She is deceitful, unprincipled, drinks too much, untrustworthy. Yet I cannot help but like her. She gave me my first show [1954]. She had remarkable taste in painting. She managed to get a gallery together and hold it together during all the early years. In the end, her taste and her lack of principle would be her downfall. The gallery too often became "tasteful." And the artists too often were lied to, cheated, were not paid, and they left.

But I liked her. And I still do. I feel sorry for her. I want to help her. That's

almost perverse in a way. The stories that artists tell about her are legion. Most having to do with money—not being paid—and rejection. Before a show went up, she would ohhhh and ahhhh and tell you how beautiful the work was and what it would mean in the art world. After the show was up, she would gradually get colder and colder, ignoring the work, acting as though the show was a failure. In the meantime she would already be soft-soaping some other artist whose show would be going up after yours.

Eleanor had beautiful and expensive taste in clothes. The kind of clothes that were so simple and unostentatious, they had to be expensive. She was tall, handsome, elegant. Now she is shriveling up and has become very short. The clothes cannot appear elegant on such a frame. She is often drunk—but then, she was always often drunk. She still has the bite to her tongue. And she still makes me feel affectionate toward her.

I had two more shows with Eleanor Ward—in the "new" Stable Gallery of the early sixties.[65] I remember in 1963 walking into the second show (Eleanor hung it) and thinking it was very beautiful. And thinking also, that nothing would sell. And that I would not sell again for a long time.

Later, Eleanor asked me what I thought about "that Pop stuff." I told her what I thought. She agreed with me. Neither of us liked it. But I saw it as some kind of wave of the future.

So did Eleanor. Though I didn't realize it at the time. The following fall when I returned to New York, she was handling Warhol. Mr. Pop himself. She became very successful. She handled Indiana, Marisol,[66] and many another good artist. The thrust of her gallery became camp. I think that she was finally more at home with camp. It reflected her sense of taste and playfulness and insincerity.

On the opening night of what became my last show at the Stable [1963], there was a wild blizzard in New York. Within hours, the streets were impassable. Three people came to the opening.

• • •

It was after the 1963 show that I started painting the Woman in the Sky. (In Clamart I had painted *My Father is the Sun*.) My intention was to gradually push her into the sky so that figuration would disappear. This I did, so that by 1967 one could possibly still feel the sensuality of the woman, though the figuration was no longer evident. And for some reason, in a very profound sense, she made me feel the architecture of a painting—whether one considered the painting as a whole, or whether one felt the life force in a broad area of grey—the architecture was the moment of relationship from space to space and time to time.

[65]The gallery moved from 924 Seventh Avenue to 33 East 74th Street.
[66]Robert Indiana (b.1928); Marisol (b.1930)

The woman was naked. She was lying with her head back. She was in an attitude of love or an attitude of birth. She was sensual and passionate. Her legs were spread. She was larger than life. (And so is life.)*

While I was in the midst of the woman paintings, Eleanor came down for dinner. And an evening of gossip. The elevator of the studio at 901 Broadway opened directly into the living area. It was a large studio with fifteen-foot ceilings. Facing the elevator—about forty feet away from the entrance—was the living room side of my painting wall. I always had a large painting hanging there. At this time, I had a nine-foot woman painting, lush and powerful in its figure and in the trail of its paint.

When Eleanor stepped from the elevator and saw the painting, she turned green. I put my arm around her and said, "Don't worry, Eleanor. You won't have to show it." And at that moment, I lost my last New York gallery.

During dinner, Eleanor told me that she had a hang-up about nudes. That when she was in high school, she'd get sick at the sight of a naked woman. She just couldn't stand it. I said that I understood, and we were very close and friendly.

The next day, she spread the word around that Schueler was painting nasty pornographic paintings.

And that was that.

I had no place to show.

. . .

While living in New York, I would always sell a few paintings during the course of a year. Just by being there. But now my work was not being seen. I was no longer invited to show in group shows. No more museum shows. No one-man shows. I was rapidly becoming an unknown artist. I was, perhaps, a bit better known than I thought. But in my feelings I was being cut off from the world.

The Maryland Institute of Art had a beautiful gallery. Bud Leake, as president, had purchased a number of buildings, including the old Baltimore and Ohio passenger station. He turned the vast spaces into a library, sculpture studios, cafeteria, painting studios, auditorium, and a very large gallery opening off a two-story lobby. I loved the space and throughout the time I was teaching at the Institute I would often study it and think about using it for a show.

Bud invited me to have a show there in 1967 and said that the Institute would pay for the shipment of the paintings from New York and back again. I tried to look at the entire enterprise as carefully and as realistically as possible. The things I would have to face were these: a certain amount

*See color illustration 10, referred to previously.

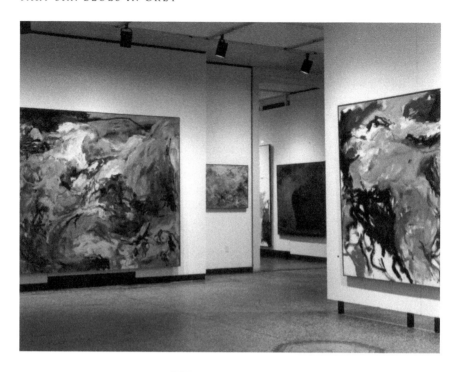

The exhibition, The Woman in the Sky, at the Maryland Institute, Baltimore, March 1967.

of money out of pocket, a tremendous amount of work, and the distinct possibility that no one outside of myself, the students and faculty would ever see the show.

Everything happened as I predicted. Paintings had to be picked out, lists made, large paintings taken off their stretchers so that they could get out of the studio. Elise[67] was a great help. I wrote a statement about the sky. Bob Friedman wrote a piece about the Woman in the Sky—for some woman paintings were to be in the show. I chose work from 1953 to 1967—in all 48 paintings and about 50 drawings and prints. A couple of paintings were 11½ feet by 22 feet. One was 10 by 12 inches. I had to have new stretchers made for the very large paintings. Finally, the students helped me hang the show.

The exhibition was beautiful. I think Sal Scarpitta called it "an anthological show." It said what I wanted it to say.

The opening was very sparse. It was easy to see the paintings.

I had done what might have been a rather foolish thing. I was tired of not selling anything in New York. I realized that the very gesture of putting up this show was an admission to myself that I was being forgotten. I hadn't

[67]Elise Piquet and Schueler were together from 1966 to the beginning of 1970.

Jon Schueler teaching at the Maryland Institute, Baltimore, with Dudley Gray in the foreground and model in the background, c1965–1966.

shown in New York since 1963. So out of some perverse humor, I doubled all of my prices. Arbitrarily. But the prices were no more than a Hartigan[68] would sell for. Nothing sold. But perhaps nothing would have sold anyway. No gallery offers emerged.

As visiting artist, I took the train down to Baltimore every Monday morning, taught Monday and Tuesday, and returned to New York late Tuesday afternoon. While the show was up, I had my students meet me in the gallery. We would sit on the floor surrounded by my paintings, and talk about art. We would talk about my work, about their work, and about the work of those masters who crossed their minds. Every day, I would spend some of my time alone with the paintings.

It was a very successful show. I saw paintings of mine hung in such a manner that they became part of a statement. I thought, Now I have laid the foundation. Now I can see what I have done, and I can start to build.

• • •

Where did I get the money? I must have saved as much as possible from my pay as visiting artist. I may have sold a few paintings—I know that I sold one the day I left. In any case, I decided that I wanted to take a leave of

[68]Grace Hartigan, who also taught at the Maryland Institute.

absence from the Maryland Institute and go back to Mallaig to work there. I felt an overpowering need to look at the Mallaig sky. It was time to be there. To be away from the city. To be away from the intellectuals. It was time to be in the image, to live there, to feel it all around me.

I had been back to Mallaig, but very briefly, the summer before [1966]. It was a strange and moving experience. I had Jamie with me. While in Mallaig I tried to find a place, some kind of house which I might use to live and work in during another period. There seemed to be nothing. The village was more crowded than ever. The herring boats were busy and many were prosperous.

Now, in the summer of 1967, I sublet my studio in New York and I took Elise with me to the Highlands. She wanted to explore the Isle of Skye rather than stay in Mallaig, which was the scene of my past life and my relationship with Jody. I liked the idea. It was pushing on one more step toward isolation.

We found a shack in Tokavaig, near Tarskavaig, overlooking the Black Cuillin Hills, where we could live and work for the summer. It was truly a shack, leaking like a sieve and seemingly impossible as a dwelling place. But Elise, the nester, saw its possibilities. It was too small for oil painting, so I sent to Edinburgh for watercolor paper. All the while I was working that summer, I felt that I was doing nothing. That somehow I had to get to painting. I associated only oil paint with work. Finally, as the summer ended and we realized that we could find no place suitable for the winter, we had to make the awful decision to return to the United States. It was only after I got home and I opened the package of watercolors that I realized that I had done something very important—something which would affect the imagery of my work—in fact, my very vision from that time on.*

It was too late to go back to my teaching job. But I had no place to paint in New York, as I had sublet my loft at 901 Broadway. So we went to Elise's house in Chester, Connecticut. She suggested that I make a studio out of the living room. But I couldn't destroy that room, which she had taken so much time and pleasure in fixing up. She then said I could use the garage. But it demanded a lot of work to make it weather-tight, to bring in electricity, etc. Besides, I had no desire to live in Connecticut. I didn't like Connecticut very much. At least not for more than a weekend.

But I had no place.

HANOVER, 25 JULY 1979

I worked all that fall and winter of 1967-8 making the garage into a studio. I thought the job would take about six weeks. In fact, it took about six months. By the following June, I had finished the studio, had turned the

*See color illustrations 21 and 22 for later examples of watercolors.

attic of Elise's house into a workroom for her, and had turned my energies to painting.

When my loft at 901 Broadway became available, I could no longer afford to keep it, thus severing my contact with New York.

. . .

I was painting and I was broke. I didn't know exactly what I was going to do. I couldn't work at the Maryland Institute because I was too far away to commute. Yet I held the idea open. I tried to shove the problem out of my mind. I stretched up some large canvases and went to work.

The studio was beautiful. It didn't have nearly the space of 901 Broadway, but it had a lovely character that was, in part, because every inch of it bore the imprint of my hand. It was truly handcrafted. Bob Germaine helped me build it. Or rather, I helped Bob build it. He was a seventy-nine-year-old retired chauffeur who lived a couple of doors away. It had a huge window facing north, admitting plenty of light. It had a good system for night painting. It had a balcony under which were stacks. On the balcony was my study. I loved it.

So I had a studio. No job. Materials I had accumulated at 901 Broadway. Not a chance of a sale—it was as though I was a million miles from everywhere. Jack Tworkov, who was head of the School of Art at Yale at this time, offered me a day a week for the next two semesters (beginning in the fall of 1968). I agreed to take it, though it wasn't going to solve my problems.

I started painting thinking of money.

Not for the first time.

. . .

DEUS EX MACHINA

I received a letter from James R. Shipley, chairman of the Department of Art at the University of Illinois in Champaign-Urbana, offering me a job as head of graduate and undergraduate painting at a salary of $20,000 a year (which was high at that time), a full professorship, tenure, retirement benefits, etc., etc. I don't think the details were spelled out in the letter.

I went crazy.

I was happy painting. I wanted nothing to interrupt work.

I was broke.

I had no desire to be in Illinois. I had no desire to be head of a department. I had no desire.

That's not true. I desired the money. I desired the position. I desired the "honor." I desired the attention. No gallery. I was being forgotten at a terrific rate.

I didn't know what to do.

For the next two months, I changed my mind each morning.

Elise and I flew out to Illinois and met the faculty and saw the school. Everyone was very pleasant. I had a long talk with Jim Shipley and told him

that I didn't know whether or not I wanted to accept his offer. I told him that he should not expect me to be an administrator. That if he did, he'd find that I was a very bad one, and in any case, if I discovered that I was so being used, I'd quit. He said that they had plenty of administrative types already, that what they needed was a spiritual leader. I said I thought I could do that! We left the decision open while I went back to Chester to make up my mind.

I talked to Jack Tworkov, and he said, "I won't stand in your way—I can fill the job here easily enough. But," he warned, "do you really want to get yourself into an administrative position—for that is what it will be?" And then he said, "If I had it to do over, I'd never have taken this job as chairman of the department. You think it's not going to be administrative, but it is all administrative. It has killed my painting."

Bud Leake said, "Take it. You deserve the recognition."

Bernie Chaet talked to me about the job at great length. He said that he was going to give me a "Spiritual Leader" T-shirt.

I asked him, "Bernie, what is the quickest way to Mallaig?"

He said, "Illinois."

Finally, I said yes.

Elise really didn't want to go. She didn't want to leave her house. She didn't think she'd be able to write out there. In the end she acquiesced,[69] although subsequently she decided to spend most of the time in Chester.

· · ·

I had been knocking myself out in my teaching. I had told Shipley before accepting his offer that I would never work more than two days a week. That much time I'd give up so that the other five days would always exist as painting time. But from the beginning, I was giving too much. I tried to get things moving on certain projects which had been experiencing a living death. I tried to get some sense of excitement and dedication in a school that had all the rigidity of a high school. The undergraduates felt imprisoned. The graduates felt that they were treated like children. They had to paint a "master's painting" in order to get their degree. For two years, they'd have to work on this painting, having crits on it by the various members of the department. A design for suicide. I immediately put an end to that by dictate. I suggested that they should take responsibility for their work—paint what they wanted to paint, and to choose from their work paintings for a show to be given at the end of their second year. I promised that I would find the space. In connection with the show, they would write something on their own work and would hold a seminar attended by the other students, and any faculty that wished to attend, to discuss the work. I also tried to

[69]Elise Piquet helped find and equip the farmhouse at Illini, Illinois where Schueler lived during the academic year 1968-69.

get an old building for the senior painters, but with no luck. All in all, I started to stir up controversy immediately.

When I came back to the university after the Xmas holidays I sensed that something was wrong—in the attitude of Shipley, in the attitude of the faculty and in the attitude of the graduate students. It turned out that Shipley felt I wasn't doing enough administrative work (I had dumped it in the hands of a former B-26 pilot I got along with),[70] the graduate students felt that I was holding too many seminars and was not looking at their work (I had given them independence from me—and they didn't want it), and the faculty thought that I had been hired to represent their interests and that I was not doing so—in fighting battles for salary increases, etc.

I reminded Shipley of my promise before I took the job—that I would not do administrative work (though I was certainly doing it), and said that I would resign as head of the department as of the end of the school year. I kept the professorship. I had a meeting with the painting faculty. We agreed that I may have been hired under false representation. I assured them that I would not spend time bucking for higher salaries and better working conditions. They'd have to take care of that themselves. In the meanwhile, I told them that I was resigning. I told the graduate students that I would hold no more seminars but would criticize their paintings every Monday night.

I also told Shipley that I wanted a year's leave of absence, during which time I'd be working in Mallaig, but that if he wanted me to, I'd teach one semester a year. He said that this couldn't be done. I said that it would be a good deal for him, but that it made little difference to me. I was taking the leave of absence.

I flew back to Chester a number of times and worked in my studio there. I gave the graduate students the personal attention they wanted. I became friendly with the faculty. Shipley understood that he no longer could demand anything of an administrative nature from me.

HANOVER, 30 JULY 1979

As it happened, I did become a "spiritual leader"—though quite against my will.

We were nearing the end of the school year. Each graduate student was to put up his show for five days. The first was a show of shaped canvases by a woman painter. She had been working hard through the year on her idea. The canvases were shaped in a three-dimensional manner. And then painted—sometimes quite abstractly—flowing fields of color—from which would emerge a penis, a hand, or a woman's hand gently caressing a penis. The canvases were erotic, in part because of the specific sexual references, but

[70]Mark Sprague.

more because of the gentleness and delicacy and sentimentality of the image and of the sensitivity with which they were painted.

I hadn't been overwhelmed by the idea of the shaped canvas—I would have just as soon seen them painted directly within a regular rectangle. But the paintings were hers, not mine. And the shaped quality—like an abstract tree—seemed very important to the artist. She was from New York, a large, aggressive girl, somewhat older than the rest of the graduate students. What the hell was her name?[71]

I arrived at school one morning, to find that this woman student's paintings were in the gallery waiting to be organized and put into position and assembled where necessary. I didn't want to disturb her, so I started walking to my office. The next thing I knew, I heard the sounds of a terrible ruckus coming from the gallery. James Shipley cursing and swearing and bawling someone out and ordering someone about.

I hurried on toward my office. I knew immediately what it was all about. I wanted to have no part of it. I had long since stopped pitting myself against administration and faculty. I was doing a simple job of teaching and doing that in a quiet, unobtrusive way. I was getting along with everyone by not creating waves, by not being critical, by keeping my mouth shut. I had a little over a month to go. I wanted it to be a quiet month. A gentle month. A friendly month. So I let myself into my office and quietly closed the door. I could still hear Shipley—though not enough to make out his words. I sat on my desk dangling my feet, waiting for everything to quiet down so that I could sneak out of the school and spend the rest of the day in my studio.

Suddenly, there was a knock on the door. I didn't answer, pretending I was not there. Another knock. "Mr. Schueler! Mr. Schueler!" A student. Knocking. Each time louder. Calling me. "Mr. Schueler! Please come. Mr. Shipley is demanding that Mira take down her show. She has to do it right now. Mr. Schueler! Mr. Schueler!" I couldn't pretend any longer. But I didn't want to be a hero. I could tell right away that the lines were drawn and that a battle it would be.

"Couldn't you call someone else? Mr. Jones? Mr. Smith? I'm terribly busy just now."

"Mr. Schueler!"

So I joined the students (there were five of them waiting outside the door) and dragged my feet toward the confrontation in the gallery.

There was nothing that had to be explained. Shipley had seen the canvases, hands, penises and all, and had blown his stack. None of that pornography was going to be shown in his school. I told him it was not pornographic. The painting was very delicate and sensitive. In fact, it was rather sentimental. Hardly pornographic. He said that it had to be taken

[71]Mira Cantor.

down. I said that I had promised the graduate students that they could create their own shows without faculty interference and that the show would have to stay. He said that it was not up to me to make that decision. I said that the students had asked me to talk to him and represent them because he was not listening to them. He said that the show was going down. I said that he would have a battle on his hands if he did force the issue.

The gallery was closed.

Later in the day Shipley told Mira that if she removed three paintings (most penis, most hand) that she could leave the others up. She said that she would rather withdraw the entire show than to have it fragmented. I called a faculty meeting. I also called a meeting of the graduate students. The is-sue for everyone was simple: censorship. For once, everyone pulled togeth-er: faculty, graduate students—and myself. It was decided that I should write a summary of the issues, along with a request that Shipley and Allen Weller meet with the entire faculty. This summary, if satisfactory, would be signed by the faculty.

We met in the auditorium. I read the statement. It accused the admin-istration—namely Weller, Dean of the School of Art and Architecture and Shipley, Head of the Department of Art, of censorship, of being afraid and kowtowing to prejudice (they said that they were afraid that some little old la-dies of the neighborhood might see the paintings and object, and they were afraid of the legislature and of appropriations, etc., etc.). We said that there was a long tradition in art of a search for the truth. That this was not the first time that the human body had been shown in a work of art, nor would it be the last. Shipley had been on a board which had purchased a very vulgar "pop" painting with genitalia running rampant all over the canvas.[72] Obvi-ously when it was truly vulgar, they did not consider it a threat. Only when it was painted with feeling and sensitivity did it go beyond the bounds of their tolerance. The faculty voted 100 percent to censure Shipley and Weller and to request that the show remain in the gallery. By this time, the period of the show was almost over. It stayed up a couple of extra days. We had the meet-ing of graduate students in which Mira gave a talk about her work, about the sources, about the meanings for her, about the symbolism and about the use of three-dimensional shaped canvas. It was all very restrained and dignified.

It turned out that the last student's show also had a lot of very explicit sex-ual references. And nothing sentimental. But no one paid any attention to it. There was no complaining by neighbors or by the legislature. The newspa-per called and wanted to know the details. I fielded them off.

So, I became a spiritual leader after all. Much against my will, feet drag-ging, I was forced into battle, being pushed forward by my loyal troops—stu-dent and faculty alike.

[72]Peter Saul's *Typical Saigon*, 1968 (93" x 144").

By the end of the semester, I was already making plans to go to Scotland. I still didn't know where I'd live and work. But I had decided that I would work in a sheep pen if necessary. The main thing was to get to Mallaig. My work demanded it.

I had saved enough money out of my pay to stay there for a year. I had sold a few paintings. I knew that Shipley would never let me work a mere three months a year. But I held the idea in my own mind as a fantasy. It gave me the illusion that I had a financial base for a long, long, period of work in Mallaig. Of course, I didn't have one. But the illusion was enough to give me courage. I committed myself to this act.

•　　•　　•

I finished my stay at the University of Illinois in June of 1969 and returned to Chester. I decided that I would put in a spell of painting at my studio there and then would leave for Scotland.

I wasn't there too long before I realized that Elise had extended her social horizons while I was away. She really wanted to break up the relationship but couldn't quite get herself to tell me.

Finally in January of 1970, I flew to Edinburgh, arriving with two suitcases and a typewriter. Two footlockers filled with painting supplies and winter gear were on their way by ship.

I left behind: Elise and all the work I had done on her house; the studio I had made out of her garage; a lot of paintings stored in the studio. It would be a year before she'd demand that I get the paintings out of her property as fast as possible. Which I did.

HANOVER, 31 JULY 1979

Alastair Reid had given me an introduction to Richard Demarco, head of the Richard Demarco Gallery in Edinburgh. I took the cab straight to his gallery from the airport. He met me at the door, and between there and his office—a distance of about 30 feet—he introduced me to about ten people. He has continued to introduce me to people up to this day. He leaves behind him a trail of introductions and a trail of misconceptions: "Jon, I want you to meet Jim Mc-Claren, Scotland's leading playwright. He's just had a huge success in London. Here's a review from *The Times*. Jim—meet Jon Schueler. He knew everyone in New York during the fifties. He was part of that scene. He was a close friend of Gorky." It would turn out that Jim had given a reading before a Chelsea theater group in London. Also, I had never met Gorky who had committed suicide before I arrived in New York. By the time Jim and Jon had straightened these things out, they were well into conversation and could easily get to know each other. I have always found that the errors and exaggerations in Ricky's introductions could bring people closer together more quickly than any discreet introduction. He indulges in the most outrageous hyperbole—everyone is always

Jim Manson, the skipper of the Margaret Ann, *and Jon Schueler at the latter's exhibition in the Mallaig Village Hall, Scotland, January 1971.*

The exhibition in the Mallaig Village Hall: paintings from 1970 and 1971.

the "greatest" or "the most famous"—to the point of embarrassment. In the meanwhile, Ricky has basked in the reflected glory of the fame he had instantly created—and is on to another conversation or introduction in another part of the room.

At this time, I was quite unprepared for the Ricky Demarco whirlwind, and found it a most exhilarating introduction to an Edinburgh I had never known before. We parked my luggage in his office and went to a nearby restaurant for lunch. Demarco knew everyone in the street along the way, and talked to the woman in charge of the restaurant as well as the waitress as though they were just emerging from the sweetest part of an affair. Love and innuendo saturated the air. They, too, were the greatest. The tiny, rather ordinary health-food bar attained a glow of success, as though this must certainly be the Edinburgh meeting place for those in the know.

On the way back to the gallery, I spotted two attractive women paused on the sidewalk while one bent to tie her shoe. She had the warmest and most unusual smile I had ever seen. A direct innocence. An all-pervading joy. I was just about to say to Ricky, I'll take that one! when Ricky and the girl exchanged greetings and wisecracks even as we hurried past. For once, no introductions. At the gallery, I asked about the smiling girl. Her name was Magda Salvesen. She had worked for the gallery and now was with the Scottish Arts Council. I wrote her name down in my notebook.

Magda.

The woman in the sky.

HANOVER, 6 AUGUST 1979

Ricky Demarco. A diminutive P.T. Barnum. A con man. A huckster. The Greatest Show on Earth. It's the best, it's the latest, it's the truth, it's the new way, the real way, the true way, and there will be another one to replace it tomorrow. Exhausted, after the Joseph Beuys and German show of the 1970 Edinburgh Festival, he came up to stay with me in Mallaig for a few days. He saw my paintings and decided to give me a show. Why? I don't think he liked the work. It wasn't hip. It wasn't new-old camp. It was about nature. However, plans were made.

Before the show went to Edinburgh in February of 1971, I hired a dump truck to carry the paintings to the Mallaig Village Hall, where I hung the paintings for three days. I felt I wanted to do something for the village in return for all the village had done for me, and that I was quite prepared for the fact that many would not like the paintings. The only way they could get to understand them would be to see them.

I hung about fifteen watercolors in the small meeting room and used the main hall for quite a number of large paintings and small paintings. For the opening, we served tea and cookies. By the end of the three days,

I think most of the village had come to see the show. We had posters up all over Mallaig, Morar and Arisaig and we spread the word wherever we could.

On the opening day, Alexander Manson came. I asked him to try to get his father, Black Jim to come. It must have been difficult, but Jim did come. He stood upright and strong, facing the paintings. I think Jim was one of the last to understand—if he ever did. His was a literal mind. He was totally and completely a man of action. But I made him know how important it was for me that he had visited my exhibition.

Many seemed to understand that I was painting the sea and the sky. One of the fishermen said that he knew the day I had painted one of the paintings. He had been at sea and had seen that sky. He wanted to believe—and I let him—that I had literally been there and had watched that particular movement of light across the water.

There was certainly enough response so that I was immensely pleased that I had put up the show. And, through the years, I have had one person after another approach me in the street in Mallaig to tell me that they had never understood my work, that they had thought that perhaps I was a bit daft, but that the other night they had been walking by the side of the sea and they had suddenly seen that the sky was a Schueler sky, and, having seen it, they understood.

When I had to leave Mallaig in 1958, a woman I didn't recall knowing said, "We are so sorry to hear that you are going. We have liked very much having you here. And we hope that you are going to have an exhibition before you go." An exhibition! My God—it had never occurred to me. And my paintings were all stripped, rolled, wrapped and crated, waiting to be picked up the next day to meet a freighter in Glasgow bound for New York.

Thirteen years later I got a second chance.

HANOVER, 7 AUGUST 1979

Poole. Deep pools. I seem to retreat into weariness. I'm not really tired. I had plenty of sleep last night. I am in good health. I want. No, I don't want.

I wish I were in Romasaig.

HANOVER, 8 AUGUST 1979

Bob Poole, the customs officer, his wife, and his two sons came to the show in 1971 and spent a good part of Sunday afternoon there. They were so interested that I invited them to visit me at Romasaig the following year to see other paintings. Afterward, I met Bob Poole in the street and he invited me into his office for a cup of tea.

He said, "I would like to tell you why your paintings mean so much to us."

His wife was a sensitive woman who loved poetry. But during the course of a severe nervous breakdown, she had lost her sense of color. Everything turned to grey. Nature was grey. She lived in a world of grey. It had been three years or more since that had happened, and she despaired of seeing color again.

"Color meant a great deal to her," Bob said again. He wanted me to understand; he wanted to emphasize the importance of color as much as he could. "Last year, we came to see your show. While looking at your paintings, the sense of color came back to her. That's why we stayed the rest of the afternoon. The color was there for her, even in the greys. And that night in our house, she could still see color, and the next morning when she woke up. She took a long walk along the shore of Loch Morar and the color never left her, nor has it to this day."

· · ·

The Richard Demarco Gallery was in a rather elegant building,[73] which had been a home in more expansive days. The gallery took up the first and second floor. I hung watercolors—some large—in the smaller room of the first floor, and grey paintings in the large exhibition room. There were two rooms on the second floor. In the front room, I hung a series of black paintings with color. It was rather an arbitrary division, yet it expressed an idea I was working with at the time and it emphasized a mood.

At the beginning of the show Ricky was at his P.T. Barnum best. He introduced me to everyone under the sun. If a person had money he was introduced. If he had horses he was introduced. If he was the brother of someone important, he was introduced. If he was a poor artist, he was introduced. Or a successful artist. Or just an artist. He arranged TV and radio interviews. He arranged a symposium on landscape painting in Scotland. Everything was done in a haphazard way, but things were done. Each day, more people came into the gallery. There were not exactly crowds—but the receptionist said that there was a larger attendance than ever before. And—miracle upon miracle—some paintings were sold. Colin Thompson of the Scottish National Gallery bought one for his private collection. Douglas Hall bought one for the Scottish National Gallery of Modern Art.[74] Many watercolors and small paintings went to private collectors.

Things were working out. I had now sold enough work to get through another year. Illinois was fading into the past. But I was not unthankful.

[73] 8 Melville Crescent, Edinburgh.
[74] *The Sound of Sleat: June Night, XI*, 1970 (40" x 48"). See color illustration 14.

Without the money I had made during that year I was head of painting, I could not have accomplished what I had.

Ricky, I began to realize, was very strange about selling. One day, a woman approached me about buying a painting. I told her that I was delighted and that Ricky would take care of her. Ricky had introduced me to her an hour before—so I went to his office and told him about the sale. About a half hour later, I passed the office. The woman was standing outside waiting for him. Ricky was joshing with one of his secretaries. Conversations with Ricky about selling were also strange. He was always having money problems. He was always cursing his board of directors because they didn't get enough money for him. He was always cursing the Scottish Arts Council because their large grants were not larger. But the chances for greater independence through selling work from his gallery and slowly building up the reputations of his stable of artists seemed to cause him to retreat. He would give shows of his own drawings, sell out, and plow all the money into the gallery. And he would, at times, fill his Mini with small paintings and head off to the smaller towns and try to sell them. There were contradictions. It was almost as though the conflict over money was necessary to him—as necessary as the money itself.

Late one afternoon, on the train from Glasgow to Edinburgh, Ricky met the movie maker Forsyth Hardy. Ricky had known him for some time. Hardy was head of Films of Scotland, a semipublic production company, which was in part financed by the Arts Council but which had to underwrite most of the films it made by the sale of previous films. They made documentaries, for the most part on subjects related to Scotland. They also made a certain number of commercial films—propaganda pieces for the Scottish Tourist Board and the like. Forsyth had produced some important films back in earlier days in London. In this present operation, he would hire a production team as the occasion arose. Thus the permanent staff of Films of Scotland was kept to Forsyth himself, an assistant, and a secretary.

With typical, all-out enthusiasm, Ricky told Forsyth about the show, about the American artist working in Mallaig, and about the manuscript I was working on at that moment, part four, "Death and the *Margaret Ann*."

Forsyth phoned that afternoon and asked if he could see the manuscript. I took it over to his office immediately. The next morning, he called and told me that he had stayed up most of the night, until he had finished reading the piece.[75] He had been unable to put it down and now he would like to talk about making a movie on me.

Within days, Forsyth introduced me to his assistant, John Black, who was to direct the film. Black was young—probably in his late twenties or early thirties, wore rather hip clothes, flair trousers and the like, and was

[75]The original part four was a great deal longer than it is now.

tall, balding, with long strands of hair brushed carefully over the shiny dome of his scalp. He had a most charming smile and ingratiating manner. He watched me intently while I spoke. I immediately liked him.

HANOVER, 9 AUGUST 1979

The movie. What happens to the artist, who has been alone, hating it, when he is suddenly on center stage, playing himself, trying to find the truth in the energy and assertion that seems to grow out of the position he is in? The camera pointed at him. The soundman twiddling dials. The camera man studying his face and the light and the sky as seen by him. He tries to tell the story in paint. But then he tries to tell the story of the paint in words. And he tries to tell it to the camera and to the director and to all of them—the assistant camera man and the director's wife [Isabel Hilton] and Magda. He's trying to say, "This is the way it was." But it never was this way, because this way is in a public place, it is on stage, it is relating minute by minute to people. The way it was, was alone, with no one watching, no energy generated by the interplay of people and love and hate and generosity. It was alone. Alone one feels exhausted, bewildered; one pulls the energy from one's gut. One has to create the energy.

HANOVER, 10 AUGUST 1979

I almost didn't have Magda. I wanted her to take extra days off from her Arts Council job.[76] She hadn't wanted to come. I needed her to help me keep control of things. And I needed her for the film. She was the Woman in the Sky, and without her, as far as I was concerned, there wouldn't be any film. Magda is a very private person. She tolerates being in the movie and being in the book because she knows that it is important to me. But that is all.

We had good luck and bad luck while shooting. For the most part, the weather was good. This was bad for me. My imagery is not blue sky, but it is a sky of storm and subtle mysteries. Rain, mist, a strange juxtaposition of cloud and light, space struggling to reveal itself. At first, I couldn't get through to the film crew that whenever we were involved with bad weather, they should search it and shoot it. On the first day, shooting on the Burma Road, every time a rain cloud would form, they would call a halt to the shooting. One time, a fascinating umber cloud enveloped us, threatening, yet tinged with a lyric golden beauty at its edge. I just couldn't get them to shoot.

[76]Although Schueler first met Magda in February of 1970, she didn't leave her job as Exhibitions Officer for the Scottish Arts Council until c. May 1971. Mallaig was at least a six hour drive from Edinburgh at that time.

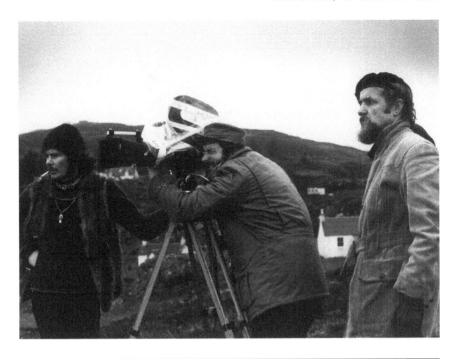

Jon Schueler (right) with cameraman Mark Littlewood (center) and soundman Bert Eles (left) in Mallaig, March 1971, shooting Jon Schueler: An Artist and His Vision, *directed by John Black for Films of Scotland.*

But by that evening, Mark Littlewood, the camera man, began to get the idea. Rain clouds were forming over the Sound of Sleat. We lugged out the camera and, using plastic bags to protect it from the drizzle, set it up on high ground near the studio. Clouds were changing and shifting in the distance. The horizon, the line of sky, became ambiguous. The grey of the sky and sea was the grey of tears. Or of a call lost in space. I explained to Mark that the horizon was a dominant theme in my painting, that its placement, explicit or implicit, low in the painting, was of the greatest importance to an understanding of the painting, and that its presence, no matter how lightly felt, could suggest meanings we would never understand. If the line of sky was to be low in the painting rectangle, it should be low in the camera frame. Fortunately he understood, and fortunately he did a lot of shooting in the next half hour before the light failed, because during most of the remaining days the weather was clear. We used these shots many times in different situations in the film, along with some early-morning shots we took at sea. And one long pan of a sunset that Mark did himself when he was coming home from the Clachan (a local pub) on the last day of shooting.

We had a chance to do a lot of footage of me working on canvases inside

the studio, but had some terrible luck. Here, John just didn't understand. I think he was better on verbal aspects of the film than on the visuals. Fortunately, Mark saw some of the visual possibilities. He was the one who hand-held a camera and got right in with me while I was working on a large canvas. It was like a battle between us. He lay on the floor shooting upwards while I stood on my platform working some of the higher areas of the painting. I splattered paint all over him. He was behind my shoulder; he was poking in close as I mixed paint on the palette. He was pushing in next to my shoulders as I applied paint to the canvas.

I very much wanted the filming of the painting to be a strong and persistent feature in the film. But first, feeling that too much film was being used up, John stopped the shooting before the paintings had evolved. And then, of the precious footage showing the development of the two paintings in the studio, about two-thirds were ruined—some because a mist formed on the camera lens that went unnoticed by the cameramen. And some was destroyed by technicians at the lab itself, who managed to run long scratches through some of the best painting-action footage we had.

On the other hand, a lot of good things happened. John turned out to be great at asking questions, so that we had a lot of wild sound and plenty of sync sound of me talking about various aspects of my life and work. Pat Higson, the editor, used this beautifully, orchestrating it in such a way that the sound became the painting, became the movie itself. Sadly, from my point of view, I was self-conscious when I tried to tell why I had come to Mallaig in the first place—a story I have told over and over and should have been able to handle with ease. But John had a lot of tape with me discussing everything from the idea of woman in the painting, the role of Magda in my life, to the moral basis of art.

It was night when the film crew joined the fishermen of the Crystal Sea. The guys all bedded down before the boat left harbor. But as we got out beyond the protection of the Sleat Peninsula, the sea rose and the boat started to roll. I stayed on the bridge with Tommy Mathieson. One time when I looked down into the fo'c'sle, I saw a scene from Dante's Inferno. Bodies drooped everywhere. One was looking at me with a foolish, sick grin on his face. Others just groaned and formed strange heaps of bedclothes and bodies. Yet in the morning, when I saw some mist over the sea that could be photographed, they all worked their way to the deck for a day of shooting.

HANOVER, 12 AUGUST 1979

I remember now one other stroke of bad luck with sync sound. Out on the Crystal Sea, I was at the wheel with Jimmy Manson[77] standing beside me. The

[77]Jim Manson's son, whom Schueler had known since 1957.

camera had been set up to show us having a conversation about the sea. The sound had been tested. Then, on the first take, Jimmy and I started talking about death and the sea. Amazingly, I had gotten him to talk and to say very forthrightly what was on his mind. When we tested, something was wrong with the sound. Another try, another failure. By the time we were shooting it the third time, the scene had lost all of its force. We became self-conscious. I was trying to recreate the mood and matter of the first shot and Jimmy had retreated into silence.

Death and the sea. He talked about the fear, the very real fear of the forces of the sea. That the awareness of this was an essential element of the fisherman's life.

· · ·

Suddenly, the ten days of shooting were over. Magda left for Edinburgh and the Arts Council.

I was alone.

It was like standing on a bare stage of a theater after the play is long since over and the people have gone home. The curtain is up; the set has been struck; a bare light bulb hangs in the center of the stage. There is a greyness which threatens to descend and blank out to forgetfulness all the emotion in you.

I immediately went to work. I knew that I would have to start painting or I wouldn't be able to face the loneliness and myself. I cleaned out the studio and the living area. Gave the floors a good sweeping. Stacked paintings. Rolled my palette table back to its proper position.

I fixed a small dinner and then sat for an hour in my rocker reading *The Scotsman*. With each passing moment, I felt more and more helpless. I felt the greyness seeping in. I went into the studio and looked at the canvases I had been working on for the film. I picked one of them and hung it on the painting wall. The palette was covered with wet color from the work I had been doing the day before. The studio reeked of turpentine. I picked up a brush.

The hours passed, until it was long after midnight. I was working with tremendous energy, trying to save myself. It was coming. It was coming alive. Then, at one point, sitting in the chair studying the painting, I looked at my hands and saw that the backs of them were turning black. I couldn't believe it. I turned my eyes away from them and went back to the canvas and then looked again. They were purply black. What was happening to me? Again I tried to push the sight away from my mind and threw all of my energy into the canvas. My attention went back to my hands. It was almost as though the strain of painting, of pushing and drawing the emotion-laden brush was threatening my hands. My hands! A painter without his hands!

I couldn't call the doctor. But finally I had to. It was about 1:30 A.M.

"Donald," I said, "I hate to bother you. But, something strange is happening to my hands."

"Describe it."

I did.

"I'll come right down."

I'll never forget that he did this for me in the dark night.

By the time Donald arrived, the purply, alizarin, black look of my hands had somewhat receded. But it was there. I told him about the departure of the film company. And about working with such intensity after they had left. And I told him about the chair, which seemed to do something to my back, as though nerves may have been pinched. The chair. Was it the chair? I threw the chair away the next day.

Dr. Duck held my hand as he looked at it. "Are your hands always this cold?" I couldn't remember.

The next day when I went outside, my hands again became uncomfortably cold, even though it was a sunny, pleasant early-spring day. Dr. Duck referred me to a specialist in Edinburgh. I drove down to see him and he, in turn, had me examined by a skin specialist. They came to the conclusion that I had Reynaud's disease. Unless I was in a very warm house, my hands and feet were terribly cold. Most of the time. I was extremely worried. Reynaud's condition. When things were bad, I could take some kind of medicine that would affect the nerve ends and cause them momentarily to release their grip on the tiny capillaries.

The gods were showing their anger. I was an artist. I was not allowed to perform, to be on stage. My studio being used by the camera man was a desecration. To feel the thrill of immediate communication was a blasphemy. No. I had made my pact with the devil. I had prayed, saying I would do anything, ANYTHING to reveal some small touch of the truth in my work. I WOULD GIVE ANYTHING TO SEE. And to see meant to be alone. The pleasure of being seen while seeing was not to be allowed. Fear and cold and an alizarin black. Toes freezing. Some sensitivity draining from the fingers, so that now—what?

· · ·

That was April of 1971. This last year, because of a recurrent back problem, I had occasion to go to an osteopath—Dr. Kenneth Ryland. He said I did not have Reynaud's condition (a serious and potentially debilitating condition), but more likely a nerve problem which might respond to manipulation. He manipulated my neck so that the cold in my hands and feet has definitely lessened.

HANOVER, 13 AUGUST 1979

Bob Friedman, in his biography of Jackson Pollock,[78] says that after [Hans] Namuth had made a movie of the artist in 1950 (he had been on stage, and now he was alone again), Jackson started drinking for the first time in almost three years. And this was the beginning of the end.

• • •

I don't know what I expected of the movie.[79] It had been designed (twenty-nine minutes) to fill the BBC TV "culture" slot. I thought that there was, then, a gambling chance that my work would be brought before the British public—whatever the hell that would mean.

By the time the film was finished, everyone except me was mad at everyone else. Then, because of the long delays over completing the film, it was too late to sell it to the BBC, which by then had changed the format of the "culture" slot. It was shown, along with three other Films of Scotland documentaries at the Usher Hall in Edinburgh in November 1972. And it had a few other showings throughout Scotland. In terms of my career, it led nowhere. Forsyth handed it over to an agent in the United States who understood the film not at all—and did nothing.

In the end, I bought the film from Films of Scotland. It had cost some eight thousand pounds to make. I bought it for around one thousand pounds. Since then, I have shown it a few times a year when I have been visiting artist at various art schools. There are always a lot of questions afterwards. Ben Heller once said that he thought it was the best film about an artist he had seen. Perhaps. Yet, I am doomed, every time I show it, to see the flaws over and over and over. They never improve. They never get worse. And I see the paintings of that year as though there has been no progression. And I see myself locked in time. I never change. My beard stays dark. I say the same things, make the same gestures, and make the same mistakes as far as the movie is concerned. I know, as the camera pans toward me and then angles up to my face, that I will have a quirky, self-conscious smile on my face. It won't go away. And I know that I'm doomed to see some sparse, self-conscious painting take place, as I was trying to get used to working with a camera pointed at my back. And the shallow image will repeat itself as I earnestly talk about integrity. It all stays. It repeats itself. It is a human document.

[78]*Jackson Pollock: Energy Made Visible* (New York: McGraw Hill, New York, 1972; New York: Da Capo Press, 1995).

[79]*Jon Schueler: An Artist and his Vision*, Films of Scotland, 1972.

HANOVER, 15 AUGUST 1979

There was a great silence after the Demarco show in Edinburgh and after the making of the movie. Ricky and I were becoming more estranged. I realized that if we were to be friends at all, I might just as well forget about the gallery. He was off on other projects—Poles, East Germans, whatever. He was beginning his "Summer School" idea, which was to take up months of his time and energy each year. His backers were backing out. I was once again feeling more and more cut off from the world. Yet, it was an extremely exciting time. Magda was now living with me in Mallaig. And the main emphasis was on work. I worked and worked. I felt the paintings growing, shifting and changing in emphasis. The paintings piled up in the studio.

But I worried about money. I seemed always to have enough. We lived extremely simply. A painting would be sold. And then another. I took some back to the United States and sold them. One way or another I was hanging on—but I couldn't figure out exactly how.

The phone rang. It was Joan Scally of the Scottish Arts Council in Edinburgh. She had been a coworker of Magda's before Magda left the council to live with me in the Highlands. Certainly by now, the Arts Council should be thinking of giving me a show in their Charlotte Square Gallery. But no. It was not exactly the Arts Council that wanted to give me a show. It was Joan Scally who had, as one of her duties, to arrange shows for the little coffee shop in the basement of the Arts Council building. With apologies, she asked me if I would show some watercolors and a few small paintings. My God! A show in the basement! In the basement of the Scottish Arts Council. Could I get any lower? My first inclination was to say no. I probably did say no. And I probably talked it over with Magda in a compulsive way, about a million times.

Then I said, "What the hell."

I wanted the paintings to be seen. I wanted them to get out into the world and assert their being.

So I said okay.

HANOVER, 17 AUGUST 1979

Just before the show in the Arts Council coffee house was to end, the phone rang.

"This is Richard Nathanson."

"Who?"

"Richard Nathanson. I am a dealer from London. I am calling from Edinburgh, where I have just seen your watercolors and some paintings of yours. And I wanted to tell you that they are absolutely beautiful."

He had been in Edinburgh on business and had gone to see the show in the main gallery of the Arts Council. Then he had gone downstairs to the men's room and then into the coffee shop. There he saw my work.

"I bought two of the watercolors," he said.

Later he went to the Royal Botanic Garden to visit the Scottish National Gallery of Modern Art, where he saw another painting of mine. (It was the painting that Douglas Hall had purchased from the Demarco show.)[80]*

"Would it be possible to see more of your work?"

I invited him up to Romasaig.

A couple of months later, Nathanson called and said that he could take a couple of days off and would like to visit me. This was no small task. He was going to fly to Glasgow from London and then take the train from Glasgow to Mallaig—a slow seven-hour trip over the Rannoch Moors. He would be arriving on the 10:00 P.M. train.

On the day of his expected arrival, he rang again. His secretary had made a mistake. He had arrived in Glasgow too late to catch the last train to Mallaig but had managed to get as far as Crianlarich, still about three hours away. He was in the station now and was going to hitch the rest of the way to Mallaig.

In Mallaig, the autumn gales were blowing in off the sea, rain pounding on the windows. "How is the weather down there?" I asked.

"It's raining. But that's all right. I'll manage."

At about two o'clock in the morning, the bell rang. I opened the door, to see bathed in the wet light, a stooped, soft-faced man, a self-conscious smile. He was without a hat. The water was dripping off a thick sheepskin coat. He carried a large, soft leather bag, which was obviously expensive. In New York, it would be sold by Mark Cross.

He had gotten a ride all the way from Crianlarich in a herring lorry.

I thought, I have to consider a person seriously who has gone to this kind of trouble.

We all talked and drank tea and looked at some paintings. And then we talked all the next morning and looked at more paintings. He asked me if he could take a few watercolors and a few small paintings with him to London. He wanted to see what he could do.

Not too many weeks passed before I began receiving checks in the mail as he sold, piece by piece, most of the work he had taken with him.

He then asked if he could handle my work. He wanted an exclusive in the British Isles and in Europe. He would arrange shows. He had contacts in Switzerland, Italy, France. He had ideas for all of those countries and others. And he wanted to put up shows in Edinburgh and London. He would take one third commission. He would lay out the money for any shows: I would pay for half—which half would be paid for "off the top" of any sales.

I had never heard of Richard Nathanson. But he had come all the way to Mallaig to see the work. And I had no gallery, no one representing me. I wanted to go with him and have all these dreams come true.

However, I had some doubts. He was very mysterious. When I wanted the names and addresses of the people who bought my work, he wouldn't give them to me. He was adamant. I told him that it would destroy our

[80]The Sound of Sleat: *June Night, XI* *See color illustration 14.

relationship. He seemed to play everything very close to the vest, as though the names of owners of my work would be a trade secret. It turned out that they were nearly all relatives—his father, a couple of his brothers, etc. And this was curious. He had sent the checks immediately—which was great—giving a sense that he had access to London collectors who would act on his recommendations. I can only imagine that he thought that the fact the paintings were sold to relatives would take some luster off the sales. But I was pleased, one way or the other.

Richard thought it would be best to show in Edinburgh first, then in London. I decided that the first show should coincide with the Edinburgh Festival, which is held every summer during the last two weeks of August and the first week of September. Richard agreed, and we understood that he would arrange for the space in 1973.

Actually, it was Magda and I who did the scouting. Every gallery, every possible space seemed already spoken for. Then, my friend, Ken Dingwall[81], suggested the possibility of the Edinburgh College of Art. A large show had been held there once before during the festival, so that there was a precedent. Finally, I rented a large part of the art school—a great, old-fashioned Renaissance pile. I chose four huge teaching studios and the large sculpture court on the ground floor, plus another large studio upstairs.

During this period, Magda became absolutely indispensable to me. I had always wanted someone to organize that part of my painting life. I am hopeless at it. Paintings have been lost. Cartons of important papers have been lost. Records in regard to paintings—their whereabouts, their organization—have been lost, or never existed. Now Magda was getting my "career" organized. She set up a card-file system which worked with a multicopy list. She had notebooks set up for information—size, number, place and date painted. Price lists, etc., etc. Slides were labeled and filed. She helped me (hating every minute of it) photograph the work.

There was a lot of paperwork in connection with registering with the Fringe,[82] agreements with the art school and so on. She did it all. Letters went back and forth. Information was gathered and sent to proper places. She wrote letters to all the radio stations, TV stations, newspapers—making contacts for possible publicity. The result was that when the time came, the media knew where to get ahold of me and a bit of what to expect. And it meant that when the time came for installation, I could throw all of my energies into that. Magda had her finger on the rest.

[81]Scottish artist with whom Schueler was constantly in touch in Britain and later in the United States when Dingwall and Eve Thomson moved to the Midwest.

[82]The official festival events are supplemented by all those of the Fringe Festival.

HANOVER, 18 AUGUST 1979

The Edinburgh Festival show of 1973* was one of the most beautiful experiences of my life. People I had never met before would come back again and again to enjoy the paintings, to talk to me, to have coffee or lunch, to see the movie. At one corner of the sculpture court, we set up a food counter—salads and quiches and cheesecakes and apple strudels—and throughout the large central area, we had tables and chairs. By setting up the restaurant, Magda had solved one of our major problems: the Edinburgh College of Art being just a bit too far from downtown Edinburgh to make it a casual walk. People could now visit the show, relax, and then see the rest of it. For the exhibition was huge. It took us nine days of hard work to arrange and order the space and to install the show. I used three of the large studios and the sculpture court to hang 150 oil paintings and fifty watercolors. There were paintings as small as 6 x 8 inches and as large as 96 x 89 inches. They were chosen from the work I had done in Mallaig from 1970 to the time of the show. The fourth studio was used for storage. Upstairs, the movie was shown every hour. One could sit in the sculpture court, having coffee or lunch, and be surrounded by the paintings.

I would meet people for lunch, or would invite people I had just met to have coffee with me. The spirit that pervaded the place was unbelievable. I was there every day all day. And not a day passed that something beautiful didn't happen to me. An art student from London, a lovely young lady, said, "You have given us a view of eternity." A crippled lady and her mother spent a morning and had lunch and came back the following day. They bought a small painting. Day after day, paintings were sold. I could not have been more surprised. They were mostly small paintings and watercolors—but some medium-sized and some large paintings were sold, too. In all, fifty paintings and 49 watercolors were sold.

Because the show was taking place during the festival, people came from all over the world. I met Italian artists, French businessmen, English professional people, and students from everywhere. A number of actors and other theater people started to drop in as the word got around about the show. Richard Sogliuzzo[83] and his wife, Cecilia, came day after day. They brought actors and writers who had gathered around Kantor.[84] I wanted to embrace everyone. I still do. We met members of the Mummenschanz, Andres

*See color illustration 18.

[83]Richard Sogliuzzo, professor of theater at the State University of New York at Albany was acting as translator for Tadeusz Kantor during the 1973 Edinburgh Festival. Sogliuzzo's friendship with Schueler stemmed from their meeting at his exhibition.

[84]Tadeusz Kantor (1915–90), Polish director, designer and actor. His expressionist, symbolic productions at the Edinburgh Festivals of 1972, 1973, and 1975 attracted much critical acclaim. Both Schueler and Sogliuzzo were audience participators in *Dainty Shapes and Hairy Apes/Lovelies and Dowdies* of 1973.

Bossard, Bernie Schürch and Floriana Frassetto. Irving and Lucy Sandler were there from New York. They bought a watercolor. Hassel Smith[85] came and was unhappy. And we met the Pilobolus dance team, who were doing very interesting work. It was a marvelous, marvelous time and I've never enjoyed anything so much in my life.

As word got around, the media would send reporters or would call me and arrange for an interview at the BBC. Edward Gage wrote a beautiful review for *The Scotsman*. Much of the publicity developed out of the fact that I was an American who lived in the Highlands. People came from all over Scotland. They had heard the description of my work, had heard me on the radio. I think that this was because of the very special place that the Highlands hold in the minds and spirits of Scottish people everywhere. I had somehow been privileged to live in that home, and had done something to catch its spirit in my work. People would come up to me to say that they had driven a hundred miles to come and see the show. I was deeply, deeply touched.

The only fly in the ointment was that except for Marina Vaizey's nice piece in the *Financial Times*, the show was covered by none of the English papers.

HANOVER, 19 AUGUST 1979

Ben Heller. During the second week of the show, Ben Heller called to say that he was flying in to see the exhibition.

We had not talked for more than a few minutes before Ben wanted to look at the paintings. First things first. I told him the plan of the show and he disappeared into one of the rooms. He came back to rave about the paintings, and then went into another room. He came back to rave about those paintings. He asked about a series of paintings. He said, "These are not out of Rothko?" I said, "No." They were a series done after the trip to Morocco that spring and had evolved from a very specific event in the desert. He went around the rooms again. He came back complaining. "What is this, Schueler? I'm beginning to feel paranoid. Every time I see a painting that I want, it has a red dot next to it."

He disappeared again. Every once in a while, I would see him move from painting to painting, writing down notes on the back of an envelope. Finally, he came to me and presented a list of watercolors and paintings that he wanted. Three were starred.

"These three," he said, "have already been purchased. But I want them if I can possibly get them. I wonder if you could have Richard Nathanson phone

[85]Schueler had met the artist Hassel Smith (b.1915) at the California School of Fine Arts in 1948.

the purchasers and tell them that I will pay them twice the amount they paid for the paintings."

He took me aside into one of the studios. "I may be crazy," he said, "but I want these paintings. I want to do something with them. I don't know exactly what I can do, but I'm going to take the paintings and give it a try. They are beautiful."

"It sounds great, Ben."

"And what is your set up with Richard Nathanson?" he asked.

"Richard has an exclusive on my work in Great Britain and on the Continent for three years. This began last spring."

"But not in the United States?"

"No, not in the United States."

Ben set out to make another round of the paintings. Then he went to see the movie. While he and Pat were watching it, I told Magda and Richard about Ben's offer to buy the three paintings which were already sold. They were both upset. Magda thought that it was insulting. I think she hated that American way of plunging right into the fray to get what one wanted. A Scot would be more reticent. Nathanson was just troubled. Aggressive Ben Heller, who had a certain kind of power and knew how to wield it.

I asked Richard to put long-distance calls through to the three buyers. Not one of them wanted to sell. In fact, each had said in no uncertain terms that they would not sell. A beautiful smile came over Ben's face. "Isn't that wonderful?" he said. "I know just how they feel. Isn't that wonderful? That's the most beautiful thing that could be said about a painting."

HANOVER, 21 AUGUST 1979

When I went to New York after the Edinburgh Festival show of 1973, I stopped in to see Ben at his office on West 40th Street near Seventh Avenue. By that time, he had sold William Heller, Inc. to Uniroyal and now had some kind of small business having to do with using computer and TV technology for fabric design. He seemed to be operating it with his left hand. A number of the paintings I had sent over to him after the show closed were now on the walls of his office, in the hall, dominating the reception area. He also had groups of antiquities in the various areas—African pieces, pre-Columbian pieces, and the like. Nathalie Lerner was still with him as his private or executive secretary.

We went out to a delicatessen for hot pastrami sandwiches. Between the office and the deli, Ben was stopped or greeted a dozen times. He knew everyone on the avenue. It would seem there couldn't be two worlds farther apart: the art world and the fabric world. But they were together in Ben Heller.

He called me a few days later. He wanted to talk to me. I was to be leaving

New York soon. He had a completely impossible schedule, but he suggested that I meet him on 82nd (80th?) and Madison. We could sit on a brick fence there and talk. He had to see someone on business in the building at that corner at 2:00. We would sit in the sun at 1:30 and have a half hour to talk.

We realized at that meeting that both of us were talking as though he was going to handle my work.

<div align="right">HANOVER, 22 AUGUST 1979</div>

We talked over a lot of things on the sidewalk.

Ben said, "Unless I am wrong, and I don't think I am, I think you are one of the leading American painters. But few people know this. We have to do something to make your name known." He told me that he had decided to become a private dealer. But he was not doing it full-time as yet. He was not interested in having a gallery. He was interested in handling antiquities—pieces of museum quality from all over the world. He was afraid that my work and the antiquities might not complement each other from the point of view of business. From the point of view of selling. From the point of view of hanging together, they complemented each other very well indeed. Dealers and museum people from all over the world would see the work when they came to see the antiquities. He believed in both. The light of his "halo"—his reputation for picking individual pieces of intrinsic worth, of picking the best would reflect back on me. People who might be afraid to buy my work because I didn't have a big reputation, might be encouraged to buy because of his reputation.

On the other hand, I needed shows. I needed to be shown across the United States and in Europe. He didn't know whether or not he could handle my business in that sense. Whether he would have time. Whether that would mix with his other work. For one thing, there would not be enough financial return in it for him—compared to a similar amount of effort put into the publicizing and selling of the antiquities. The only way he could see that he could make money for his effort would be to buy a certain number of paintings from me each year and wait for them to gain in value as a result of his efforts. In any case, he would immediately raise the prices, as he felt my paintings were way underpriced in the States.

Would he be of help to me, or would he be preventing the chance of a regular gallery discovering me and handling my work? He didn't know. I didn't know. But I was more than enthusiastic about what Ben was offering.

We shook hands on the deal.

Ben would have an exclusive on my work in the United States. He would work with Richard Nathanson in Europe—he had some very good contacts in London and on the Continent. The European prices would have to be raised—perhaps in a year's time—to approach the New York ones. But an allowance should be made, which we'd have to work out.

Ben asked me how much it cost me a year to live and paint. He was surprised at the cost of supplies, which was more than my cost of living. Still, he felt that he should be able to sell enough to cover all of my expenses.

Meanwhile he had shown the work that had been sent over from Scotland and had already sold some pieces. The response, he said, had been very strong.

I left Ben at the door of the office where he had his two o'clock appointment.

I thought: Finally, I am stepping away from the edge of the cliff.

• • •

That Friday, Magda and I went out to East Hampton to spend the weekend with Ben and Patsy at their summer house.

On Saturday morning, I was up early. The butler gave me *The New York Times* to read while I had breakfast. On the lower right-hand corner of the front page was a story about the sale of the Jackson Pollock painting *Blue Poles* to the government of Australia for their new museum.

The owner of *Blue Poles* had been Ben Heller. The amount paid to him by the purchaser was $2,000,000—the highest price ever paid for a relatively contemporary painting.

HANOVER, 23 AUGUST 1979

Preparations for the Whitney show.

I had kept up with Jack Baur[86] through the years. At least I knew, one way or the other, that he was aware of my work. He liked nature; he had liked my vision of nature. The Whitney Museum owned a couple of paintings of mine[87] and occasionally they were brought out and hung. In fact, around this time I walked into the Whitney and saw a large red painting of mine hanging in the lobby. Periodically, I showed him slides of my work. And one time when I had brought a few paintings to New York from Scotland, I asked him over to Bob Friedman's house for coffee and to see the work.

Around the time of this 1973 visit, I learned that Jack Baur would soon be retiring as head of the Whitney and that there were a few things he wanted to do before leaving. One of which was to give me a show—if possible. There is a small gallery—one room—on the main floor which is used to give one-man shows to artists without a gallery, whose work has merit

[86]Jack Baur, director of the Whitney Museum of American Art.
[87]*Snow Cloud and Blue Sky*, 1958 (80" x 71"), *See Color illustration 5; *Red Snow Cloud*, 1961 (79 ½" x 90"); and a lithograph, *Night Sun*, 1962 (22" x 17 ½").

but is not being seen. Usually, this means shows for younger artists. I wasn't younger, but I certainly had no place to show.

But he had to sell the curators on the idea, with a good chance that they would reject it. The more powerful of them were dedicated to certain movements of the '60's which were antipathetic to what I stood for.

Luckily, I had the movie which I had brought with me from Scotland at Baur's request. And Ben now had the paintings. The curatorial staff was invited to see the film in their projection room. (It was wonderful to watch it being screened with top equipment.) And then afterward, they were invited to see the paintings, beautifully lit, in Ben's apartment.

Who knows what went on behind the scenes, but I heard later from Jack Baur that the Whitney would give me a show in the spring of 1975. Ben would co-operate with Jack in choosing the paintings, getting them together, and providing the information. As it turned out, he would also have a word in hanging and lighting the show and in painting one of the walls a deep grey.

HANOVER, 24 AUGUST 1979

1973-1974

My life seemed to be falling into a very satisfactory rhythm. We would spend three or four months at a stretch in Mallaig. I would work with great intensity, seven days a week. It was an experience that any artist would want and could understand. I thought about nothing except work. I would put in two-week sessions every now and again just working on watercolors. Totally involved. Then I would retreat from the watercolor room and start working in my studio. I would immerse myself in oil painting. The place would reek of turpentine.

Once in a while, we would take walks, visit Archie and Barbara MacLellan or Hamish and Joan Smith. Sometimes friends from Edinburgh, London, from the United States would visit us. I would stay in the studio while they went for hikes across the moors, and would come out for a visit when they returned. Often I would work while they sat in the living room before the fire, talking. I have never worked so hard or so consistently. Magda would think up diversions so that every three months or so we would take a little trip. Then, refreshed, we would drive back in the Mini to Mallaig and to work. It was one of the high points of my life. I felt to the utmost my dedication to my work. The studio was filling with paintings. I had Magda, the loveliest woman I had ever known. We had already been together for three years. I now believed our relationship could last forever. Then, I had Ben. I felt secure in his concern. I knew what he thought of the work, and how important it was that I go on producing as I had been producing. And I had faith in his ability. As he told me, it was my duty to paint. It was his duty to sell the work and see to it that I had an adequate income. He staked his pride on that.

Almost immediately, I started getting invoices from Nathalie Lerner signifying sales of paintings. Large paintings, small paintings. Watercolors.

Ben's commission was fifty percent, but well worth it. There was just no way that this activity could take place without his help, his skill.

As time passed, I heard less and less from Richard Nathanson. Ben, by doubling the price of the paintings, made it impossible for him to operate in Europe. I felt sad. It had been his phone call from the basement of the Scottish Arts Council which had started all of this. I felt grateful. And I felt sentimental.

At the same time, though, I was moving into another business relationship in New York. Peter and Alexandra Rose very much wanted to handle my work. Peter was a specialist, being in touch with corporations, decorators, banks, architects. More and more businesses were forming their own collections and hanging paintings in boardrooms or public areas. The Roses worked out a deal with Ben, splitting the commission on anything they sold.

HANOVER, 25 AUGUST 1979

The same vacillation between feelings of doubt and certainty that occurs when paintings don't sell takes place when you sell paintings. I knew better, yet when Ben almost trebled my prices, I started to feel that my own worth was reflected in the price. I found myself having to talk about my connection with Ben because it seemed to reflect or reveal my own worth. I couldn't stop myself.

HANOVER, 26 AUGUST 1979

By the spring of 1974, Ben required more paintings. He wrote to say that he and Patsy would come up to Mallaig to select them. Time was of the essence to him. I can't tell you how many calls were made back and forth across the Atlantic to get them in and out of Mallaig within thirty-six hours.

He looked at every painting in the studio. He made a first choice. He went through them again. He narrowed his choice down, going over and over and over the paintings. He would remember each painting in intimate detail. He would remember those paintings he had of mine in New York. This was the Ben Heller I knew from the beginning—from that day in 1954 when he came down to my 12th Street studio and I met a man whose voracious appetite for painting was as great as my need to create them. We talked about our plans for the Whitney show. Ben said that he had begun making contacts for other shows. The Whitney show was just the beginning. We would have to orchestrate shows. There were plenty of paintings. We didn't have to worry about that. There were few artists who were so prolific. We just had to find the best circumstances to show the work.

• • •

We decided to take Ben and Patsy for a walk along the Burma Road. We looked across the Sound of Sleat to the Isle of Skye and climbed to the top

of the Cruaich to see the jagged force of the Black Cuillin Hills and the pro-
foundly female, round sensuality of the Red Cuillin Hills.

And there it all was spread out in front of us.

We sat and rested a while.

"What people don't realize," he said, " is that your work is completely abstract."
I nodded.

"And then what they don't realize is that your work is absolutely real."

"That's it, Ben," I said. "That's exactly it. That's what I want. The abstract
is real and the real *is* abstract."

It's right in front of you. Right in front of your eyes. That's where the mys-
tery is. That's where the truth lies.

<p style="text-align:center">• • •</p>

There were two shipments of paintings sent to New York before the Whitney
show. One was of the group Ben had assembled when he visited Romasaig.

Later in the year he had planned to make another trip up to Mallaig, but
for one reason or another, he couldn't make it. So he had me send over a
group of slides and he chose paintings from them. He had always been dead
against choosing from slides, but on this occasion he could see no alternative.

It was necessary to have as many as possible to choose from. He had sold
a number of paintings. And he had already sparked another show. Sherman
Lee, director of the Cleveland Museum of Art, had seen my work while vis-
iting Ben's home. The outcome was a show entitled: *Landscapes, Interior and
Exterior: Avery, Rothko and Schueler.* This would be held at the Cleveland Mu-
seum in the summer of 1975, after the Whitney show had closed. Ed Hen-
ning, curator of American Painting, would do a catalog. Which he did. It
was beautiful, with some paintings in color and some in black and white. A
color reproduction of a painting of mine was on the cover. The black-and-
white reproductions of my work had the appearance of drawings I wish that
I had made.

In any case, a lot of hard work had to go into that show—picking out
the paintings of mine, getting ahold of certain Rothkos (the Rothkos came
mainly from Ben's collection), making arrangements with Mrs. Sally Avery
for the loan of paintings she owned. All of this work and much, much, more
was done by the museum and by Ben. I kept painting away.

HANOVER, 28 AUGUST 1979

My fingers move over the keys. To open which door?

Clyfford Still is about seventy-eight years old. The Metropolitan Museum
is mounting a large show of his work in November.

I will be sixty-three in September. Can I live two more lifetimes?

When I pause, I always feel that I am just beginning.

I've got to get going. I can't see why I shouldn't be able to write today. I had been concerned about getting part two of the manuscript to Gunther Stuhlmann. Bob Friedman has formed this introduction to his agent[88]. But that couldn't have stopped me. I was stopped yesterday.

The Whitney show: From one point of view, it was not all that big a deal. Some might even look at it as a prize for losers. However, I was very happy to have the exhibition, and I was deeply touched by the sensitivity of Jack Baur's statement in the brochure. And by the sense it gave of his understanding and commitment:

> Jon Schueler has walked a difficult path between opposites. His paintings look abstract but are not. The character of the Scottish coast, where he lives, speaks through these poetic canvases with remarkable clarity and exactness. One has only to compare them with the Highland skies to understand how true the paintings are to the light, the atmosphere, the dramatic spirit of the place.
>
> And yet these are basically abstract pictures, not unrelated to the work of Mark Rothko or some of Clyfford Still's big canvases. They have that kind of largeness, mystery and power. They strike a more precarious balance between observation and abstract form than do most paintings that try to wed the two—such as those of Milton Avery or Georgia O'Keeffe, to name at random artists who have succeeded in their own way.
>
> Schueler's solution is more difficult because it is less obvious. He risks more by deliberately exploring a narrow area where nothing is secure, where everything is changing, evanescent and evocative. We see his paintings one minute as clouds and sea and islands, the next as swirling arrangements of pure color and light. And they shift back and forth in our vision from one pole to the other, amassing richness from both. It is hardly necessary to add that their impact is unabashedly romantic and poetic.

On the cover of the brochure was a reproduction of *Ode to Bunty: A Winter Dream*.[89]

Most of the people who came to the opening were friends. Many I had not seen for years. I was happy next to tears. I introduced Magda to many. Others were already known to her. Eleanor Ward came. And Leo Castelli. God bless Leo. He spent some time looking at the paintings and sought me out afterwards to comment on the beauty of the work. Many commented on

[88]Gunther Stuhlmann, who had edited the five volumes of *The Diary of Anaïs Nin*, was at this point considering taking on *The Sound of Sleat*.
[89]1974 (69" x 76").

the spirit of the show. And of the opening. It had that quality of the Edinburgh Festival show. People felt they knew each other just because they were there. And Mary [Rogers] came—I hadn't seen her for years—appearing quite matronly. Jody was so beautifully warm in her response to the work. (She told me afterwards that she had spent some time with Leo in the exhibition room. Jody had said, "See, Leo? You were right. You were right, Leo." And he nodded his head in agreement.)

I wish that Judy had been there.

And Jane. Poor Jane.

And what happened to June Lathrop? I never saw her again.

But Elise came to the show, jaunty and attractive.

And many other women from the past. When I'd see them, I would feel they were of my present and future, as well.

Big party at Ben's. I stood in one place in the vestibule all evening—while people came up and talked. Women brought me food.

HANOVER, 29 AUGUST 1979

I felt good. I felt solid, outgoing. I loved my friends. I loved the women of my past and present. I loved the staff at the Whitney, who were so warm and responsive to the work. I can't tell you how responsive they were. Including Smitty [Marshall Smith], the guard, who has kept an autographed copy of the announcement card in his living room.

I felt good in a way I had never felt before. I had felt happy, in ecstasy, thrilled. But I had never felt just good. My feet feeling the solid earth—even though Ben said that I was flying.

I had so many friends. So many deep, warm friendships. I had my work, and I had such a beautiful response to my work. I had Ben—who was my friend, and who was embracing that very difficult arena where work comes out into the world. And above all, I had Magda who was so very special, so unlike any woman I had known before, so strangely independent, keeping her own counsel, not getting mixed up in the contradictory passions of my creative being—yet taking over so many areas of work that I could only think of it in terms of a dedication to the work to equal mine. Talking to Sandra II about Magda—about her very special qualities and about my feeling of dedication toward her—I said that I would never do anything to hurt our relationship—it was too precious to me. I felt there was nothing that could be worth testing the beauty of our relationship.

I was happy.

• • •

We flew back to Scotland by way of Iceland, where we spent a day and a half. The lava flows are so new in geologic time that the first flecks of green are just beginning to cap the surface. The long, porous surfaces, chilled

darkness of an underworld, left us slightly depressed. We ate our meal in silence.

But I was so eager to get back home and to get to work. I couldn't wait. The thrill of it. To have just put up a show in New York, where friend after friend would see the work. And ahead of me the embrace of my studio in Mallaig, where canvases were stretched and primed, waiting the onslaught. I could feel the pressure of work inside me—the desire for the outpouring of imagery, a dozen paths to be followed at once. Once again, I was just beginning, with all the thrill and excitement that that suggests.

We were both too eager to get to Mallaig to spend more than the necessary time in Edinburgh. We saw Magda's mother, took care of some business and errands, packed up the Mini, and headed north. North! It was Magda's insistence more than mine which made us start a day earlier than we had planned. Magda had been working with Hilary Runcieman, creating a much-needed play school in Mallaig. Now she'd be able to turn her attention to it once again.

NORTH! MALLAIG! WORK!

We arrived on a Sunday—late afternoon. The sun was bright against the waves and brushed a subtle light against small storms forming over the sea near Rhum. My picture was in the making.

On Monday we drove into Mallaig to do the shopping. I decided to spend the day cleaning the studio and making everything ready. And in visiting the MacLellans that evening. The following morning, I took care of some correspondence and finished my preparations in the studio. The brushes were laid out. The palette was ready. The heat had been on for over twenty-four hours, and the chill was out of the air. I decided that I would start to work that afternoon after lunch. By two o'clock.

I felt so very good. Ready to work.

Magda fixed a lunch of soup and rich Mallaig bread and apples and cheese.

While we were still sitting at the table waiting for the coffee to cool, Magda said, "I think we should go our separate ways."

"What!"

"I think we should now go our separate ways."

I could feel a life force draining out of me. Death must be like that.

I knew there was no point in arguing. Magda was going to leave. She had made up her mind. A year ago, I would have fought and argued. But now I knew Magda better. Once before, she had suggested leaving. After our first two-year "contract"—which I had taken as a joke, but which had been real to Magda. Now the second two years had passed, and she was ready to go. I could just as easily have known that it was going to happen, but I had put it out of my mind.

"What are you going to do?"

"Well, I realized that you have become more involved with New York. You talked about getting a studio there."

It had been a long-standing dream of mine to be able to work in Mallaig

and New York—flowing back and forth between the two places I loved, and the two tensions which were so much a part of my being.

"I thought I might enroll at Moray House in Edinburgh to get my teaching credentials."

"Your teaching credentials!"

"Yes. I have decided I want to teach. English Literature in a secondary school. So I have to take education courses and get my teaching certificate."

"To teach where?"

"Preferably in Edinburgh."

My voice had a hollow sound to it. It was hard to pull sound and meaning from the black lethargy which was coming over me.

"Why didn't you tell me?"

"Well—I didn't know exactly what I would have to do. I visited Moray House while we were in Edinburgh—"

"When?"

"Friday morning. The day after we arrived. I found out that I can enroll now and start classes in October."

"What did you want to do until then?"

"I thought it would be nice if we could spend the month here—until the first of June—and then I would leave."

"Me. Here alone."

"But you love it here. And you'll be going back to New York."

"I can't do that, Magda. I'm not that cool."

"What do you want to do?"

"We'll see. I couldn't stand it here alone. I'll close Romasaig for a while. I'll go to New York and find a place. I'll need lots of people."

She kept looking at me but didn't say anything. She was on another planet. And seemed quite happy to be there.

HANOVER, 30 AUGUST 1979

Magda couldn't have been lovelier. The peace of angels smoothed her face. She was terribly busy. She had to visit everyone she knew in Mallaig, Hilary of the play school, the MacLellans, Hamish and Joan, Mrs. Watts, the postmistress and Mrs. Innes at the grocery store. She said good-bye to all of them. She wouldn't be back in the fall. She would be studying at Moray House.

I didn't know what to say to any of them. There was nothing for me to say. It was all Magda's show. I felt like a shadow on the periphery. I remember standing in the backyard with Hamish. Magda was talking to someone, wishing a fond farewell. It was as though I wasn't there. Hamish, who is seldom non-plussed, said, "Acting. It's all acting." But it wasn't acting. It was a graciousness which went so deep that it had to create its own realities.

Pain was not to be displayed. It was better to pretend I was not there. Or rather, that I was part of a sensible arrangement. But no one referred to my part in public.

So, she said good-bye, neatly and tidily, to all those in Mallaig who mattered to her. And as tidily, the yard was cleaned up and the house was cleaned like it had never been cleaned before. Stacked next to the garage were over a dozen herring boxes which Magda had lugged over the moors from various places where they had floated to shore. They formed a wall next to the corrugated iron of the garage—practically holding it up. I had always teased Magda about her Scottish frugality. Nothing should be wasted. The boxes could be cut up and used for kindling—which, indeed they were. Now Magda wanted them all hauled down to the pebble beach and burned. I entered into the spirit of the thing. It was a flaming rite, Magda hauling down the crates in the gathering damp and darkness, and I slamming them on to the fire. The flames went crazy, lighting up the beach and the separate forms of Magda and me. A bit of rage in me fed the flames. But the relief could last only minutes when the sadness took over.

That night in bed, I told her about my conversation with Sandra II,[90] in which I had expressed my love for her, Magda, and said that I would never do anything to jeopardize our relationship, which had been the most meaningful I had ever had. With that, she started to cry and said, "It's too late, too late!" and she cried in my arms until she fell asleep.

I didn't even know what she meant.

Under the watercolor table, Magda had gathered herring baskets full of cereal boxes, colored paper, hunks of wood, anything which might conceivable be used for the play school. I had teased her about taking this room over. Now she hauled all the stuff out and burned it.

She gave away the plants which had cheered the living area. One plant was in a pot hanging from the ceiling. I had particularly liked this one because of the gentle way it had divided the living area from the kitchen area. She took it down and gave it away. She had only seen me as a person who made fun of the plants.

Outside and inside Romasaig became more and more pristine. Bits of door which needed painting were painted. The fence was finished. Everything was made tidy. Everything was put in its proper place. Everything that could be thrown away was thrown away. By the day we left, the place looked cold and unlived in. But very neat and very clean.

I was torn. I wanted to stay and work. But I knew that I could not stay and keep my sanity. I was going to have all I could do to hold myself together until I got to New York. I locked the doors of Romasaig. I was going to leave it that way, cold and neat, until I returned. Rolls of canvas, dozens

[90]Sandra Levowitz

of stretcher bars, cans of primer, turpentine, hundreds of tubes of paint—all would have to wait for me. And stacked through the house—in the hall, in the spare bathroom, in the living area, in the studio, were over a couple of hundred finished paintings.

A F T E R W O R D

With the description of Magda's leaving, the last of the events that needed to be woven into the narrative, Schueler felt that he had completed the book. The job of editing the manuscript remained. As in earlier times, after an intense period of writing, he plunged back into painting, but the project would be revived in the summers, especially that of 1982, when instead of going to Mallaig, he settled into B.H. Friedman's study/apartment in Provincetown, Massachusetts, for two months. That same summer, Russell Banks, living in Schueler's New York loft, read a copy of the manuscript and sent him enthusiastic encouragement. Banks, along with Jay Parini and B.H. Friedman, wrote a strong letter of recommendation to publishers. Although several independent editors initially took up the project, the book was not to appear during Schueler's lifetime. Magda Salvesen, who had returned to live with Schueler in 1976 after a year's "sabbatical", would herself take on the responsibility for seeing the project to its completion.

Meanwhile, a New Yorker profile on Jon Schueler and Magda Salvesen by Whitney Balliett appeared in February 1985. Besides airing many of the themes and preoccupations of The Sound of Sleat, it contained a remarkable description of the artist in the process of painting.

Schueler's painting career continued to develop between 1979 and 1992, the year of his death. Perhaps the single most satisfying exhibition of that period was the one that came about in 1981. Duncan Macmillan, the director of the Talbot Rice Art Centre of the University of Edinburgh, had wanted a show of the very large Schueler paintings for his enormously high ceilinged and imposing space. As the cost of shipping the paintings over from New York was prohibitive, Schueler came up with the suggestion that he take over the gallery as a studio and create the paintings for the exhibition right there. It was a risk on Macmillan's part, but he agreed. To Schueler, it was an invigorating challenge, which resulted in the six very large canvases called The Search.

In the United States, in a quiet way, the number of shows increased. Out of the blue, a letter arrived in 1982 from Mr. Sachs of the A.M. Sachs Gallery, asking him to phone. This led to the 1983 one-man exhibition in his gallery on West 57th Street, New York and to another in 1984. When Katharina Rich Perlow took over that gallery and later changed the name to her own, Schueler was invited to exhibit with her. Four one-person shows took place in her gallery between 1986 and 1991. After Schueler's death, the ACA Galleries in New York became the agents for his work.

Outside New York, John Stoller in Minneapolis, Minnesota, Dorry Gates in

Jon Schueler painting in the Talbot Rice Art Centre, University of Edinburgh, Scotland, August-September 1981.

Kansas City, Missouri and Dorothy Rosenthal in Chicago all mounted Schueler exhibitions during the 1980s and early 1990s and continued to represent him until they retired. The years, therefore, were punctuated by studio visits from these dealers/ friends to see the latest work and to make selections. Back in Edinburgh, the Scottish Gallery started showing his work in 1991. The later paintings of strong colors and energetic gestures (in spite of almost constant back pain) reflect a response to the rhythms of models who usually came to the studio twice a week.

Schueler continued to return to his studio in Mallaig. Since 1970, he had rented the old schoolhouse, Romasaig, from his friend Archie MacLellan under the most amicable circumstances. However, in the summer of 1987, when Schueler had remained in New York (as a new road was being blasted into existence close to the Scottish studio), an apologetic letter arrived from Archie saying that he now required the house for one of his sons. It was a devastating blow. Suffering from what was at first diagnosed as polymyalgia and then Parkinson's disease, Schueler didn't feel that he had the energy to set up another studio in Mallaig, even in the unlikely event that a suitable space became available. Fortunately, the problem was resolved: Schueler was for the first time given the opportunity to buy

Romasaig, and Brian McLellan then used the money to build himself and his family a completely new house in the hamlet of Mallaig Vaig. During 1991, his last summer in Scotland, Sue Pirnie, of the Highland Regional Council, organized a touring exhibition of his work, The Skies of Mallaig, which came to the Mallaig Village Hall, the very same place where twenty years before he had put on a show for the people of the village prior to the paintings leaving for the Richard Demarco Gallery in Edinburgh. Schueler, ill and very frail, visited the exhibition for a short while every day during the week it was there, talking to Mallaig friends and acquaintances who drew up a chair beside him. All recognized, in their own way, the power of the Sound of Sleat, and the Sleat Peninsula, and off in the distance the islands of Skye, Rhum, Eigg and Muck.

Inevitably, there is some overlap in the subjects/categories listed, but the index aims to be as comprehensive as possible.

Bold=photograph